ART VISIONARIES

MARK GETLEIN
ANNABEL HOWARD

Laurence King Publishing

ART
VISIONARIES

SIONARIES

LAURENCE KING

Published in 2016 by
Laurence King Publishing Ltd
361–373 City Road
London EC1V 1LR
e-mail: enquiries@laurenceking.com
www.laurenceking.com

A catalogue record for this book is available from
the British Library.

ISBN: 978 1 78067 577 0

Printed in China

Book Design: Robin Farrow
Cover Design: Pentagram
Cover Image: *Pablo Picasso with his sculpture Tête
de Femme, Vallauris, 1951.*
Picture Researcher: Julia Ruxton

INTRODUCTION

At the dawn of the twentieth century, art as we know it was barely 100 years old. Like modernity itself, it was a child of the nineteenth century. Not so long previously, painting and sculpture had been classified as 'fine' arts, together with poetry, music and architecture. But, as the nineteenth century began, the adjective tended to drop away, leaving only art. Often distinguished with a capital A, the word took on a prestige it had never enjoyed before. The transformation was not lost on contemporary observers. 'In place of the fine arts, which we all knew by name, we have Art, the new king that the century has raised up', wrote a French journalist in 1835. 'Art is practically a cult, a new religion', observed another. 'Even money, that power of our time, is forced to recognize a rival force.'

The word 'artist' also took on a more elevated sense. Now clearly distinguished from artisans, artists were inspired creators wholly dedicated to serving this new religion, whatever the cost. 'Artists above all, my dear friend,' French poet Alphonse de Lamartine wrote in a letter of 1810, 'artists, I love these people who aren't sure of a meal tomorrow, but who wouldn't trade their philosophical hovel, their brush or their pen for a pile of gold.'

As manifestations of art, painting and sculpture began to evolve in ways that reflected the quickening pace of history itself. 'For some twenty years, art has been in permanent revolution,' a Parisian journalist lamented in 1851. 'A crowd of schools, one stranger and more eccentric than the other, are born and die with frightening rapidity.' Romanticism, realism, Impressionism, Symbolism – the parade of 'isms' had begun.

The twentieth century would see an explosion of them: Fauvism, Cubism, Expressionism, Futurism, metaphysical painting, Suprematism, Constructivism, Neo-plasticism, Dada, Surrealism, Spatialism, Art Informel, Abstract Expressionism, Pop Art, Poor Art (Arte Povera), Minimalism, Conceptualism, Land Art and more. Some were discerned and named by critics, writing a first draft of art history on the fly; others were founded by artists or poets, who declared their intentions in statements and manifestos.

Under pressure from artists with new sensations and ideas to express, art in the twentieth century revealed itself to be an open-ended idea and earlier certainties about its nature were overturned, one after the other. The assumption that art's task was to represent the visible world was swept aside by the invention of abstraction. The belief that art was the last refuge of the handmade was challenged by the exhibition of manufactured objects as art. Beauty, so closely associated with art, was yet shown to be not vital to it. Painting and sculpture, long held to be synonymous with art, were joined by collage, happenings, performance, photography, video, objects, environments and installations. Bronze and marble, the privileged materials of sculpture, made way for iron and steel, for wood, clay, neon tubing, fibreglass, textiles and cardboard.

The geography of art shifted, as Paris, the acknowledged capital of art since the nineteenth century, was supplanted in the mid-twentieth century by New York, which in turn took its place in a constellation of world cities. The demographics of art were transformed as well, with women claiming a place in accounts of art history and appearing in increasing numbers as pre-eminent contemporary artists.

This book brings together 75 artists who defined art in the twentieth century, from the revolutionary enthusiasms of its opening years through the gilded assurance of its final decade. Arranged chronologically by birth date, the entries trace the unfolding of the century through the lives, works and words of the artists who created it. My co-author and I divided the project neatly between us. I am responsible for the first two thirds of the book, from Wassily Kandinsky to Ilya and Emily Kabakov; Annabel Howard enters with Christo and Jeanne-Claude and continues to the end. She did, though, also do Robert Rauschenberg, and I hereby confess that Eva Hesse is my doing.

Mark Getlein

129.4 × 131.1 cm (51 × 51⅝ in).
Solomon R. Guggenheim Museum, New
York. Solomon R. Guggenheim Founding
Collection. By gift, 37.241.

'The content of painting is painting. Nothing has to be deciphered.'

Wassily Kandinsky

1866–1944

RUSSIA

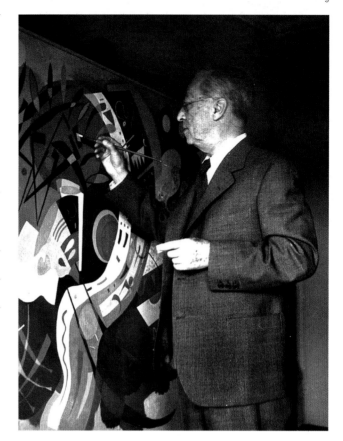

Abstraction was the most radical artistic innovation of the twentieth century and no one was more central to its invention than Wassily Kandinsky. Kandinsky may not have painted the very first abstract picture – his name is among a small handful of candidates – but it was he who developed the possibilities of abstraction most variously, who pleaded its cause most eloquently and who wrote some of its most influential theoretical statements.

In his book *On the Spiritual in Art*, Kandinsky positioned abstraction as a manifestation of the spiritual awakening that was finally beginning to break the spell of the nineteenth century – 'the whole nightmare of the materialistic attitude,' he called it, 'which has turned the life of the universe into an evil, purposeless game'. Now, all across Europe, new directions in art were linked by a common tendency towards abstraction, as artists turned inward: 'Consciously or unconsciously, artists turn gradually towards an emphasis on their materials, examining them spiritually, weighing in the balance the inner worth of those elements out of which their art is best suited to create.'

The element that most enchanted Kandinsky was colour. 'Colour is a means of exerting a direct influence upon the soul,' he wrote. 'Colour is the keyboard, the eye is the hammer, the soul is the piano, with its many strings. The artist is the hand that purposefully sets the soul vibrating by means of this or that key.' Colours, forms, lines and even objects all had unique spiritual sounds that an artist could orchestrate to touch the soul of a sensitive spectator, giving rise to 'emotions we cannot put into words'. This was the ultimate goal of what he called 'pure' or 'absolute' painting.

Kandinsky's own path to abstraction had been through colour, which he began to use with increasing freedom, leading to works such as *Picture with an Archer*. That same year, he began to paint spontaneous *Improvisations* and grander, more carefully planned *Compositions*. Although each painting took a theme as its point of departure, only vestigial traces of recognizable subject-matter remained by the time they were finished. Finally, in paintings such as *Black Lines*, Kandinsky let go of subject-matter entirely. 'This occurred without force, quite naturally, and of its own accord,' he recalled not long afterwards. 'In these latter years, forms that have arisen of their own accord right from the beginning have gained an ever-increasing foothold, and I have immersed myself more and more in the manifold value of abstract elements.'

Kandinsky's earliest abstract paintings met a savage critical reception and opposition to abstraction persisted, to some degree, for his entire life. Nevertheless, his faith never wavered. 'In my opinion,' he wrote, 'this consistent opposition . . . is the best proof of the necessity of abstract art and the extent of its power. Anything that progresses smoothly and quickly is invariably a nonentity.'

Above Portrait of Wassily Kandinsky, 1936.

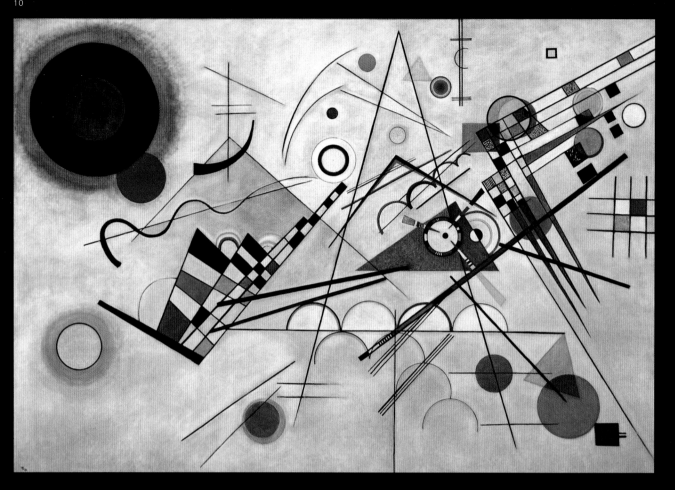

Above *Composition VIII* (*Komposition VIII*), 1923. Oil on canvas, 140 × 201 cm (55⅛ × 79⅛ in). Solomon R. Guggenheim Museum, New York. Solomon R. Guggenheim Founding Collection, by gift, 37.262.

Left *Picture with an Archer*, 1909. Oil on canvas, 175 × 144.6 cm (68⅞ × 57⅜ in). Museum of Modern Art, New York. Gift and Bequest of Mrs Bertram Smith. Acc. n.: 619.1959.

Opposite *Sky Blue*, 1940. Oil on canvas, 100 × 73 cm (39⅜ × 28¾ in). Musée Moderne, Centre Georges Pompidou, Paris.

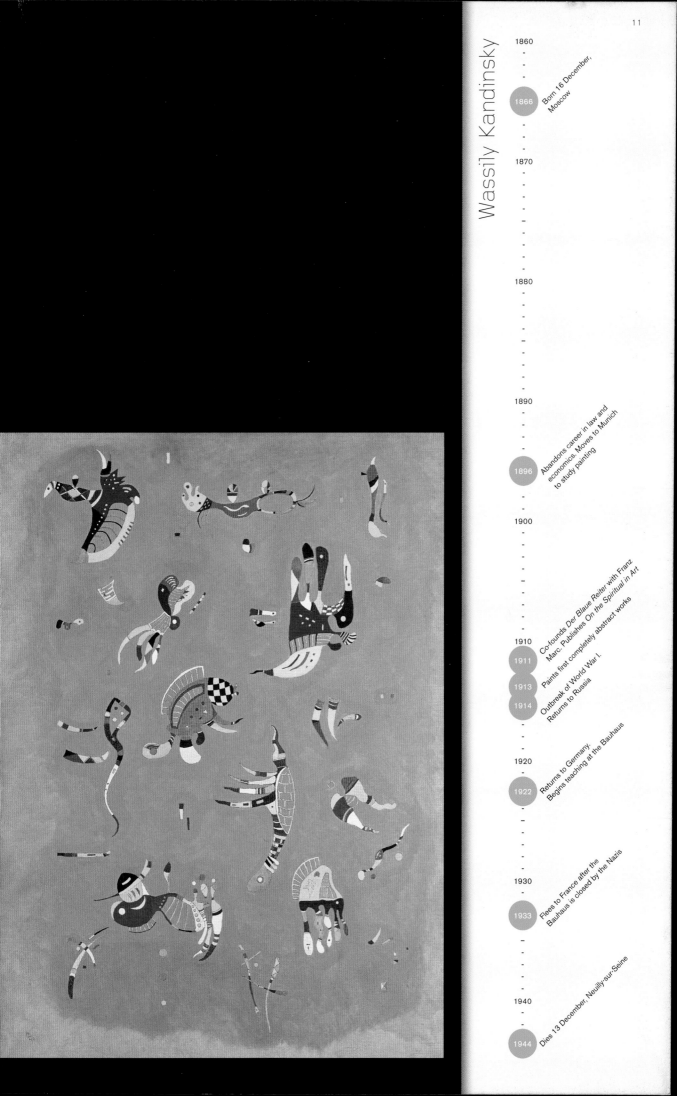

Wassily Kandinsky

1860
-
-
-
1866 Born 16 December, Moscow
-
-
-
1870
-
-
-
-
-
-
-
-
-
1880
-
-
-
-
-
-
-
-
-
1890
-
-
-
-
-
-
1896 Abandons career in law and economics. Moves to Munich to study painting
-
-
-
1900
-
-
-
-
-
-
-
-
-
1910
-
1911 Co-founds *Der Blaue Reiter* with Franz Marc. Publishes *On the Spiritual in Art*. Paints first completely abstract works
1913
1914 Outbreak of World War I. Returns to Russia
-
-
-
-
-
1920
-
1922 Returns to Germany. Begins teaching at the Bauhaus
-
-
-
-
-
-
-
1930
-
1933 Flees to France after the Bauhaus is closed by the Nazis
-
-
-
-
-
-
1940
-
-
-
1944 Dies 13 December, Neuilly-sur-Seine

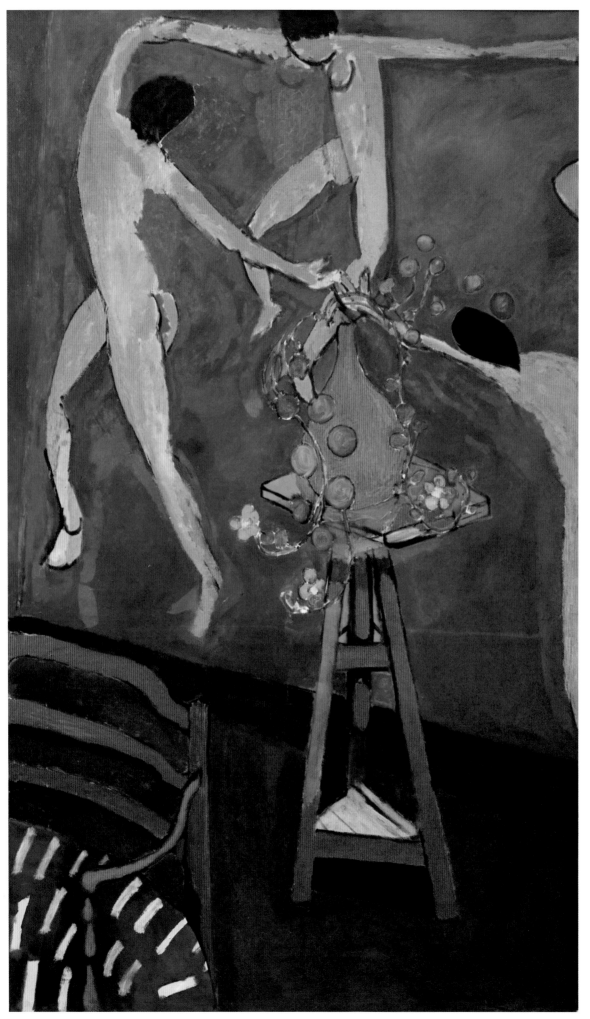

'What I dream of is an art of balance, purity and serenity.'

Henri Matisse

1869–1954

FRANCE

'All things considered, there is only Matisse,' Picasso said. The two painters who dominated the art of the twentieth century were linked by mutual admiration – a friendship that modulated from wary to warm – and a productive rivalry. 'There is only one person who has the right to criticize me,' said Matisse. 'That is Picasso.'

Henri Matisse discovered his calling by chance. At 20, he was resigned to working as a law clerk when an illness sent him to the hospital for an extended stay. To help him pass the time, his mother brought him a box of paints. 'From the moment I had that paintbox in my hands, I felt that this was my life,' he recalled. 'Here was a sort of Paradise regained, where I was completely free, alone and at peace.' The idea of painting as a paradise stayed with him for the rest of his life: 'What I dream of is an art of balance, purity and serenity, devoid of troubling or depressing subject-matter, an art that could be . . . a soothing, calming influence on the mind.'

Matisse's paradise was made of colour. Along with André Derain, he initially began to work with pure colour following the principles of Neo-Impressionism, with its short, discrete brush strokes. During the summer of 1905, the two friends overthrew this discipline in favour of colour applied in dashes and lines, in scribbles and flat areas, colour freed from its descriptive function, arbitrary and exuberant. The paintings they showed that autumn created a sensation. A critic compared them to *fauves*, wild beasts, and, as Fauvism, the name stuck. It was the first avant-garde movement of the twentieth century.

Matisse quickly moved on from the explosive, fragmented style of Fauvism towards the joyful, serene and luxurious art that he had envisioned. He drew inspiration from Cézanne and Gauguin, from Italian primitives such as Giotto, from patterned textiles, Byzantine icons, tribal sculpture and the painting and decorative arts of Islamic cultures. Colour flooded into such paintings as *Nasturtiums and 'The Dance'* uniting foreground and background, inside and outside in one continuous space. 'For me, the subject of a picture and its background have the same value . . . there is no principal feature, only the pattern is important,' he explained.

Born under grey northern skies, Matisse loved the brilliant light of the Mediterranean. He settled eventually in Nice and travelled to Tahiti to experience the light of the Pacific ('like the light produced in a gold chalice when you look right into it'). Memories of his time there surfaced in *Beasts of the Sea*, one of the cut-paper works of his last years. 'Colour helps to express light,' he said. 'Not the physical phenomenon, but the only light that really exists, that of the artist's brain.'

Opposite *Vase of Nasturtiums and 'The Dance' (II)*, 1912. Oil on canvas, 193 × 114 cm (76 × 44⅞ in). Pushkin Museum, Moscow.

Above Portrait of Henri Matisse by Gjon Mili for *Life* magazine, 1948.

Above *Artist and Goldfish* (*Goldfish and Palette*), 1914. Oil on canvas, 146.5 × 112.4 cm (57¾ × 44¼ in). Museum of Modern Art, New York. Gift and Bequest of Florene M. Schoenborn and Samuel A. Marx. Acc. n.: 507.1964.

Opposite above *Beasts of the Sea*, 1950. Paper collage on canvas, 295.5 × 154 cm (116⁵⁄₁₆ × 60⅝ in). National Gallery of Art, Washington, DC. Ailsa Mellon Bruce Fund 1973.18.1.

Opposite below *La Musique*, 1939. 114.9 × 115.2 cm (45¼ × 45⅜ in). Albright-Knox Art Gallery, Buffalo. Room of Contemporary Art Fund, 1940 (RCA1940.013).

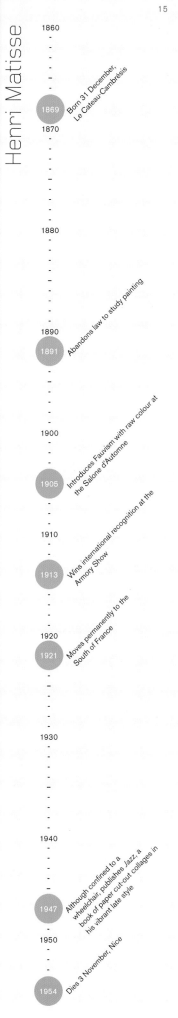

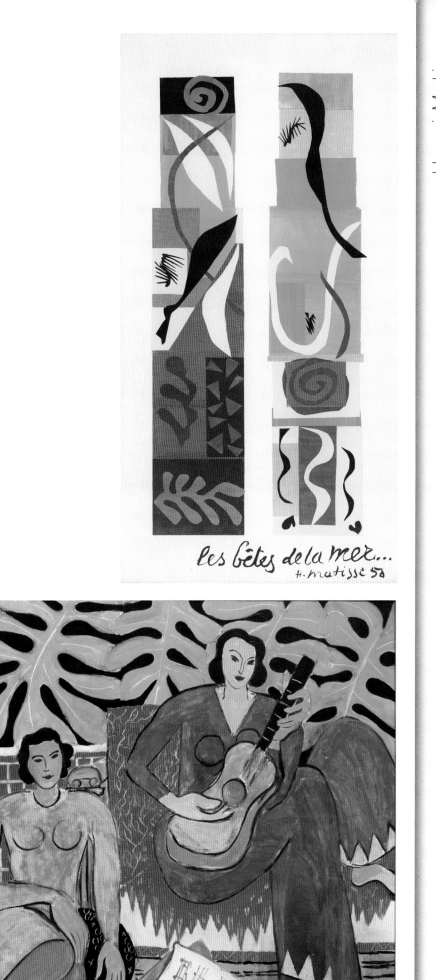

Henri Matisse

'It is the task of art to express
a clear vision of reality.'

Piet Mondrian

1872–1944

THE NETHERLANDS

Piet Mondrian was almost 50 by the time the artist we know, the painter of 'black, white and little coloured planes' (as he put it) emerged. He had been painting for thirty years. 'It took me a long time to discover that particularities of form and natural colour evoke subjective states of feeling, which obscure *pure reality*,' he explained. 'It is the task of art to express a clear vision of reality.'

Mondrian's view of art's purpose was the fruit of a formative engagement with Theosophy, a spiritual movement that attracted numerous followers during the decades surrounding the turn of the twentieth century. Theosophy taught that art and nature were both manifestations of the universal. This idea sustained Mondrian as he began to contemplate an art that did not depict natural forms but instead reflected 'pure reality' in its own manner. He retained a lifelong faith in the theosophical doctrine of evolution – humankind's spiritual progress towards a recovery of its original unity, a state of harmony with the universe that had been ruptured by the development of individual consciousness. 'Abstract-Real painting,' he wrote, 'gives an image of this regained harmony.'

Under the influence of Cubism, which showed him that form could be shattered, he evolved from painting landscapes to producing such works as *Flowering Appletree*. 'But I still felt that I worked as an Impressionist and was continuing to express particular feelings, not pure reality,' he later recalled. He embarked on a sequence of abstract styles, at the same time writing his founding theoretical statement, 'The New Plastic in Painting', which he published in instalments in *De Stijl*, a periodical founded by the painter Theo van Doesburg. 'The truly modern artist *consciously* recognizes aesthetic emotion as cosmic, universal,' Mondrian

wrote. 'The conscious recognition results in an abstract plastic – limits him to the purely universal . . . The new plastic cannot be cloaked in what is characteristic of the particular, natural form and colour, but must be expressed by the abstraction of form and colour – by means of the straight line and determinate primary colour.'

Neo-plasticism, which Mondrian also called Abstract-Real painting, was an art of rectangular planes in primary colours (red, yellow, blue) and non-colours (white, grey, black) delineated by vertical and horizontal black lines and set intuitively in dynamic equilibrium. Mondrian viewed these elements as universal and eternal, and he offered them up as a common vocabulary: 'Neo-plasticism should not be considered a personal conception. It is the logical development of all art, ancient and modern; its way lies open to everyone as a principle to be applied.' He especially urged architects to take up Neo-plastic principles, convinced that the equilibrium of a Neo-plastic environment would prepare the way for the emergence of equilibrium in society itself, at which point art would no longer be needed. 'Only then,' he wrote, 'will "art" become "life".'

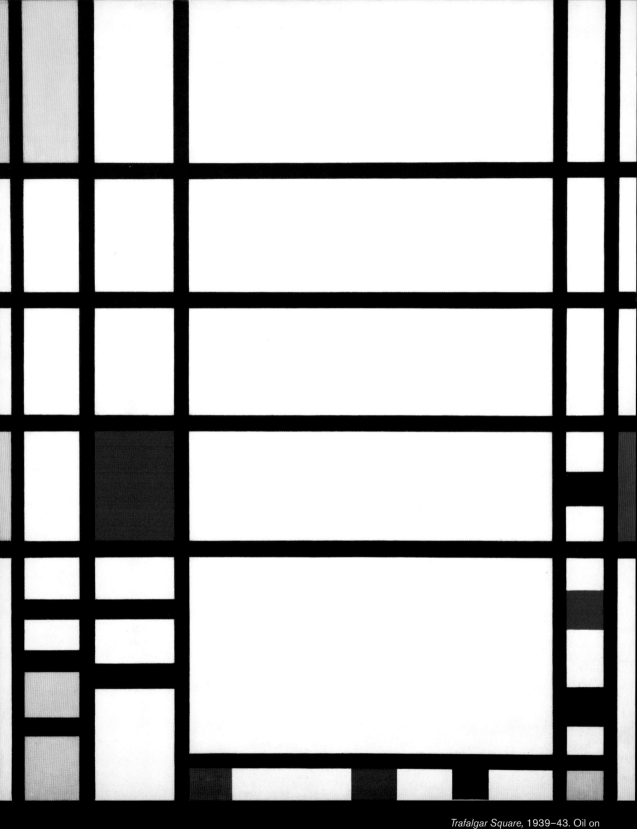

Piet Mondrian

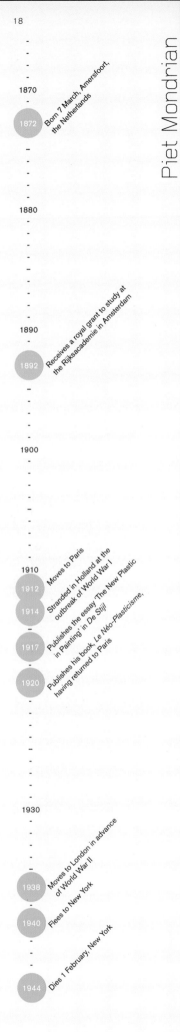

1870

1872 — Born 7 March, Amersfoort, the Netherlands

1880

1890

1892 — Receives a royal grant to study at the Rijksacademie in Amsterdam

1900

1910

1912 — Moves to Paris

1914 — Stranded in Holland at the outbreak of World War I

1917 — Publishes the essay 'The New Plastic in Painting' in *De Stijl*

1920 — Publishes his book, *Le Néo-Plasticisme*, having returned to Paris

1930

1938 — Moves to London in advance of World War II

1940 — Flees to New York

1944 — Dies 1 February, New York

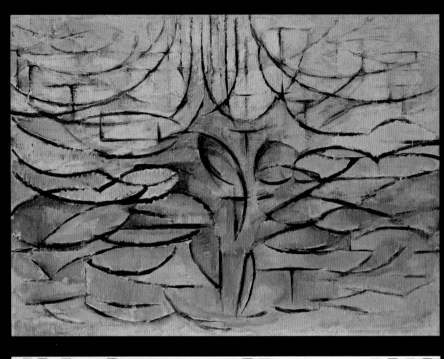

Above *Bloeiende Appelboom* (*Flowering Appletree*), 1914. Oil on canvas, 78.5 × 107.5 cm (31 × 42⅜ in). Gemeentemuseum, The Hague. © 2015 Mondrian/Holtzman Trust c/o HCR International, Washington, D.C.

Below *Broadway Boogie Woogie*, 1942–43. Oil on canvas, 127 × 127 cm (50 × 50 in). Museum of Modern Art, New York. Given anonymously. Acc. n.: 73.1943.

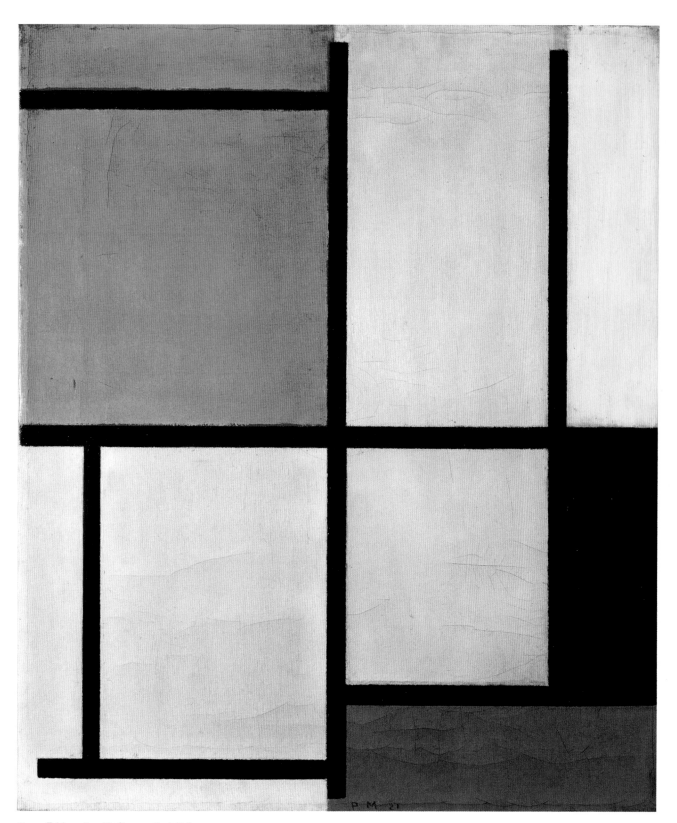

Above *Tableau 3, with Orange-Red, Yellow,*
Black, Blue and Gray, 1921. Oil on canvas,
49.5 × 41.5 cm (19½ × 16⅜ in).
Kunstmuseum, Basel.

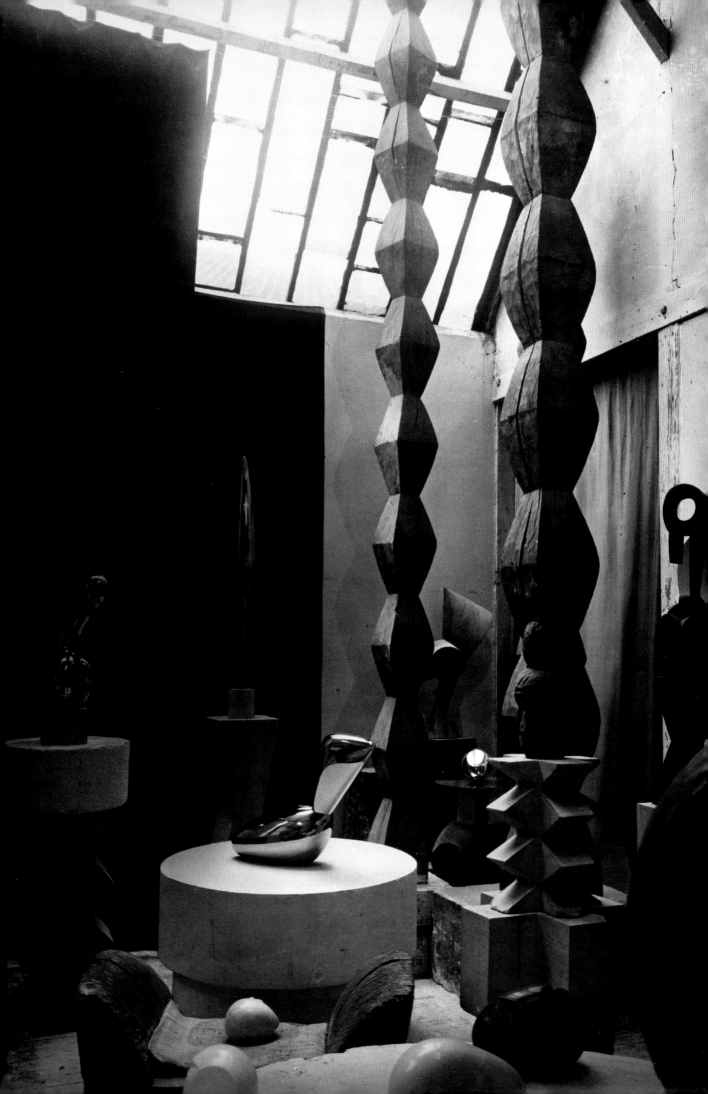

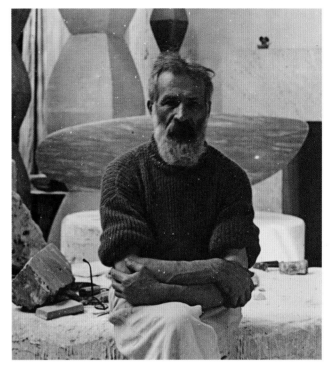

'One arrives at simplicity in spite of oneself.'

Constantin Brancusi

1876–1957

ROMANIA/FRANCE

Born into a peasant family in a remote village in Romania, Constantin Brancusi earned a degree from the School of Arts and Crafts in Craiova, then went on to become a prize-winning student in sculpture at the Academy of Fine Arts in Bucharest. He continued his studies in Paris at the Académie des Beaux-Arts. Auguste Rodin took him on as a pupil in his studio, but the presence of the great man proved overpowering. 'I was imitating him . . . I was miserable,' Brancusi recalled. 'I had to leave Rodin. I upset him, but I had to find my own path. I arrived at simplicity, peace and joy through my own intimate difficulties.'

Brancusi turned his back on the academic tradition he had excelled at, with its centuries-old emphasis on the human figure. 'Male nudes in sculpture are not even as beautiful as toads,' he declared. He gave up the academic technique of modelling in clay in favour of direct carving in wood and stone. He simplified his forms, smoothing away details in order to depict the inner essence of his subject. 'Simplicity is not an end in art,' he wrote, 'but one arrives at simplicity in spite of oneself, in approaching the real sense of things.' Some of his sculptures remained unique works; others, however, he repeated, translating them into different materials, refining their contours. Rejecting the sombre patinas of traditional bronze sculpture, he polished his bronzes to a mirror-like shine. To raise his sculptures off the ground, he carved bases of wood and limestone, sculptural forms in their own right.

Brancusi's radically different works were at the centre of two of the most famous art scandals of the twentieth century. In 1920, *Princess X* was removed from exhibition at the Salon des Indépendants in Paris. It is 'the very synthesis of woman', Brancusi explained. To most viewers, however, the statue was clearly phallic.

The second scandal took place in the United States in 1926, when customs officials refused to believe that a bronze version of *Bird in Space* was a work of art and thus exempt from customs duty. Instead, they imposed the standard tariff for manufactured metal objects. In the ensuing court case, the judge ruled in Brancusi's favour, a decision widely viewed as a victory for avant-garde art in general.

In 1938 Brancusi finished his great work, the memorial complex at Târgu Jiu, in his native Romania, which culminates in an almost 30-metre-tall (98-feet) version of *Endless Column*. After this, his production slowed to a trickle. He spent the war years largely confined to his studio and, after the war, he remained something of a recluse. Dressed simply in the white clothes of a Romanian peasant, he moved about his studio, tending his sculptures. 'Do not look for obscure formulas or for mysteries,' he advised viewers. 'I give you pure joy.'

Opposite View of Brancusi's Studio, c. 1929. Gelatin silver print, 29.8 × 23.8 cm (11¾ × 9½ in), showing *Princess X* (1915–16), *Bird in Space* (1927), *Leda* (1926), *Endless Columns* I to III (1918–1928), *Exotic Plant* (1923–24). Musée National d'Art Moderne, Centre Georges Pompidou, Paris.

Above Self-portrait of Constantin Brancusi in his studio, c. 1933–34. Musée National d'Art Moderne, Centre Georges Pompidou, Paris.

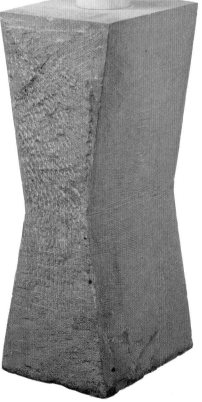

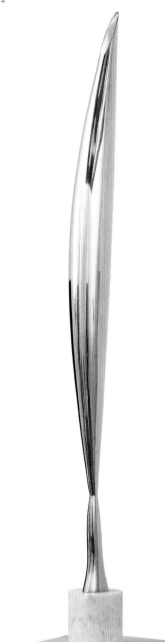

Left *Bird in Space*, 1941. Bronze (polished), 193.4 × 13.3 × 16 cm (76³⁄₁₆ × 13¼ × 6¼ in). Musée National d'Art Moderne, Centre Georges Pompidou, Paris.

Right *Endless Column*, version I, 1918. Oak, 203.2 × 25.1 x 24.5 cm (80 × 9⅞ × 9⅝ in). Museum of Modern Art, New York. Gift of Mary Sisler. Acc. n.: 645.1983.

Opposite *Blond Negress II*, 1933 (after marble of 1928). Bronze on four-part pedestal of marble, limestone and two oak sections (carved by artist), 181 × 36.2 × 36.8 cm (71¼ × 14¼ × 14½ in). Museum of Modern Art, New York. The Philip L. Goodwin Collection. Acc. n.: 97.1958.a-e.

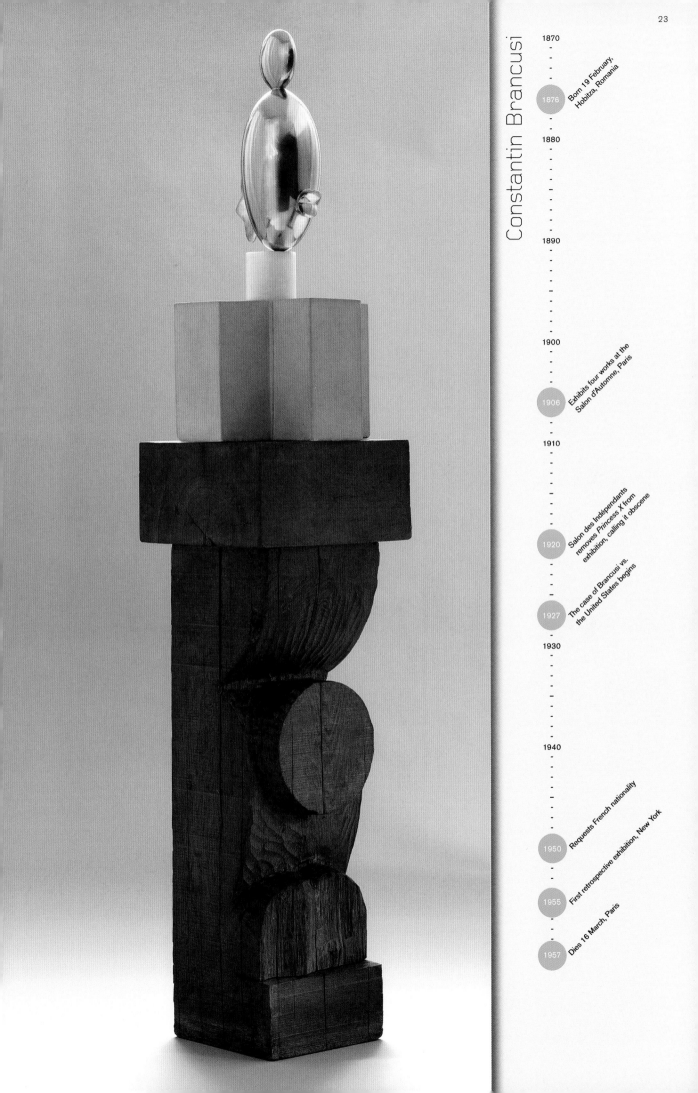

Constantin Brancusi

1870

1876　Born 19 February,
　　　Hobitza, Romania

1880

1890

1900

1906　Exhibits four works at the
　　　Salon d'Automne, Paris

1910

1920　Salon des Indépendants
　　　removes *Princess X* from
　　　exhibition, calling it obscene

1927　The case of Brancusi vs.
　　　the United States begins

1930

1940

1950　Requests French nationality

1955　First retrospective exhibition, New York

1957　Dies 16 March, Paris

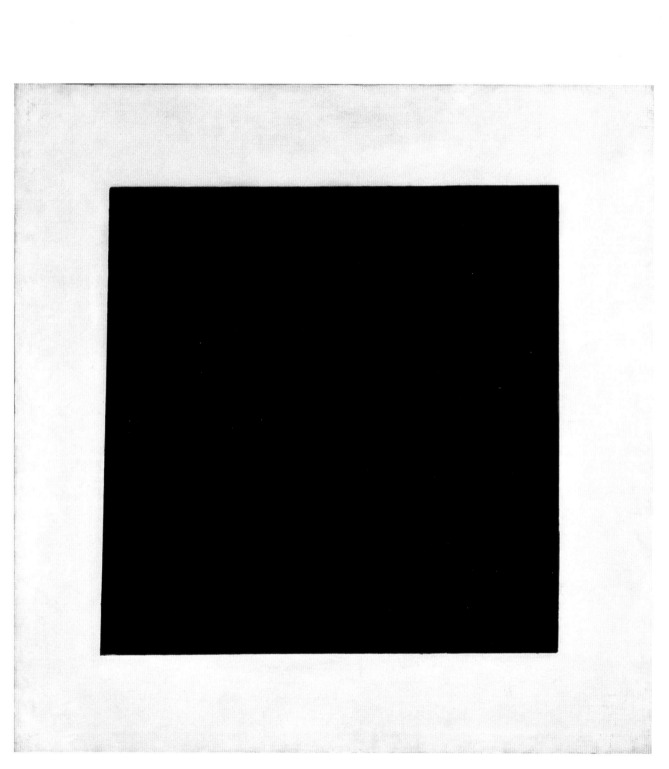

Black Square. c. 1923. Oil on canvas,
106 × 106 cm (41¾ × 41¾ in).
Russian State Museum, St Petersburg.

'The square is a living royal infant.'

Kazimir Malevich

1878–1935

UKRAINE/RUSSIA

It is one of the most famous images in twentieth-century art: a black square painted on a square white canvas. Hung high up in a corner, the way icons were displayed in Russian homes, the radical painting greeted visitors to an exhibition in Petrograd in 1915. It was the work of Kazimir Malevich and it announced the début of a new movement in art. 'I have transformed myself *in the zero of form* and dragged myself out of the *rubbish-filled pool of academic art*,' Malevich thundered in the accompanying manifesto. 'I transformed myself in the zero of form and emerged from nothing to creation, that is to Suprematism, to the New Realism in painting – to non-objective creation . . . The square is not a subconscious form. It is the creation of intuitive reason . . . It is the first step of pure creation in art.'

Like most Russian artists of his generation Malevich had undergone a rapid creative evolution, quickly absorbing styles from Impressionism through Cubism and Futurism. He joined several avant-garde groups and became known as a leading Russian Futurist. In 1915, he and two fellow Futurist painters split off to plan a new movement and accompanying journal. 'Since in it we intend to reduce everything to zero, we have decided to call it *Nul*,' Malevich wrote. 'Afterwards we ourselves will go beyond zero.' A few months later, Malevich came up with a different name, Suprematism. The journal (which never appeared) was retitled *Supremus*.

Suprematist vocabulary consisted of geometric shapes in pure colour on a white ground. The coloured shapes aspired to express the force of sensations, Malevich wrote, while the white ground evoked infinite space. 'At the present time man's path lies through space and Suprematism is a colour semaphore in its infinite abyss. The blue colour of the sky has been defeated by the Suprematist system, has been broken through and entered white, as the true real conception of infinity.'

During the 1920s, Malevich ceased painting and devoted himself to teaching. He stated that painting had become obsolete and that Suprematist forms should instead appear on fabrics, ceramics and other objects of daily life. He designed dishes with Suprematist decoration and began working on a purely theoretical Suprematist architecture, creating three-dimensional compositions called architectons.

The Russian avant garde had initially been embraced by the new political order that followed the October Revolution of 1917. However, things began to change after Stalin came to power. The institute where Malevich had been teaching was closed down. He was criticized as a bourgeois artist and jailed for the crime of 'formalism'. After he died, his art was suppressed. Works in Russian museums were hidden from public view for 50 years. He was known in the West solely through the 70 works that remained in Berlin following his retrospective exhibition there in 1927.

Above Portrait of Kazimir Malevich, c. 1925.

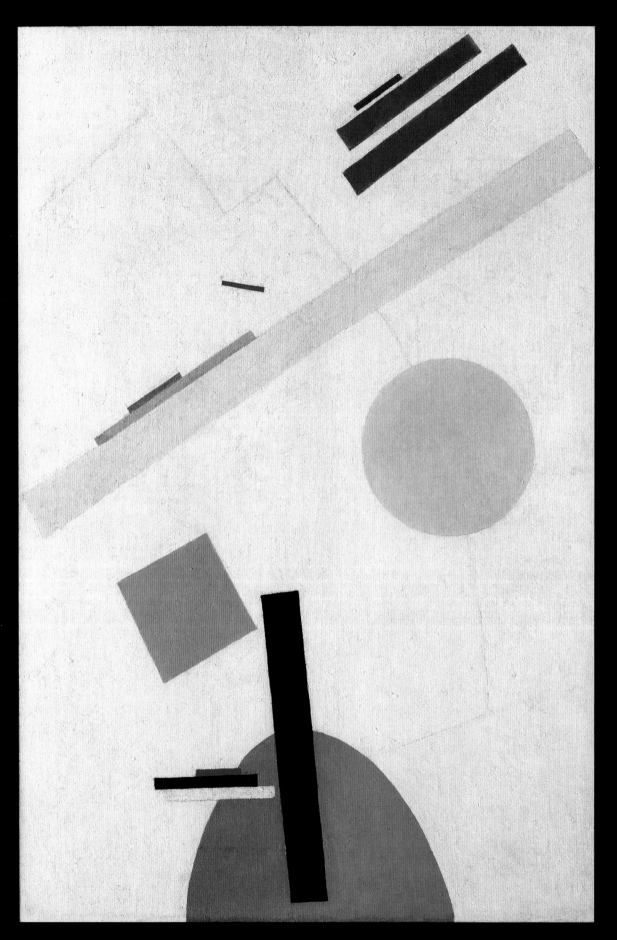

Suprematist Painting, 1916–17. Oil on canvas, 97.8 × 66.4 cm
(38½ × 26⅛ in). Museum of Modern Art, New York. 1935
acquisition confirmed in 1999 by agreement with the Estate of
Kazimir Malevich and made possible with funds from the Mrs John
Hay Whitney Bequest (by exchange). Acc. n.: 819.1935.

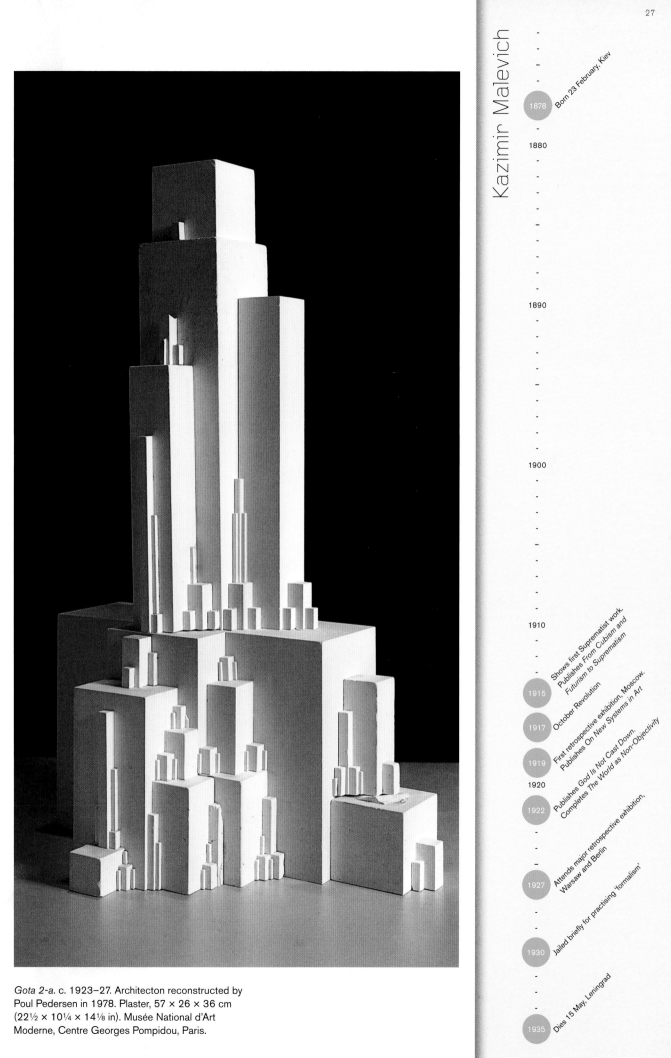

Gota 2-a. c. 1923–27. Architecton reconstructed by
Poul Pedersen in 1978. Plaster, 57 × 26 × 36 cm
(22½ × 10¼ × 14⅛ in). Musée National d'Art
Moderne, Centre Georges Pompidou, Paris.

Kazimir Malevich

1878 Born 23 February, Kiev

1880

1890

1900

1910

1915 Shows first Suprematist work.
Publishes *From Cubism and
Futurism to Suprematism*

1917 October Revolution

1919 First retrospective exhibition, Moscow.
Publishes *On New Systems in Art*

1920

1922 Publishes *God Is Not Cast Down.*
Completes *The World as Non-Objectivity*

1927 Attends major retrospective exhibition,
Warsaw and Berlin

1930 Jailed briefly for practising 'formalism'

1935 Dies 15 May, Leningrad

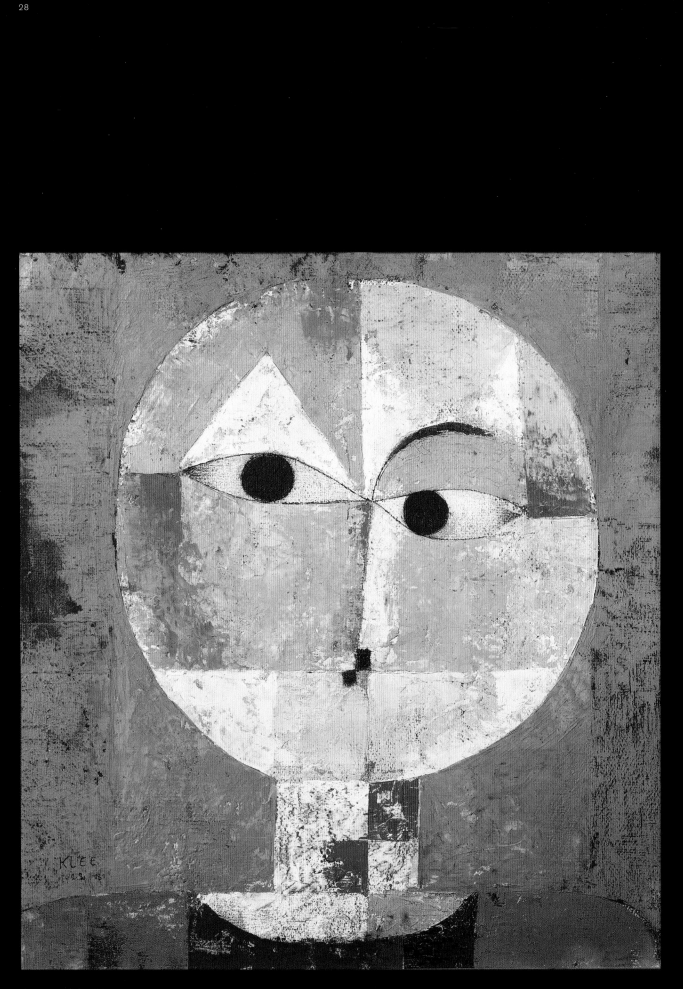

Senecio, 1922. Oil on canvas,
40.5 × 38 cm (16 × 15 in).
Kunstmuseum, Basel.

'One eye sees, the other feels.'

Paul Klee

1879–1940

SWITZERLAND

'As time passes I become more and more afraid of my growing love of music. I don't understand myself,' the young Paul Klee noted in his diary. A gifted violinist, the son of two musicians, he was about to leave secondary school and he was not sure of his path. Music, poetry and painting all tempted him. The next year finds him studying drawing in Munich. 'The conviction that painting is the right profession grows stronger and stronger in me,' he writes. 'Writing is the only other thing I still feel attracted to.' The following year, his mind is made up: 'The recognition that at bottom I am a poet, after all, should be no hindrance in the plastic arts!' He will pour his energies into art, but it will be a poetic art, with music serving as a constant touchstone.

During his first decade as an artist Klee devoted himself almost exclusively to graphic work, especially etchings and ink drawings. In Munich, he grew close to Wassily Kandinsky and Franz Marc, whose belief in the spiritual nature of art he shared, and he participated in their second *Der Blaue Reiter* exhibition. A trip to Paris that same year brought him into contact with Robert Delaunay, whose prismatic colour abstractions impressed him deeply and whose theoretical essay on light he translated into German. But it was not until 1914, on a trip to Tunisia, that his own gift for colour blossomed. 'Colour possesses me,' he recorded at the end of a blissful day. 'That is the meaning of this happy hour: colour and I are one. I am a painter.'

In his watercolours of Tunisia, Klee produced a fusion of abstraction and figuration, setting recognizable elements such as domes and dwellings within loose grids of pure colour. He would draw on these ideas for the rest of his life, combining them with his graphic abilities to elaborate a witty and mysterious universe – its sights and sounds, its personages and creatures, its landscapes and symbols all familiar yet strange, as though creation had taken a different path. 'Art does not reproduce the visible, rather it makes visible,' he wrote. 'The artist of today is more than an improved camera, he is more complex, richer and wider. He is a creature on earth and a creature within the whole, that is, a creature on a star among stars.'

Music and poetry accompanied Klee throughout his life. He composed poems, though he was careless about keeping track of them. He married a pianist, played chamber music and practised the violin every day until his final illness prevented it. On his tombstone are words he wrote about himself: 'I cannot be grasped in the here and now. For I reside just as much with the dead as with the unborn. Somewhat closer to the heart of creation than usual. But not nearly close enough.'

Above Portrait of Paul Klee, c. 1929.

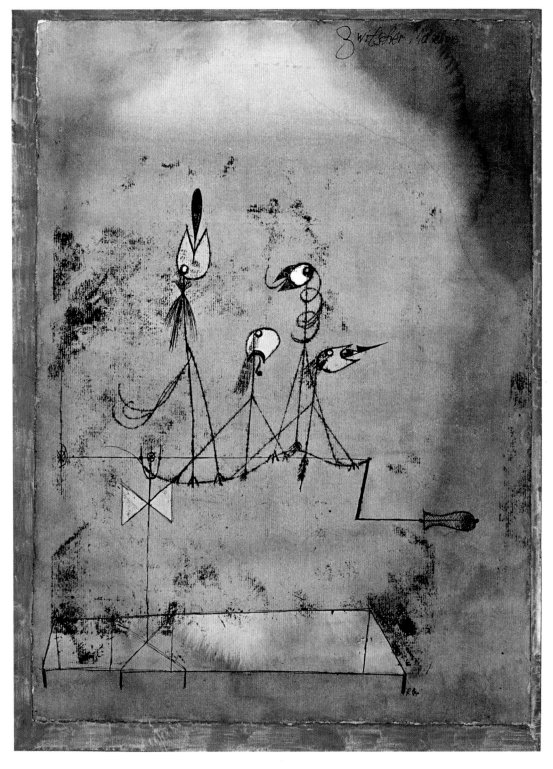

Above *Twittering Machine*, 1922.
Drawing on paper: watercolour and pen
and ink on oil transfer, 41.3 × 30.5 cm
(16¼ × 12 in). Museum of Modern Art,
New York. Purchase. 564.1939.

Opposite above *Heroische Bogenstriche*
(*Heroic Strokes of the Bow*), 1938.
Coloured paste on newspaper on dyed
cotton fabric on board, 73 × 53 cm
(28¾ × 20⅞ in). Museum of Modern
Art, New York. Nelson A. Rockefeller
Bequest. Acc. n.: 958.1979.

Opposite below *Fire at Evening*, 1929.
Oil on cardboard, 33.8 × 33.4 cm
(13⅜ × 13¼ in). Museum of Modern
Art, New York. Mr and Mrs Joachim Jean
Aberbach Fund. 153.1970.

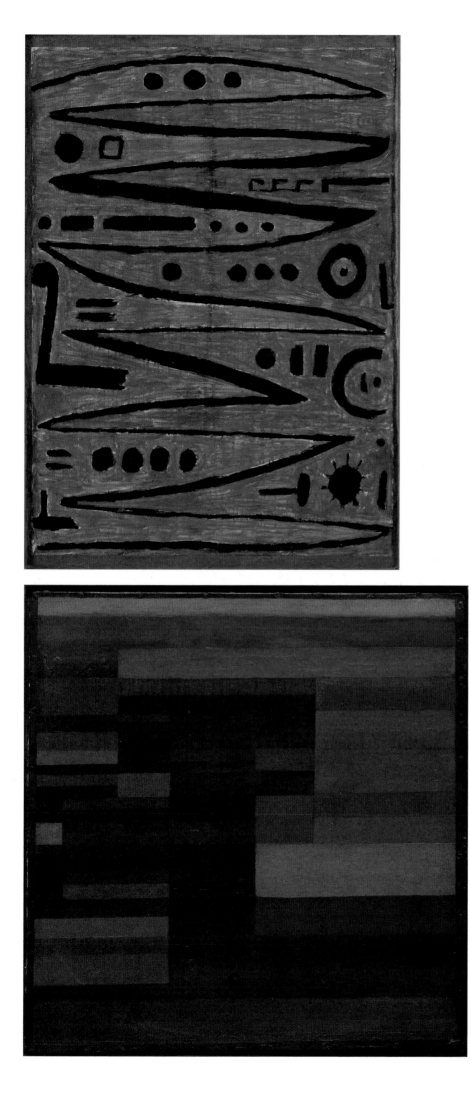

Paul Klee

1870

1879 Born 18 December, Münchenbuchsee

1880

1890

1900

1906 Exhibits with the Munich Secession

1910

1912 Participates in second *Der Blaue Reiter* exhibition. Visits Paris

1914 Visits Tunisia. World War I begins

Publishes *Creative Credo*. Major retrospective exhibition, Munich

1920

1921 Begins teaching at the Bauhaus

1930

1933 Nazis come to power. Emigrates to Switzerland

1940 Dies 29 June, Locarno-Muralto

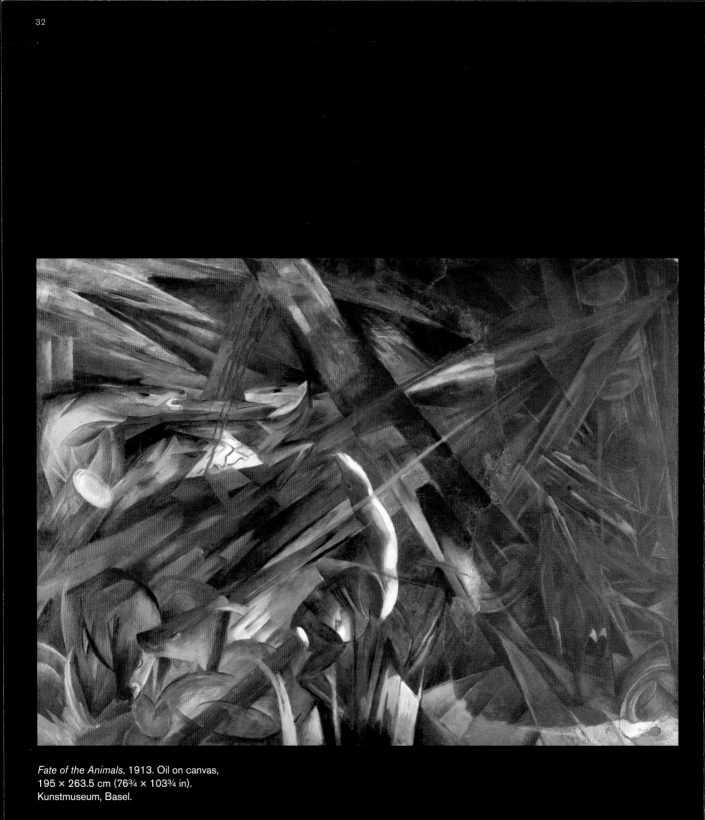

Fate of the Animals, 1913. Oil on canvas,
195 × 263.5 cm (76¾ × 103¾ in).
Kunstmuseum, Basel.

'We look for and paint the inner, spiritual side of nature.'

Franz Marc

1880–1916

GERMANY

In 1915, while stationed on the Western Front during World War I, Franz Marc received a postcard illustrating one of his own paintings, *Fate of the Animals*. In a letter to his wife, he described his reaction: 'At first glance I was completely shaken. It is like a premonition of this war, horrible and gripping; I can hardly believe that I painted it! ... It is artistically logical to paint such pictures *before* wars, not as dumb reminiscences afterwards, for then we must paint constructive pictures indicative of the future, not memories as is now the case.' Marc would not live to paint the constructive pictures he thought would be needed. He was killed near Verdun the following year.

Marc painted animals because they seemed to him purer and more beautiful than people. But he was trying to paint more than simply animals: 'I am striving to empathize pantheistically with the quiver and flow of blood in nature, trees, animals, the air. I am striving to make *pictures* of this, with new movements and colours that mock our old easel picture.' To express these pantheistic feelings, Marc elaborated a personal theory in which colours were associated with qualities and emotions. 'Blue is the male principle, astringent and spiritual,' he wrote to a friend. 'Yellow is the female principle, gentle, gay and sensual. Red is *matter*, brutal and heavy.' Mixtures produced new colours and qualities, which could be offset by placing a complementary colour nearby.

Through an organization of avant-garde artists in Munich, Marc met Wassily Kandinsky, in whom he sensed a kindred spirit. Together, they founded *Der Blaue Reiter* ('the blue rider') and organized two important exhibitions under its name. Planned as an almanac, *Der Blaue Reiter* published only a single issue before the war put an end to it, but it remains one of the most important documents of twentieth-century art.

Visits to exhibitions in Bonn and Cologne in 1912 exposed Marc to the works of the Italian Futurists and the latest developments in Cubism; in Paris, he saw the most recent colour abstractions of Robert Delaunay. With remarkable speed, he absorbed and transformed these influences, forging a mature style of prismatic, interpenetrating colour planes that allowed him not merely to depict animals but, in paintings such as *Foxes*, to suggest animal consciousness. 'Is there a more mysterious idea for an artist than perhaps how nature is reflected in the eye of an animal?' he wrote. 'How pathetic and soulless is our convention of putting animals in a landscape that belongs to our eyes instead of putting ourselves into the soul of the animal in order to guess the images they see.'

In the end, animals disappointed Marc. They, too, contained much that was hateful, he wrote to his wife. In last works such as *Fighting Forms*, his imagery became increasingly abstract.

Above Portrait of Franz Marc at Sindelsdorf, c. 1914. Gabriele Münter und Johannes Eichner-Stiftung, Munich.

Above *Fighting Forms*, 1914. Oil on canvas, 91 × 131.5 cm (35⅞ × 51¾ in). Pinakothek der Moderne, Munich.

Opposite *Foxes*, 1913. Oil on canvas, 88 × 66 cm (34⅝ × 26 in). Stiftung Museum Kunstpalast, Düsseldorf. Gift of Helmut Horten, 1962.

Franz Marc

Born 8 February, Munich

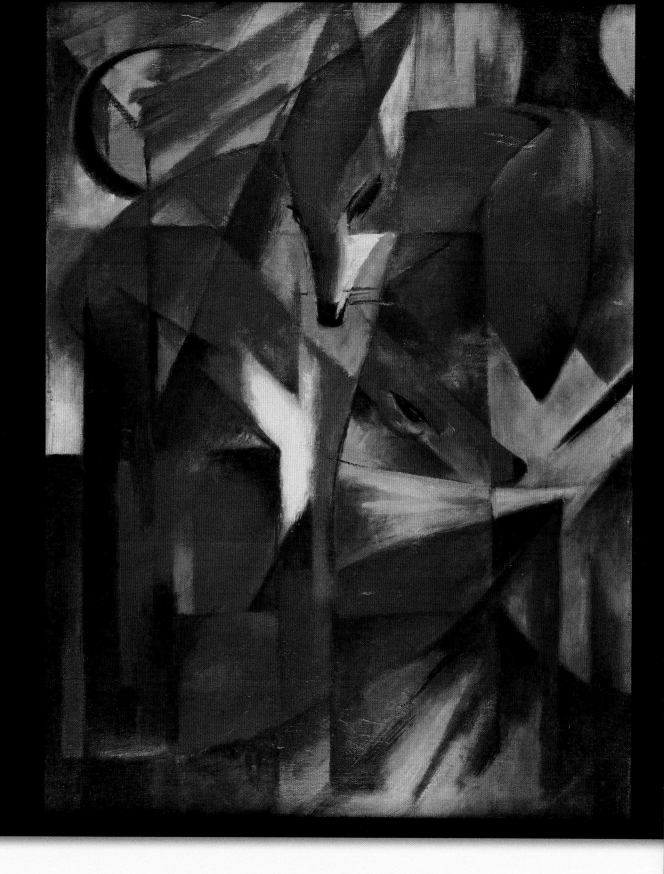

Enrolls at the Art Academy in Munich

Visits Paris. Abandons studies at the Academy

First solo exhibition. Sees early Cubist
works of Picasso and Braque

Co-founds *Der Blaue Reiter*
with Wassily Kandinsky

Sees the work of Picasso, Robert
Delaunay and the Futurists on
travels to Cologne, Paris and Bonn

Volunteers for military service at
the outbreak of World War 1

4 March, killed near Verdun

1900 1903 1910 1911 1912 1914 1916

'I invent images from machines.'

Fernand Léger

1881–1955

FRANCE

It was World War I that made Fernand Léger. He left for the front a young artist in the orbit of Cubism; he returned entranced by the look of modern machinery and enthusiastic about the working-class men he met in uniform. 'It was at war that I discovered ordinary French people, who are magnificent. I felt the richness, the beauty of their slang, the strength of its expressions,' he recalled. 'I touched the war. The breeches of the cannons, the sun beating down on them, the rawness of the object itself. That's where I was formed.'

Léger's first paintings after the war were inspired by machinery. Speaking of works such as *Propellers*, he said, 'I invent images from machines, as others have made landscapes from their imagination ... I try to create a beautiful object with mechanical elements.' To create a beautiful object meant breaking with sentimental painting and he held artists to the standards of industrial workers: 'A worker would not dare to turn in a part that was anything less than cleaned, polished and burnished ... The painter must seek ways to achieve a clean picture with *finish*.' He even depicted people as though they possessed the smooth surfaces of machinery, their faces devoid of expression, which he considered too sentimental.

Léger embraced the irruption of billboards in the landscape and advertising in the city. He revelled in the contrasts they provided and he introduced them into his art. He was so taken with cinema that he contemplated giving up painting for it and, in 1924, he made *Ballet mécanique*, the first plotless film. 'Contrasting objects, slow and rapid passages, rest and intensity – the whole film was constructed on *that*.'

Beginning in the 1930s, Léger became increasingly preoccupied with creating a style that could both depict and appeal to the ordinary working people he had identified with politically since the war. Work, leisure and nature became his central themes, culminating in such paintings as *The Constructors*, a tribute to modern labour. Elsewhere, he set pure colour flying in joyous banners and arcs across the strong black outlines of his figures. This was no fantasy, he insisted, but an aspect of modern life he had experienced in New York, where projected advertisements swept Broadway at night. 'You're there, you're talking to someone and all of a sudden, he turns blue. Then the colour goes away, another arrives and he turns red, yellow. That colour ... is free: it exists in space. I wanted to do the same thing for my canvases.'

'I've been called the primitive of modern times, and it's true. I was interested in cyclists, in machines, in scrap metal,' Léger said towards the end of his life. 'My era was one of great contrasts and I am the one who made the most of it. I am the witness to my time.'

Above Portrait of Fernand Léger by Galatine, 1933.

Opposite *The Constructors* (definitive state), 1950. Oil on canvas, 300 × 228 cm (118⅛ × 89¾ in). Musée Léger, Biot, France.

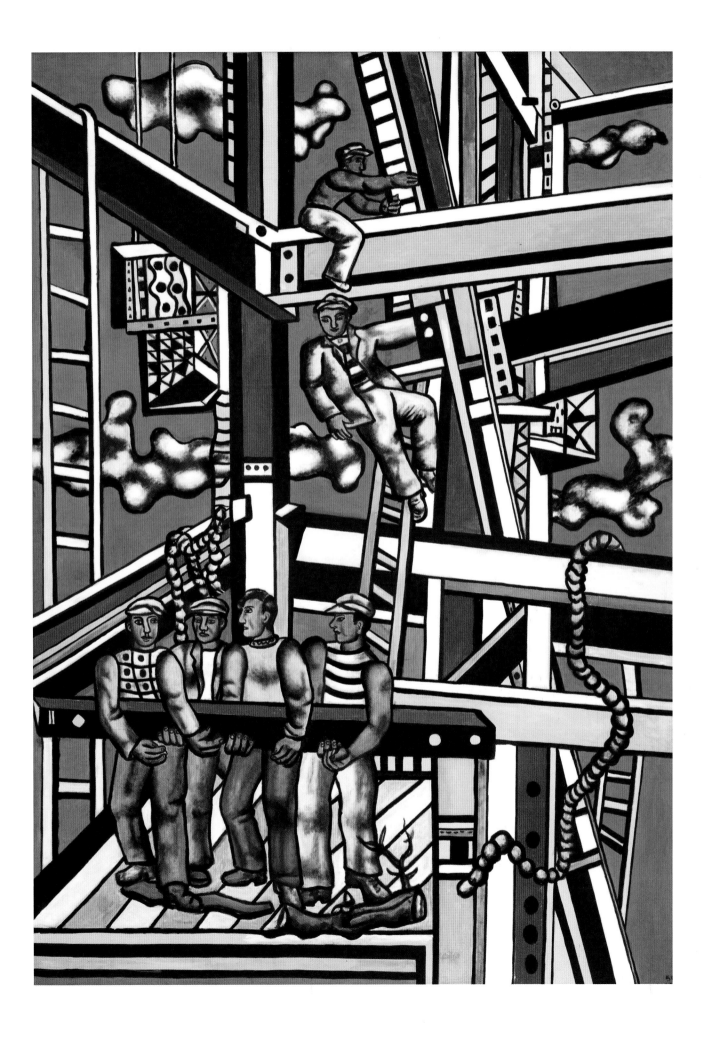

Fernand Léger

1880

1881 — Born 4 February, Argentan

1890

1900

1910 — Exhibits as a Cubist at the Salon des Indépendants and the Salon d'Automne

1911 — Outbreak of World War I. Mobilized as a sapper

1914

1919 — First solo gallery exhibition

1920 — Completes Ballet mécanique

1924

1930

1940 — Leaves for New York. Remains in the United States for the duration of World War II

1950

1953 — Major retrospective exhibition, The Art Institute of Chicago

1955 — Grand Prize at São Paulo Biennial. Dies 17 August, Gif-sur-Yvette

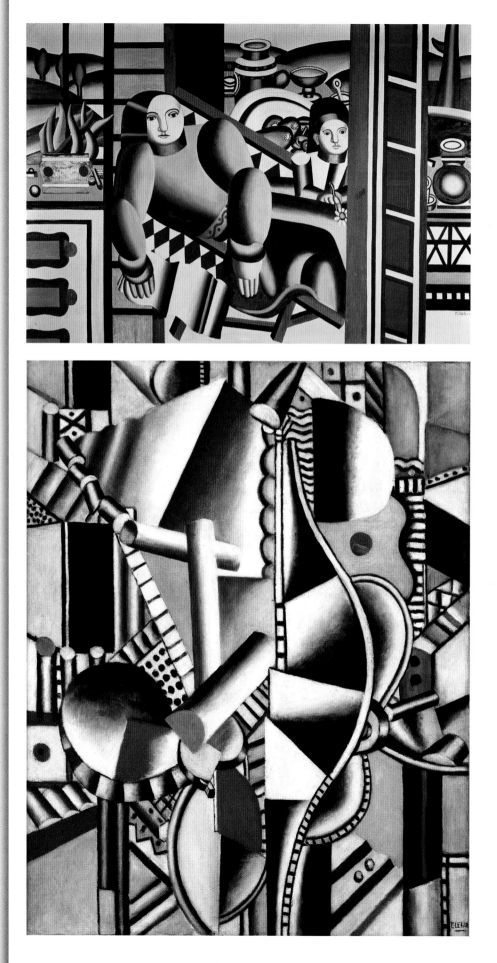

Opposite above *Woman and Child*, 1922.
Oil on canvas, 171.2 × 240.9 cm
(67⅜ × 94⅞ in). Kunstmuseum, Basel.
Gift of Dr. H.C. Raoul La Roche 1956. Inv.
G 1956.13.

Opposite below *Propellers*, 1918. Oil on
canvas, 80.9 × 65.4 cm (31⅞ × 25¾ in).
Museum of Modern Art, New York.
Katherine S. Dreier Bequest.
Acc. n.: 171.1953.

Below *The Great Parade* (definitive state),
1954. Oil on canvas, 299.1 × 400.1 cm
(117¾ × 157½ in). Solomon R.
Guggenheim Museum, New York. 62.1619.

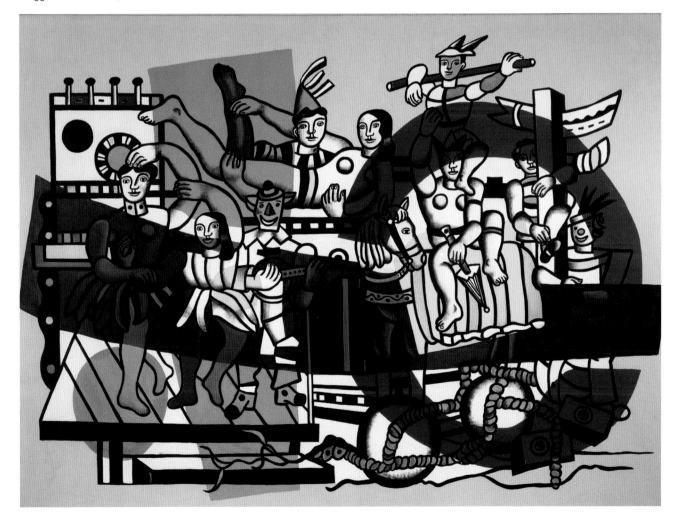

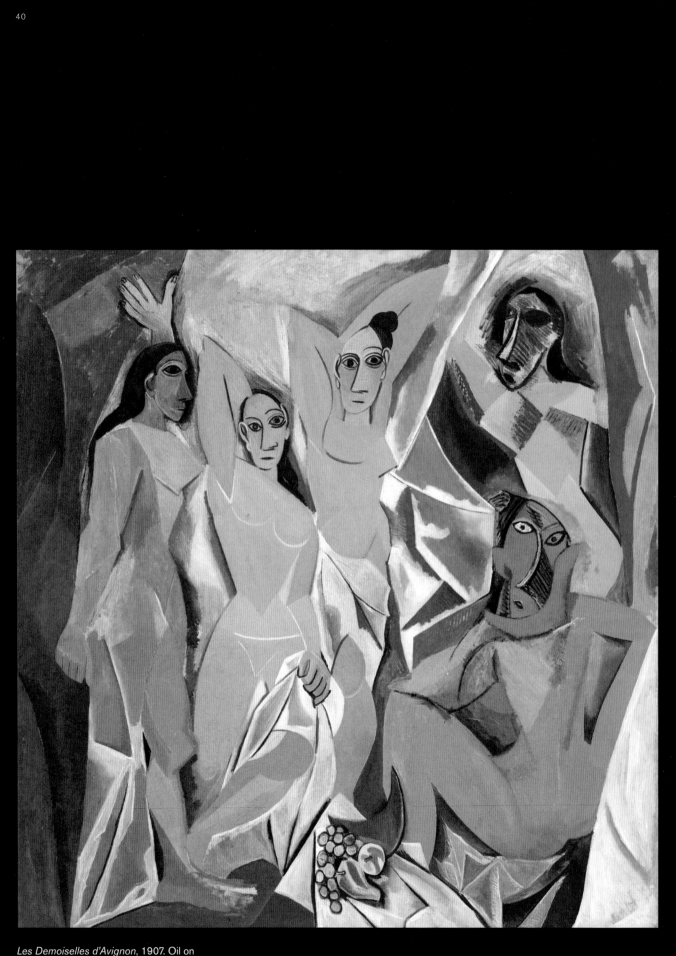

Les Demoiselles d'Avignon, 1907. Oil on
canvas, 243.9 × 233.7 cm (96 × 92 in).
Museum of Modern Art, New York.
Acquired through the Lillie P. Bliss
Bequest. 333.1939.

'Art is the lie that enables us to realize the truth.'

Pablo Picasso

1881–1973

SPAIN

Pablo Picasso had the most voracious eye of the twentieth century. All that intrigued him, he absorbed, possessed and transformed. With his technical virtuosity, stylistic range and protean output, he dominated European art for four decades and remained a towering presence until his death, a living and still prolific link to the century's legendary beginnings.

Picasso's talent showed itself early. Encouraged by his father, a painter and drawing instructor, he mastered traditional representational skills while still a child. At 14, he began advanced classes at the School of Fine Arts in Barcelona. Two years later, he was sent to Madrid to study at the Royal Academy of San Fernando. Restless and rebellious, he left after a few months.

For several years, Picasso moved between Spain and Paris, where he won admiration for his sympathetic depictions of poor people and outcasts, painted in a palette dominated by blue. After settling permanently in Paris, he began to favour ochres and rose tones, and his subject-matter shifted to a cast of youths, nudes and melancholy circus performers. 'It is the success of my youth that has become my protective wall,' he said later. 'The blue period, the rose period – they were the screen that sheltered me.'

In 1907, spurred on by the radical paintings of Henri Matisse, Picasso began work on a large painting of nudes set in a brothel. As the painting progressed, influences from Iberian sculpture were joined by a new fascination with African and Oceanic art. The heady mixture, unresolved, became *Les Demoiselles d'Avignon*. Art critic André Salmon called it 'the ever-glowing crater from which the fire of contemporary art erupted'.

Among the artists who visited Picasso's studio to see *Demoiselles* was Georges Braque. The two men soon began an intense friendship in which their individual egos were subsumed in a common project, the invention and elaboration of Cubism. 'Almost every evening, either I went to Braque's studio or Braque came to mine,' Picasso recalled about their collaboration at its height. 'Each of us *had* to see what the other had done during the day. We criticized each other's work. A canvas wasn't finished until both of us felt it was.'

The most austere, nearly abstract phase of Cubism gave way to a Cubism that delighted in exchanges with the real world. From this point on, Picasso's art did not so much evolve as expand to embrace multiple manners, practised simultaneously. The Surrealists claimed him as one of their own and he allowed his work to be shown in their exhibitions. In his old age, he turned his attention increasingly to art history, executing variations on masterpieces he had admired all his life. 'To me there is no past or future in art,' he said. 'If a work of art cannot live always in the present it must not be considered at all.'

Above Portrait of Pablo Picasso, c. 1957.

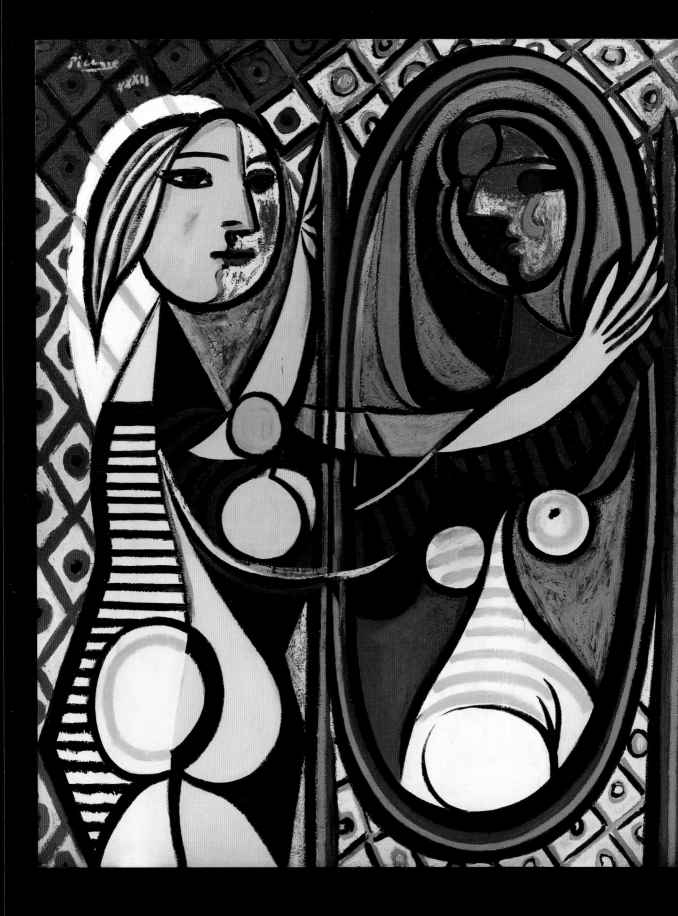

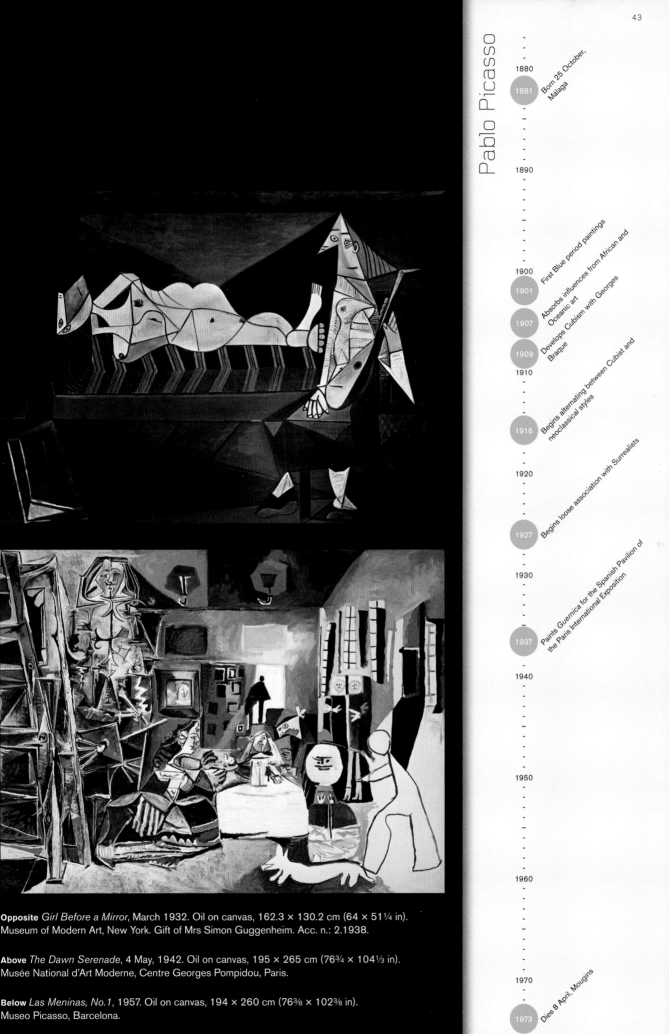

1880

1881 · Born 25 October, Málaga

1890

1900

1901 · First Blue period paintings

1907 · Absorbs influences from African and Oceanic art

1909 · Develops Cubism with Georges Braque

1910

1916 · Begins alternating between Cubist and neoclassical styles

1920

1927 · Begins loose association with Surrealists

1930

1937 · Paints *Guernica* for the Spanish Pavilion of the Paris International Exposition

1940

1950

1960

1970

1973 · Dies 8 April, Mougins

Opposite *Girl Before a Mirror*, March 1932. Oil on canvas, 162.3 × 130.2 cm (64 × 51¼ in). Museum of Modern Art, New York. Gift of Mrs Simon Guggenheim. Acc. n.: 2.1938.

Above *The Dawn Serenade*, 4 May, 1942. Oil on canvas, 195 × 265 cm (76¾ × 104⅓ in). Musée National d'Art Moderne, Centre Georges Pompidou, Paris.

Below *Las Meninas, No.1*, 1957. Oil on canvas, 194 × 260 cm (76⅜ × 102⅜ in). Museo Picasso, Barcelona.

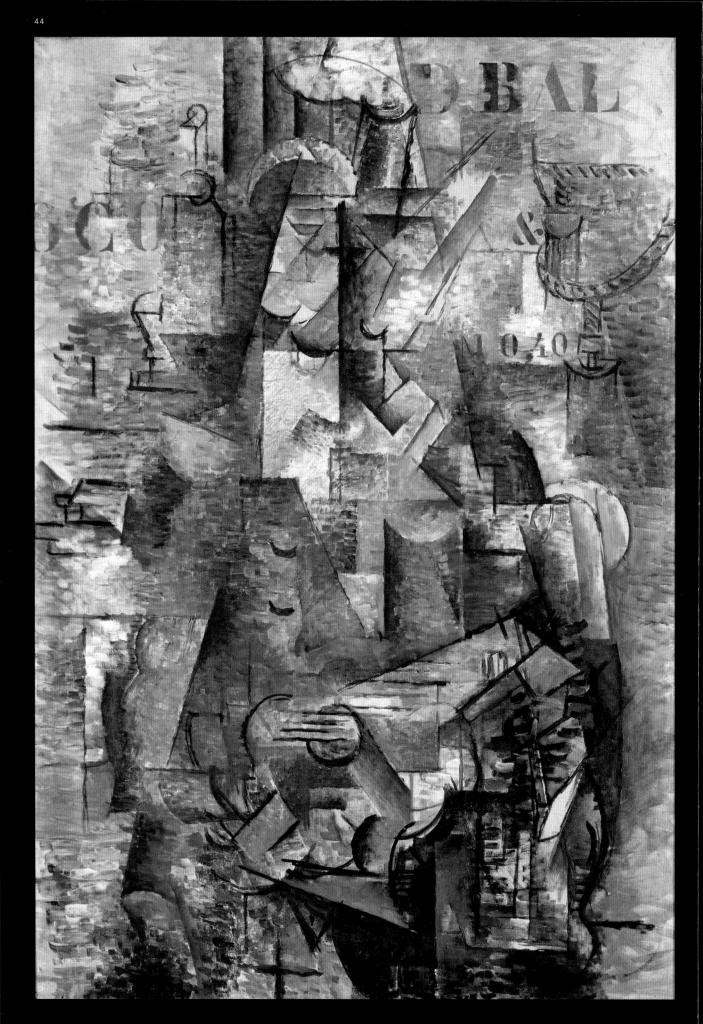

'Painting is a nail to which I fasten my ideas.'

Georges Braque

1882–1963

FRANCE

'I didn't think to become a painter any more than I thought to breathe,' Georges Braque recalled late in life. 'I liked to paint and I worked hard.' Son of a painting contractor and amateur artist, Braque left school at 17 to train as a painter–decorator in preparation for entering the family business. His apprenticeship took him to Paris, where two years later he enrolled as an art student at the Académie Humbert.

At the Salon d'Automne of 1905, Braque was taken with what the critics dubbed Fauvism: 'It was very enthusiastic painting and it suited my age, I was 23.' He adopted a Fauvist style and achieved his first successes. Then, in 1907, everything changed.

The Salon d'Automne mounted a retrospective of the paintings of Paul Cézanne, who had recently died. 'The discovery of his work overturned everything,' Braque recalled. 'I had to rethink everything.' The following month, he met Picasso. The two realized that they were wrestling with the same problem, the creation of a picture space that did not rely on conventional perspective. They began to work together towards what would become known as Cubism. Braque treasured the memories of that time to the end of his days. 'We lived in Montmartre, we saw each other every day, we talked . . . Picasso and I said things to each other during those years that no one will say again, things that no one would know how to say anymore . . . things that would be incomprehensible and that gave us so much joy . . .'

World War I brought the heady years of Cubism to an end. The two painters went their separate ways, guided by very different temperaments. Back from the war, Braque picked up where he had left off and continued to develop Cubist space in new directions. Still life remained a favourite subject. 'In a still-life composition, distance is an arm's length,' he said.

'A tactile perspective, a perspective that awakens the sense of touch.' It was the desire to touch things as well as see them that had driven Braque to develop Cubism, which rescued objects from the deep space of conventional perspective and brought them within reach. He mixed sand and sawdust into his paints to increase their material presence, what he called a communion of the visual and the tactile.

What Braque valued above all in painting was *poésie*, an ineffable quality that arose from harmony, relationships, rhythm and metamorphosis. 'When you ask me whether a particular form in one of my paintings depicts a woman's head, a fish, a vase, a bird, or all four at once, I can't give you a categorical answer, for this "metamorphic" confusion is fundamental to the *poésie*.' It was a mystery. But paintings, Braque felt, should guard their mystery. 'Only one thing counts in art: that which can't be explained.'

Opposite *The Portuguese*, 1911. Oil on canvas, 116.5 × 81.5 cm (45¾ × 32 in). Kunstmuseum, Basel.

Above Portrait of Georges Braque, 1950.

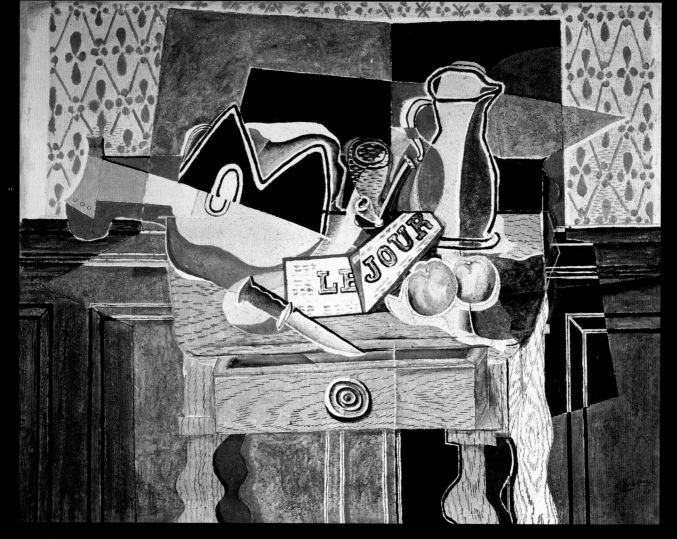

Above *Still Life: Le Jour*, 1929. Oil on canvas, 115 × 146.7 cm (45¼ × 57¾ in). National Gallery of Art, Washington, DC.

Opposite *Studio V*, 1949–50. Oil on canvas, 147 × 176.5 cm (57⅞ × 69½ in). Museum of Modern Art, New York. Acquired through the Lillie P. Bliss Bequest. Acc. n.: 123.2000.

George Braque

Born 13 May, Argenteuil

Exhibits at the Salon des Indépendants

Meets Picasso

First fully developed Cubist paintings

First collage (*papier collé*)

Called up for service in World War I. Wounded the following year

1880 · 1882 · | · · · · 1890 · · · · | · · · · · 1900 · · · · · 1906 1907 1908 1910 1912 1914 · · · · · 1920 · · · ·

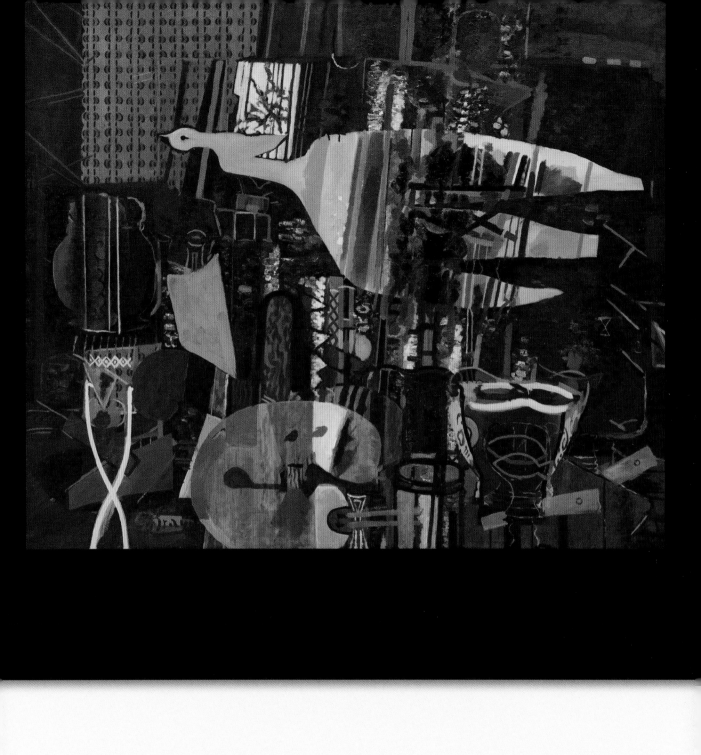

'I shall leave this existence with a contempt for all that is not art.'

Umberto Boccioni

1882–1916

ITALY

Umberto Boccioni did not mince words. 'Whoever considers Italy today as *the country of art* is a necrophile who considers a cemetery to be a delightful alcove,' he wrote. 'To be still calling Italy the country of art is a ferocious archaeological irony that we Futurist painters laugh at cheerfully in order not to spit in the face and kick in the rear every imbecile who repeats it.' The Futurists were determined to drag Italy kicking and screaming into the twentieth century. They wanted, 'To destroy the cult of the past . . . to render and magnify the life of today, incessantly and tumultuously transformed by science triumphant.'

Futurism was founded as a literary movement by the poet Filippo Tommaso Marinetti, who published his *Manifesto of Futurism* in 1909. A year later, Boccioni and four of his friends issued their *Manifesto of the Futurist Painters*, creating a parallel movement. Marinetti praised 'the beauty of speed' and declared that a racing car was more beautiful than a Greek statue. Following his lead, the Futurist painters set dynamism at the heart of their project: 'Everything moves, everything rushes by, everything is in constant swift change . . . Because images persist on the retina, things in movement multiply, change form, follow one another like vibrations in the space they traverse.' They wanted to capture these sensations on canvas, using divisionist colour for maximum luminosity. 'Divisionism is an attitude of the spirit,' said Boccioni, 'a stage at which human sensibility has arrived . . .' Most radically, they proposed a new relationship between painting and viewer: 'Painters have always shown us things and persons as if set directly in front of us. We, however, will put the *viewer* in the centre of the picture.'

The trilogy, *States of Mind*, was his first fully Futurist work. Set in a railway-station, the three paintings evoke the emotions of people saying their farewells, of passengers on the train as it hurtles away and of those left behind. Then, turning to sculpture, in a new manifesto, he proclaimed that sculpture must henceforth 'make objects come to life by rendering their prolongation into space perceivable, systematic and three-dimensional, since no one can doubt that one object leaves off where another begins and that there is nothing that surrounds our own body . . . that does not cut through it and slice it into cross-sections with an arabesque of curves and straight lines.' He embodied these ideas in works such as *Unique Forms of Continuity in Space*.

Boccioni devoted 1914 to writing *Futurist Painting and Sculpture*. His grand summary of Futurist theory and practice was received coolly by other Futurists, leaving him exhausted and discouraged. His last canvases depict not motion and modernity but stillness and structure, with a backward glance at Cézanne – 'touching base', perhaps, before a new departure that was not to be.

Above Portrait of Umberto Boccioni, 1912.

Opposite *Unique Forms of Continuity in Space*, 1913. Bronze (cast 1931), 111.2 × 88.5 × 40 cm (43⅞ × 34⅞ × 15¾ in). Museum of Modern Art, New York. Acquired through the Lillie P. Bliss Bequest. 231.1948.

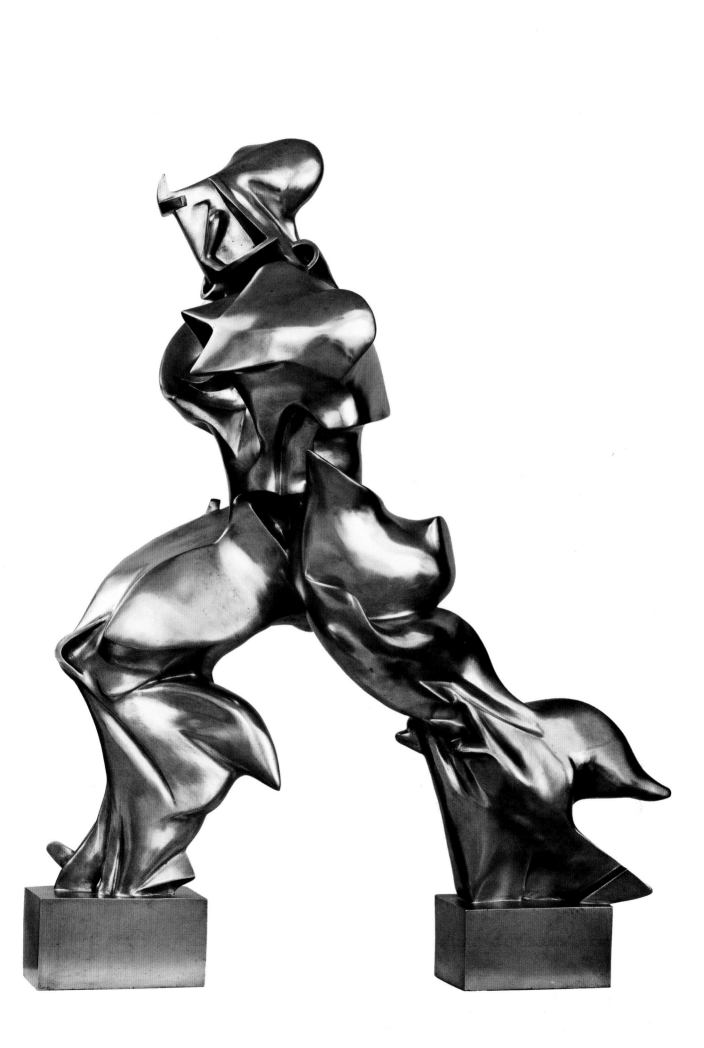

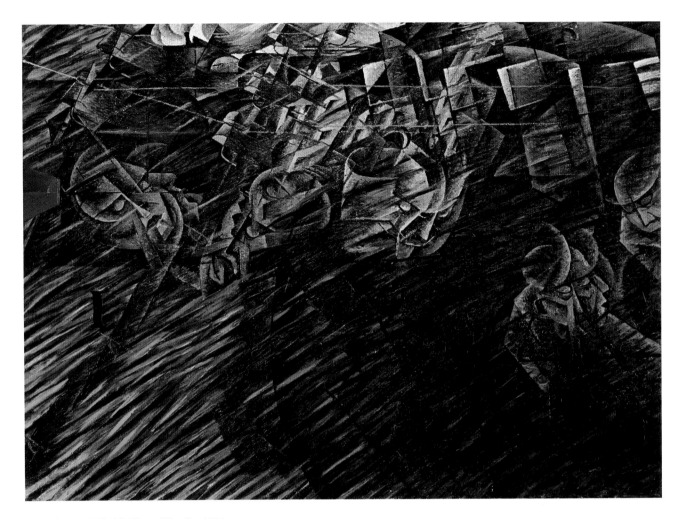

Above *States of Mind II: Those Who Go*, 1911.
Oil on canvas, 70.8 × 95.9 cm (27⅞ × 37¾ in).
Museum of Modern Art, New York. Gift of Nelson
A. Rockefeller. 65.1979.

Opposite *Dynamism of a Soccer Player*, 1913.
Oil on canvas, 193.2 × 201 cm (76⅛ × 79⅛ in).
Museum of Modern Art, New York. The Sidney
and Harriet Janis Collection. Acc. n.: 580.1967.

Umberto Boccioni

Born 19 October, Reggio Calabria

Moves to Rome. Takes up painting

1880 1882 1899 1890

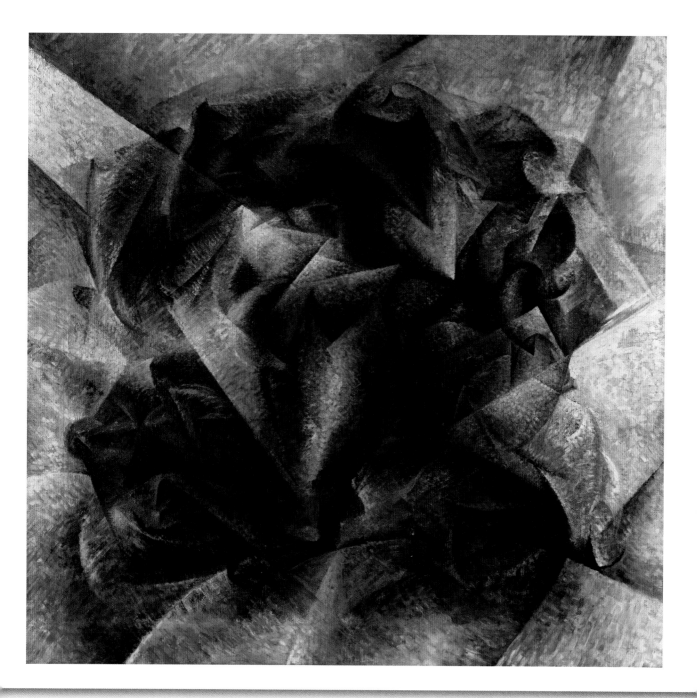

Visits Paris and Russia

Signs the *Manifesto of the Futurist Painters*. First solo exhibition, Venice

Participates in the first Futurist exhibition, Milan

Exhibition of Futurist art tours Europe. Publishes *Technical Manifesto of Futurist Sculpture*

Publishes *Futurist Painting and Sculpture*. World War I begins

Enlists in the Italian army. Dies after being thrown from a horse, 17 August, Verona

1906 1910 1911 1912 1914 1916

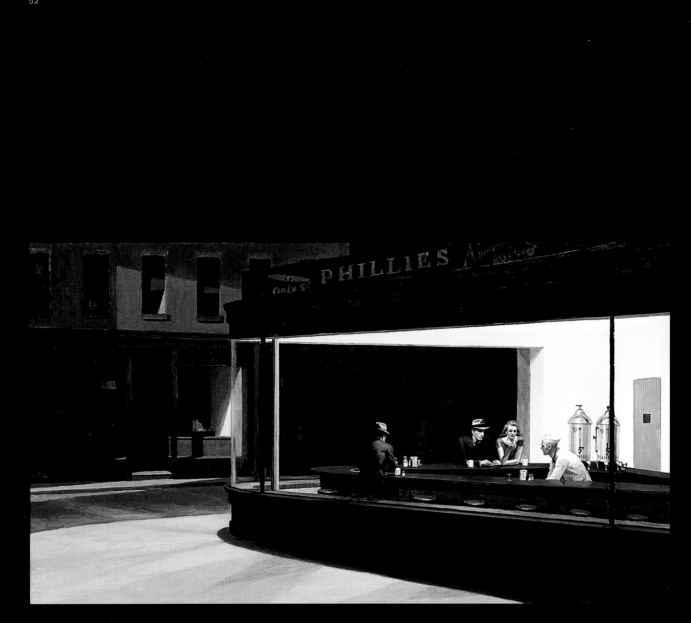

Nighthawks, 1942. Oil on canvas, 84.1 × 152.4 cm
(33⅛ × 60 in). Art Institute of Chicago.

'I would like my work to communicate, but if it doesn't, that's all right too.'

Edward Hopper

1882–1967

UNITED STATES

Edward Hopper is among the handful of painters who continued the nineteenth-century project of realism into the twentieth century, unwilling to surrender entirely to photography the privilege of recording the texture of modern life. His heroes were the painters who had rendered the full weight of things – Gustave Courbet, Édouard Manet, Thomas Eakins, Winslow Homer – and he inscribed himself in the long list of artists who had struggled to express their personal vision through fidelity to optical experience. 'I believe that the great painters . . . have attempted to force this unwilling medium of paint and canvas into a record of their emotions,' he wrote. 'I find any digression from this large aim leads me to boredom.'

As an art student, Hopper studied illustration as well as painting, and he supported himself as a freelance magazine illustrator for almost twenty years until his paintings began to attract attention. He detested the work. 'I was always interested in architecture, but the editors wanted people waving their arms,' he later recalled. 'Maybe I am not very human. What I wanted to do was to paint sunlight on the side of a house.'

Hopper travelled to Europe several times during his twenties, including two extended stays in Paris. The beauty and visual unity of the city enchanted him, as did the throngs of people seemingly bent on pleasure. His palette lightened in response to the softer light he found there and the Impressionist paintings he grew to know. Back in New York, he continued to paint reminiscences of Paris, and most of the paintings he showed in his first solo exhibition depicted French scenes. 'It seemed awfully crude and raw here when I got back,' he later recalled. 'It took me ten years to get over Europe.'

It was by embracing that crudeness and rawness that Hopper forged his mature style. Having seen at first hand the connection between Impressionist painting and the light, architecture and spaces of Paris, he created a style that acknowledged the clear, strong sunlight of New York and New England and the electric light of the night. He painted the isolated frame houses of the countryside and the plain brick facades of the city. He set his imagined scenes in the unremarkable spaces of ordinary lives – diners and motel rooms, offices and movie theatres, gas stations and automats.

The people in Hopper's paintings seem essentially solitary, lost in their own thoughts even when they are together. He became known as the painter of loneliness, a label that made him uneasy. 'It formulates something you don't want formulated,' he said to an interviewer. Elsewhere he wrote, 'Great art is the outward expression of an inner life in the artist, and this inner life will result in his personal vision of the world . . . The inner life of a human being is a vast and varied realm.'

Above Portrait of Edward Hopper, c. 1941.

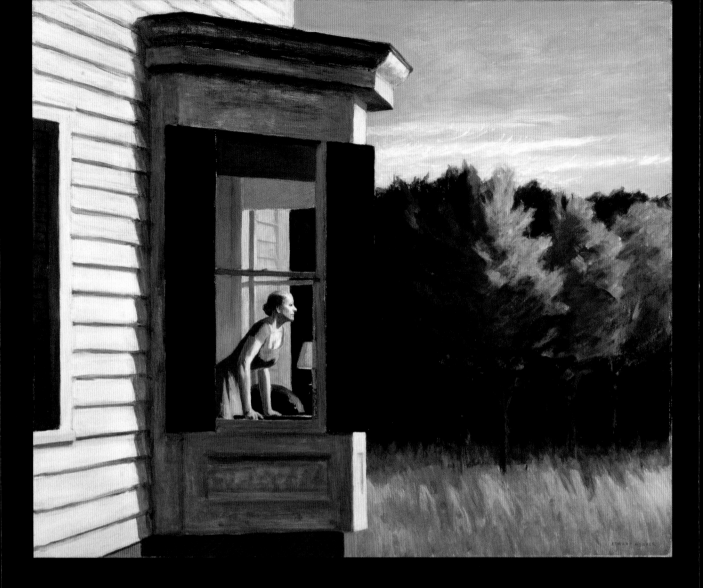

Edward Hopper

Born 22 July, Nyack,
New York

Travels to Paris to paint, the
first of two extended stays

Returns to New York. Takes up
work as a freelance illustrator

1870 1880 1882 1890 1900 1906 1907 1910

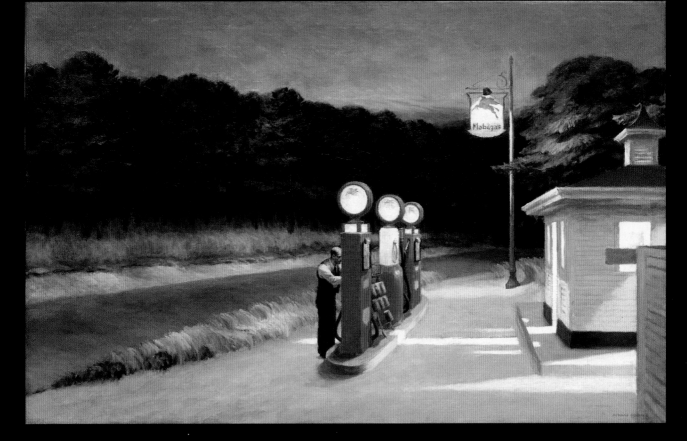

Above *Gas*, 1940. Oil on canvas,
66.7 × 102.2 cm (26¼ × 40¼ in).
Museum of Modern Art, New York.

Opposite *Cape Cod Morning*, 1950. Oil on
canvas, 86.7 × 102.3 cm (34⅛ × 40¼ in).
Smithsonian American Art Museum,
Washington, DC. Mrs Simon Guggenheim
Fund. 577.1943.

First solo exhibition in a commercial gallery

Begins to summer on Cape Cod

First solo museum show, New York

Travelling museum retrospective opens, New York

Dies 15 May, New York

1924 1930 1933 1940 1950 1960 1964 1967

'I hardly need to abstract things for each object is unreal enough already.'

Max Beckmann

1884–1950

GERMANY

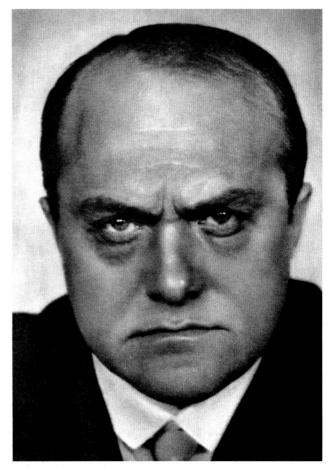

'It's a wild and wonderful life I'm leading right now,' Max Beckmann wrote to his wife when he first began serving as a medical orderly in World War I. 'Nowhere else has the unspeakable contradiction of life been more obvious to me.' Like many participants, Beckmann initially found the experience of war intoxicating. The horror would not sink in until the following year, when he was sent to the Western Front and witnessed the second battle of Ypres. 'I saw Ypres appearing like a mirage in the hot mists of the distance,' he wrote after it was over. 'Monstrous sulphurous yellow craters from explosions ... entire plateaus of house skeletons, and wide, desolate plains thick with crosses, helmets and churned-up graves.' The following month he suffered a nervous breakdown. The war was over for him.

Beckmann had been a conservative painter before the war, working in an evolving style that looked to Impressionist, Renaissance and Romantic models. When he began to paint again, it was the 'almost brutal, raw sincerity' of early Netherlandish and German art he was drawn to. In paintings such as *Night*, he forged a modern style in which angular, harshly modelled figures were crowded into a compressed, claustrophobic space. With it, he hoped 'to capture the terrible, thrilling monster of life's vitality ... We have had four years of staring into the stupid face of horror.' He hoped to achieve 'a transcendental objectivity out of a deep love for nature and humanity'.

Beckmann is associated with the New Objectivity, a trend in German painting that rejected Expressionism in favour of a cool, factual look at social realities in the wake of World War I. Yet his 'transcendental objectivity' also had a mystical component, inspired by an interest in Gnosticism, the Cabala and the esoteric teachings of Theosophy. 'What I want to show in my work is the idea that hides itself behind so-called reality,' he said. 'I am seeking the bridge that leads from the visible to the invisible .' Other painters of the twentieth century sought to channel this search through abstraction. Beckmann, however, refused to part from the painterly representation of things in space, 'the infinite deity which surrounds us'. He would instead approach transcendence by turning to myth, allegory and symbolism.

Departure marks the first appearance of mythic material in Beckmann's work. In the eight completed triptychs that followed, and in numerous individual paintings, figures from Classical mythology and characters from Beckmann's own cast of archetypes act out enigmatic scenes. Begun as the Nazis came to power and continued during his exile in Amsterdam, the German occupation of the Netherlands and his final years in the United States, Beckmann's allegorical paintings allowed him to transpose contemporary events along with his personal fears, desires, memories and experiences into a timeless realm.

Opposite *Falling Man*, 1950. Oil on canvas, 141 × 88.8 cm (55½ × 34⅞ in). National Gallery of Art, Washington, DC.

Above Portrait of Max Beckmann, c. 1920.

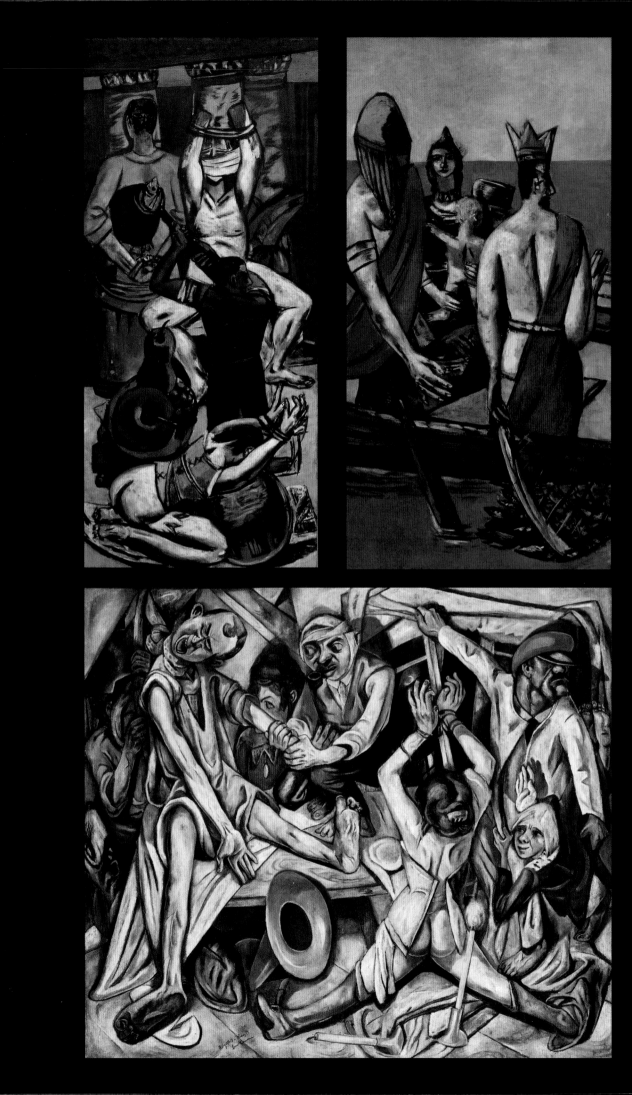

Departure, 1932–33. Oil on canvas,
215.3 × 314.6 cm (84¾ × 123⅞ in).
Museum of Modern Art, New York.
Given anonymously (by exchange).
Acc. n.: 6.1942.ac.

Night, 1918/19. Oil on canvas,
133 × 154 cm (52⅜ × 60⅝ in).
Kunstsammlungen Nordrhein-
Westfalen, Düsseldorf.

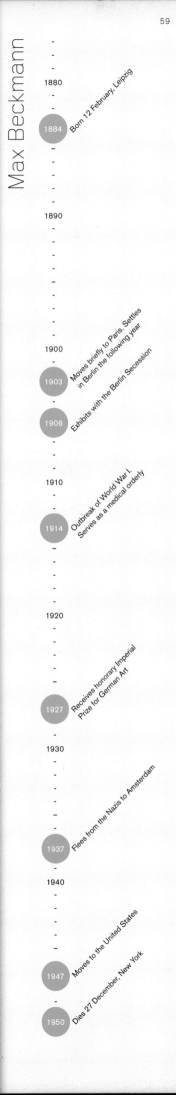

Max Beckmann

1880

1884 — Born 12 February, Leipzig

1890

1900

1903 — Moves briefly to Paris. Settles in Berlin the following year

1906 — Exhibits with the Berlin Secession

1910

1914 — Outbreak of World War I. Serves as a medical orderly

1920

1927 — Receives honorary Imperial Prize for German Art

1930

1937 — Flees from the Nazis to Amsterdam

1940

1947 — Moves to the United States

1950 — Dies 27 December, New York

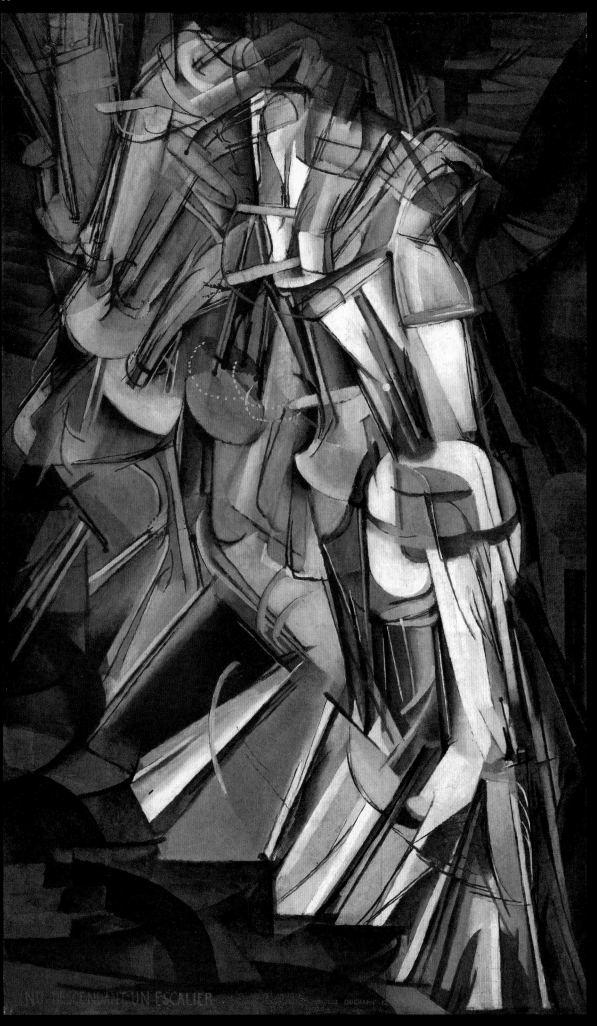

'I wanted to put painting once
again at the service of the mind.'

Marcel Duchamp

1887–1968

FRANCE

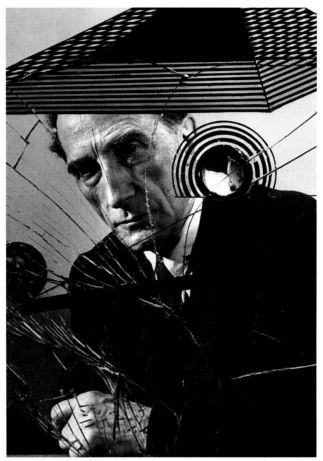

When Marcel Duchamp submitted *Nude Descending a Staircase* to the Salon des Indépendants in 1912, the hanging committee of Cubist painters asked him to make some changes. With its provocative title and depiction of motion, the painting did not conform to their vision of Cubism. 'Cubism had lasted two or three years, and they already had an absolutely clear, dogmatic line on it,' Duchamp said. 'It was a real turning-point in my life. I saw that I would never be much interested in groups after that.' He withdrew the work and showed it elsewhere, most famously in New York, where it created a sensation.

Nude Descending a Staircase was an early example of Duchamp's lifelong resistance to what he called 'retinal' painting, painting that appealed primarily to the eye. 'I was interested in ideas – not merely in visual products,' he said. 'I wanted to put painting once again at the service of the mind.' A painting, he said elsewhere, 'is the diagram of an idea'.

Duchamp soon gave up painting altogether in favour of other ways of making art, most radically with 'readymades', ordinary manufactured objects that he designated as art by bestowing on them a word or phrase 'meant to carry the mind of the spectator towards other regions more verbal'. The most notorious readymade was *Fountain*, a porcelain urinal that Duchamp signed with the fictive name 'R. Mutt' and submitted anonymously to an exhibition in New York.

Duchamp designated a number of readymades during his first years in New York, but he felt that the gesture should not be performed too often, lest it lost its playful quality and become merely another system for producing things. His major work of those years was *The Bride Stripped Bare by Her Bachelors, Even*, also known as *Large Glass*. Meticulously crafted, *Large Glass* depicts a mechanical scene of desire and frustration in which, unable to reach the naked bride in the upper panel, the bachelors below can only spray their essential 'illuminating gas' into the air. Duchamp later created a facsimile edition of his extensive notes and diagrams for the work. *Large Glass*, he said, 'must not be "looked at" in the aesthetic sense of the word. One must consult the book and see the two together. The conjunction of the two things entirely removes the retinal aspect that I don't like.'

Duchamp returned to themes from *Large Glass* in his last and most astonishing work, *Given: 1. The Waterfall, 2. The Illuminating Gas . . .* informally known as *Étant donnés* ('given' in French). The viewer becomes a voyeur as, peeping through two small holes cut at eye level in a pair of old wooden doors, he sees a brick wall with an opening, and through the opening, a life-size female nude reclining provocatively on a bed of twigs, holding aloft an illuminated gas lamp before an Edenic landscape.

Opposite *Nude Descending a Staircase (No. 2)*, 1912. Oil on canvas, 147 × 89.2 cm (57⅞ × 35⅛ in). Philadelphia Museum of Art. The Louise and Walter Arensberg Collection, 1950.

Above Portrait of Marcel Duchamp by Allan Grant, 1953.

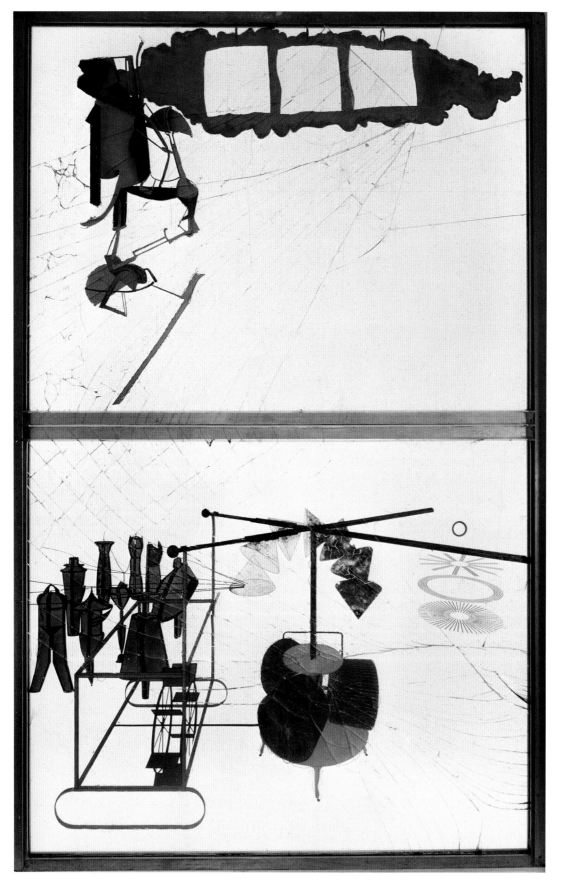

Above *The Bride Stripped Bare by Her Bachelors, Even* (*The Large Glass*), 1915–23. Front view. Oil, varnish, lead foil, lead wire and dust on two glass panels, 277.5 × 175.9 cm (109¼ × 69¼ in). Philadelphia -Museum of Art. Bequest of Katherine S. Dreier, 1952.

Opposite above *Fountain*, 1950 (replica of 1917 original). Porcelain urinal, 30.5 × 38.1 × 45.7 cm (12 × 15 × 18 in). Philadelphia Museum of Art. Gift (by exchange) of Mrs Herbert Cameron Morris, 1998.

Opposite below *Étant donnés: 1° la chute d'eau, 2° le gaz d'éclairage . . .* (*Given: 1. The Waterfall, 2. The Illuminating Gas . . .*), interior view, 1946–66. Mixed media assemblage: (exterior) wooden door, iron nails, bricks and stucco; (interior) bricks, velvet, wood, parchment over an armature of lead, steel, brass, synthetic putties and adhesives, aluminium sheet, welded steel-wire screen and wood; Peg-Board, hair, oil paint, plastic, steel binder clips, plastic clothes pegs, twigs, leaves, glass, plywood, brass piano hinge, nails, screws, cotton, collotype prints, acrylic varnish, chalk, graphite, paper, cardboard, tape, pen ink, electric light fixtures, gas lamp (Bec Auer type), foam rubber, cork, electric motor, biscuit tin and linoleum, 242.6 × 177.8 × 124.5 cm (95½ × 70 × 49 in). Philadelphia Museum of Art. Gift of the Cassandra Foundation, 1969.

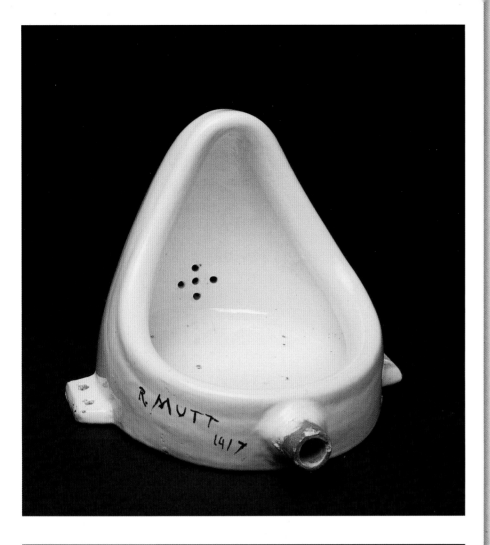

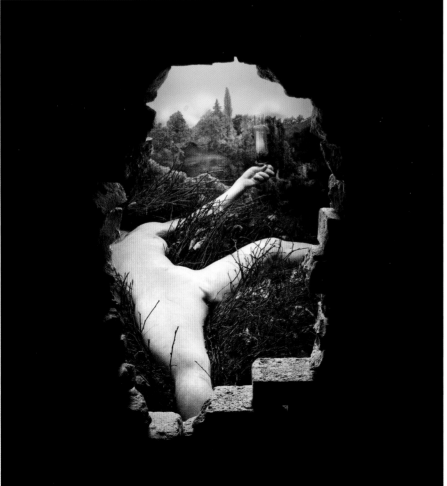

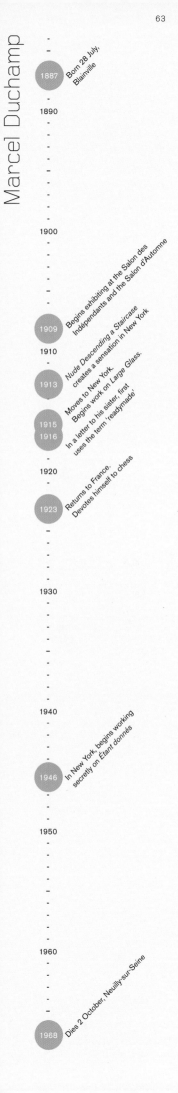

Marcel Duchamp

1887 Born 28 July, Blainville

1890

1900

Begins exhibiting at the Salon des Indépendants and the Salon d'Automne

1909

1910 *Nude Descending a Staircase* creates a sensation in New York

1913 Moves to New York. Begins work on *Large Glass*.

1915 In a letter to his sister, first
1916 uses the term 'readymade'

1920 Returns to France. Devotes himself to chess

1923

1930

1940 In New York, begins working secretly on *Étant donnés*

1946

1950

1960

Dies 2 October, Neuilly-sur-Seine

1968

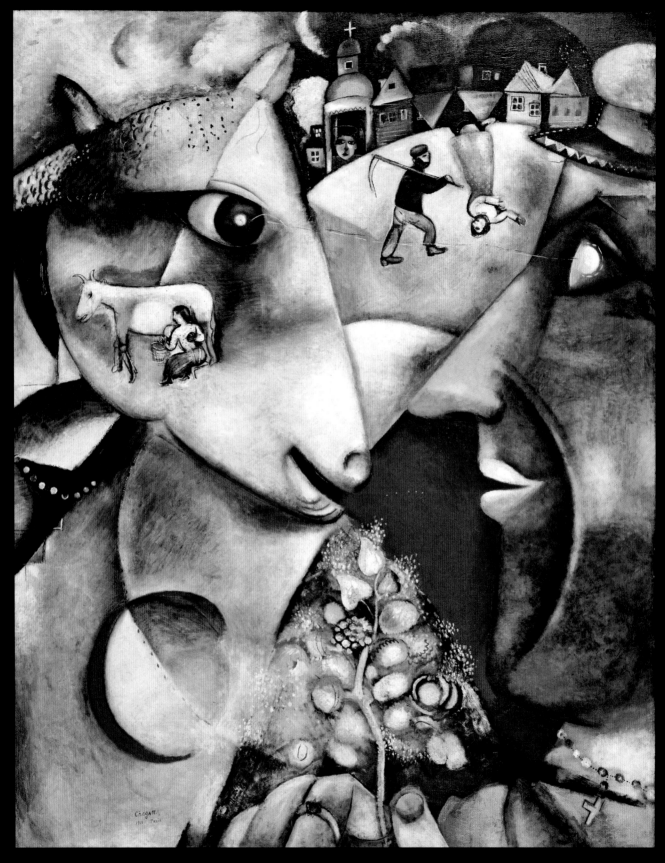

I and the Village, 1911. Oil on canvas,
192.1 × 151.4 cm (75⅔ × 59⅔ in).
Museum of Modern Art, New York. Mrs
Simon Guggenheim Fund. 146.1945.

'I have always tried to remain within the general tradition of a kind of folk art.'

Marc Chagall

1887–1985

BELARUS/FRANCE

In 1944, when Vitebsk, newly liberated by the Red Army, was praised by Stalin for its courage, Marc Chagall was moved to publish an open letter in a Yiddish newspaper in New York, where he had fled at the last possible moment (from Vichy France). 'I haven't seen you in a long time, my dear city,' it reads in part. 'I did not live with you, but I didn't have one single painting that didn't breathe with your spirit and reflection . . . The best I could wish for myself is – if you said I was and remain forever faithful to you. Otherwise, I wouldn't be an artist.'

The world Chagall grew up in vanished during his lifetime. The Vitebsk of his childhood was a provincial capital in the Pale of Settlement, the region along the western border of Imperial Russia where for generations Jews had been allowed permanent residence. A minority in the Pale overall, Jews were a significant presence – often a majority – in its cities and small towns, making the region into a vast, Yiddish-speaking 'empire within an empire'.

Chagall belonged to the generation that began to leave this world behind, assimilating into the secular cultures of Europe and Russia. He attended a Russian secondary school in Vitebsk, studied art in Saint Petersburg, then moved to France, where he lived for most of the rest of his life. Yet Yiddish remained the language in which he expressed himself most freely, and in his kaleidoscopic paintings he ceaselessly recombined motifs from the traditional Jewish world he had known – the city of Vitebsk, the small towns (*shtetlach*) of his forebears and the villages of the Russian peasants.

It was in Paris that Chagall's gifts flowered and he remained grateful to the city all his life. 'I seemed to be discovering light, colour, freedom, the sun, the joy of living, for the first time,' he later recalled. 'It was from then on that I was at last able to express, in my work, some of the more elegiac or moonstruck joy that I had experienced in Russia.' Chagall took what was useful to him from the Cubist tendencies that prevailed when he arrived, but his artistic goals were fundamentally different. 'I have always tried to remain within the general tradition of a kind of folk art and, at the same time, of all great art that also appeals immediately to the less sophisticated, to the people,' he said. Although details in Chagall's paintings occasionally give visual form to Yiddish expressions, he cautioned against understanding his work as anecdotal or fantastic. Rather, he said, he sought to illustrate a logic of the illogical. He sought to construct a world 'where everything and anything is possible and where there is no longer any reason to be at all surprised, or rather *not* to be surprised by all that one discovers there.'

Above Portrait of Marc Chagall by David Rubinger, c. 1965.

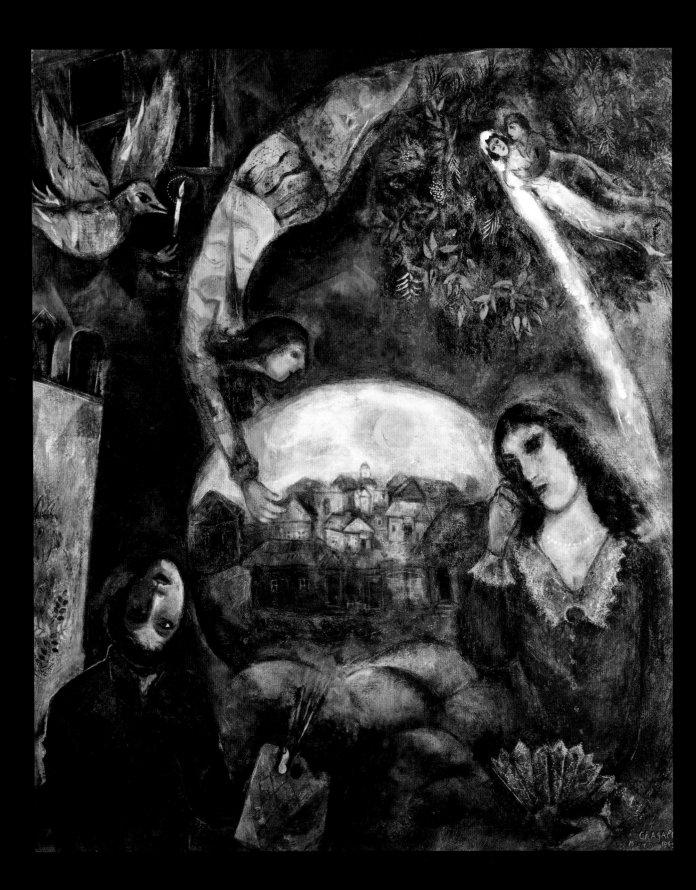

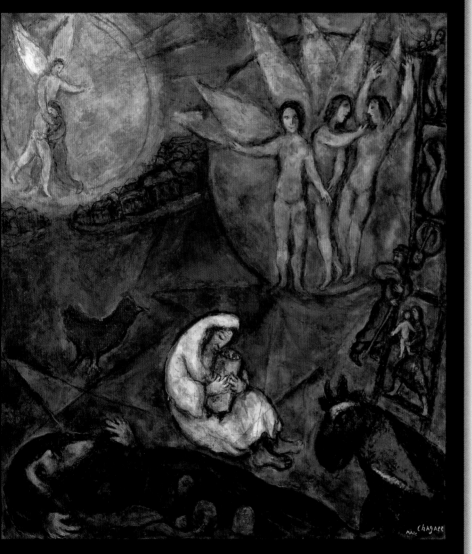

Opposite *Around Her*, 1945. Oil on canvas, 131 × 109.5 cm (51⅝ × 43 in). Musée National d'Art Moderne, Centre Georges Pompidou, Paris.

Above *The Dream of Jacob*, 1956/1967. Oil on canvas, 125 × 109.5 cm (49¼ × 43 in). Musée National d'Art Moderne, Centre Georges Pompidou, Paris.

Marc Chagall

- **1887** Born 7 July, Vitebsk, Ukraine
- **1912** Exhibits at the Salon des Indépendants
- **1914** Stranded in Russia at outbreak of World War I
- **1921** Completes murals for the Moscow State Yiddish Theatre
- **1923** Returns to Paris
- **1941** Flees from Vichy France to New York
- **1948** Returns to France
- **1973** Musée Marc Chagall opens
- **1985** Dies 28 March, Saint-Paul-de-Vence

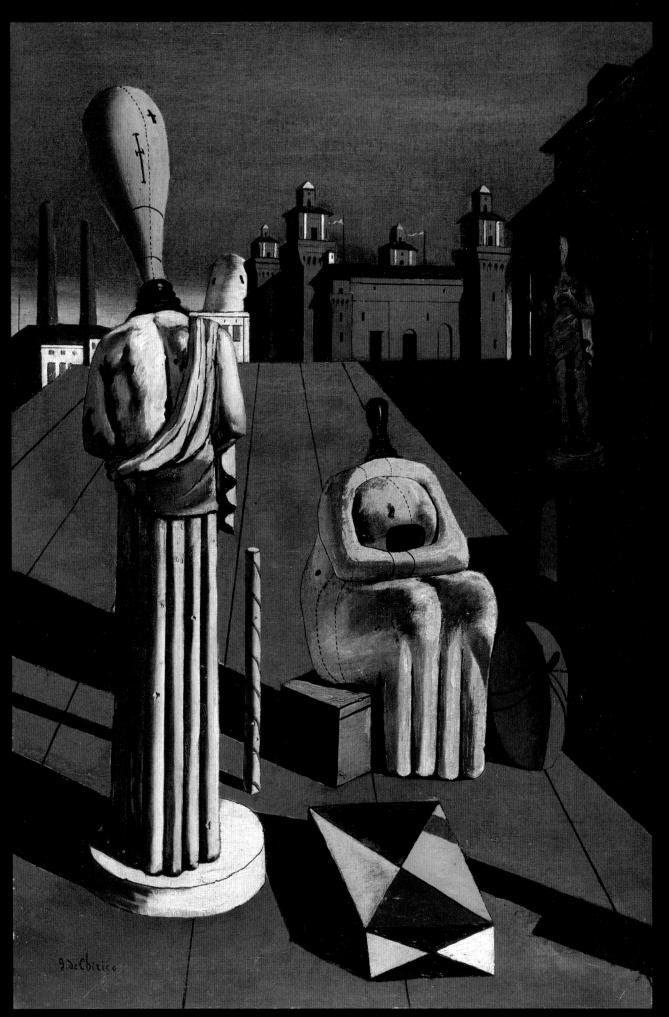

'One must picture everything in the world as an enigma.'

Giorgio de Chirico

1888–1978

GREECE/ITALY

Like many artists at the dawn of the twentieth century, Giorgio de Chirico was drawn to the philosophy of Friedrich Nietzsche, which he first encountered as a student in Munich. It was reading Nietzsche, he said, that opened his eyes to the existence of 'strange, unknown, solitary things', and it was under the philosopher's influence that he began to have what he called his revelations. '*Subjects* no longer came to my imagination, my compositions had no *sense*, above all no *common sense*', he recalled. 'They were calm: but each time I looked at them I experienced exactly what I had experienced at the moment of their conception.'

For de Chirico, Nietzsche was, above all, a poet whose writings evoked the mystery and melancholy of autumn afternoons in Italian cities, especially Turin, where he had lived during the autumn of 1888, and where madness overtook him. Through enigmatic cityscapes featuring deserted piazzas, empty arcades, solitary statues, towers topped with colourful pennants snapping in the wind, distant trains and ships, and the clear skies and long shadows of Italian afternoons, de Chirico tried to express the feeling that he had discovered in Nietzsche's work. Writing in 1913, the poet Guillaume Apollinaire referred admiringly to de Chirico's 'strangely metaphysical paintings'. De Chirico adopted the adjective when, together with the Italian painter Carlo Carrà, he formulated the principles of Metaphysical Painting (*La Pittura Metafisica*), several years later.

'The appearance of a metaphysical work of art is serene; it gives the impression, however, that something new must happen amid this same serenity, and that other signs apart from those already apparent are about to enter the rectangle of the canvas,' de Chirico wrote in 1919. He urged artists to pay close attention to those moments in which reality seemed dreamlike, in which everyday scenes and objects suddenly seemed enigmatic, as though drained of logical connections. 'The dream is an extremely strange phenomenon and an inexplicable mystery; even more inexplicable is the mystery and appearance that our mind confers on certain objects and on certain aspects of life . . . Art is the fatal net that catches these strange moments in flight.'

Such ideas made de Chirico a hero to the Surrealists in Paris, who acquired, interpreted and publicized the paintings he had left in his studio in 1915 when he returned to Italy to serve in World War I. It is not too much to say that de Chirico showed the Surrealist writers what Surrealist painting could look like. Paradoxically, however, even as he was hailed by the Surrealists, de Chirico left his first manner behind. In 1919, following a revelation he experienced standing before a painting by Titian in Rome, he became obsessed by technique and by the painting of the Old Masters. For the rest of his long career, he was determined to be great in the way that they had been great. Modern painting, he wrote, was a plague.

Opposite *The Disquieting Muses*, 1916. Oil on canvas, 97 × 66 cm (38⅕ × 26 in). Private collection.

Above Portrait of Giorgio de Chirico by Carl Van Vechten, 1936.

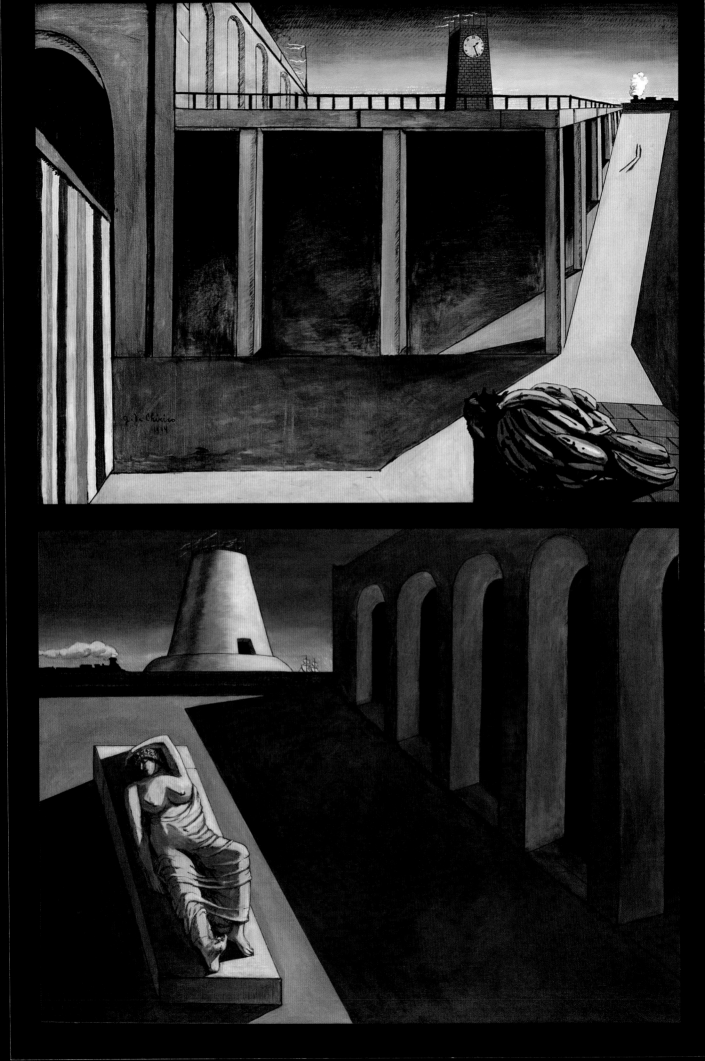

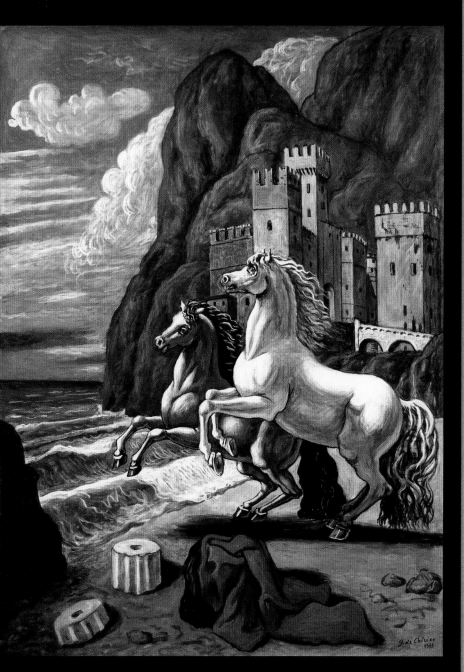

1888 Born 10 July, Volos, Greece

1890

1900

1903 Enrols at the School of Fine Arts, Athens

1906 Enrols at the Academy of Fine Arts, Munich

1910

1911 Moves from Florence to Paris

1913 Paintings described as 'metaphysical' by Guillaume Apollinaire

1915 Called up for service in World War I. Returns to Italy

1917 With Carlo Carrà, formulates Metaphysical Painting (*La Pittura Metafisica*)

1920

1925 Returns to Paris. Meets and breaks with the Surrealists

1930

1932 Returns to Italy

1940

1950

1960

1970

1978 Dies 20 November, Rome

Opposite above *Gare Montparnasse* (*The Melancholy of Departure*), 1914. Oil on canvas, 140 × 184.5 cm (55⅛ × 72⅝ in). Museum of Modern Art, New York. Gift of James Thrall Soby. 1077.1969.

Opposite below *Ariadne*, 1913. Oil and graphite on canvas, 135.6 × 180.3 cm (53⅜ × 71 in). The Metropolitan Museum of Art, New York. Bequest of Florene M. Schoenborn, 1995. Acc. n.: 1996.403.10.

Above *Cavalli antichi ai piedi del castello* (*Horses at the Foot of the Castle*), 1968. Oil on canvas, 100 × 76 cm (39⅜ × 30 in). Fondazione Giorgio e Isa de Chirico, Rome.

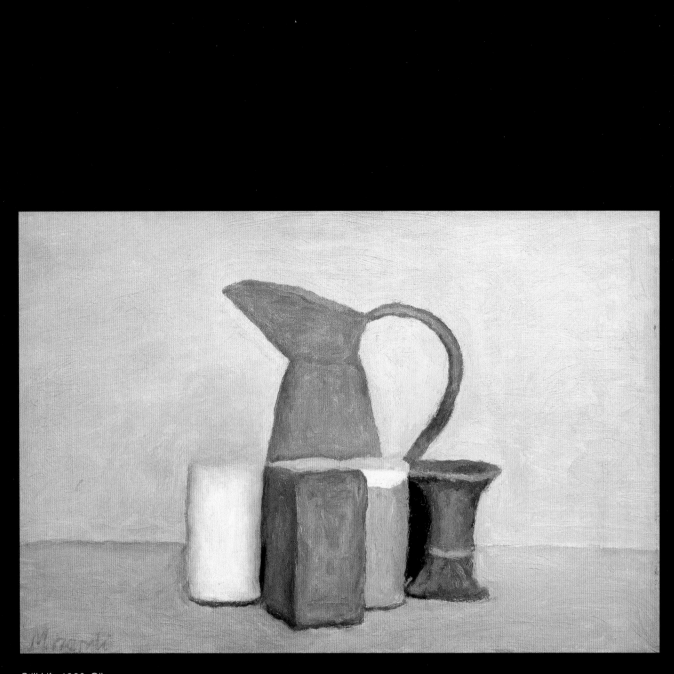

Still Life, 1960. Oil on canvas,
30 × 45 cm (11⅘ × 17⅔ in).
Private collection.

'I believe that nothing can be more abstract, more unreal, than what we actually see.'

Giorgio Morandi

1890–1964

ITALY

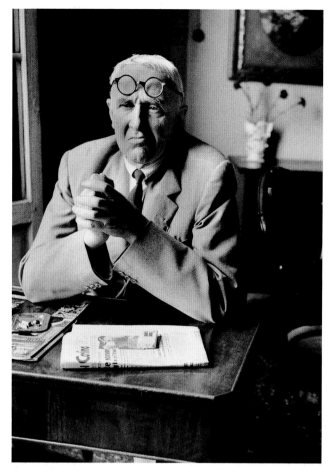

The objects huddle together in the barest indication of a setting: one expanse of colour indicates a surface, another suggests a backdrop or a wall. The objects themselves are unremarkable – vase, pitcher, bottle, bowl, canister. Their useful lives are in the past; they exist now purely to be painted. Again and again the same objects appear in new arrangements. At times they take on the monumental grandeur of architecture. At other times they seem to draw together for safety, a small and vulnerable community. Spatial ambiguities destabilize what we think we are seeing – contours and edges coincide, volumes deflate, dark forms open into the background, intervals of space shift forward and take on substance. No wonder the California light-and-space artist Robert Irwin called the still lifes of Giorgio Morandi 'a litmus test in seeing'.

'I am essentially a painter of the kind of still-life composition that communicates a sense of tranquillity and privacy, moods which I have always valued above all else,' Morandi said simply. Indeed, Morandi's attachment to tranquillity and privacy was legendary. He spent his entire life in Bologna, where he shared an apartment with his three sisters and, until she died in 1950, his mother (his father had died when Giorgio was 19). His bedroom doubled as a painting studio. He taught drawing in the public schools until he was 40, then etching techniques at the Academy of Fine Arts until he retired. 'I have been fortunate enough to lead . . . an uneventful life,' he said in summary. 'My only ambition is to enjoy the peace and quiet which I require in order to work.'

Morandi's life may have been uneventful but he was not the hermit he is sometimes made out to be. He travelled often within Italy, where he had a large network of accomplished and influential friends. He welcomed a steady stream of visitors in Bologna. Since the 1920s,

his painting had received critical attention – praised, censured or dismissed in the violent ideological battles that swept across Italy during the decades before and after World War II. As a student he had absorbed the lessons of Paul Cézanne, Cubism and Futurism. As a young artist he found his footing as a Metaphysical painter, though he did not stay with the style for long. He kept abreast of developments in contemporary art, including the rise of abstract painting, but he was never tempted to abandon his subject-matter.

'I believe that nothing can be more abstract, more unreal, than what we actually see.' he said. 'It is very difficult, perhaps impossible, to express in words the feelings and images that the visible world, the formal world, gives rise to. These are, in effect, feelings that bear no relation, or which are only very indirectly related, to everyday affections and interests, since they are determined by forms, colours, the space and the light.'

Above Portrait of Giorgio Morandi by Franz Hubmann, 1958.

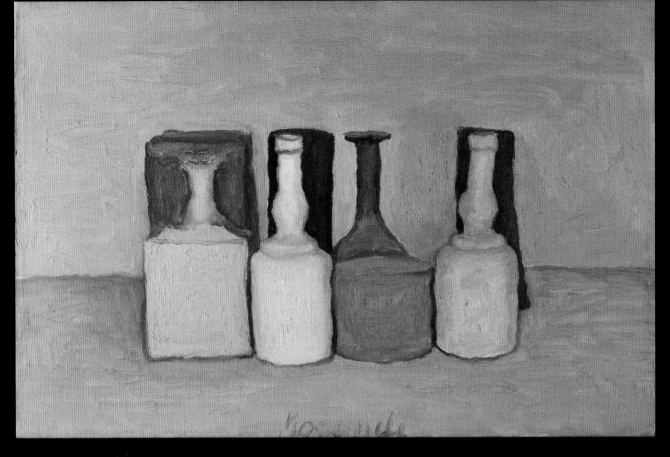

Above *Still Life*, 1956. Oil on canvas, approx. 30 × 45 cm (11⅘ × 17⅔ in). Collezione Comunale d'Arte, Bologna.

Opposite *Still Life*, 1956. Oil on canvas, 25.2 × 35.2 cm (9¹⁵⁄₁₆ × 13⅞ in). Yale University Art Gallery, New Haven. Gift of Mr and Mrs Paul Mellon, B.A. 1929. 1995.47.1.

Giorgio Morandi

Born 20 July, Bologna

Paints his first Metaphysical works

Participates in group exhibition of Metaphysical Painting (*Pittura Metafisica*), Florence

1890 1900 1910 1918 1920 1922

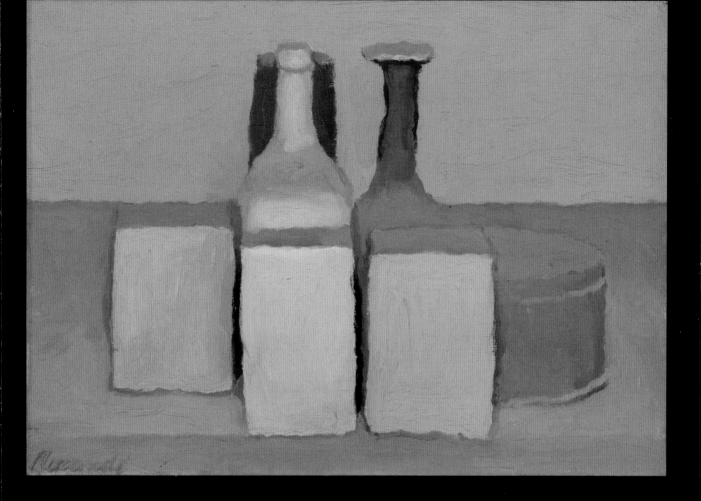

Appointed instructor in etching techniques, Academy of Fine Arts, Bologna

First solo exhibition, Rome Quadriennale

Awarded First Prize for an Italian Painter, Venice Biennale

Awarded Grand Prize for painting, São Paulo Biennial

Dies 18 June, Bologna

1930 1939 1940 1948 1950 1957 1960 1964

Portrait of the Journalist Sylvia von Harden, 1926. Mixed media on panel, 121 × 89 cm (47⅔ × 35 in). Musée National d'Art Moderne, Centre Georges Pompidou, Paris.

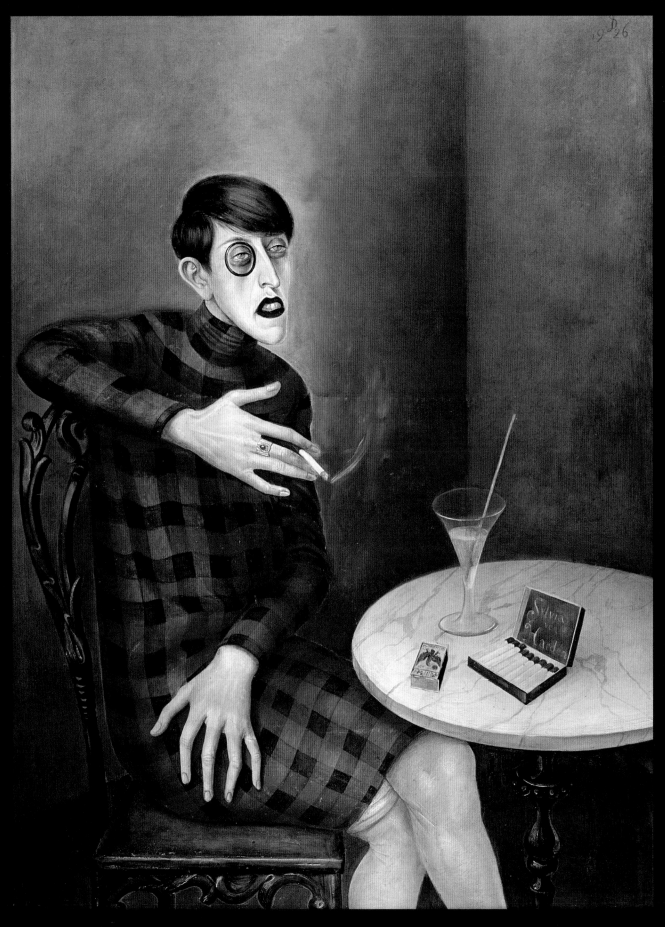

'Artists shouldn't try to improve
or convert ... They should only
bear witness.'

Otto Dix

1891–1969

GERMANY

Of the artists who returned from World War I alive, no one had experienced the horror more completely than Otto Dix. For three years he had fought as a machine-gun troop leader on the Western and Eastern fronts. He never forgot the things he saw and, in his art, he tried to make sure no one else would forget them either.

Like so many young men of his generation, Dix had welcomed the war. Steeped in the philosophy of Friedrich Nietzsche, he longed to experience life intensely. 'The war was a terrible thing but nevertheless something powerful,' he recalled decades later. 'I couldn't by any means miss it. You have to have seen humanity in this unfettered state to know anything about humanity.'

Dix's wartime drawings show him alternating a realistic approach with a Cubo-Futurist style. After the war, he co-founded the Dresden Secession, an organization of Expressionist artists. He was also drawn briefly to the methods and attitudes of the Dada group in Berlin, making such corrosive images as *The Skat Players* under its banner. Ultimately, however, Dix's admiration for the works of the Old Masters that he had known as a student prevailed, and he developed a realistic style with its roots in the painting of the Northern Renaissance. 'For me . . . newness in painting derives from extending subject-matter, from heightening forms of expression whose essence is already present in the Old Masters,' he said. 'In any case the object remains the primary thing for me and the form is determined by the object.' Dix was not the only painter of the time to turn away from the feverish subjectivity of Expressionism towards a cooler, more factual style. Detecting a trend, a contemporary art historian dubbed the phenomenon the New Objectivity (*Neue Sachlichkeit*).

As a leading painter of the New Objectivity, Dix had two great subjects: the war and the brilliant, decadent and ultimately doomed society of the Weimar Republic that succeeded it. He became Weimar's favourite portraitist, and he shocked and thrilled his public with depictions of prostitution, lust murders, nightclubs and street scenes. In his war paintings and his series of prints called *Der Krieg* (*The War*), he brought forth nightmarish images of rotting cadavers, hideously wounded soldiers and bombed-out lunar landscapes. 'I didn't paint war pictures in order to prevent war,' he said. 'I would never have been so presumptuous. I painted them in order to exorcise war. All art is exorcism.'

When the Nazis came to power in 1933, Dix was fired from his teaching post and condemned as a degenerate artist. He moved to a village near the Swiss border, where he painted landscapes, allegories and religious subjects, often containing coded criticisms of the regime. In 1944, towards the end of World War II, he renounced his painstaking Renaissance-inspired style in favour of a rougher, more direct approach.

Above Portrait of Otto Dix by Hugo Erfurth, 1925.

Above *Shock Troops Advance under Gas*, from *The War*, 1924. Etching, aquatint and drypoint from a portfolio of 50, 19.3 × 28.8 cm (7⅝ × 11⁵⁄₁₆ in). Museum of Modern Art, New York. Gift of Abby Aldrich Rockefeller. Acc. n.: 159.1934.12.

Opposite *The Skat Players*, 1920. Oil on canvas, 110 × 87 cm (43¼ × 34¼ in). Nationalgalerie, Staatliche Museen zu Berlin.

Otto Dix

Born 2 December, Untermhaus

Moves to Dresden to study art

Outbreak of World War I. Called up as a reservist

Volunteers for the front

Resumes art studies, Co-founds Dresden Secession

Moves to Berlin. Participates in the New Objectivity (*Neue Sachlichkeit*) exhibition, Mannheim

1891 1900 1910 1914 1915 1919 1920 1925

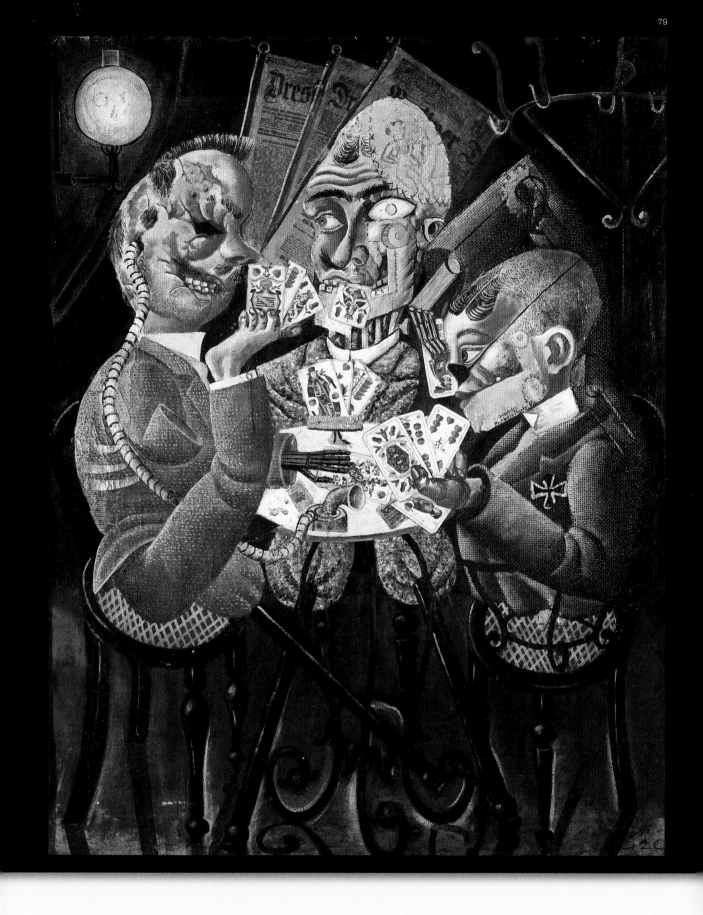

Nazis come to power.
Dismissed from teaching post

Dies July 25,
Singen

1933 1940 1950 1960 1969

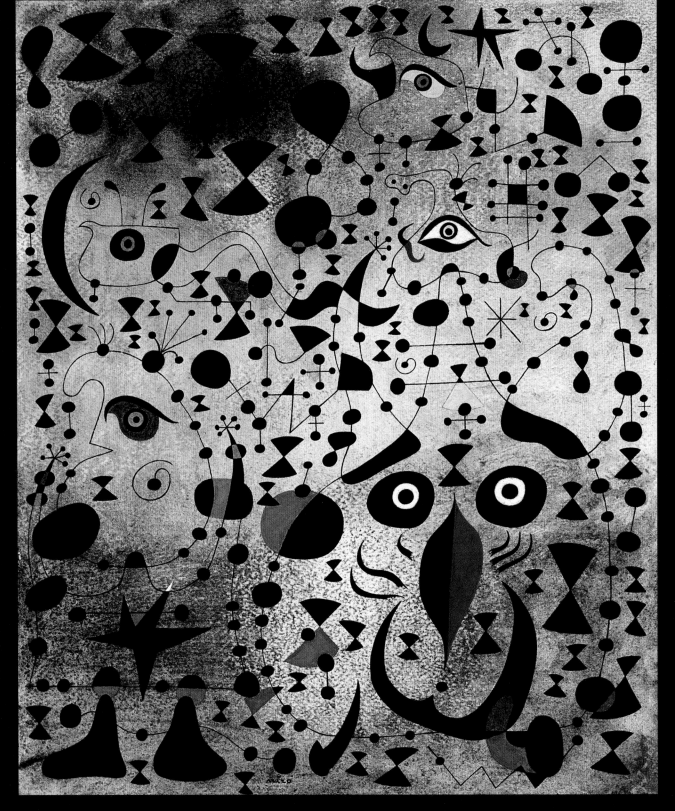

The Beautiful Bird Revealing the Unknown to a Pair of Lovers, 1941.
Gouache and oil wash on paper,
45.7 × 38.1 cm (18 × 15 in). Museum
of Modern Art, New York. Acquired
through the Lillie P. Bliss Bequest, 1945.

'For me a form is never something abstract; it is always a sign of something.'

Joan Miró

1893–1983

SPAIN

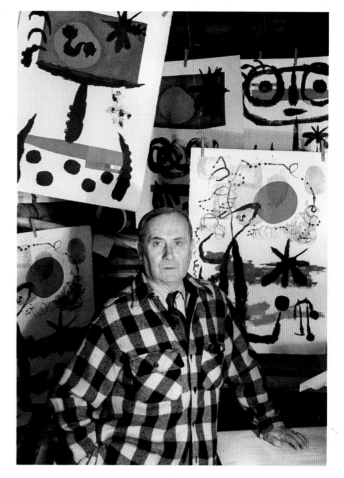

'Just as Picasso has been labelled a Cubist, I've been labelled a Surrealist,' Joan Miró told a Spanish interviewer in 1931. 'But what I want to do above and beyond anything else, is to maintain my total, absolute, rigorous independence.' Indeed, although he exhibited with the Surrealists and shared their interest in dreams, *eros* (intimate or romantic love) and the unconscious, Miró never officially joined the movement, instinctively rebelling against the severe discipline imposed by its founder, the writer André Breton. 'He was waiting for the proof of what he had written . . . to help his work as a theorist,' Miró recalled. 'A theory, that means nothing to me.'

If Miró distrusted literary men, poets were another matter entirely. Arriving in Paris, he quickly fell in with a circle of young painters and poets, and it was reading poetry that inspired him to move away from the realistic style he had been practising. One of the first fruits of this new direction was *The Hunter*, a lively scene described with great exactitude in fine lines and simple shapes that repeat across the canvas, suggesting surprising transformations and correspondences. It was Miró's breakthrough painting and the Surrealists took notice.

Miró developed his personal language of signs and symbols by exploring different ways of generating paintings. He first turned his attention to dream paintings such as *The Siesta*, made from drawings inspired by hallucinations brought on by hunger. In later years, he opened his working method up to accident and improvisation. 'Rather than setting out to paint something, I begin painting,' he explained. 'The form becomes a sign for a woman or a bird as I work.' Though not always decipherable, every form in his work was a sign of something, Miró insisted. For him, nonrepresentational art was 'a deserted house'.

Art, Miró said, 'must reveal the movement of a soul trying to escape the reality of the present . . . in order to approach new realities, to offer other men the possibility of rising above the present.' Nowhere is this goal more clearly realized than in the *Constellations*, a series of works created during the first years of World War II. 'I felt a deep desire to escape,' Miró recalled. 'I closed myself within myself purposely.' Based in forms suggested by reflections in the water, inspired by night, music and the stars, the *Constellations* teem with life that seems at once microscopic and cosmic. Shown for the first time in 1945 in New York, these paintings exerted a major influence on the painters then working their way towards Abstract Expressionism.

Above Portrait of Joan Miró by Denise Colomb, c. 1974.

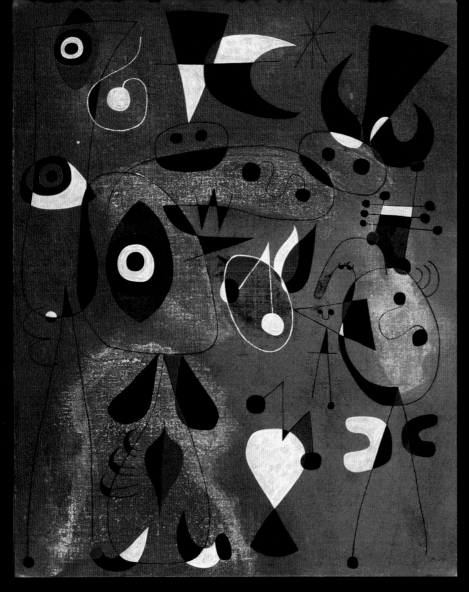

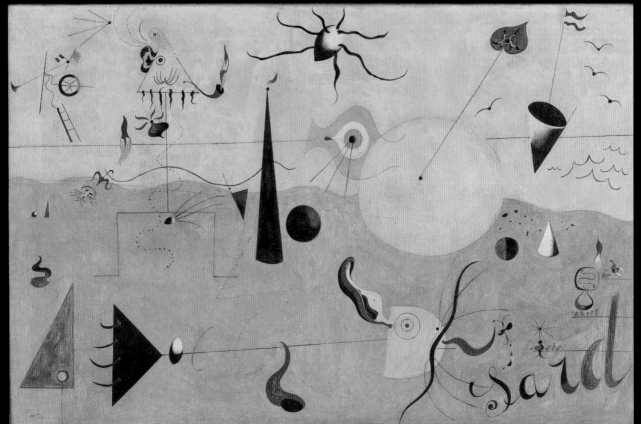

Opposite above *Women, Birds and a Star*, 1949. Oil on canvas, 92.7 × 74 cm (36 ½ × 28⅛ in). The Metropolitan Museum of Art, New York. Jacques and Natasha Gelman Collection, 1998. Inv. 1999.363.55.

Opposite *The Hunter* (*Catalan Landscape*), 1923–24. Oil on canvas, 64.8 × 100.3 cm (25½ × 39½ in). Museum of Modern Art, New York. Purchase. 95.1936.

Above *The Siesta*, 1925. Oil on canvas, 114 × 146 cm (44⅞ × 57½ in). Musée National d'Art Moderne, Centre Georges Pompidou, Paris.

Joan Miró

1890

1893 — Born 20 April, Barcelona

1900

1910

1912 — Enrols in the progressive art school founded by painter Francesc Galí

1920

1921 — Moves to Paris, returning to Catalonia for extended periods

1925 — Begins showing with the Surrealist group

1930

1940

1941 — First retrospective exhibition, MoMA, New York

1950

1956 — Moves to Majorca, where he had taken refuge during World War II

1960

1970

1975 — Opening of the Joan Miró Foundation, Barcelona

1980

1983 — Dies 25 December, Palma

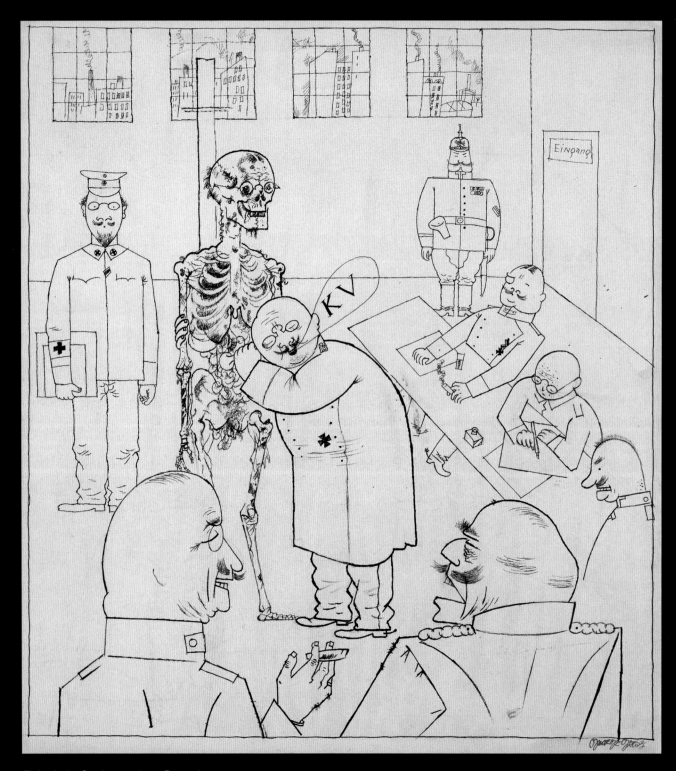

Fit for Active Service, 1916–17. Pen and
brush and ink on paper, 50.8 × 36.5 cm
(20 × 14⅜ in). Museum of Modern Art,
New York. A. Conger Goodyear Fund.
234.1947.

'This world is ugly, sick and mendacious.'

George Grosz

1893–1959

GERMANY

George Grosz was a troublemaker of genius. As a student in high school, his behaviour once prompted a teacher to slap him. Outraged, Grosz slapped the teacher right back and was promptly expelled. A few years later, when he picked up his pen to skewer the citizens of the Weimar Republic, it was clear that his unwillingness to defer to authority had only intensified. Over the course of a decade, Grosz's satirical drawings caused him to be prosecuted for obscenity, blasphemy and insulting the army. 'I drew and painted from a spirit of contradiction,' he said, 'and attempted in my work to convince the world that this world is ugly, sick and mendacious.'

It was not just humanity in general but Germany in particular that disgusted Grosz. 'To be German always means to be tasteless, stupid, ugly, fat, inflexible . . . a reactionary of the worst sort,' he fumed to a friend in 1916. He had volunteered for the army in 1914 only because he was certain that he would soon be drafted. Discharged for medical reasons, he was nevertheless recalled in 1917, when the need for soldiers grew desperate. 'This time my nerves shattered before I saw the front, decomposing corpses and barbed wire,' he wrote. After a spell in an insane asylum, he was released as 'permanently unfit for war'.

Grosz emerged from the war years newly politicized, less willing to entertain and more determined to provoke. He joined the Communist party, and when the anarchic art movement Dada arrived in Berlin from Switzerland he was drawn to it immediately. He participated gleefully in the Dadaists' raucous public meetings and he helped organize the First International Dada Fair. 'What did the Dadaists do?' he wrote. 'They said this: huff and puff as much as you like – recite a sonnet by Petrarch, or by Rilke, or gild the heels of your boots, or carve Madonnas

– the shooting goes on, the usury goes on, the starving goes on, the lying goes on. What earthly good is art?'

Grosz continued to publish his increasingly famous drawings after the energies of Dada dissipated. In 1925, his paintings were included in the exhibition that identified the New Objectivity (*Neue Sachlichkeit*) as a trend in German art. He foresaw more accurately than many of his compatriots the threat posed by the rise of the Nazi Party – its admirers were exactly the kind of people he had been mocking for years. They knew it as well as he did and he was threatened often enough that in 1933, just weeks before Hitler was appointed Chancellor, he emigrated to the United States, a country he had been fascinated by since he was a child. 'I am torn in two,' he told an interviewer there during the war. 'It is like living in a haunted house, you can't escape it and you can't forget.'

Above Portrait of George Grosz by Emil Bieber, 1928.

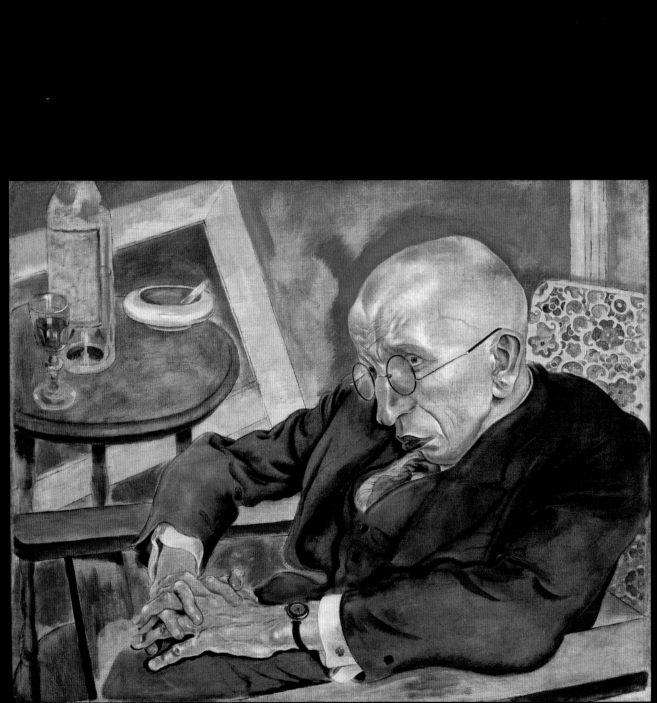

Above *The Poet Max Herrmann-Neisse*,
1927. Oil on canvas, 59.4 × 74 cm
(23⅜ × 29⅛ in). Museum of Modern Art,
New York. Purchase. Acc. n.: 49.1952.

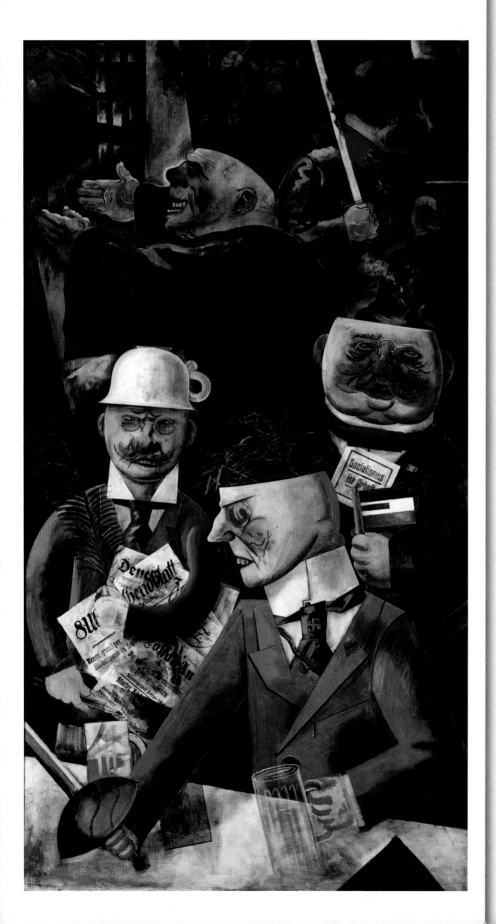

1890

1893 Born 26 July, Berlin

1900

1910

1920 Helps organize the First International Dada Fair, Berlin

1925 Included in the New Objectivity (Neue Sachlichkeit) exhibition, Mannheim

1930

1932 Retrospective exhibition, Brussels

1933 Moves to New York as the Nazis come to power

1937 Included in the notorious Degenerate Art exhibition, Munich

1940

1950

1954 Retrospective exhibition, New York

1959 Returns to Germany. Dies 6 July, Berlin

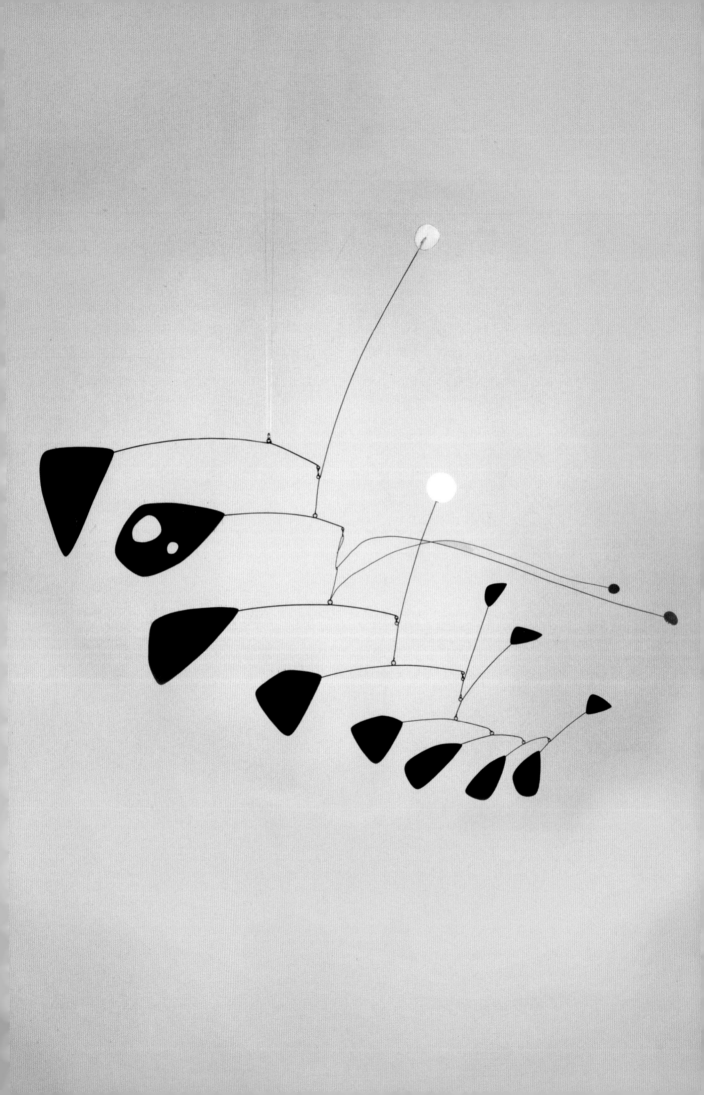

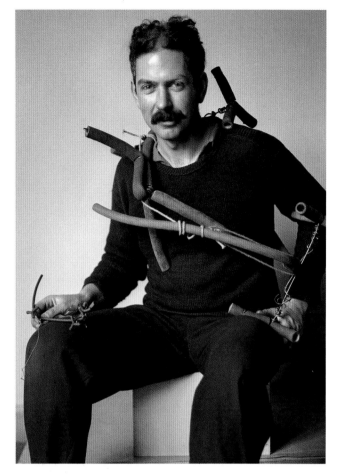

'I want to make things that are fun to look at, that have no propaganda value whatsoever.'

Alexander Calder

1898–1976

UNITED STATES

During the twentieth century, sculpture began to move. It happened in fits and starts. In 1913 in Paris, Marcel Duchamp mounted a bicycle wheel on a kitchen stool for the pleasure of watching it spin. In 1920 in Moscow, Aleksandr Rodchenko constructed objects out of concentric geometric shapes and suspended them in mid-air, while in New York, Man Ray suspended a construction of wooden coat-hangers that clacked and shivered when touched. Finally, a decade later, Alexander Calder set movement at the heart of his aesthetic, initiating a lifelong exploration of suspended forms that could be set in motion by a current of air or the touch of a hand.

Calder was living in Paris when his big idea came to him. A young artist with a background in engineering, he had already made something of a name for himself with clever wire portraits that looked like drawings in space and an ingenious miniature circus, which he performed privately for friends. A visit to Piet Mondrian's studio in 1930 opened his eyes to the possibilities of abstract art. 'It was a very exciting room,' he later recalled: 'on the solid wall between the windows there were experimental stunts with coloured rectangles of cardboard tacked on . . . I suggested to Mondrian that perhaps it would be fun to make these rectangles oscillate.' Mondrian did not think it would be the least bit fun, but Calder held fast to his insight. He began to experiment with abstract painting, then, after a couple of weeks, he reverted to working in three dimensions, creating abstract constructions of wire, wood and coloured shapes that moved. When Duchamp dropped by the studio to see the new works, Calder asked what he should call them. 'Mobiles,' said Duchamp. Another artist, Hans Arp, wondered humorously whether Calder would now be calling his sculptures that did not move 'stabiles'. Calder promptly adopted both terms.

Calder's very first mobiles were animated by motors or tiny hand-cranks, but within a year he had largely abandoned mechanical means in favour of the unpredictable forces of air currents and human interaction. 'A Mobile: a little local *fiesta*,' wrote Jean-Paul Sartre, 'a pure stream of movement in the same way as there are pure streams of light.' For Calder, they reflected the universe itself. 'Since the beginning of my work in abstract art, and even though it was not obvious at that time, I felt that there was no better model *for me* to work from than the Universe,' he said. 'Spheres of different sizes, densities, colours and volumes, floating in space, surrounded by vivid clouds and tides, currents of air, viscosities and fragrances – in their utmost variety and disparity.' Above all, he wanted to delight. 'I want to make things that are fun to look at, that have no propaganda value whatsoever.'

Opposite *Antennae with Red and Blue Dots*, c. 1953. Aluminium and steel wire, 111.1 × 128.3 × 128.3 cm (43¾ × 50½ × 50½ in). Tate, London.

Above Portrait of Alexander Calder by André Kertesz, 1929. © Estate of André Kertész. All rights reserved.

Above *Kiki de Montparnasse* II,
1930. Steel wire, 30.5 × 26.5 ×
34.5 cm (12 × 10½ × 34½ in).
Musée National d'Art Moderne,
Centre Georges Pompidou,
Paris.

Opposite *The Crab*, 1962. Painted
steel, 304 × 609 × 304 cm
(119⅝ × 239¾ × 119⅝ in).
Museum of Fine Arts, Houston.
Museum purchase.

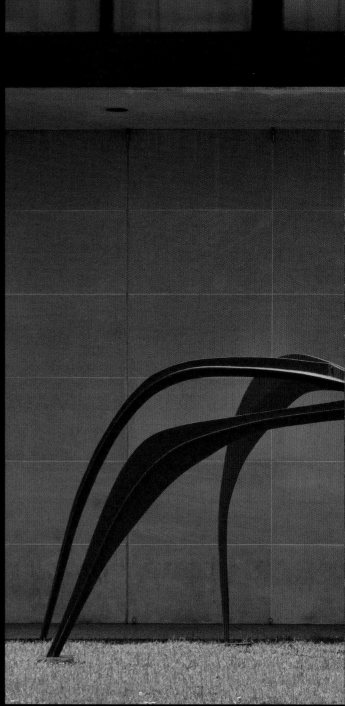

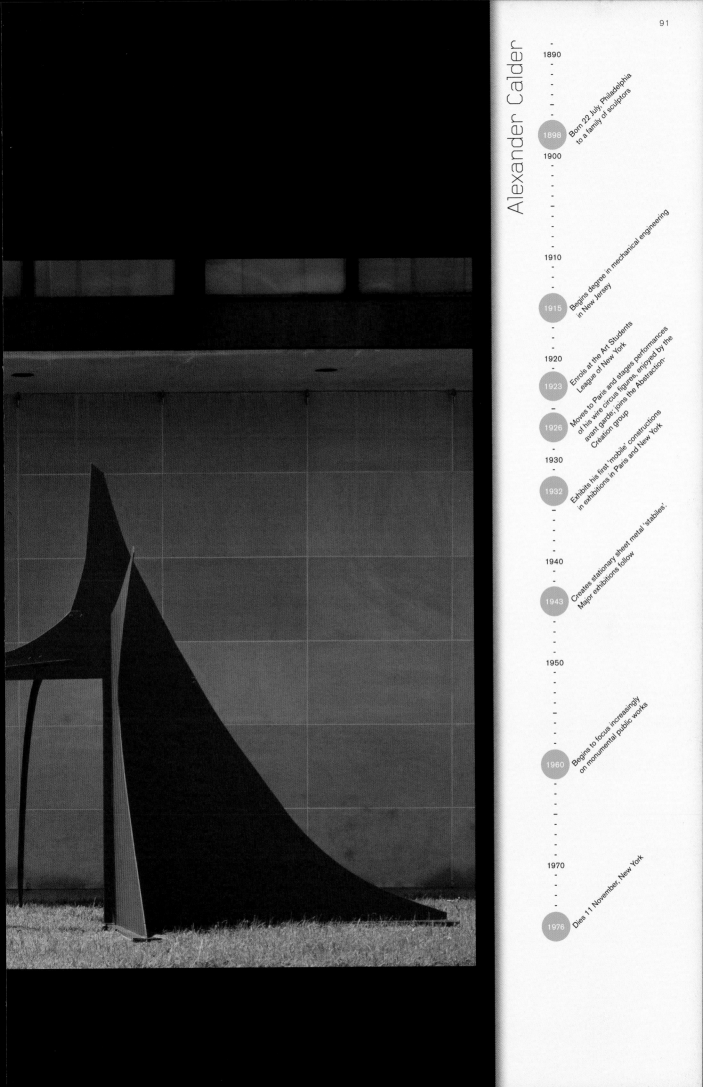

Alexander Calder

1890

1898 Born 22 July, Philadelphia to a family of sculptors

1900

1910

1915 Begins degree in mechanical engineering in New Jersey

1920

1923 Enrols at the Art Students League of New York

1926 Moves to Paris and stages performances of his wire circus figures, enjoyed by the avant garde; joins the Abstraction-Création group

1930

1932 Exhibits his first 'mobile' constructions in exhibitions in Paris and New York

1940

1943 Creates stationary sheet metal 'stabiles'. Major exhibitions follow

1950

1960 Begins to focus increasingly on monumental public works

1970

1976 Dies 11 November, New York

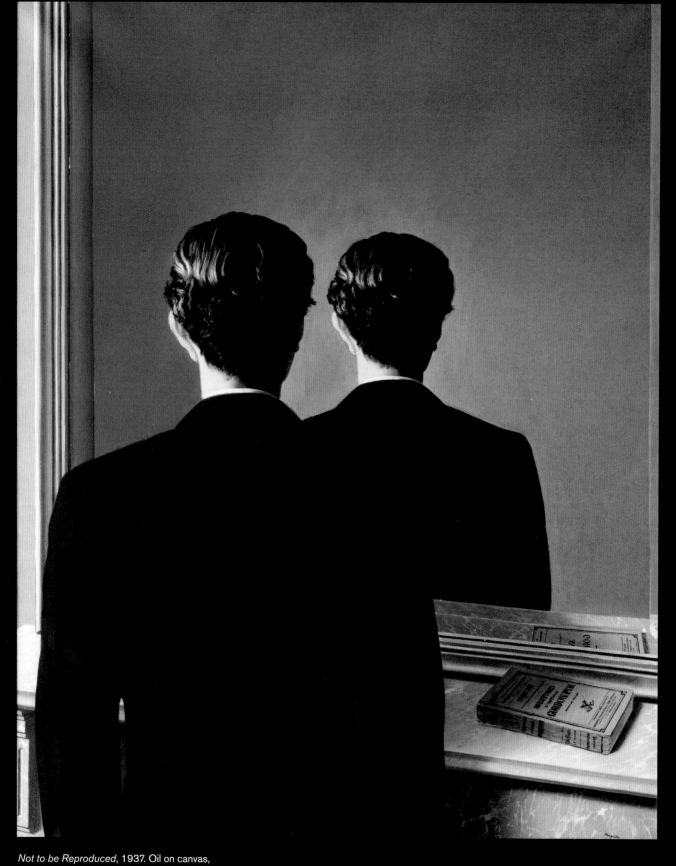

Not to be Reproduced, 1937. Oil on canvas,
81 × 65 cm (31⅞ × 25⅔ in). Museum
Boijmans Van Beuningen, Rotterdam.

'The mind loves the unknown.'

René Magritte

1898–1967

BELGIUM

René Magritte depicted inexplicable events as though they were the most ordinary sights in the world. In his paintings, the atmosphere mutates into blue blocks of sky, a miniature train erupts through the back wall of a fireplace, anonymous men in bowler hats float upright amid the facades of Brussels and no one bats an eye. 'Everything in my paintings ... flows from a conviction that the universe we belong to is, in fact, enigmatic,' he said. 'My pictures were conceived as material signs of the freedom of thought.'

Magritte was a founding member of the Brussels group of Surrealists, one of the numerous Surrealist factions that flourished in Belgium between 1924 and World War II. Although they were in contact with their Parisian counterparts and sometimes collaborated with them, the Brussels Surrealists developed their own approach and often distanced themselves from France. Whereas André Breton in Paris insisted that artists should practise automatism as a direct link to the unconscious, the Brussels group, less enamoured of dreams and the unconscious in general, preferred to subvert images of everyday reality. 'I don't believe in the unconscious, or that the world offers itself to us as a dream other than during our sleep ...' said Magritte. 'I don't believe in the imagination, either. Imagination is arbitrary, and I am looking for the truth and the truth is mystery ... The surreal is reality that hasn't been separated from its mystery.'

To make mystery visible, Magritte cultivated a bland, matter-of-fact style that sought not so much to situate itself within the development of art as to sidestep art altogether. He believed that stylistic evolution in art had ended with Cubism and he was one of the few artists to take seriously Dada's claim that it had done away with art once and for all. 'We can't go on destroying the idea of art, because it's been destroyed now,' he said. 'How to go on? It's a delicate matter. To be in a situation which does not involve one in destruction, or construction either.' His solution was not to think of art, but only of painting convincing images: 'My painting is nothing but the description (without originality or fantasy) of a thought whose only terms are the figures of the visible world.'

Magritte tried at every opportunity to discourage viewers from finding symbolic meanings in his poetically titled paintings or interpreting them in any way. 'There are many enigmas which are difficult to resolve and one might think in front of my pictures that they are enigmas of that kind,' he said. 'But the mystery we are speaking of is by definition without an answer. This implies neither despair nor hope. I have no right to think that it's either encouraging or discouraging. It's simply the way things are.'

Above Portrait of René Magritte by Steven Schapiro, 1965.

1898 Born 21 November, Lessines

1900

1910

Designs the first of many fashion advertisements; provocative word–image associations inform his paintings

1920

1922 Begins full-time painting; befriends future Surrealist poets and writers

1926 First solo exhibition, Brussels. Moves to
1927 Paris and becomes a leading Surrealist

1930 Returns to Brussels

1940

1950

1960

1965 Major retrospective at MoMA, New York, confirms Magritte as Belgium's greatest modern painter

1967 Dies 15 August, Brussels

Above *The Promenades of Euclid*, 1955. Oil
on canvas, 162.9 × 129.9 cm (64 × 51 in).
Minneapolis Institute of Arts. The William
Hood Dunwoody Fund.

Below *The Key of Dreams*, 1927. Oil on
canvas, 38 × 55 cm (15 × 21⅔ in).
Staatsgalerie Moderne Kunst, Munich.

'A hole can itself have as much shape-meaning as a solid mass.'

Henry Moore

1898–1986

UNITED KINGDOM

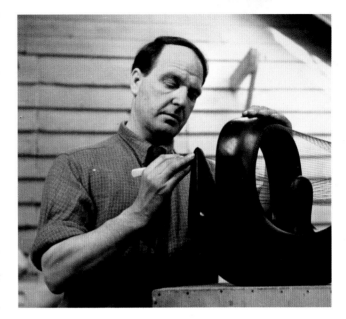

As a student, Henry Moore turned away from the Classical and Renaissance sculpture that his teachers expected him to emulate. Determined to find his own way, he began to frequent the non-Western collections of the British Museum. 'After the first excitement it was the art of ancient Mexico that spoke to me most,' he recalled. Pre-Columbian artists 'were true sculptors in sympathy with their material, and their sculpture has some of the character of mountains, of boulders, rocks and sea-worn pebbles.'

To be 'in sympathy' with materials was high praise from Moore, whose early works adhered to the doctrine of 'truth to materials': the idea that stone, for example, should not be carved to imitate the softness of flesh but should retain its essential 'stoniness'. For Moore and like-minded artists, truth to materials was a rallying cry for direct carving as opposed to the academic techniques of modelling and casting. It was Constantin Brancusi who had shown the way. 'Since the Gothic, European sculpture had become overgrown with moss, weeds – all sorts of surface excrescences which completely concealed shape,' Moore wrote, sweeping aside the Renaissance and all that followed. 'It has been Brancusi's special mission to get rid of this overgrowth and to make us more shape-conscious.'

Moore cultivated his own shape-consciousness by collecting pebbles, shells, bones and pieces of driftwood. 'I find that having many objects like that about, handling them, gives me ideas,' he said. 'There are universal shapes to which everybody is subconsciously conditioned and to which they can respond if their conscious control does not shut them off.' In his mature work, he 'rhymed' the human form with landscape, so that monumental reclining figures were brought into harmony with undulating hills, sea-smoothed rocks and

wind-carved cliffs. He opened up his forms with holes, so that masses, hollows and voids wrapped around each other. 'The first hole made through a piece of stone is a revelation,' he wrote. 'A hole can itself have as much shape-meaning as a solid mass.'

Moore regarded sculpture as an outdoor art and he enjoyed working in natural light. 'It is quite difficult to imagine, in the more or less artificial light of a well-planned studio, what outdoor light can do to a sculpture. A dull cloudy day with a diffused light demands a contrast in direction and size of masses and planes in a sculpture.' This was a primary consideration in England, in particular, he wrote, because there are so many sunless days.

Even at its most abstract, Moore's sculpture always retained a purchase on the forms of the natural world. 'Sculpture, for me, must have life in it, vitality,' he said. 'It must have a feeling for organic form, a certain pathos and warmth . . . It should always give the impression, whether carved or modelled, of having grown organically, created by pressure from within.'

Above Portrait of Henry Moore by Kurt Hutton for *Picture Post*, 28 July 1945.

Opposite *Reclining Figure*, 1957–58. Travertine marble, length 508 cm (200 in). Commisioned for the forecourt of the UNESCO building, Place de Fontenoy, Paris.

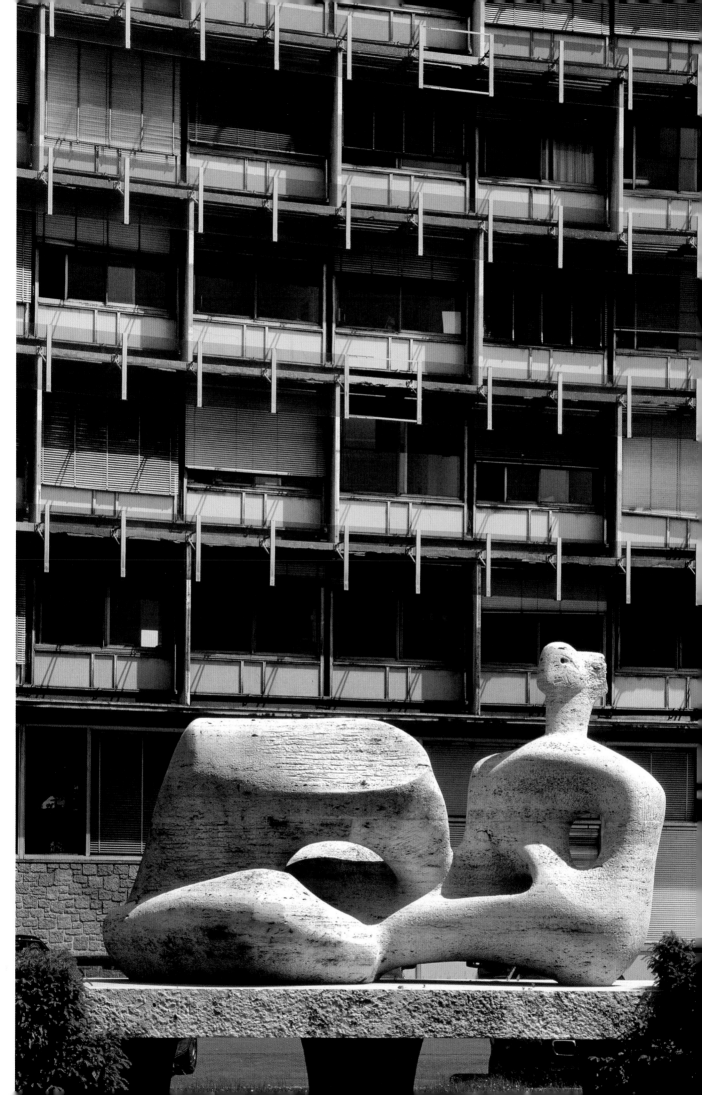

Henry Moore

1890
-
-
-
-

1898 Born 30 July, Castleford

1900
-
-
-
-

1910
-
-
-
-

1920
-
-

1928 First solo exhibition, London

1930
-
-

1938 Embraces modelling and casting

1940
-
-

1948 Awarded International Prize for Sculpture, Venice Biennale

1950
-
-

1958 *Reclining Figure* installed outside UNESCO headquarters, Paris

1960
-
-
-
-

1970
-

1972 Major retrospective exhibition, Florence
-

1977 Sets up the Henry Moore Foundation, Perry Green, Hertfordshire

1980
-
-

1986 Dies 31 August, Much Hadham

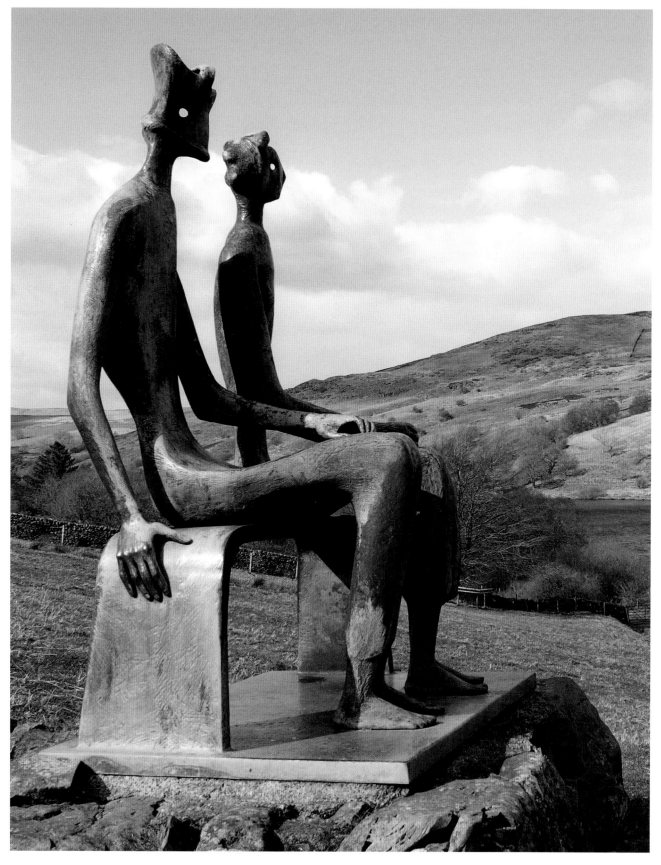

Opposite above *Family*, 1935. Elm wood, height
101.6 cm (40 in). Henry Moore Foundation,
Much Hadham. Gift of the artist.

Opposite below *Pink and Green Sleepers*, 1941. Pencil,
wax crayon, coloured crayon, chalk, watercolour wash,
pen and ink, 38.1 × 55.9 cm (15 × 22 in). Tate, London.

Above *King and Queen*, 1952–53 (cast 1950). Bronze
(edition of 5+1), height 164 cm (64½ in). Sited by
Moore at the Glenkiln Estate, Dumfries Keswick Estate,
Glenkiln, Dumfries.

Concetto spaziale, Attese (*Spatial Concept, Expectations*), 1960. Slashed canvas and gauze, 100.3 × 80.3 cm (39½ × 31⅝ in). Museum of Modern Art, New York. Gift of Philip Johnson. Acc. n.: 508.1970.

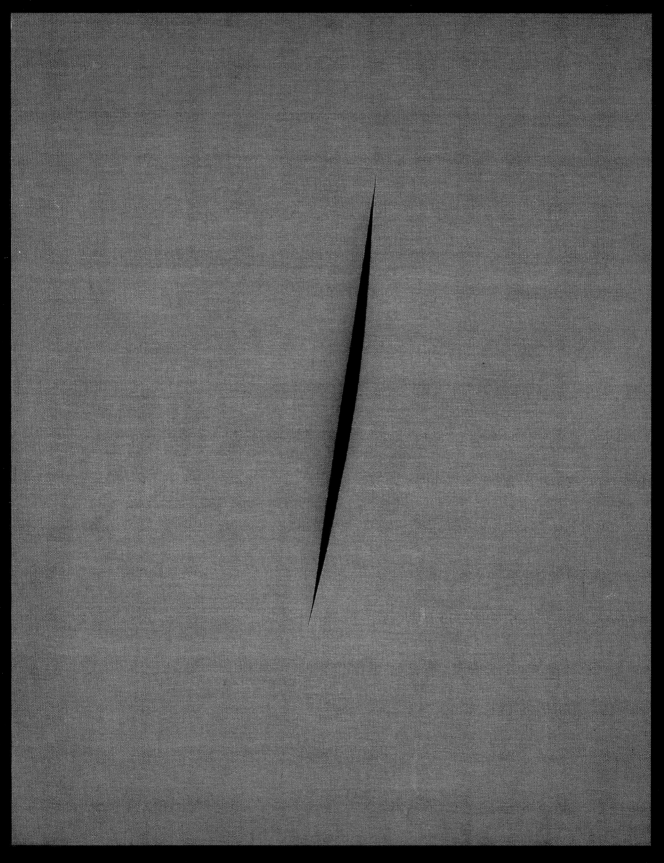

'My discovery was the hole and that's that.'

Lucio Fontana

1899–1968

ITALY

When Lucio Fontana returned to Milan from Argentina after World War II, Allied bombings had destroyed his studio and everything in it. An academically trained artist, he had specialized in funerary monuments and commemorative sculptures, a career that culminated in 1939 with a large bas-relief for the ceiling of a shrine to Fascist martyrs. Mussolini himself had attended the unveiling. During the same years, however, Fontana had had a parallel career as one of the most radical artists in Italy, creating abstract sculptures and turbulent glazed ceramics. ('People called my ceramics primeval,' he wrote. 'The material looked as if it had been hit by an earthquake.') After the war, almost all of this was forgotten or lost.

Fontana announced his return by founding a movement called Spatialism, which called for art to reinvent itself in response to the dawning space age. Spatialism emphasized the interrelation of art and science, and it encouraged artists to embrace new technologies such as radio, television and radar. Most radically, it declared that a work of art that lasted for a second was as valid as one that endured for millennia. 'Art is eternal, but it cannot be immortal,' Fontana wrote. 'We seek to liberate art from matter, to liberate the sense of the eternal from the preoccupation with immortality.'

In his series of spatial environments (*Ambienti spaziali*) Fontana was as good as his word: only one of the originals still exists. The first was *Black Environment* (*Ambiente nero*), which consisted of large papier-mâché forms painted with fluorescent colours, suspended from the ceiling of a darkened room and lit with ultraviolet light. 'Entering, you were completely alone with yourself,' Fontana recalled. 'Each viewer reacted according to his state of mind at the moment.' A second environment followed two years later, *Spatial Light* (*Luce spaziale*),

a continuous looping line of white neon light suspended from the ceiling.

Fontana's most famous spatial innovation occurred when he began to puncture holes (*bucchi*) through his canvases. 'The discovery of the cosmos is a new dimension,' he explained, 'it is infinity, so I made a hole in the canvas . . . and I created an infinite dimension . . . infinity passes through it, light passes through and there's no need to paint.' In later series, the *bucchi* were joined by surface accretions of sand, impasto, stones and coloured glass.

In 1958, Fontana began what would be his most sustained series, the *tagli*, or slashes – monochromatic canvases defaced by one or more slashes, their edges gently coaxed apart to reveal a black infinity (in reality a tenting of stiff black fabric). Fontana referred to his works as spatial concepts (*Concetti spaziali*) believing that to call them objects was too materialistic. 'My discovery was the hole and that's that,' he said towards the end of his life. 'I can go happily to my grave after that discovery.'

Above Portrait of Lucio Fontana joking around, Galleria del Naviglio, Milan, 1950s.

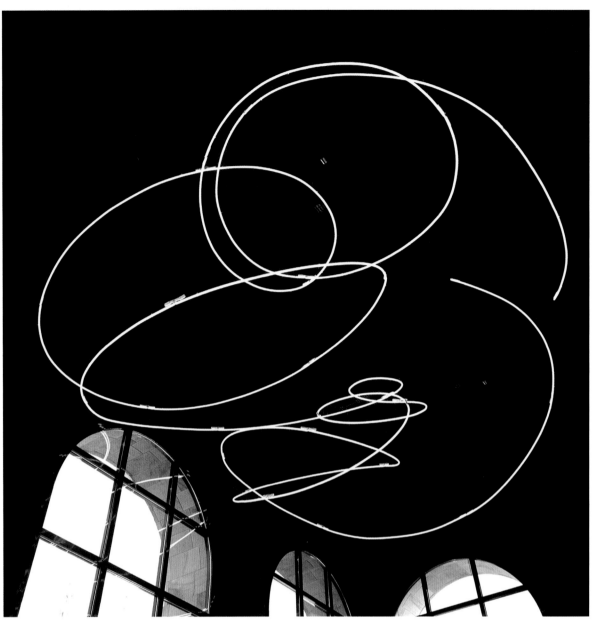

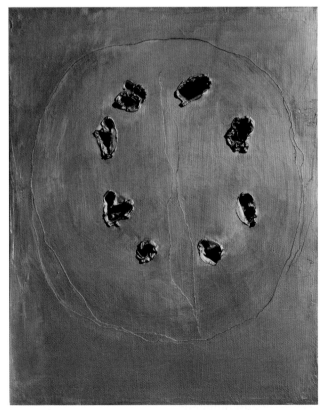

Above *Neon Structure*, created for the 9th Milan Triennale, 1951. Tubes of fluorescent neon light, 250 × 1000 × 800 cm (98½ × 393¾ × 315 in). Museo del Novecento, Milan.

Left *Spatial Concept*, 1964. Oil on canvas, 100.3 × 81 cm (39½ × 31⅞ in). Private collection.

Opposite *Spatial Concept, Stones*. 1955. Oil and coloured glass stones on canvas, 100 × 70 cm (39⅓ × 31½ in) Fondazione Lucio Fontana, Milan.

Lucio Fontana

1899 Born 19 February, Rosario de Santa Fe, Argentina

1900

1905 Relocates to Milan, later studies sculpture in Brera

1910

1920

1934 Joins Abstraction-Creation in Paris

1930

1940 Co-founds Argentina's Academia Altamira, promoting new art for the modern world

1947 Publishes his first Spatialist manifesto (*Spazialismo*) rejecting figurative art and conventional abstraction

1949 Begins puncturing and slashing his canvases in a lifelong exploration of spatial concepts (*Conceti spaziali*)

1950

1960

1966 Receives the Venice Biennale Grand Prize for Painting

1968 Dies 7 September, Comabbio, Italy

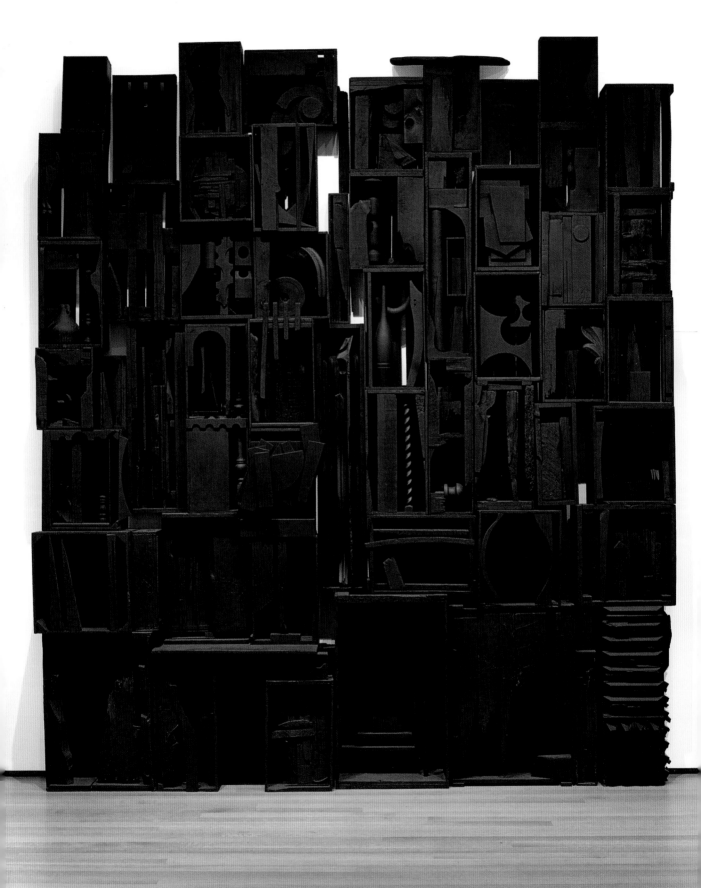

'If an object is in the right place, it's enhanced to grandeur.'

Louise Nevelson

1899–1988

UNITED STATES

'Who is an artist? I say, we take a title. No one gives it to us. We make our lives.' Thus rang out the voice of Louise Nevelson in her magnificent old age, confident, triumphant and defiant. To hear her tell it, she knew from the beginning that she was destined to be an artist, and so did her family and teachers: 'In the first grade, I already knew the pattern of my life. I didn't know the living of it, but I knew the line.' Marriage took her to New York, where she studied voice and drama as well as painting. When the marriage ended, she travelled to Europe, where she studied painting and worked as an extra in films. Returning to New York, she took classes in modern dance. 'At that time, dance was a vital force,' she recalled. 'It was like dance was *carrying* America at that time. Martha Graham, but the nature of her spirit, but the nature of her energy, but her presence and intensity, reflected our times.'

It was during World War II that Nevelson began to work towards her mature style as a sculptor. Her son was away at war. 'It threw me into a great state of despair,' she said. 'But it isn't only *one son*. It's that the *world* was at war and *every* son was at war . . . That is when I began using found objects. I had all this wood lying around and I began to move it around. I began to compose. Anywhere I found wood, I took it home and started working with it.' She painted her woods matt black before using them, so she could see their forms more clearly. Years later, she would broaden her palette to include white and gold, each with its own room in her studio, but black remained her favourite. 'The most aristocratic colour of all,' she called it. 'The only aristocratic colour.'

Nevelson was almost 60 when she created the exhibit *Moon Garden Plus One*, a sculptural environment that included the brooding *Sky Cathedrals*, her first wall sculptures. Monumental reliefs made of stacked wooden boxes that served as reliquaries for pieces of scavenged wood, the *Sky Cathedrals* combined the shallow, fractured space of Cubism with the engulfing scale of American postwar abstract painting. Wall sculptures became Nevelson's signature works and she rang variations on them for the rest of her career.

Nevelson followed *Moon Garden Plus One* with *Dawn's Wedding Feast*, an all-white sculptural environment. She hoped to find a buyer for the entire work, but in the end its components were dispersed, obscuring her historical contribution to the development of installation as an art form. 'Space has atmosphere and what you put into it will colour your thinking and your awareness,' she said. 'If an object is in the right place, it's enhanced to grandeur.'

Opposite *Sky Cathedral*, 1958.
Assemblage of wood painted black,
343.9 × 305.4 × 45.7 cm
(135½ × 120¼ × 18 in).
Museum of Modern Art, New York.

Above Portrait of Louise Nevelson by Nancy R. Schiff, 1980.

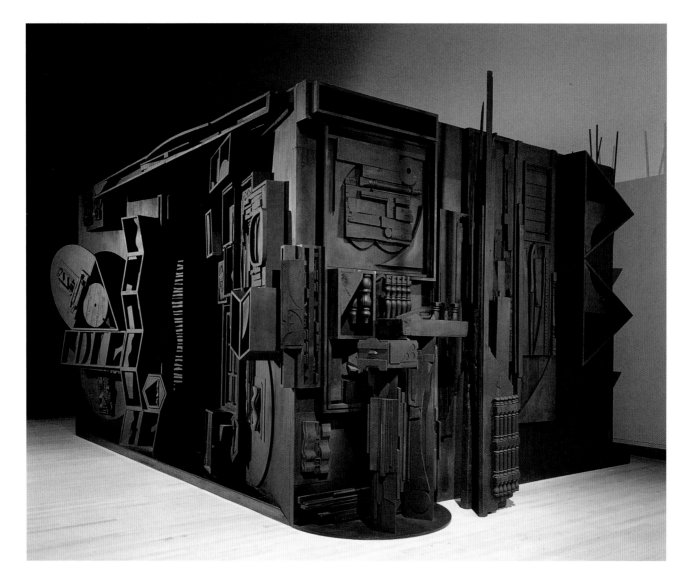

Above *Mrs N's Palace*, 1964–77. Assemblage of wood painted black and mirror, 355.6 × 607.1 × 457.2 cm (140 × 239 × 180 in). The Metropolitan Museum of Art, New York. Gift of the artist, 1985 (1985.41.1-.127).

Opposite *Dawn's Wedding Chapel II*, 1959. Assemblage of painted wood, 294.3 × 212.1 × 26.7 cm (115⅞ × 83½ × 10½ in). Whitney Museum of American Art, New York. Purchase with funds from the Howard and Jean Lipman Foundation Inc. 70.68a-m.

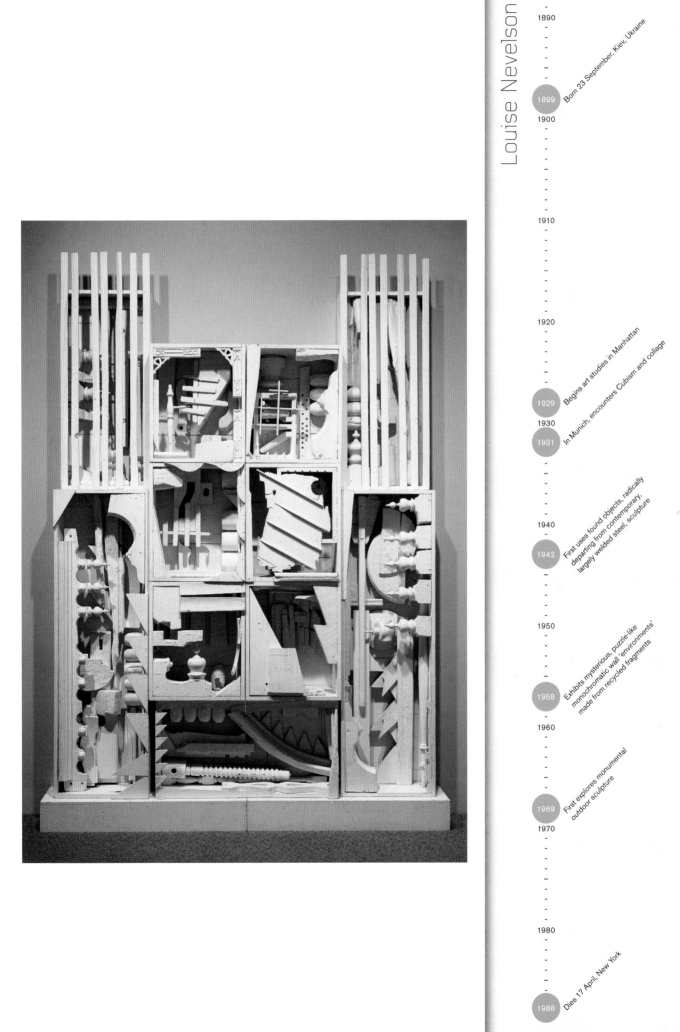

1890

1899 Born 23 September, Kiev, Ukraine

1900

1910

1920

1929 Begins art studies in Manhattan

1930

1931 In Munich, encounters Cubism and collage

1940

1942 First uses found objects, radically departing from contemporary, largely welded steel, sculpture

1950

1958 Exhibits mysterious, puzzle-like monochromatic wall 'environments' made from recycled fragments

1960

1969 First explores monumental outdoor sculpture

1970

1980

1988 Dies 17 April, New York

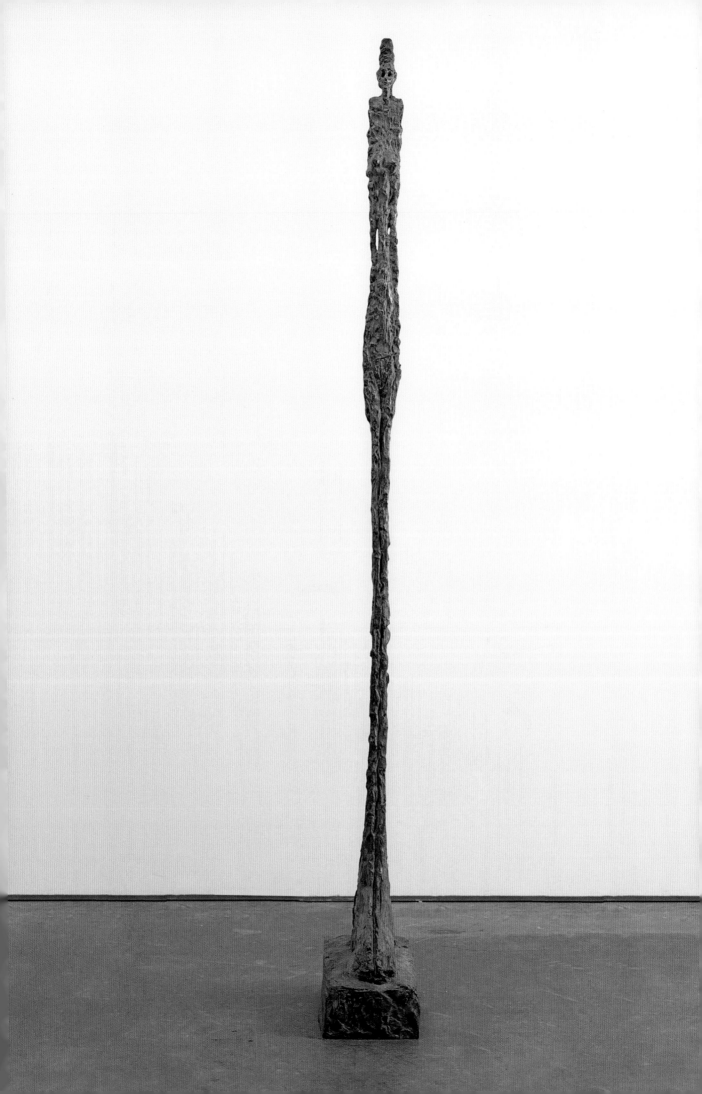

'Gradually things deteriorated.
Reality escaped me.'

Alberto Giacometti

1901–1966

SWITZERLAND

Alberto Giacometti enjoyed reminiscing about his father, an Impressionist painter. 'My father was very, very kind,' he said. 'When we were young, our father let us do whatever we wanted. He gave us advice when we asked for it, but he stopped there.' Alberto and his brother Diego became artists. Their brother Bruno became an architect.

Encouraged by his father, Giacometti drew as a child and modelled his first sculpture, a bust of Diego, when he was only 13. 'I had the feeling that there was no obstruction at all between seeing and doing,' he recalled of his younger self. 'I dominated my vision, it was paradise.' Then, in late adolescence, things began to change and what was once easy began to seem impossible. 'Gradually things deteriorated,' he said. 'Reality escaped me.'

Giacometti gave up painting and sculpting from life. He began working from memory and realizing objects that, as he said, 'presented themselves to my mind in a finished state'. By turns game-like, erotic, menacing and mysterious, his sculptures drew the attention of the Surrealists, who welcomed him as a member of their group. Works such as *Woman with Her Throat Cut* distinguished Giacometti as one of the greatest Surrealist sculptors. Yet Surrealism was essentially a way-station for him, and he knew it: 'I imagined with terror that one day I would be forced to sit on a stool before a model. I felt that in one way or another I had to reach that point.'

The point was reached in 1935, when Giacometti decided to work briefly from a model in preparation for some sculptures he had in mind. The sculptures never happened. Instead, work from the model continued for five years. He began working again from memory, but to his horror, his sculptures grew smaller and smaller as he tried to capture what he had seen. Only when they were minute did heads and figures seem even slightly real to him. Refusing finally to allow the figures to shrink, he was dismayed now to find that they seemed lifelike only if they were long and thin. The men walked in long strides. The women stood stock still.

For the rest of his life, Giacometti attempted to portray what he actually saw: figures situated at a certain distance, surrounded by almost limitless space. 'When I'm at a café, I watch people walking along the opposite sidewalk, I see them very small, like tiny little figures, which I find marvellous,' he explained. 'But it's impossible for me to imagine that they are actually life-size.' The mystery of seeing never lost its magic for him. '[F]or me, reality is still as unknown and unexplored as the first time any attempt was made to depict it. That is to say, all representations produced to date have been only partial.'

Opposite *Standing Woman*, 1948 (cast 1949). Painted bronze, 166 × 16.5 × 34.2 cm (65⅜ × 6½ × 13½ in). Museum of Modern Art, New York. James Thrall Soby Bequest. Acc. n.: 1222.1979.

Above Portrait of Alberto Giacometti by Denise Colomb, 1954.

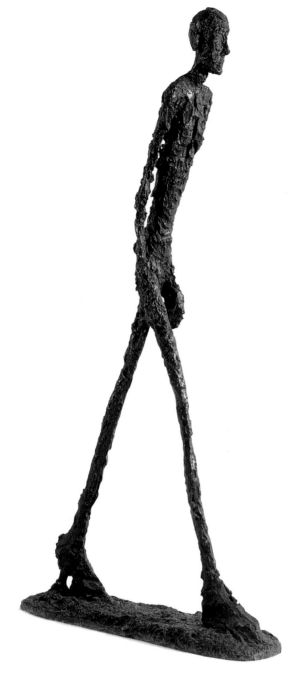

Above *Man Walking*, version I, 1960. Bronze,
182.2 × 26.6 × 96.5 cm (71¾ × 10½ × 38 in).
Albright-Knox Art Gallery, Buffalo. Gift of
Seymour H. Knox, Jr, 1961.

Below *Woman with Her Throat Cut*, 1932.
Bronze (cast 1949), 20.3 × 87.6 × 63.5 cm
(8 × 34½ × 25 in). Museum of Modern Art,
New York. Purchase. Acc. n.: 696.1949.

Opposite *Annette, the Artist's Wife*, 1961.
Oil on canvas, 116 × 89.5 cm (45⅔ × 35¼).
The Metropolitan Museum of Art, New York.
Jacques and Natasha Gelman Collection, 1998.
Inv. 1999.363.26.

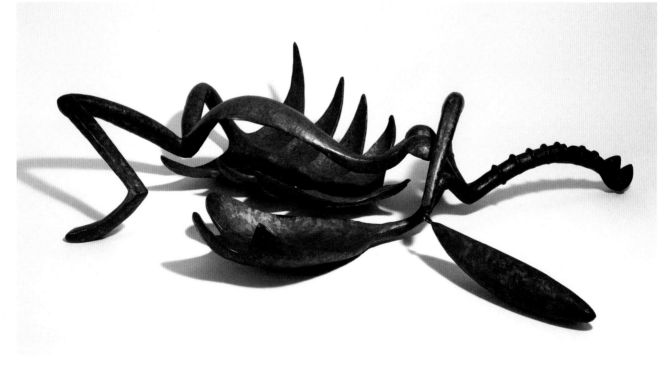

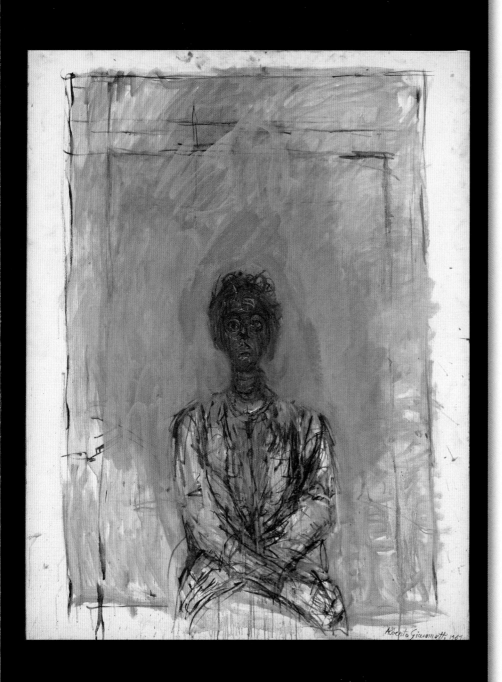

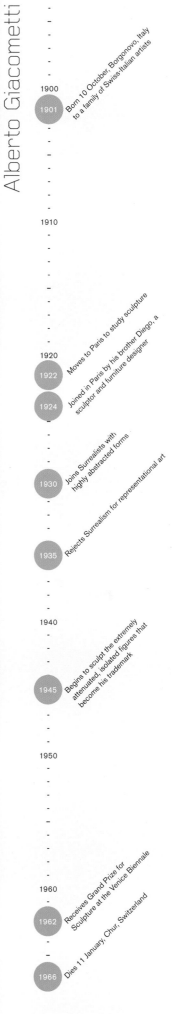

Alberto Giacometti

1900

1901 — Born 10 October, Borgonovo, Italy to a family of Swiss-Italian artists

1910

1920

1922 — Moves to Paris to study sculpture

1924 — Joined in Paris by his brother Diego, a sculptor and furniture designer

1930 — Joins Surrealists with highly abstracted forms

1935 — Rejects Surrealism for representational art

1940

1945 — Begins to sculpt the extremely attenuated, isolated figures that become his trademark

1950

1960

1962 — Receives Grand Prize for Sculpture at the Venice Biennale

1966 — Dies 11 January, Chur, Switzerland

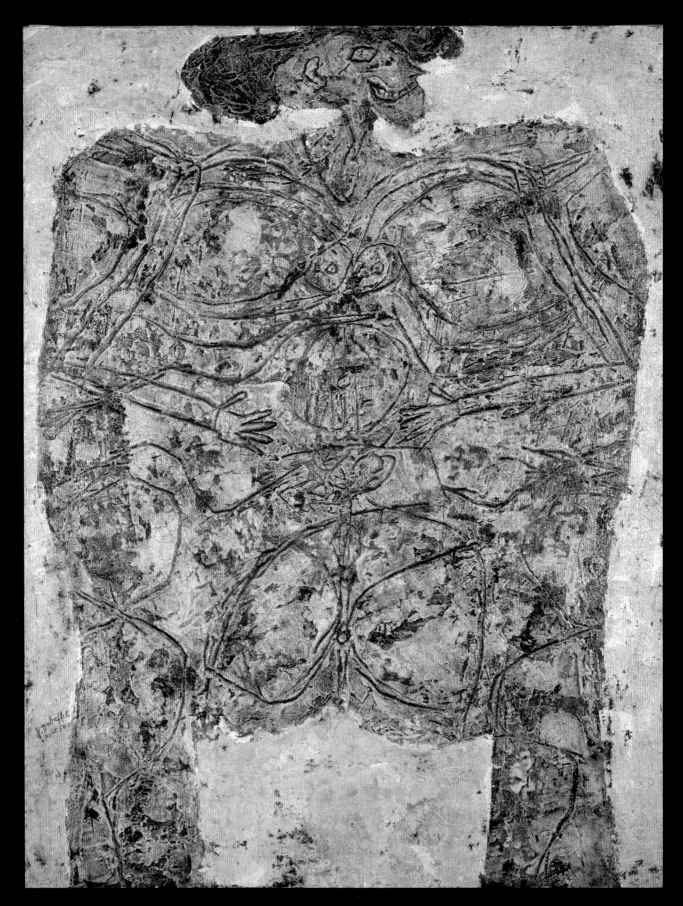

Le Métafizyx, 1950. Oil on canvas,
116 × 89.5 cm (45⅝ × 35³⁄₁₆ in).
Musée National d'Art Moderne,
Centre Georges Pompidou, Paris.

'Delirium seems salutary to me.
I love madness.'

Jean Dubuffet

1901–1985

FRANCE

Jean Dubuffet wanted nothing so much as to tear down the oppressive edifice of culture. 'I don't like culture,' he said, 'I don't like the memory of the past, I find it debilitating and harmful. I believe in the supreme value of forgetting.' In place of the usual libraries and museums, he suggested erecting an immense statue of Oblivion in the central square of every town, and he proposed founding 'institutes of deculturation' to help people clean out their minds. As for his own work, he said, 'I strive to make art as though human beings had never made it before.'

In Dubuffet's view, Western culture had betrayed the true nature of art by turning it into an intellectual activity practised by a clan of professionals. 'The intellectual is crazy about ideas, he loves to chew on ideas, he can't even conceive that there are other sorts of chewing-gum apart from ideas,' he wrote. 'But in fact, art is precisely a gum that has nothing to do with ideas.' It had to do, he said, with 'clairvoyance'. Dubuffet found his ideal in what he named *art brut* (raw art – today known in English as Outsider Art). *Art brut* was made by people 'unscathed by artistic culture', he wrote, 'motivated purely by the need to express the festivities that take place in their minds'. He assembled a large collection of *art brut*, much of it made by patients in psychiatric hospitals, and he wrote about it passionately.

In his own art, Dubuffet rejected traditional aesthetic categories, beginning with the concept of beauty. In his portraits of Parisian intellectuals and his series depicting women's bodies, he stripped ugliness of negative connotations. 'The grotesque in my works is neither mocked nor celebrated,' he said, 'it is denied. I work to clear a space where ideas of beauty and ugliness, of sublime and base, of tragic and joyous have no place.' Tirelessly inventive, Dubuffet methodically explored materials, subjects and methods in rapid succession. In paintings about texture he approached abstraction, only to swerve away and take up a childlike figurative style for the series *Paris Circus*. In 1962, he doodled a motif he called *l'Hourloupe*, which for the next 12 years he used to generate paintings, sculptures and entire environments such as *Winter Garden*.

'I need a work of art to wrap itself in surprise, to have some aspect that has never been seen before that disorients you and takes you to a completely unexpected place,' Dubuffet wrote. 'To my way of thinking, as soon as an art loses this strangeness, it loses all effectiveness; it's no longer good for anything.' Under the conditions of modern artistic life, a work could be fully effective only briefly, he believed. 'I consider that works of art grow old and die, like all other things.'

Above Portrait of Jean Dubuffet by Francis Chaverou, Vincennes, 1972.

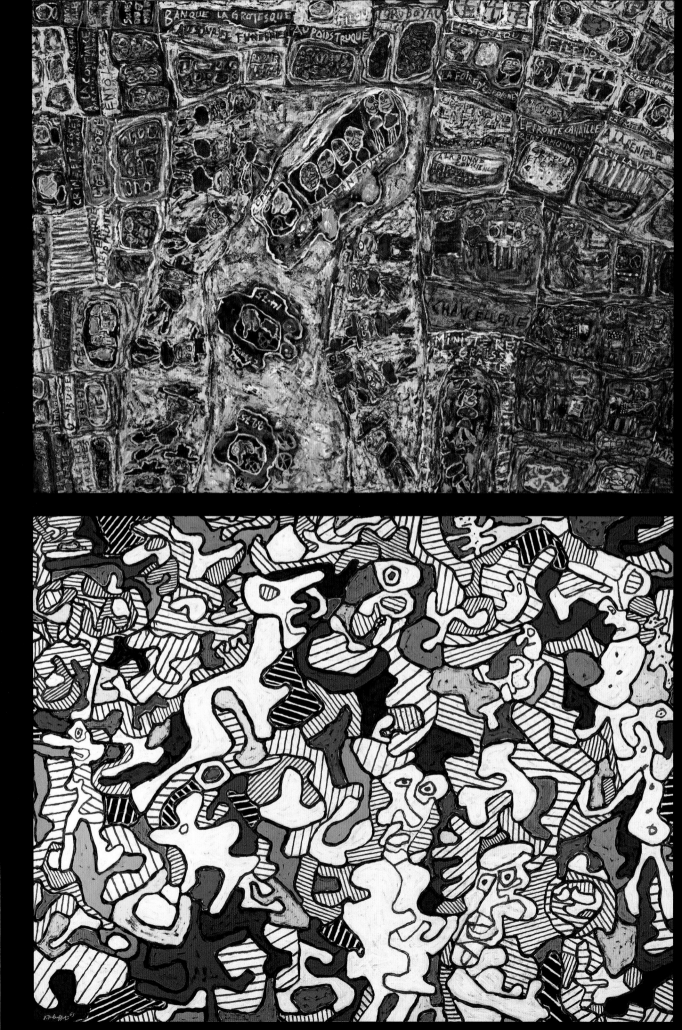

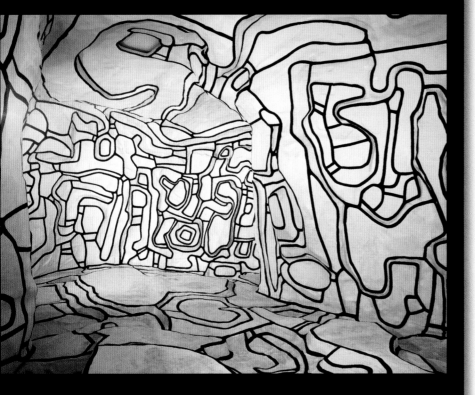

Opposite above *Business Prospers*, from *Paris Circus*, 1961. Oil on canvas, 165.1 × 220 cm (65 × 86⅝ in). Museum of Modern Art, New York. Mrs Simon Guggenheim Fund. 115.1962.

Opposite below *La Vie de Famille*, 1963. Oil on canvas, 98 × 131 cm (38⅗ × 51⅗ in). Musée des Arts Décoratifs, Paris.

Above *Winter Garden*, 1968. Epoxy resin, polyurethane, 480 × 960 × 550 cm (189 × 377¾ × 216⅜ in). Musée National d'Art Moderne, Centre Georges Pompidou.

Jean Dubuffet

- 1900
- 1901 — Born 31 July, Le Havre
- 1910
- 1920
- 1930
- 1940 — Commits to painting after sporadic involvement for years
- 1942 — First solo exhibition, Paris
- 1944 — Begins to champion unschooled raw art (*art brut*) of children and the mentally ill
- 1945
- 1950
- 1960 — Develops *l'Hourloupe* style from doodles he made while on the telephone
- 1962
- 1968 — *Winter Garden* sees *l'Hourloupe* style applied to monumental sculpture
- 1970
- 1973 — Establishes the Dubuffet Foundation
- 1980
- 1985 — Dies 12 May, Paris

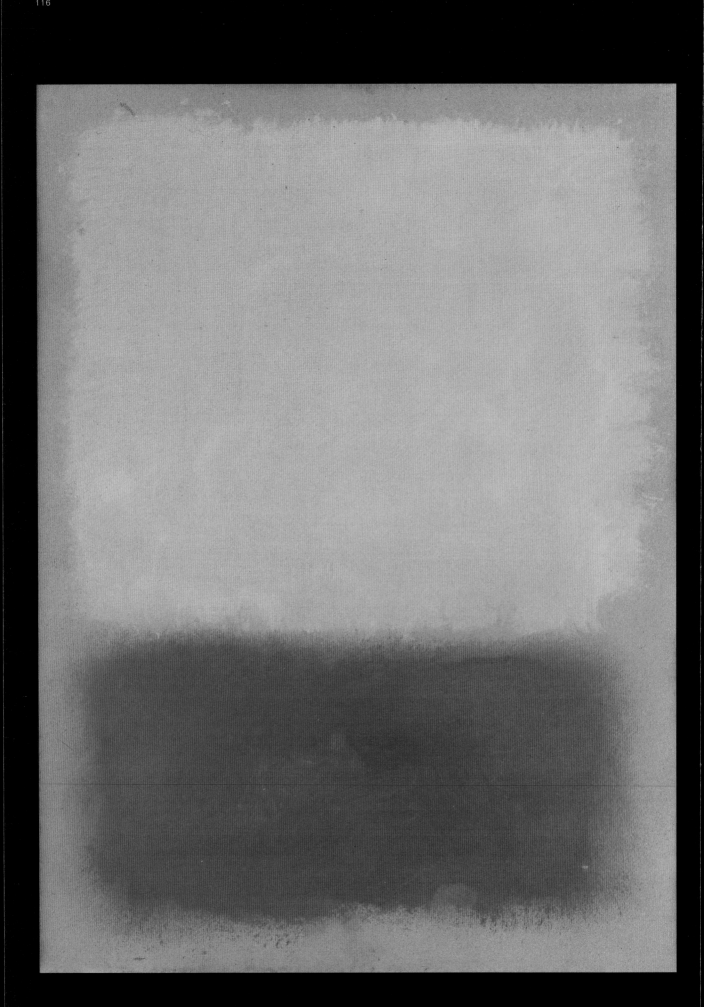

'There is no such thing as good painting about nothing.'

Mark Rothko

1903–1970

UNITED STATES

'The progression of a painter's work, as it travels in time from point to point, will be towards clarity: towards the elimination of all obstacles between the painter and the idea, and between the idea and the observer.' Rothko wrote that statement in 1943, but he did not publish it until the year he touched on his mature style. This style would serve him for the rest of his life: soft-edged, thinly painted rectangles and bands of colour, stacked on a rectangular colour field, extending towards the edges but floating free. Into this symmetrical vessel he poured as much as he could express about the human condition.

To arrive at clarity, Rothko had indeed eliminated many elements that proved to be obstacles. The first was the human figure. 'I belong to a generation that was preoccupied with the human figure,' he recalled. 'It was with the most reluctance that I found that it did not meet my needs.' He turned to mythology, whose personages 'were able to make intense gestures without embarrassment'. Influenced by Surrealism, he resorted to abstract, biomorphic forms, 'in order to paint gestures that I could not make people do'. These, in turn, gave way to amorphous coloured shapes that he spoke of as performers in a drama, actors who were 'able to move dramatically without embarrassment and execute gestures without shame'. Rectangles began to appear amid Rothko's cast of shapes and in 1949 he finally painted an image that employed them exclusively. The intensity he had been searching for all along would henceforth be embodied not in outward dramas of motion and gesture, but in inward dramas of stillness and presence.

Scale was essential to the impact of Rothko's work. 'I paint very large pictures,' he said. 'The reason I paint them . . . is precisely because I want to be intimate and human. To paint a small picture is to place yourself outside your experience . . . However you paint the larger picture, you are in it. It isn't something you command.' He wanted viewers to approach his paintings and stand close, so that the colours filled their field of vision and became for a time their entire world. He was wary of having his work exhibited on the vast walls of museum spaces, where, dwarfed by the setting, they risked appearing decorative.

Rothko disliked the way critics and fellow painters focused on the formal elements of his paintings. What he hoped, he said, was that his paintings would speak to the spiritual needs of sensitive observers. 'I'm not interested in relationships of colour or form or anything else,' he told an interviewer. 'I'm interested only in expressing basic human emotions – tragedy, ecstasy, doom . . . The people who weep before my pictures are having the same religious experience I had when I painted them.'

Opposite *Untitled*, 1968. Synthetic polymer paint on paper, 45.4 × 60.8 cm (17⅞ × 23⅞ in). Museum of Modern Art, New York. Gift of the Mark Rothko Foundation, Inc. Acc. n.: 463.1986.

Above Portrait of Mark Rothko by Consuelo Kanaga, c. 1949. Brooklyn Museum of Art, New York. Gift of Wallace B. Putnam from the Estate of the Artist.

Above *No. 14* (*Browns over Dark*),
1963. Oil on canvas, 228.5 × 176 cm
(90 × 69¼ in). Musée National d'Art
Moderne, Centre Georges Pompidou,
Paris.

Opposite *Untitled* (*Violet, Black, Orange,
Yellow on White and Red*), 1949. Oil on
canvas, 207 × 167.6 cm (81½ × 66 in).
Solomon R. Guggenheim Museum, New
York. Gift, Elaine and Werner Dannheisser
and The Dannheisser Foundation, 1978.

Mark Rothko

Born 25 September, Dvinsk, Latvia

Emigrates to Portland, Oregon

In New York, the largely
self-taught artist co-founds
'The Ten' Expressionist group

1903 · I · · · · 1910 · · 1913 · · I · · · · 1920 · · · · · · 1930 · · · · 1935 · · · ·

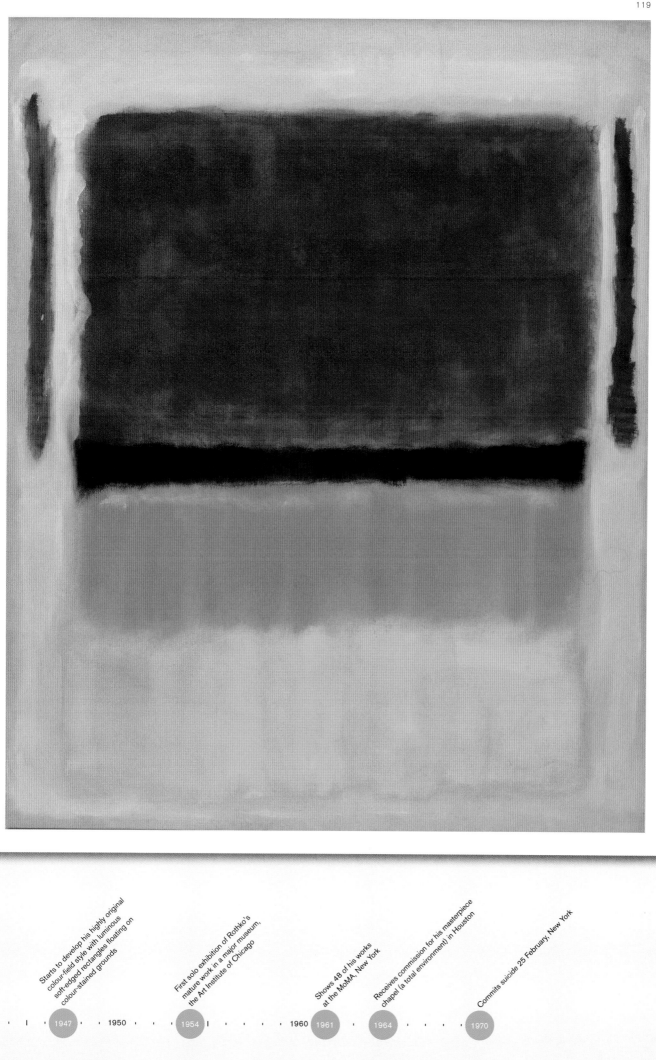

Starts to develop his highly original colour-field style with luminous soft-edged rectangles floating on colour-stained grounds

First solo exhibition of Rothko's mature work in a major museum, the Art Institute of Chicago

Shows 48 of his works at the MoMA, New York

Receives commission for his masterpiece chapel (a total environment) in Houston

Commits suicide 25 February, New York

1947 1950 1954 1960 1961 1964 1970

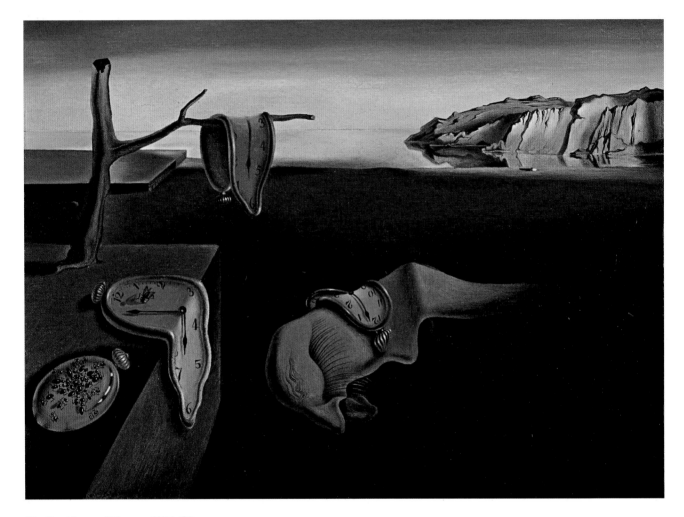

The Persistence of Memory, 1931. Oil
on canvas, 24.1 × 33 cm (9½ × 13 in).
Museum of Modern Art, New York. Given
anonymously. Acc. n.: 162.1934.

'A painting is a paltry thing next to the magic that radiates constantly from me.'

Salvador Dalí

1904–1989

SPAIN

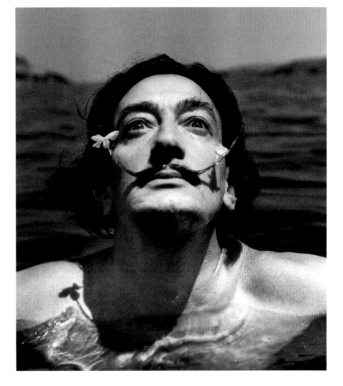

'I am very sorry, but I am infinitely more intelligent than these three professors, and I therefore refuse to be examined by them. I know this subject much too well.' Thus the young Salvador Dalí responded, somewhat to his own surprise, to a question he was asked at his final examination in art history. He was promptly expelled from school. It did not matter: his paintings were already attracting attention. He had visited Paris and met Pablo Picasso, and he counted fellow students Federico García Lorca and Luis Buñuel among his closest friends. As a member of the Spanish avant garde, he designed the sets for Lorca's first play and collaborated with Buñuel on the script for a film based in dream imagery.

In 1929, Dalí travelled to Paris to join Buñuel and to make their film, *Un Chien Andalou* (*An Andalusian Dog*). The film's enthusiastic reception sealed his acceptance by the Parisian Surrealists, to whom he had been introduced by Joan Miró. That autumn, the catalogue for his first solo exhibition in Paris carried a prologue by none other than André Breton, the leader of the Surrealist movement. Among the paintings on view was *The Great Masturbator*, which Breton claimed gave him nightmares for years afterwards.

Dalí's principal contribution to Surrealist theory was his paranoiac-critical method, a way of seeing that he predicted would 'systematize confusion and thereby contribute to a total discrediting of the world of reality'. Based in Freud's characterization of paranoia as interpretive delusion, Dalí's method revelled in double images – 'a representation of an object that is also, without the slightest pictorial or anatomical modification, the representation of another entirely different object', he explained. In *Metamorphosis of Narcissus,* he depicted a moment of paranoiac insight in which the form of a boy gazing at his reflection is reinterpreted as a hand holding an egg.

Breton eventually lost patience with Dalí's flamboyance, ambition and suspect political views. Christening him 'Avida Dollars' (an anagram of Salvador Dalí, meaning, roughly, 'eager for dollars'), he expelled him from the Surrealist group. Again, it did not matter: Dalí had become an international celebrity. He spent World War II in the United States and visited annually thereafter. He cultivated an outlandish public persona, published a scandalous autobiography, collaborated with Alfred Hitchcock and Walt Disney in Hollywood and designed gardens, jewellery and tableware. He appeared in fashion journals and television commercials. His painting technique grew increasingly polished, and his interests shifted from the subconscious to contemporary physics and Christian mysticism. What held it all together, he insisted, was the pleasure of being Salvador Dalí. 'Painting is only one of the expressive means of my total genius, which exists when I write, when I live, when I manifest in one way or other my *magic*,' he said. 'A painting is a paltry thing next to the magic that radiates constantly from me.'

Above Portrait of Salvador Dalí in his pool at Port Lligat, Cadaqués, 1953.

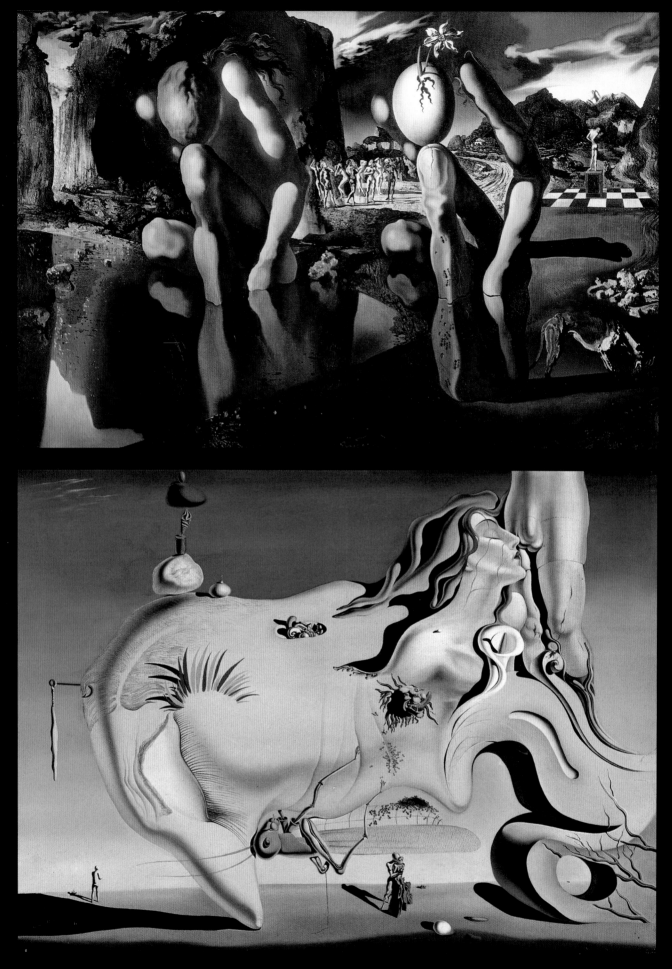

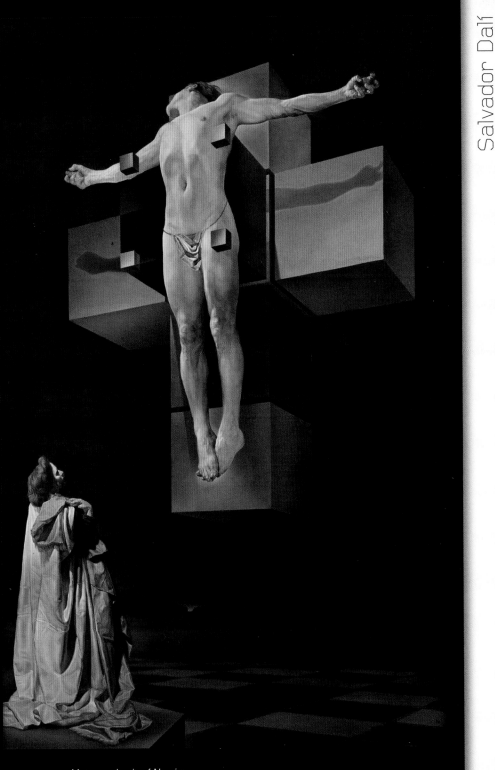

1900

1904 Born 11 May, Figueres

1910

1920

1924 Expelled from the Royal Academy of Fine Arts of San Fernando for insurrection, but achieves artistic recognition

1929 Joins Surrealists in Paris and develops 'paranoic-criticism' to access the subconscious

1930

1934 Solo exhibition in New York, including *Persistence of Memory*, causes sensation

1937 Expelled by Surrealists for commercialization and right-wing politics

1940

1948 Returns to Europe having spent World War II in United States; output continues to be prolific

1950

1960 Painting included in the International Surrealist Exhibition, New York, provokes protest from André Breton and other Surrealists

1970

1980

1989 Dies 23 January, Figueres

Opposite above *Metamorphosis of Narcissus*, 1937. Oil on canvas, 51.1 × 78.1 cm (20⅛ × 30¾ in). Tate, London.

Opposite below *The Great Masturbator*, 1929. Oil on canvas, 110 × 150 cm (43⁷⅓ × 59 in). Museo Nacional Centro de Arte Reina Sofía, Madrid. Salvador Dalí Bequest, 1990.

Above *Crucifixion*, 1954. Oil on canvas, 194.3 × 123.8 cm (76½ × 48¾ in). The Metropolitan Museum of Art, New York. Gift of the Chester Dale Collection, 1955. Inv. 55.5.

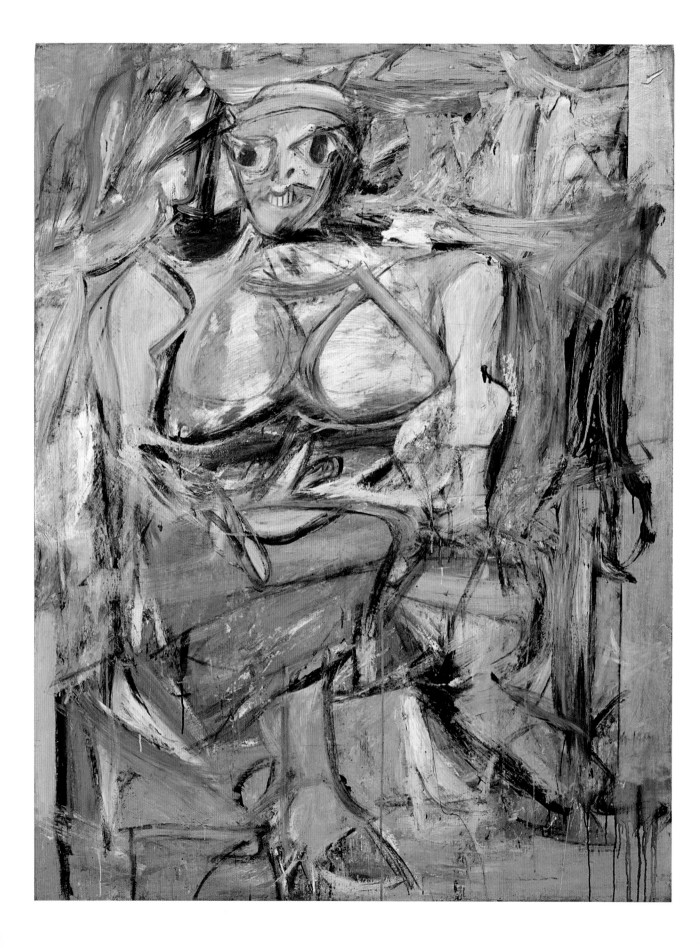

'Those women are perhaps the feminine side of me – but with big shoulders.'

Willem de Kooning

1904–1997

THE NETHERLANDS/UNITED STATES

Willem de Kooning arrived in the United States from Holland as a stowaway. He had come, he said, 'to become a commercial artist, make a lot of money, play a lot of tennis, and find those long-legged American girls'. Though he had studied both applied and fine art in Rotterdam, painting as such did not interest him then. 'I didn't understand the nature of painting,' he recalled. 'I didn't intend to become a painter – that came later.'

Whatever his intentions, de Kooning quickly found himself at home in the community of avant-garde artists in New York. A decade later, a stint assisting Fernand Léger on a mural proved a turning-point. 'You got the feeling from Léger that to be an artist was as good as being anything else,' he recalled fondly. 'I changed my attitude to art. Instead of doing odd jobs and painting on the side, I painted and did odd jobs on the side.'

Odd jobs sustained a life of barely scraping by, which de Kooning accepted with characteristic humour ('I'm not poor. I'm broke!' he liked to say). When he could no longer afford artist's colours, he resorted to commercial enamel paint and, because commercial colours were unstable, he limited himself to black and white. 'I needed a lot of paint and I wanted to get free of materials. I could get a gallon of black paint and a gallon of white paint – and I could go to town,' he said later. Included in his first gallery show in 1948, the paintings caught the attention of critics, who hailed the arrival of an important abstract painter.

De Kooning, however, did not think of himself as an abstract painter. He refused to place subject-matter, any subject-matter, off limits. 'The argument often used that science is really abstract, and that painting could be like music and, for this reason, that you cannot paint a man leaning against a lamp-post, is utterly ridiculous,' he said. De Kooning never painted a man leaning against a lamp-

post. What he painted were women, most famously in the *Woman* series of the early 1950s. First shown in 1953, they provoke strong reactions to this day. 'I look at them now and they seem vociferous and ferocious,' de Kooning said years later. 'I think it had to do with the idea of the idol, the oracle and, above all, the hilariousness of it.'

Women and abstractions based in emotions inspired by landscape occupied de Kooning for the rest of his career. The style of his first years of fame became emblematic of Abstract Expressionism, and he was one of the painters for whom the term Action Painting was coined. 'Art never seems to make me peaceful or pure,' he said. 'I always seem to be wrapped in the melodrama of vulgarity.'

Opposite *Woman I*, 1950–52.
Oil on canvas, 192.7 × 147.3 cm
(75⅞ × 58 in). Museum of Modern Art,
New York. Purchase. 478.1953.

Above Portrait of Willem de Kooning by
Henry Bowden, c. 1945.

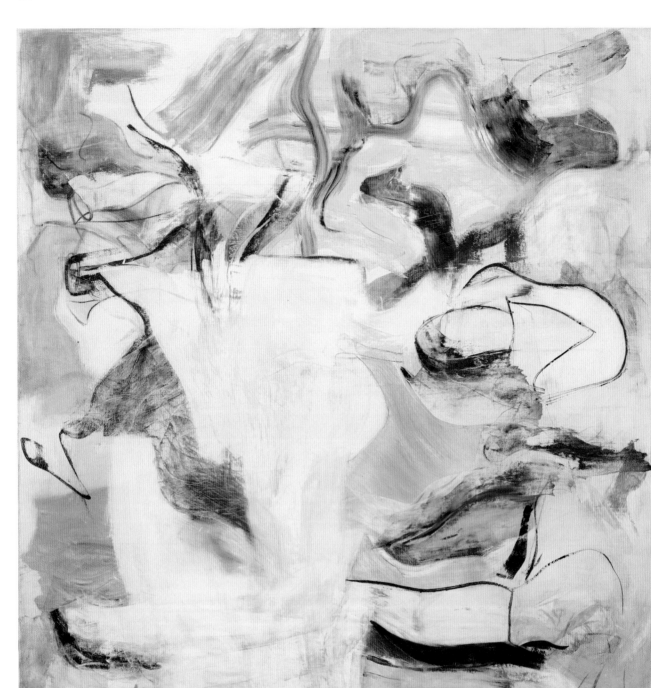

Above *Pirate* (*Untitled II*), 1981.
Oil on canvas, 223.4 × 194.4 cm
(88 × 76¾ in). Museum of Modern
Art, New York. Sidney and Harriet
Janis Collection Fund. Acc. n.:
107.1982.

Opposite above *Painting*, 1948.
Enamel and oil on canvas,
108.3 × 142.5 cm (42⅝ × 56⅛ in).
Museum of Modern Art, New York.
Purchase. 238.1948.

Opposite below *Merritt Parkway*, 1959.
Oil on canvas, 203.2 × 179.1 cm
(80 × 70⅝ in). Detroit Institute of
Arts. Gift of W. Hawkins Ferry.

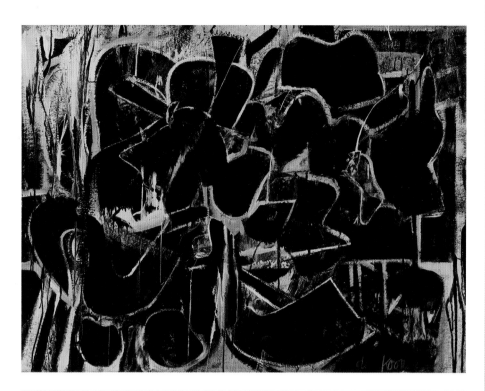

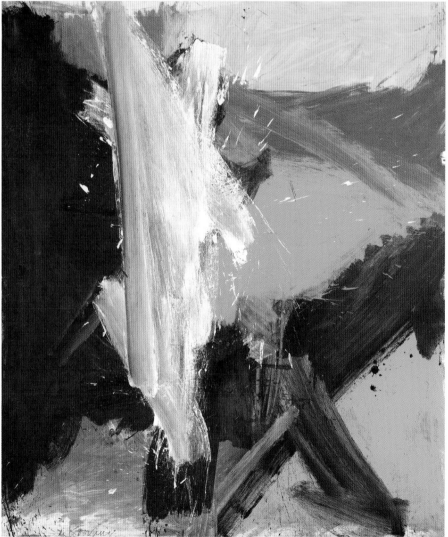

Willem de Kooning

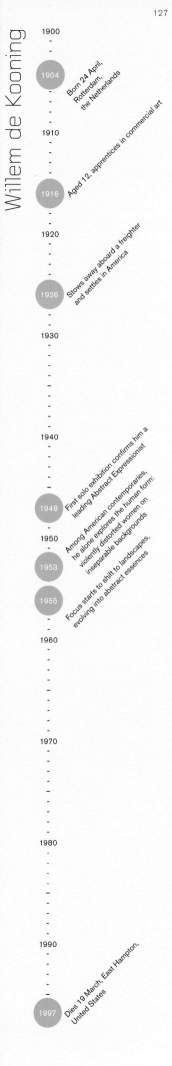

1900

1904 — Born 24 April, Rotterdam, the Netherlands

1910

1916 — Aged 12, apprentices in commercial art

1920

1926 — Stows away aboard a freighter and settles in America

1930

1940

1948 — First solo exhibition confirms him a leading Abstract Expressionist

1950

1953 — Among American contemporaries, he alone explores the human form: violently distorted women on inseparable backgrounds

1955 — Focus starts to shift to landscapes, evolving into abstract essences

1960

1970

1980

1990

1997 — Dies 19 March, East Hampton, United States

'I've never conceived of myself
as anything other than a painter.'

David Smith

1906–1965

UNITED STATES

Like many young American artists during the years between the wars, David Smith learned about the European avant garde by poring over the pages of the French art and literary journal *Cahiers d'Art*. Not knowing French, he absorbed all he could from the illustrations. 'I learned from the pictures, just the same as if I were a child in a certain sense,' he recalled. Amid the great influx of images in 1929 were photographs of two recent sculptures by Pablo Picasso made of welded iron. 'Seeing iron and factory materials used as a way of producing art was quite a revelation.' Smith said. 'I realized that I, too, knew how to handle this material.'

Knowing how to handle iron and steel involved skills more common in a factory than in an artist's studio. Picasso, as Smith would soon learn, had turned to his compatriot Julio González to fabricate his sculptures. A painter from a family of metalworkers, González had learned welding during a stint working in a car factory. Collaborating with Picasso had a transformative effect on González, who abandoned painting and became a prominent sculptor himself. Smith called him 'the first master of the torch'.

Like González, Smith had learned welding while working in a car factory. He improved his skills under the informal tutelage of two commercial welders at the industrial building where he relocated his studio, for safety, and again during the World War II years, when he worked as a welder in a locomotive factory. 'The material called iron or steel I hold in high respect,' he said. 'What it can do in arriving at a form economically, no other material can do. The metal itself possesses little art history. What associations it possesses are those of this century: power, structure, movement, progress, suspension, destruction, brutality.'

Smith assembled his sculptures from new metal and from scraps, from found objects and industrial components. Unlike the Minimalist sculptors of the next generation, who would continue to use industrial materials but have their works fabricated professionally, Smith wanted only the marks of his own hand on his work. 'I can't use studio assistants any more than Mondrian could have used assistants to paint in solid areas,' he said. With the notable exception of his *Cubi* series, whose brilliant steel surfaces he finished by scribbling over them with a mechanical grinder, Smith painted most of his sculptures, favouring raw colours over pretty ones.

'I like the colour to produce a challenge,' he said. 'It adds another challenge, dimensional challenge, in the concept of the work.' As his style matured he took to working in open-ended series. 'In this way I try to get out all I have to say,' he explained. 'The trouble is, every time I make one sculpture, it breeds tens more, and the time is too short to make them all.'

Above Portrait of David Smith by John Stewart, c. 1951–52.

Opposite *Cubi XXVIII*, 1965. Stainless steel, 274.32 × 279.4 × 114.3 cm (108 × 110 × 45 in). The Eli and Edythe L. Broad Collection, Los Angeles.

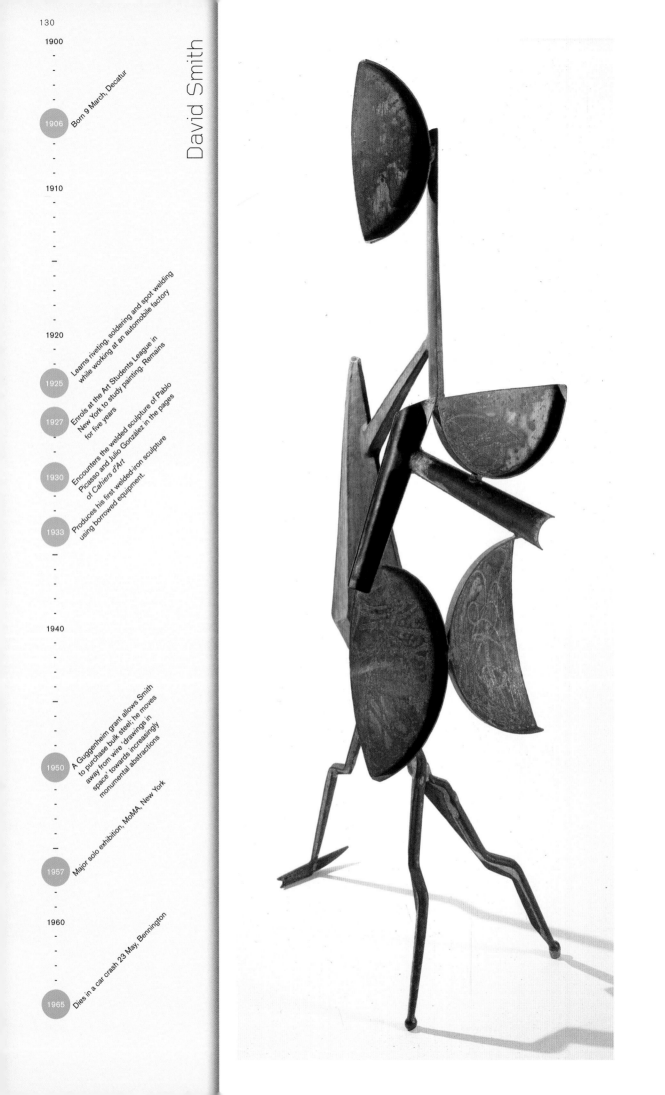

David Smith

1900
-
-
-
-
1906 Born 9 March, Decatur
-
-

1910
-
-
-
-
—
-
-
-
-
-

1920
-
1925 Learns riveting, soldering and spot welding while working at an automobile factory
Enrols at the Art Students League in New York to study painting. Remains for five years
1927 Encounters the welded sculpture of Pablo Picasso and Julio Gonzalez in the pages of *Cahiers d'Art*
1930 Produces his first welded-iron sculpture using borrowed equipment.
1933
-
-
-
-
-

1940
-
-
-
-
-
-
1950 A Guggenheim grant allows Smith to purchase bulk steel; he moves away from wire 'drawings in space' towards increasingly monumental abstractions
-
-
-
1957 Major solo exhibition, MoMA, New York
-
-

1960
-
-
-
1965 Dies in a car crash 23 May, Bennington

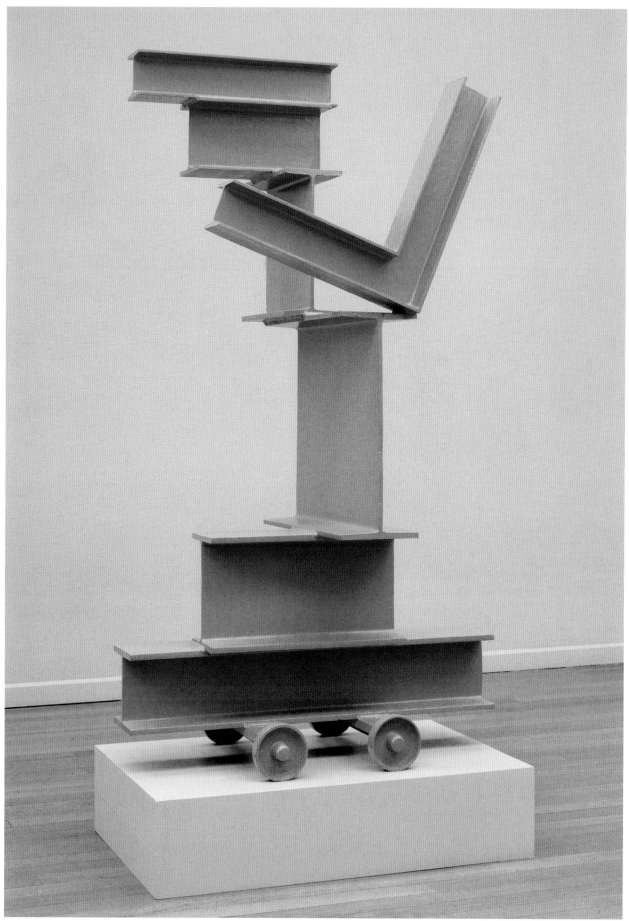

Opposite *Tanktotem IV*, 1953. Steel,
235.2 × 73.6 × 86.3 cm (92⅝ × 29 × 34 in).
Albright-Knox Gallery, Buffalo.

Above *Untitled* (*Zig VI?*), 1964. Painted steel,
200.3 × 112.7 × 73.7 cm (78⅞ × 44⅓ × 29 in).
Tate, London.

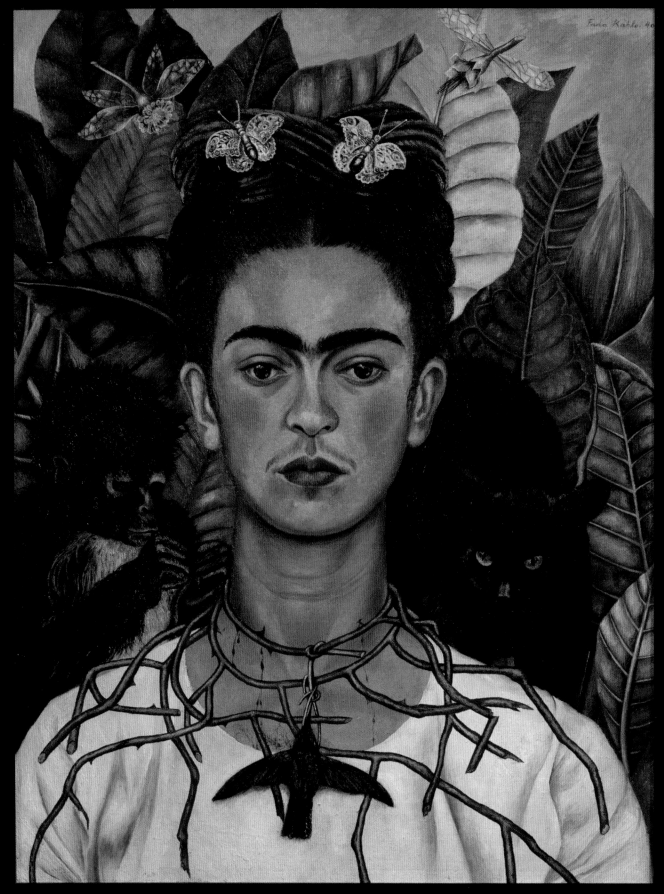

Self-Portrait with Thorn Necklace and Hummingbird, 1940. Oil on canvas, 63.5 × 49.5 cm (25 × 50½ in). Harry Ransom Humanities Research Center, University of Texas, Austin. Nicholas Murray Collection.

'I never painted dreams.
I painted my own reality.'

Frida Kahlo

1907–1954

MEXICO

'I am painting a little bit too. Not because I consider myself an artist or something like that, but simply because I have nothing else to do here, and because working I can forget a little all the troubles I had last year.' Thus Frida Kahlo wrote to an American friend in 1933. She had come to the United States with her famous husband, the muralist Diego Rivera, who had a number of commissions and exhibitions lined up. The troubles of the preceding year, including her mother's death and a bloody miscarriage, had inspired paintings unlike any she had produced before, transforming her from a fledgling painter of people into an artist who fearlessly portrayed her most intimate experiences, desires and emotional states. She had found her subject in herself.

'The collision had thrown us forward and the handrail went through me like a sword through a bull.' Kahlo was 18 when a bus she was taking was hit by a streetcar. Her injuries – including the hole gored through her pelvis by the iron handrail – were so extensive that the doctors did not expect her to live. She first began to paint during her long convalescence. Her recovery was never complete, however, and the rest of her life was marked by fatigue, recurring pain, multiple surgical interventions and progressive physical deterioration.

'Diego: nothing compares to your hands, nothing like the green-gold of your eyes. My body is filled with you for days and days,' Kahlo wrote to Rivera. They met in 1928 and married the following year. In the course of their tumultuous life together they loved, separated, divorced, remarried and were faithful and unfaithful, but their fundamental bond seemed unbreakable. From Rivera, Kahlo absorbed the ideals of *mexicanidad*, the culture and identity of Mexico, with its embrace of indigenous folk arts and pre-Columbian cultures, and to please him she traded in her European clothing for the native Mexican costumes, fringed shawls and bold jewellery that came to constitute her public image. It is this persona, proud and unknowable, that stares out at us from her self-portraits.

'Some critics have tried to classify me as a Surrealist, but I don't consider myself one,' she said. Kahlo dazzled André Breton, the acknowledged leader of the Parisian Surrealists, when he visited Mexico in 1938. Her regal appearance, he wrote, had awakened him to the beauty of Mexico itself; her painting was an independent manifestation of Surrealism, miraculously flowering far from European influence. Breton expressed all this and more in the catalogue essay he wrote for Kahlo's first solo gallery show. He subsequently arranged for her paintings to be shown in Paris and included in the International Surrealist Exhibition that he organized in Mexico City. Kahlo was glad of the critical attention but rebelled at being pigeon-holed. 'I never painted dreams,' she said. 'I painted my own reality.'

Above Portrait of Frida Kahlo painting a portrait of Mrs Jean Wright, January 1931.

Above *Fulang-Chang and I*, 1937–39
(front and back). Oil on composition
board in painted mirror frame and mirror
with painted mirror frame, 56.6 × 44.1.9
cm (22¼ × 17⅜ in) and 64.1 × 48.5 cm
(25¼ × 19⅛ in). Museum of Modern Art,
New York. Mary Sklar Bequest.
Acc. n.: 277.1987.a-c.

Opposite *The Shattered Column*, 1944.
Oil on canvas, mounted on hardboard,
40 × 30.7 cm (15¾ × 12⅛ in).
Fundacion Dolores Olmedo Patiño, A.C.

Frida Kahlo

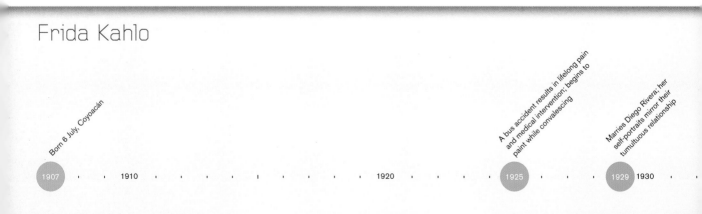

Born 6 July, Coyoacán

A bus accident results in lifelong pain
and medical intervention; begins to
paint while convalescing

Marries Diego Rivera; her
self-portraits mirror their
tumultuous relationship

1907 1910 1920 1925 1929 1930

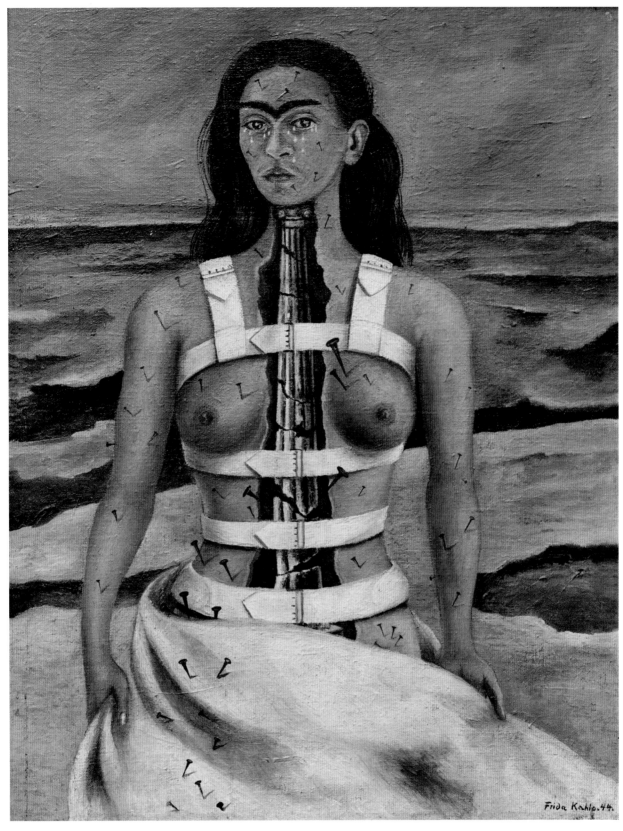

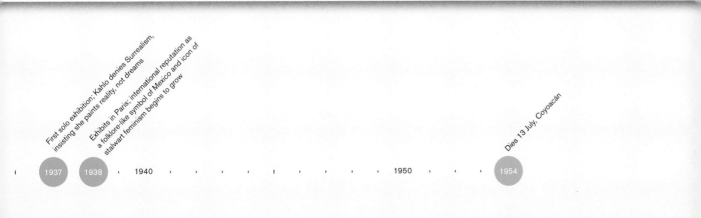

First solo exhibition; Kahlo denies Surrealism, insisting she paints reality, not dreams

Exhibits in Paris; international reputation as a folklore-like symbol of Mexico and icon of stalwart feminism begins to grow

Dies 13 July, Coyoacán

1937 1938 1940 1950 1954

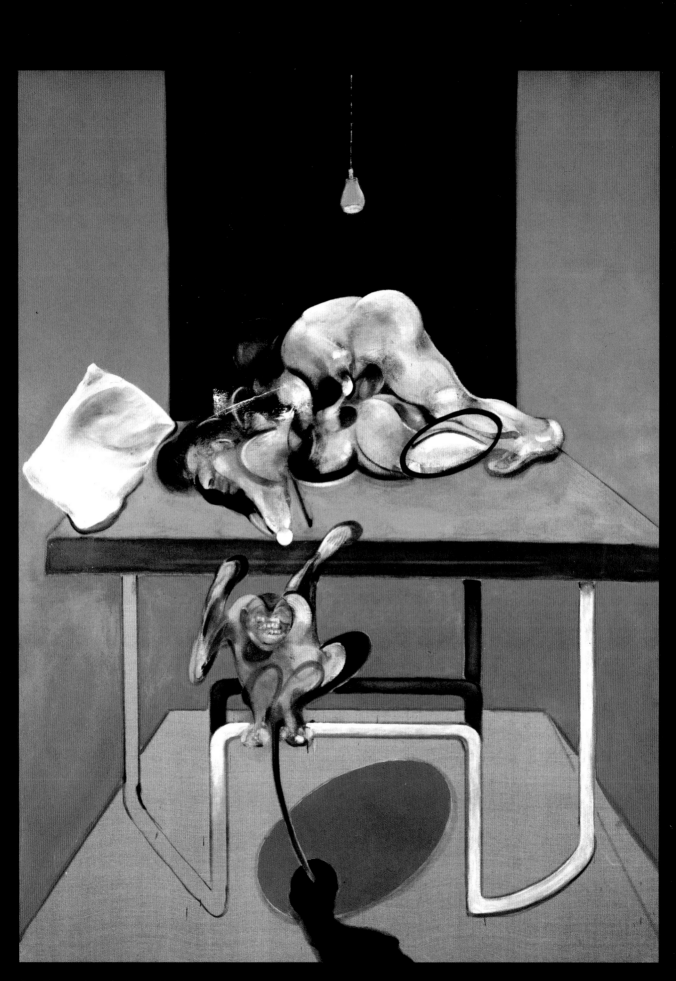

Two Figures with a Monkey, 1973. Oil on
canvas, 198 × 147.5 cm (78 × 58 in)
(approx.). Private collection.

'It's just my nature to be optimistic. We live, we die and that's it, don't you think?'

Francis Bacon

1909–1992

UNITED KINGDOM

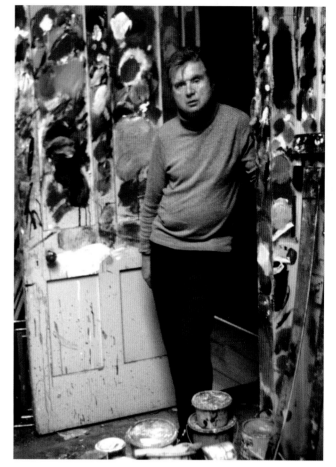

A seated pope, screaming; naked men merging in desire, their coupling tinged with violence; a solitary figure seated under a naked light bulb in a windowless interior; studies for a crucifixion, the victim indistinguishable from a carcass in a slaughter house; triptychs in memory of a lover dead from alcohol and sleeping pills – in an age when advanced art was dominated by abstraction, Francis Bacon defiantly painted the human figure, determined to capture what he called 'the brutality of fact'.

Bacon always professed surprise that people found his paintings violent. 'I never look for violence,' he said. 'There is an element of realism in my pictures which might perhaps give that impression, but life is so violent; so much more violent than anything I can do!' Born in Ireland to English parents, he grew up a child of privilege during volatile and dangerous times. He was shy, effeminate and severely asthmatic – all unforgivable failings in the eyes of his father, who had him regularly whipped by the young and, to Bacon, erotically charged Irish grooms in the stables, and threw him out of the house at 16. Bacon drifted to London, Berlin and Paris, surviving on a small allowance, petty thievery, odd jobs, illegal gambling and older men. While in Paris, he encountered the work of Pablo Picasso, which spurred him to become a painter.

'I can daydream for hours and pictures fall in just like slides,' Bacon said. His images welled up from what he called 'the everyday wash of life . . . the whole of my experience', but what most helped give them form were photographs. Bacon collected photographs from newspapers, magazines and books. Illustrations from a book on diseases of the mouth and a famous close-up from Sergei Eisenstein's silent film *Battleship Potemkin* lie behind his many screaming figures. Eadweard Muybridge's stop-motion photographs of naked wrestlers provided the template for his paintings of male love-making. 'I think of the contours of those bodes that have particularly affected me, but then they're grafted very often onto Muybridge's bodies,' he explained. Even portraits of people he knew were executed from memories grafted onto photographs he commissioned.

Bacon always turned aside questions about what his paintings meant. People could find their own meanings, he insisted. Only once, when pressed by someone he trusted, did he venture a general statement about his art: 'It's concerned with my kind of psyche, it's concerned with my kind of – I'm putting it in a very pleasant way – exhilarated despair.' Bacon's bleak and deeply personal paintings struck a chord because they seemed to carry within them the terrible violence of the twentieth century and the lonely existentialism of the postwar years. 'I am an optimist, but about nothing,' he said. 'It's just my nature to be optimistic. We live, we die and that's it, don't you think?

Above Portrait of Francis Bacon at his studio by Edward Quinn, 1979.

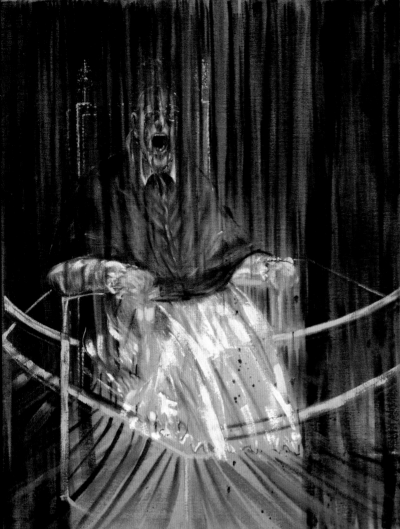

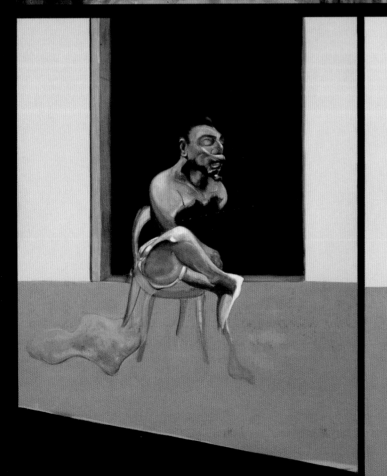

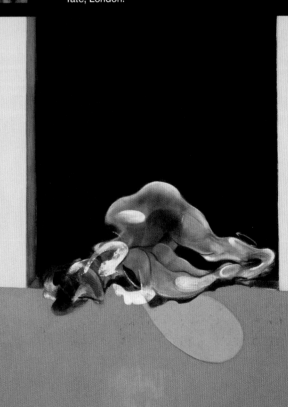

Study after Velasquez, 1953. Oil on canvas, 153 × 118 cm (60¼ × 46½ in). Private collection.

Triptych – August 1972, 1972. Oil on canvas, 153 × 118 cm (60¼ × 46½ in). Tate, London.

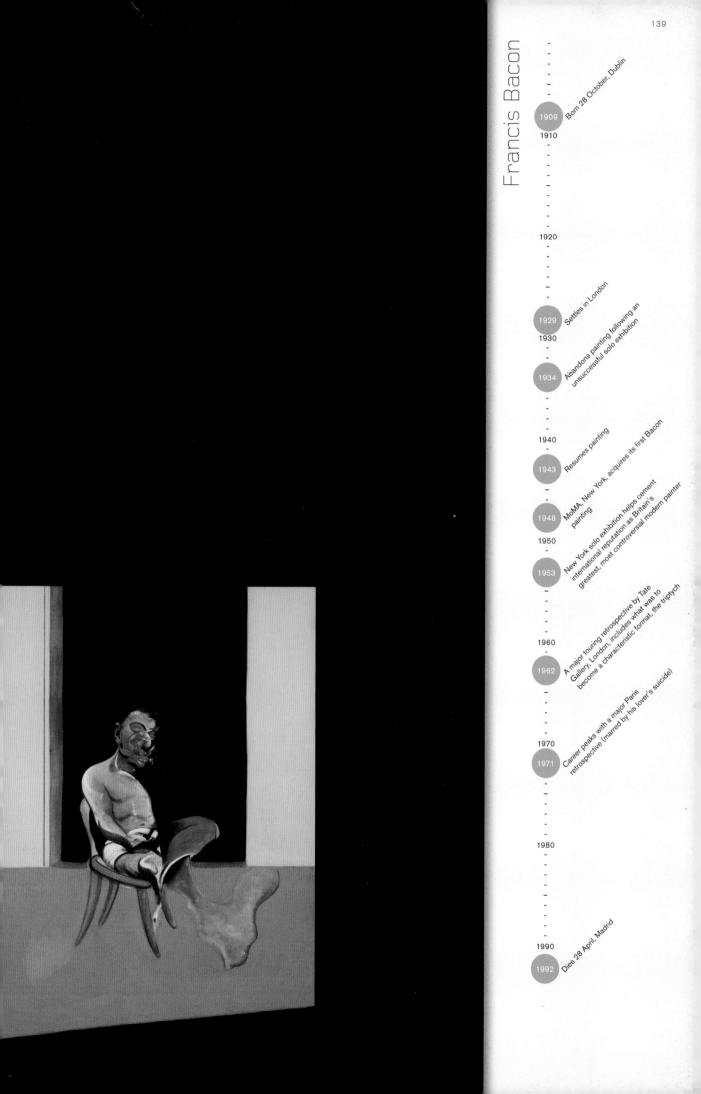

Francis Bacon

- **1909** Born 28 October, Dublin
- 1910
- 1920
- **1929** Settles in London
- 1930
- **1934** Abandons painting following an unsuccessful solo exhibition
- 1940
- **1943** Resumes painting
- **1948** MoMA, New York, acquires its first Bacon painting
- 1950
- **1953** New York solo exhibition helps cement international reputation as Britain's greatest, most controversial modern painter
- 1960
- **1962** A major touring retrospective by Tate Gallery, London, includes what was to become a characteristic format, the triptych
- 1970
- **1971** Career peaks with a major Paris retrospective (marred by his lover's suicide)
- 1980
- 1990
- **1992** Dies 28 April, Madrid

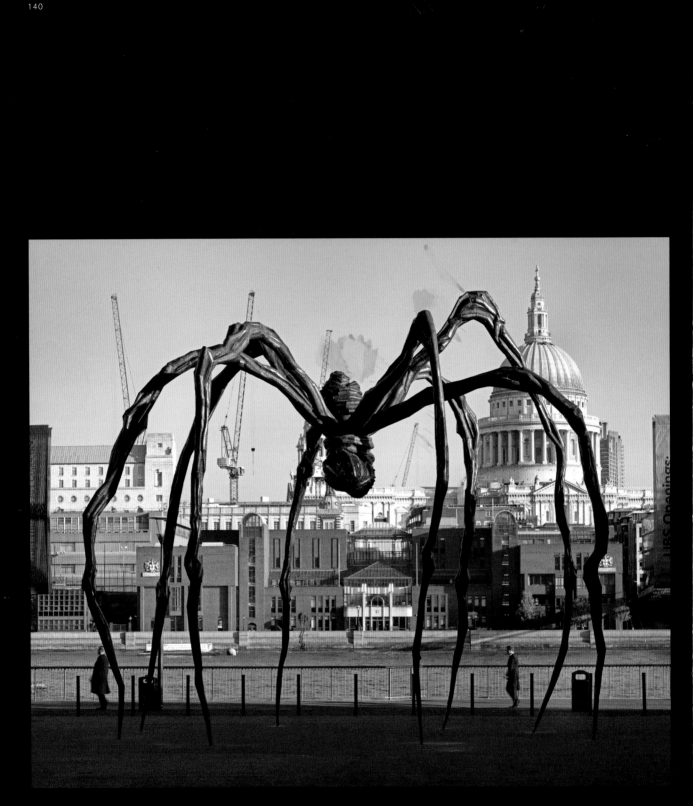

MAMAN, 1999. Bronze, stainless steel
and marble, 927.1 × 891.5 × 1023.6 cm
(365 × 351 × 403 in). Installed at the
Tate Modern, London, in 2007.
© The Easton Foundation, New York.

'I am saying in my sculpture today what I could not make out in the past.'

Louise Bourgeois

1911–2010

FRANCE/UNITED STATES

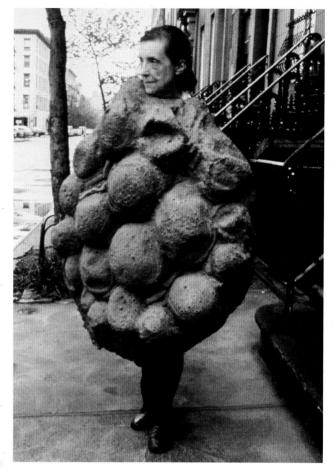

Louise Bourgeois could not let go of the past, and the past would not loosen its hold on her. 'My childhood has never lost its magic, it has never lost its mystery and it has never lost its drama,' she said. It was her greatest source of pain and the wellspring of her art.

'I was born in the rag business,' she wrote. Her parents dealt in antique tapestries, restoring them in a workshop at their house in the country and selling them from their gallery in Paris. 'My mother would sit out in the sun and repair a tapestry or a petit point,' Bourgeois recalled. 'She really loved it.' A severe case of influenza contracted when Louise was a child had left her mother with a chronic lung ailment that would prove fatal. Into this situation her father introduced a young woman. He had engaged her to serve as the children's governess and English tutor, and as such she lived with the family for ten years. She was also his mistress. 'Now you will ask me: how is it that in a middle-class family this mistress was a standard piece of furniture?' said Bourgeois. 'Well, the reason is that my mother tolerated it! And this is the mystery.' It was a mystery that could not be explored, for her mother died the year Louise entered university. Bourgeois did not tell this story publicly until 1982, the year a major retrospective signalled her rediscovery by a younger generation of artists who adopted her as one of their own. But she had been channelling its emotional legacy into sculpture all along.

Her first mature works were slender, abstract, standing figures that evoked people she had left behind when she moved to New York. Tapering to a point at the base, the figures had no feet and so could not leave her. 'That was an attempt at not only re-creating the past but controlling it,' she said. After her father's death, she withdrew from the art world for a decade and underwent psychoanalysis. When she began exhibiting again, her childhood had moved to centre stage along with childhood's forbidden subject, the erotic. Her new work was often sexually suggestive, as in the emerging tumescent forms that make up the cloudscape of *Cumul I*. With age, her imagery grew more overt and she discussed it more frankly: the copulating figures seen through the uncomprehending eyes of a young girl, the transposition of her mother into a gigantic spider, modest, protective and skilful.

'My goal is to relive a past emotion,' Bourgeois said. 'My sculpture allows me to re-experience fear, to give it a physicality, so that I am able to hack away at it. I am saying in my sculpture today what I could not make out in the past.'

Above Portrait of Louise Bourgeois in 1975 wearing her latex sculpture *Avenza* (1968–69), which became part of *Confrontation* (1978). Photo by Mark Setteducati. © The Easton Foundation, New York.

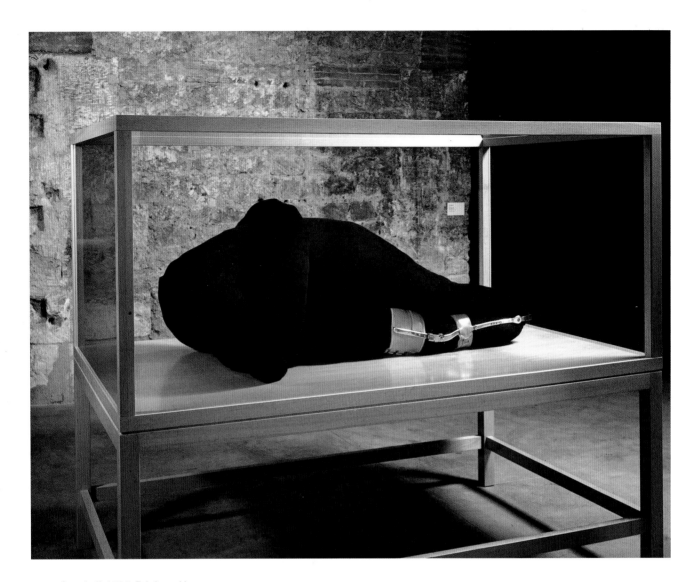

Above *Couple II*, 1996. Fabric and knee
brace, 68.6 × 152.4 × 81.3 cm
(27 × 60 × 32 in); wood and glass
vitrine, 165 × 119 × 201 cm
(65 × 47 × 79 in). Albright-Knox
Art Gallery, Buffalo. © The Easton
Foundation, New York.

Opposite above *Untitled*, 2002.
Needlepoint and aluminium,
43.2 x 30.5 x 30.5 cm (17 × 12 × 12 in).
The Easton Foundation, New York, NY.
© The Easton Foundation, New York.

Opposite below *Cumul I*, 1969. Marble,
56.8 × 127 × 121.9 cm (20⅜ × 50 ×
48 in). Musée National d'Art Moderne,
Centre Georges Pompidou, Paris. © The
Easton Foundation, New York.

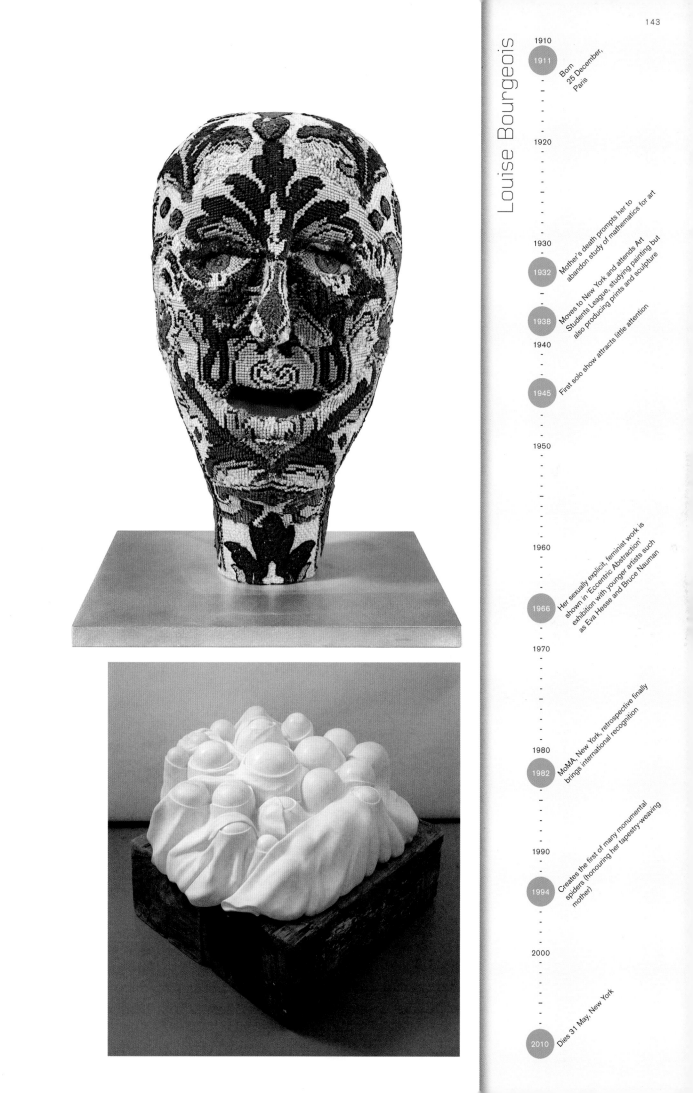

Louise Bourgeois

1910

1911 Born 25 December, Paris

1920

1930

1932 Mother's death prompts her to abandon study of mathematics for art

Moves to New York and attends Art Students League, studying painting but also producing prints and sculpture

1938

1940 First solo show attracts little attention

1945

1950

1960

Her sexually explicit, feminist work is shown in 'Eccentric Abstraction' exhibition with younger artists such as Eva Hesse and Bruce Nauman

1966

1970

MoMA, New York, retrospective finally brings international recognition

1980

1982

Creates the first of many monumental spiders (honouring her tapestry-weaving mother)

1990

1994

2000

Dies 31 May, New York

2010

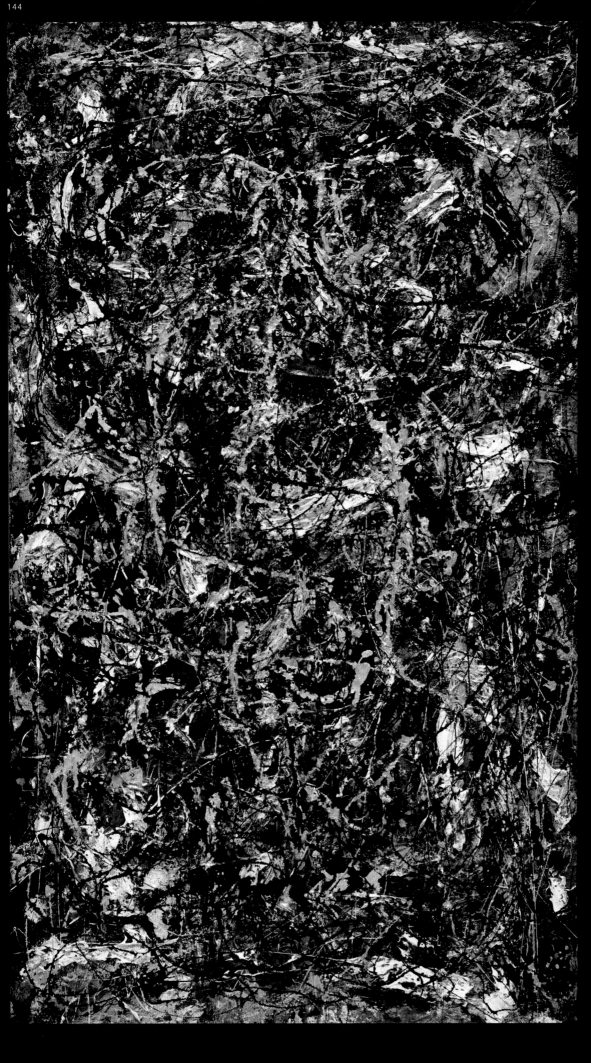

'When I am in my painting, I'm not aware of what I'm doing.'

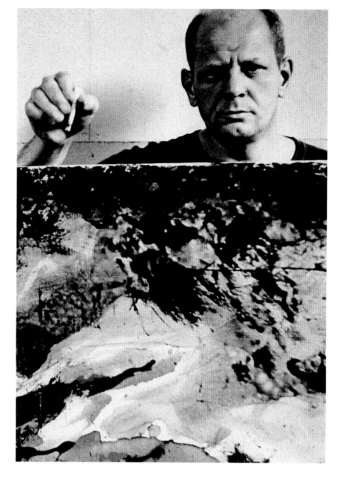

Jackson Pollock

1912–1956

UNITED STATES

'My painting does not come from the easel ... I prefer to tack the unstretched canvas to the hard wall of the floor ... On the floor I am more at ease. I feel nearer, more a part of the painting, since this way I can walk around it, work from the four sides and literally be *in* the painting. This is akin to the Indian sand painters of the West.' When Jackson Pollock published this description of his new working method, no one had yet seen the results. He had occasionally included poured passages in his easel paintings in the past, but no one could have predicted the scale and energy of the work he was about to unveil: engulfing, restless abstractions made by flowing, dripping, flinging, pouring and flicking liquid paint over raw canvas. Photographs of the painter at work in his studio captivated the public imagination. Never had the act of painting seemed so exciting, so heroic.

The youngest of five brothers, Jackson Pollock was born in Wyoming and grew up in Arizona and California. He began to conceive of himself as an artist while still in high school, inspired by the example of his oldest brother, who had left home to study art when Jackson was a boy. After coming to New York, Pollock studied at first with his brother's teacher, the Regionalist painter Thomas Hart Benton, and tried to mould himself into a realist. But when Benton left the city, other ideas and influences came crowding in: American Indian art, the unconscious, Jung, Surrealism, and the two artists he came to admire most, Pablo Picasso and Joan Miró. He began to develop a personal iconography of signs and symbols, biomorphic forms and abstracted figures, which he deployed in the paintings he showed in his first solo gallery exhibition in 1943.

In 1945, Pollock married the painter Lee Krasner and the couple moved to a rural hamlet at the east end of Long Island. There, in a small barn refurbished to serve as a studio, he first spread his canvas on the floor and worked from above. For three years the paintings flowed – open, airy, confident compositions with no beginning, no middle and no end. 'Energy and motion made visible,' he called them.

And then it was over. An alcoholic since his teens, Pollock began drinking again, heavily. He turned to a new approach, pouring black paint on canvas and allowing imagery to emerge. ('I think the non-objectivists will find them disturbing – and the kids who think it's simple to splash a Pollock out,' he wrote to a friend.) He tried occasionally to reanimate his abstract style but never regained his footing. By the time of his death, drunk at the wheel of a car, he had not painted in almost two years.

Opposite *Full Fathom Five*, 1947. Oil on canvas with nails, tacks, buttons, key, coins, cigarettes, matches, etc., 129.2 × 76.5 cm (50⅞ × 30⅛ in). Museum of Modern Art, New York. Gift of Peggy Guggenheim. 186.1952.

Above Portrait of Jackson Pollock in his studio by Tony Vaccaro, 1953.

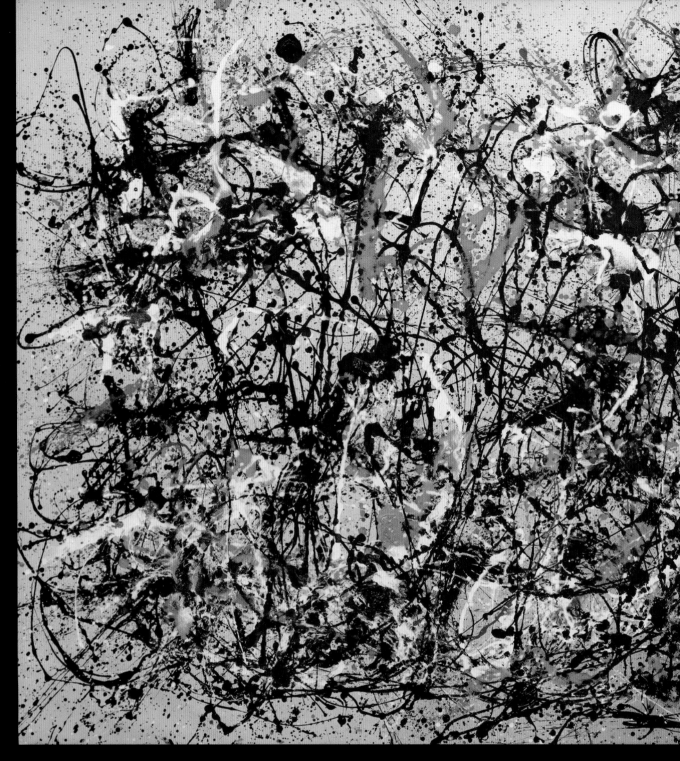

Above *Autumn Rhythm (Number 30)*, 1950. Enamel on canvas,
266.7 × 525.8 cm (105 × 207 in). Museum of Modern Art,
New York. George A. Hearn Fund, 1957. Acc.n.: 57.92.

Jackson Pollock

Born 28 January, Cody, Wyoming

Begins studies that
encompass Jungian
psychology and
Surrealist automatism
in Los Angeles and
Manhattan

1900 · · · · | · · · · 1910 1912 · · · | · · · · 1920 · · · · | · 1928 · 193

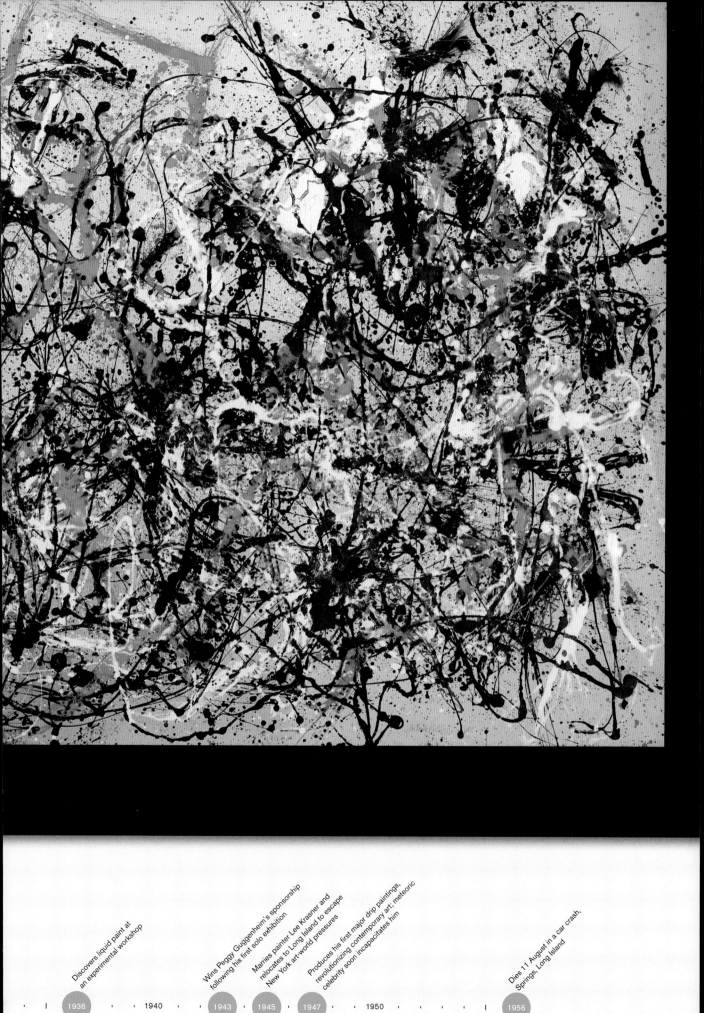

Discovers liquid paint at
an experimental workshop

Wins Peggy Guggenheim's sponsorship
following his first solo exhibition

Marries painter Lee Krasner and
relocates to Long Island to escape
New York art-world pressures

Produces his first major drip paintings,
revolutionizing contemporary art; meteoric
celebrity soon incapacitates him

Dies 11 August in a car crash,
Springs, Long Island

1936 1940 1943 1945 1947 1950 1956

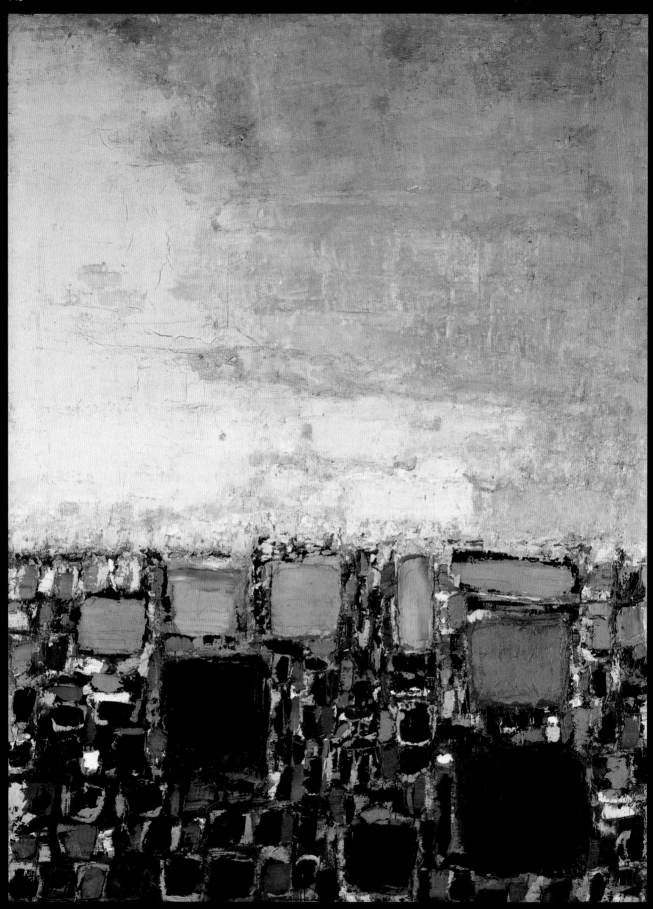

Roofs, 1952. Oil on hardboard,
200 × 150 cm (78¾ × 59 in).
Musée National d'Art Moderne,
Centre Georges Pompidou, Paris.

'What I'm attempting is a continuous renewal, truly continuous, and it isn't easy.'

Nicolas de Staël

1914–1955

RUSSIA/FRANCE

'Braque, Matisse and Cézanne and nothing else.' With these words Nicolas de Staël swept aside his contemporaries and aligned himself with the great inheritors of the French classical tradition; his was an epicurean art of balance and harmony, nourished and renewed by an intense engagement with the visible world. He had begun as one of the most promising abstract artists of his generation, a painter of muted colour harmonies in dynamic, tightly structured compositions. He became a stylistically restless artist who turned his abstract manner to the elusive task of capturing the world as it presented itself to his eyes.

France was de Staël's adopted country. He was born in Imperial Russia, into an aristocratic–military family. Following the revolution, the family managed to flee to Poland, where the parents soon died, leaving Nicolas and his sisters in the care of a friend, who arranged for them to be taken in by a prosperous couple in Belgium. After completing his schooling, de Staël studied art and architecture in Brussels, then left to live for a year in Morocco. He settled in France in 1938 and was naturalized a decade later, the year he painted *Water of Life*. With its palette of earth tones, its sensuous surface of thickly trowelled paint, and its construction from bands of colour, *Water of Life* is typical of the style that earned de Staël his first admirers.

The dynamic bands of de Staël's first maturity gave way to more static colour patches. Sumptuously applied with a palette knife, they chattered across the canvas or flocked together to compose larger forms. In *Roofs*, they began to inhabit an ambiguous territory, creating an abstract composition that also suggested the slate roofs and limestone facades of Paris under an overcast sky. 'You give me hope that one day my friends will make out how to receive images of life in coloured masses and not otherwise, shimmering with a thousand thousand vibrations,' he wrote to a sympathetic critic. In coloured masses the world flooded into his paintings – landscapes and seascapes, nudes and still lifes, soccer players, musicians and dancers. 'Breathe, breathe,' he wrote, 'never think of the definitive without the ephemeral.'

Success, when it came, profoundly disturbed de Staël. The attention, the expectations, the money all disoriented him. 'I've lost my universe and my silence,' he wrote to a friend. 'I'm becoming blind. Ah, God . . . to go back! To be nobody for others and everything for myself.' Unable to go back, de Staël went furiously forward, shifting his style yet again. His paintings became more directly figurative and rich impasto gave way to thinly brushed colours. 'What I'm attempting is a continuous renewal, truly continuous, and it isn't easy,' he wrote to his gallerist. Leaving his wife and children, he went to Antibes to work in total isolation and there he put an end to his days.

Above Portrait of Nicolas de Staël by Denise Colomb, 1954.

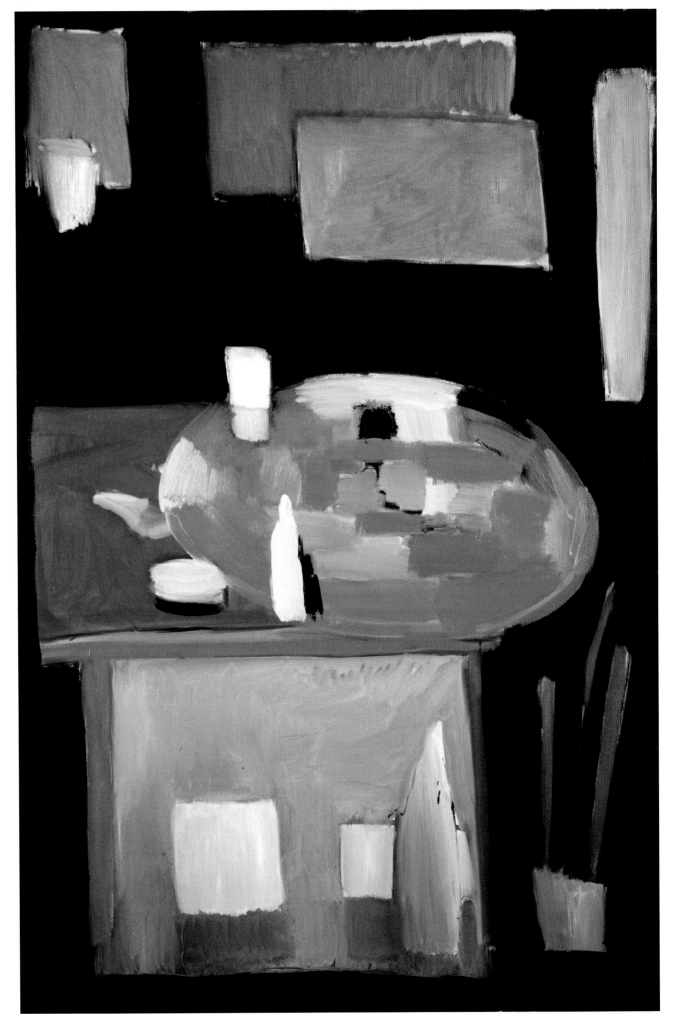

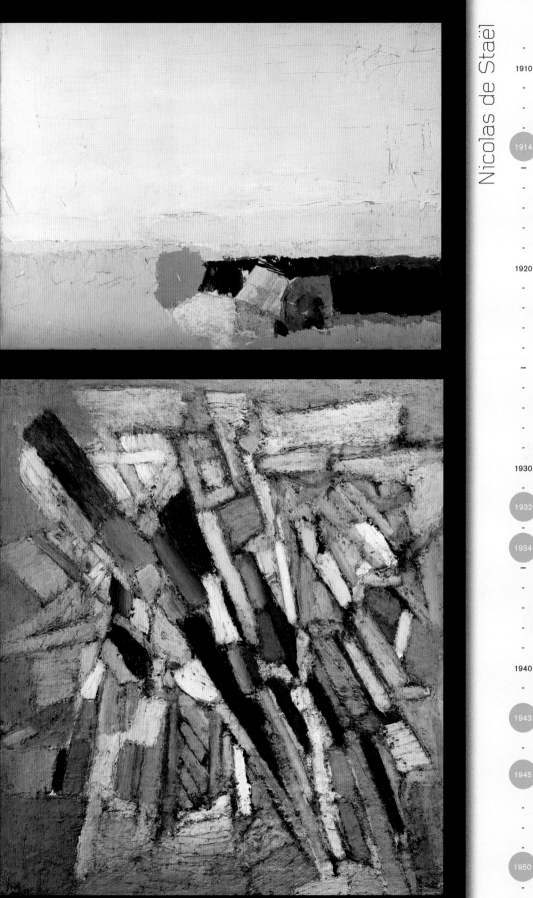

Nicolas de Staël

1910

1914 — Born 5 January, St Petersburg

1920

1930

1932 — Studies art in Brussels

1934 — Moves to Paris, though continues to travel widely

1940

1943 — Starts to abandon representation, developing a unique style with knife and trowel to build relief-like, superimposed blocks of colour

1945 — Wins acclaim at Salon d'Automne and Salon de Mai

1950 — First US exhibition. At his peak of abstraction, he resumes representational painting

1954 — A major Parisian exhibition of his work unleashes avant-garde criticism for abandoning abstraction

1955 — Commits suicide 16 March, Antibes

Opposite *Atelier Vert*, 1954. Oil on canvas, 145.4 × 97.2 cm (57¼ × 38¼ in). Present location unknown.

Above *Seafront*, 1952. Oil on canvas, 54 × 73.5 cm (21¼ × 28¹⁵⁄₁₆ in). Private collection.

Below *Water of Life* (*Eau de Vie*) 1948. Oil on canvas, 101 × 81.3 cm (39¾ × 32 in). Private collection.

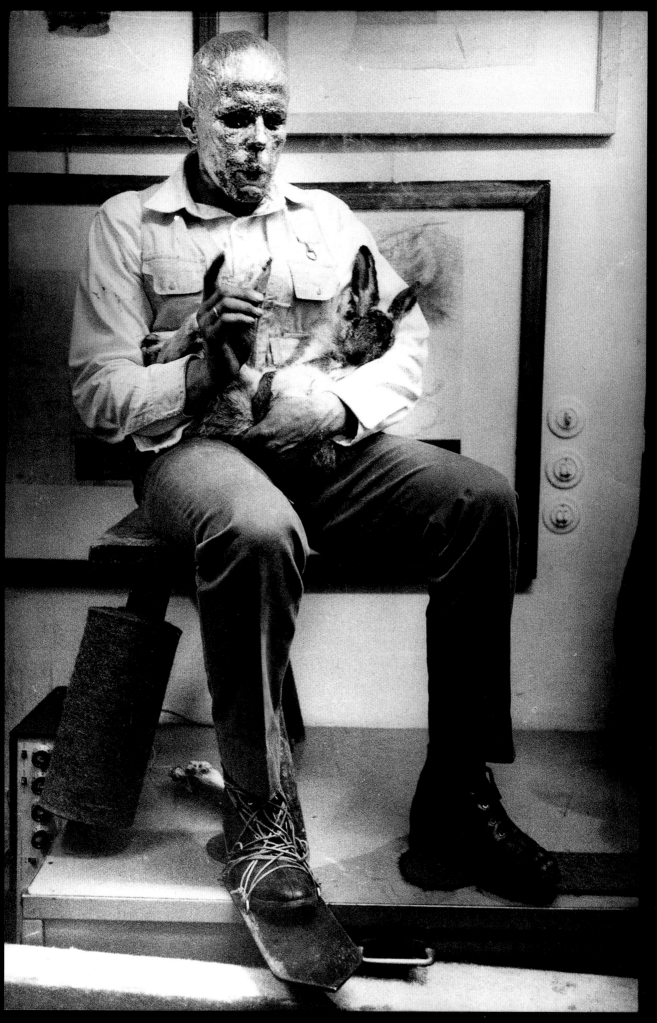

'Every action changes me radically.'

Joseph Beuys

1921–1986

GERMANY

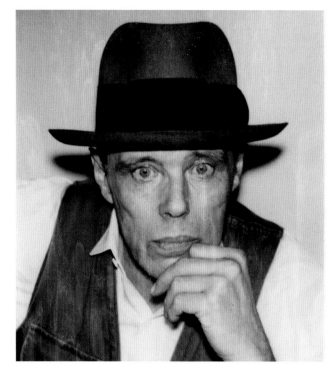

'I not only want to stimulate people, I want to provoke them.' Joseph Beuys's art and personal history are indivisible. Surrounding the work itself are his polemics, the messianic stance he adopted, his teaching – considered by him his 'greatest work of art' – and his social–political activities, including his ecological work and the foundation of the Free International University. Charismatic, Beuys acquired mythical status while receiving criticism for his absolutist views.

Trained in sculpture in the aftermath of World War II, Beuys belonged to the generation that came of age under the Nazi regime and experienced the country's destruction and the revelation of the Holocaust. In the mid-1950s, he suffered a severe depression, under which he produced watercolours drawn from his early interests in natural sciences and Nordic mythology, which became enduring references for his later work.

Central to Beuys's art was the myth of his rebirth – a wartime story in which he recalled being nurtured back to life by nomadic Tartars after a plane crash in Crimea. 'They covered my body in fat to help it regenerate warmth and wrapped me in felt, as an insulator to keep the warmth in.' Not truly autobiographical (the German army found him), this emblematic self-mythologizing constituted the source for his self-identification as artist–healer. Recast in numerous installations including *The Pack*, fat and felt became metaphors for human survival and regeneration. For Beuys, art became a 'medium for revolutionary change in the sense of completing the transformation from a sick world to a healthy one'.

In the early 1960s, during his brief involvement with Fluxus – an international movement advocating a unity between life and art – Beuys's work shifted from object-making to action-based art as he mounted his first performances. Imbued with symbolism, they incorporated physical endurance invested with a shamanic dimension and sought strong visceral reactions from the audience. 'Every action changes me radically. In a way it's a death, a real action and not an interpretation.' Head anointed with honey and gold, he communed with a dead hare cradled in his arms. In like manner, ensconced in a felt blanket, he confined himself with a coyote for three days in a New York gallery. Together with animals, mutable materials such as rust, blood and bone evoked a ceremonial place and transformative processes that, Beuys claimed, 'continue in most of them: chemical reactions, fermentations, colour changes, decay, drying up'.

In later years, Beuys increasingly turned to performance–lectures, expounding his extended notion of art as 'social sculpture' in which 'every human being is an artist' as creativity reshapes social structures. 'To impose forms on the world around us is the beginning of a process that continues into the political field . . . Everyone will be a necessary co-creator of a social architecture, and, so long as anyone cannot participate, the ideal form of democracy has not been reached.'

Opposite *How to Explain Pictures to a Dead Hare*, 1965. Performed at Galerie Schmela, Düsseldorf. Photo: Ute Klophaus.

Above Portrait of Joseph Beuys by Andy Warhol, 1979. Polaroid, 10.8 x 8.5 cm (4¼ × 3⅓). Hamburger Kunshalle, Hamburg.

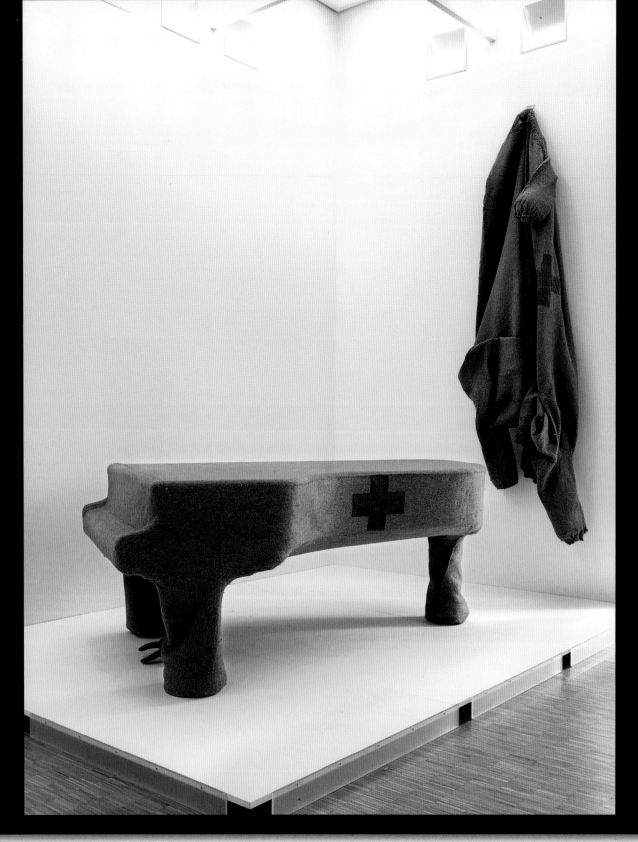

Josef Beuys

Born 12 May, Krefeld

Injured in a wartime plane crash;
Beuys's fabricated rescue by nomads
informs his artistic oeuvre of
indistinguishable fact/fiction

1920 1921 1930 1940 1944 1950

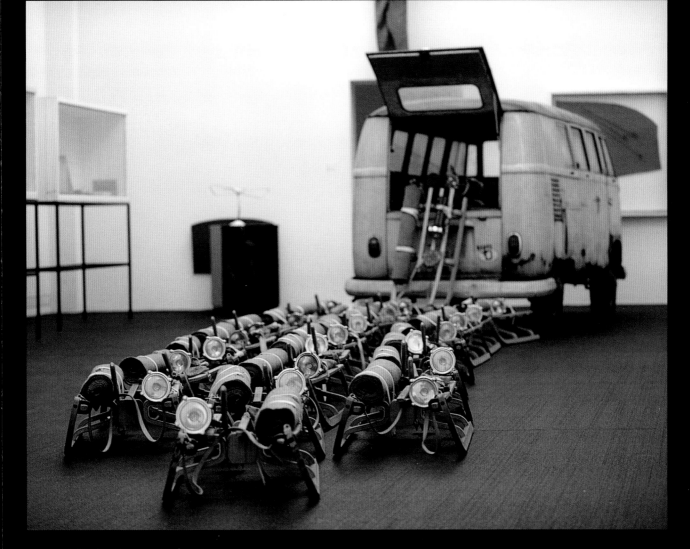

Opposite *Infiltration Homogen for Grand Piano*, 1966. Grand piano covered with felt and fabrics, 100 × 152 × 240 cm (39⅜ × 57⅞ 94½ in). Musée National d'Art Moderne, Centre Georges Pompidou, Paris.

Above *The Pack*, 1969. 24 sledges and a VW bus. Photo of exhibition at Neue Galerie, Kassel, Germany, 23 November 2011.

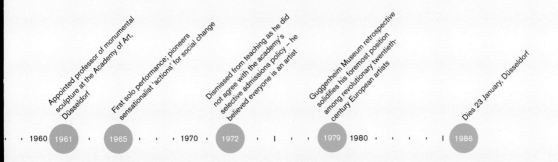

Appointed professor of monumental sculpture at the Academy of Art, Düsseldorf

First solo performance; pioneers sensationalist 'actions' for social change

Dismissed from teaching as he did not agree with the academy's selective admissions policy – he believed everyone is an artist

Guggenheim Museum retrospective solidifies his foremost position among revolutionary twentieth-century European artists

Dies 23 January, Düsseldorf

· 1960 1961 · 1965 · · 1970 · 1972 · | 1979 1980 · · · · | 1986

'It's very similar but
it's not the same.'

Roy Lichtenstein

1923–1997

UNITED STATES

Roy Lichtenstein could never say just what it was that inspired him to paint his first comic-strip panel. He was working at the time in an Abstract Expressionist style. As an experiment, he tried integrating cartoon characters into his paintings. The experiment was a failure, but it left him with a comic strip lying around his studio, 'and the idea of doing one without apparent alteration just occurred to me', he recalled. 'I did one really almost half seriously to get an idea of what it might look like . . . I kind of got interested in organizing it as a painting and brought it to some kind of conclusion as an aesthetic statement, which I hadn't really intended to do to begin with.' When he tried to return to his gestural abstract style, the cartoon painting kept tugging at him. 'I couldn't keep my eyes off it, and it sort of prevented me from painting any other way, and then I decided this stuff was really serious.'

What Lichtenstein found serious was the visual shorthand that cartoonists and commercial illustrators had developed; their repertoire of clichés for drawing such things as facial features and explosions; and the restricted vocabulary of black lines, flat colours and Benday dots imposed by the technology used to mass-produce images on newsprint. He modified the images so that they had the internal relationships and unity of paintings, while preserving their impersonal, mechanical look. 'They look a lot like the original, but really there's nothing in my work that's in the same positions,' he said. 'It's very similar but it's not the same.'

Lichtenstein showed his paintings of comic-strip panels and commercial illustrations for the first time in 1962. He was immediately grouped together with Andy Warhol and other artists as part of the New Realism, a dry term that was soon replaced by a snappy English import, Pop Art. American Pop acknowledged the flood of new products that appeared during the wave of prosperity following World War II, when Europe was still rebuilding and under rationing. 'It changed the landscape a lot,' said Lichtenstein. 'You were aware that the real architecture was not Le Corbusier but McDonald's hamburger-stands . . . there was a feeling that whatever was new in the environment went through this filter of commercial art and had a certain kind of appearance and feeling.'

Lichtenstein ceased working with comics by the late 1960s, but he translated other subjects into their formal language for the rest of his career: slurpy brush strokes, empty mirrors, paintings by Pablo Picasso and other modern masters, and domestic interiors. In his old age he even turned to classical Chinese landscape painting. 'I like it to appear to be serene,' he said, 'but also to be pseudo serene.'

Opposite *Drowning Girl*, 1963. Oil and synthetic polymer on canvas, 171.6 × 169.5 cm (67⅝ × 66¾ in). Museum of Modern Art, New York. Philip Johnson Fund and gift of Mr and Mrs Bagley Wright. Acc. n.: 685.1971.

Above Portrait of Roy Lichtenstein by Mario De Biasi, 1964.

Roy Lichtenstein

Left *Artist's Studio, 'The Dance'*, 1974. Oil and synthetic polymer paint on canvas, 244.3 × 325.5 cm (96⅛ × 128⅛ in). Museum of Modern Art, New York. Gift of Mr and Mrs S.I. Newhouse, Jr 362.1990.

Above *Picture and Pitcher*, 1977. Painted bronze, 241.3 × 101.6 × 62.2 cm (95 × 40 × 24½ in). Albright-Knox Gallery, Buffalo. Edmund Hayes and Charles Clifton Funds, 1978.

Adopts comic-strip imagery, encouraged by 'happenings' while teaching at Rutgers University

First major solo exhibition (completely pre-sold); pioneers Pop Art with parodies of contemporary culture

Becomes full-time artist, exploring sculpture and new subject-matter, all in his signature tongue-in-cheek, dispassionate style

First of several large-scale commissions in public settings

Dies 29 September, Manhattan

· 1960 · 1961 · 1962 · 1964 · 1970 · · · · · · 1978 · 1980 · · · · · · 1990 · · · · · 1997

Blue with Four Red Bars (*Blau amb quatre barres roges*), 1966. Oil and sand on canvas, 169.9 × 195.3 cm (66⅞ × 76⅞ in). Museo Nacional Centro de Arte Reina Sofía, Madrid.

'A work of art is a support
for meditation.'

Antoni Tàpies

1923–2012

SPAIN

I'm sure that my life would have taken a quite different course if I hadn't fallen ill,' Antoni Tàpies told an interviewer. He was born into a cultivated family of Catalan nationalists; his adolescence was marked by the Spanish Civil War and the early years of the Franco dictatorship. Weakened by wartime distress and deprivation, he developed a lung disease and remained bedridden for nearly two years. 'Astonishingly, the illness didn't sap my mental energies: on the contrary, it was a revelatory experience,' he said. 'I'm convinced that the breathing difficulties resulting from my illness, and the special breathing exercises which I had to do, enabled me to acquire a new spiritual clarity ... And it was these "visions" which steered me towards art.'

Tàpies became a founding member of Dau al Set, a literary and artistic group oriented towards Dada and Surrealism. After several years, however, he suffered a crisis in his work and began a restless period of searching. 'I wanted to start again from scratch,' he said. 'Looking for new spiritual models, I read a great deal about Eastern philosophies: the Vedanta, yoga, Taoism and Zen.' Eventually, by mixing coarse marble dust with resin, pigment and ink, he arrived at surfaces that resembled old, weathered walls. 'To another artist, it may not have been very important, but my name means "wall" in Catalan, so it seemed a mark of identity to me,' he said. On these walls he incised or painted numbers, letters and symbols that pointed to esoteric meanings.

As Tàpies's art evolved, he integrated humble materials into his works – cardboard, twine, rags, bits of wood, straw, mud. Among his motifs he accorded a place of honour to the human foot, a humble part of the anatomy, often misshapen from long servitude. He tried painting directly with varnish, brushing and pouring translucent, pale honey-coloured shapes that flowed and puddled. Art, he said, was something like a magic show. The magician knows perfectly well that he is dealing in illusions, but spectators, if they are to enjoy themselves, must enter into the game and stop thinking he is out to deceive them. 'If you do not allow yourself to be "put under" these spells that make up the convention we call art,' he said, 'you might as well give up.'

Modern physics, Zen Buddhism and the writings of the medieval philosopher, theologian and mystic Ramon Llull were abiding sources of inspiration for Tàpies, who saw his art as being rooted in the tradition of mysticism. 'I have never believed that art has intrinsic value,' he said. 'What matters is its role as a trigger, as a springboard that leads us to knowledge ... A work of art is but a support for meditation, a tool to fix your attention, to stabilize or excite the mind.'

Above Portrait of Antoni Tàpies by Raphael Gaillarde, 1991.

Right *Composition LXIV*, 1957. Mixed media on canvas, 97 × 162 cm (38⅕ × 63¾ in). Hamburger Kunsthalle, Hamsburg.

Below *Le Chapeau Renverse,* 1967. Mixed media on canvas, 97.6 × 162.3 cm (38⅖ × 63⅞ in). Musée National d'Art Moderne, Centre Georges Pompidou, Paris.

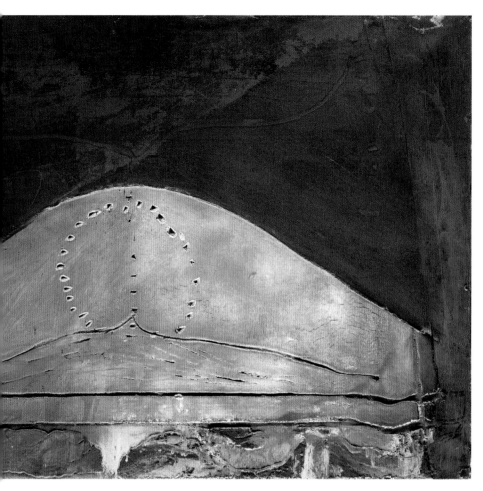

Antoni Tàpies

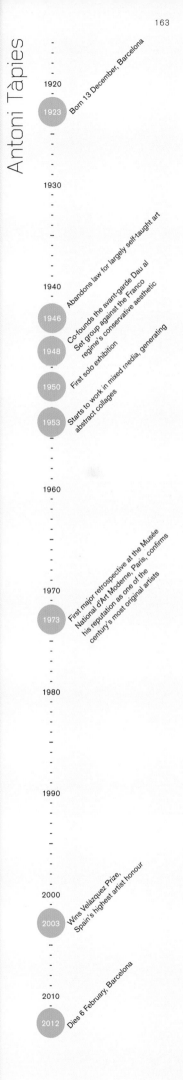

1920

1923 — Born 13 December, Barcelona

1930

1940

1946 — Abandons law for largely self-taught art
Co-founds the avant-garde Dau al
Set group against the Franco
1948 — regime's conservative aesthetic
First solo exhibition
1950 — Starts to work in mixed media, generating
abstract collages
1953 —

1960

1970

1973 — First major retrospective at the Musée
National d'Art Moderne, Paris, confirms
his reputation as one of the
century's most original artists

1980

1990

2000

2003 — Wins Velázquez Prize,
Spain's highest artist honour

2010

2012 — Dies 6 February, Barcelona

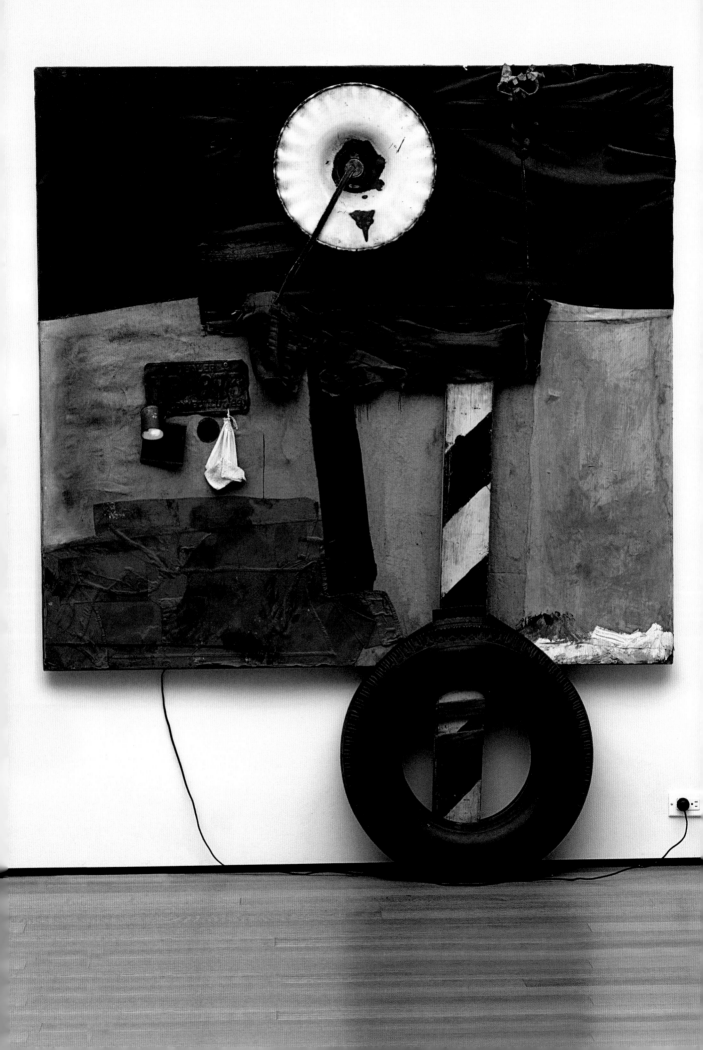

'There is no reason not to consider the world as one gigantic painting.'

Robert Rauschenberg

1925–2008

UNITED STATES

The early 1950s were the heyday of Modernism in New York, and the United States found its artistic voice in the Abstract Expressionism of Jackson Pollock, Willem de Kooning and Robert Motherwell. These were artists that the young Rauschenberg admired, theirs the works he studied, notably at Black Mountain College. But he soon realized that this was not the kind of art he wanted to create and, in response, he experimented. In 1952, he organized an 'event', a collaborative piece of Performance Art with musician John Cage and dancer Merce Cunningham. This marked Rauschenberg's break from the tradition of over 100 years of Modernism. The following year Rauschenberg asked de Kooning if he could erase one of his drawings. De Kooning reluctantly agreed, and the result created a scandal. Rauschenberg described *Erased de Kooning* as 'poetry', but critics saw it as vandalism and a provocative challenge. It became emblematic of a new artistic era.

Not only did Rauschenberg reject the Modernist style, he also rejected the Modernist ideologies of prophetic genius and individual identity. He questioned their introverted notion of truth, looking away from himself and away from 'high art' out to the world. 'I found everything I needed on the streets of New York,' he said. 'People threw all sorts of things away.' In works such as *First Landing Jump*, he abandoned traditional materials to assemble found objects – anything from road signs to bedclothes – and incorporated them into his canvases. These works became impossible to categorize: they were part painting, part sculpture. He described them as 'combines', and saw them as a bridge between art and reality. The impact of this shift in vision is so great

it is impossible to quantify. Today, Rauschenberg's work is seen not only as a playful, intelligent precursor to Postmodernism, but also as the foundation stone for postwar art. At the time, however, critics were horrified. One of his first dealers had to remove the gallery guest book 'because of the obscenities being written into it . . . many people really thought it was immoral'.

Rauschenberg pre-empted the Pop artists in works such as *Tracer* by replacing the objects on his canvas with appropriated images. Throughout his career he continued to experiment with the materials and processes of creation. He used printmaking and, from the 1960s, increasingly worked with silkscreen and print transfer in works that became gradually more documentary and eclectic in style. In the mid-1980s he experimented with metal, producing a series referred to as *Gluts,* in which he experimented with the visual and sculptural properties of the material, making works that appear by turns volumetric, fragile, crude, beautiful and refined. Rauschenberg's oeuvre constantly challenged his contemporaries and defied categorization; his work was the catalyst that shifted art from High Modernist sincerity to the wit and irony that has characterized it since.

Opposite *First Landing Jump*, 1961. Combine painting: cloth, metal, leather, electric fixture, cable and oil paint on composition board with automobile tyre and wooden plank on floor, 226.3 × 182.5 × 22.5 cm (89⅛ × 72 × 8⅞ in). Museum of Modern Art, New York. Gift of Philip Johnson. Acc. n.: 434.1972.

Above Portrait of Robert Rauschenberg by David Montgomery, 1969.

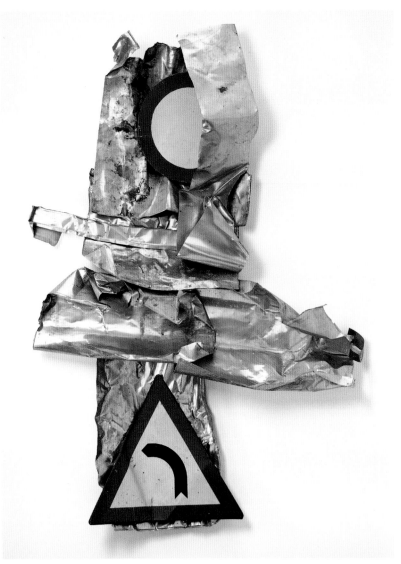

Left *Chrome Castle Glut*, 1987.
Assembled metal parts, 107 × 80.7 × 17.2 cm
(42⅛ × 31¾ × 6¾ in). Maxine and Stuart Frankel
Foundation for Art.

Below *Port of Entry* from *Anagram (A Pun)*, 1998.
Pigmented ink transfer on paper on aluminium
panels, 314.3 × 457.2 cm (123¾ × 180 in).
San Francisco Museum of Modern Art. Purchase
through a gift of Phyllis Wattis. © Robert
Rauschenberg Foundation / Licensed by VAGA,
New York, NY.

Opposite *Tracer*, 1964. Oil and silkscreen
on canvas, 213.6 × 152.4 cm (84 × 60 in).
Nelson-Atkins Museum of Art, Kansas City.
Purchase: Nelson Gallery Foundation, F84-70.

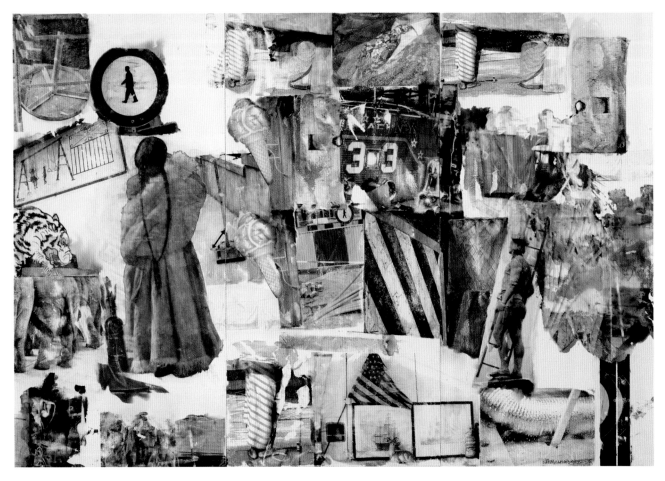

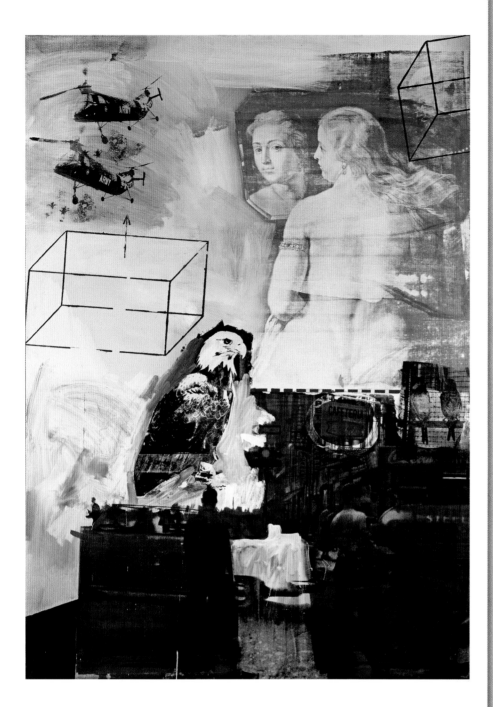

Robert Rauschenberg

1920

1925 — Born 22 October,
Port Arthur

1930

1940

1946 — Begins six years of study in art,
significantly at Black Mountain College

1950

1953 — Erases a de Kooning drawing,
controversially challenging
art's possibilities

1954 — Blurs boundaries with 'combines',
assemblages and multi-source
transfer paintings

1960

1962 — Begins high-texture screen-printing

1964 — Becomes first American to win Venice
Biennale's Grand Prize; subsequently
focuses on performance

1970

1980

1990

1997 — Major travelling retrospective confirms
his colossal impact on Modernism

2000

— Dies 12 May, Captiva Island

2008

Blue Monochrome, 1961. Dry pigment in
synthetic polymer medium on cotton over
plywood, 195.1 × 140 cm (76⅞ × 55⅛ in).
Museum of Modern Art, New York. The Sidney
and Harriet Janis Collection. 618.1967.

'For colour! Against line and drawing!'

Yves Klein

1928–1962

FRANCE

A proponent of absolute monochromy – 'For colour! Against the line and the drawing!' was his motto – Yves Klein, though he began painting in Paris at the height of geometric abstraction, claimed to be the heir of Impressionism and Eugène Delacroix. For Klein, monochromatic surfaces did not represent the final blow to painting as they had for Aleksandr Rodchenko in the 1920s. Rather, they were synonymous with 'landscapes of freedom' and 'zones of immaterial pictorial sensibility'.

From adolescence, Klein immersed himself in the discipline of judo: 'What interests me about Judo, what fascinates me, is Movement, the end of Movement that is always abstract and purely spiritual.' Self-taught, he introduced himself to the art world with *Yves Paintings*, a booklet of monochromes. Supposedly painted between 1950 and 1954 they turned out to be commercially printed coloured paper. The gesture was belatedly interpreted as an early manifestation of Conceptual Art, or a simple prank. Klein immediately grasped that to be the commentator on his own artistic output would be to control its interpretation. His strategies were many, from producing essays and manifestos, to organizing lectures and flamboyant public events, to staging elaborate publicity stunts.

Klein first exhibited his monochromes in various shapes and colours. They were intended to be experienced as autonomous elements but, to his dismay, viewers 'reassembled them as components of polychromatic decoration'. 'Enslaved by visual habit, this public, however select, could not enter into the contemplation of the "COLOUR" of a single painting at a time,' he complained. 'This triggered my blue period.'

Having developed and patented International Klein Blue (IKB) – an extraordinarily luminous aquamarine pigment that maintains its intensity once fixed on the canvas – Klein launched 'Epoca Blu' in 1957, a show of identical rectangular blue monochromes. While his techniques of applying paint included sponges and fingers, the pigment here was applied with a house-paint roller to avoid painterly brush marks. His palette later expanded to embrace gold and pink.

In addition to IKB-impregnated works such as sponge sculptures, Klein produced several series of body imprints using paint-soaked nude models as 'living brushes' or by spraying paint around their forms. Pushing his experiments further, he adopted rain and fire as media. 'Because every work of creation, regardless of its cosmic position, is the representation of pure phenomenology – every phenomenon manifests itself of its own accord,' he wrote. 'This manifestation is always distinct from form, and is the essence of the immediate, the trace of the immediate.' His fascination with the immaterial was encapsulated in 'The Void', an exhibition consisting of an empty gallery repainted white, which aimed to reveal the space as intangible sensibility.

Associated with the movement Nouveau Réalisme (New Realism), Klein was part of the European avant garde and well acquainted with such artists as Lucio Fontana and Piero Manzoni. What has proved enduring is not the provocative showman but rather the artist who established a new aesthetic of monochromy.

Above Portrait of Yves Klein by Charles Paul Wilp, 1958.

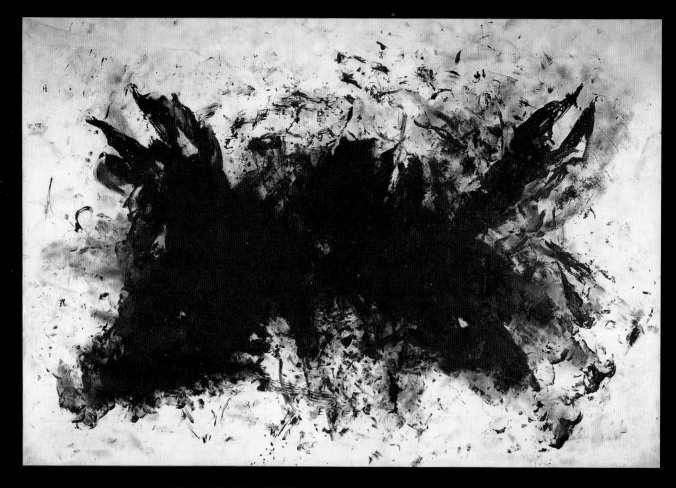

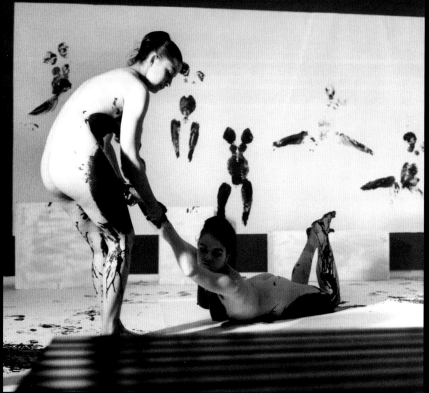

Above *Large Blue Anthropophagy: Homage to Tennessee Williams*, 1960. Pigment and synthetic resin on paper mounted on cloth, 275 × 407 cm (108¼ × 163¼ in). Musée National d'Art Moderne, Centre Georges Pompidou, Paris.

Left Yves Klein's performance *Anthropometry ANT49*, Paris 1960. Musée National d'Art Moderne, Centre Georges Pompidou, Paris.

Opposite *Tree, Large Blue Sponge*, 1962. Pigment, synthetic resin, plaster and sponge, 150 × 90 × 42 cm (59 × 35⅝ × 16½ in). Musée National d'Art Moderne, Centre Georges Pompidou, Paris.

171

Yves Klein

1928 — Born 28 April, Nice, to artist parents

1930

1940

1950

1953 The self-taught painter announces his 'manifesto of the monochrome', seeking transcendental freedom through pure colour

1956 Chemically develops and patents IKB, his trademark ultramarine blue; its intense cosmic brilliance advances Klein's aesthetic of the immaterial

1957 Begins to transcend painting with air, fire, water and voids in metaphysical performances

1960 Creates anthropometry body-imprints, using IKB-covered nude models as his living brushes; pioneers the movement Nouveau Réalisme

1962 Dies 6 June, Paris

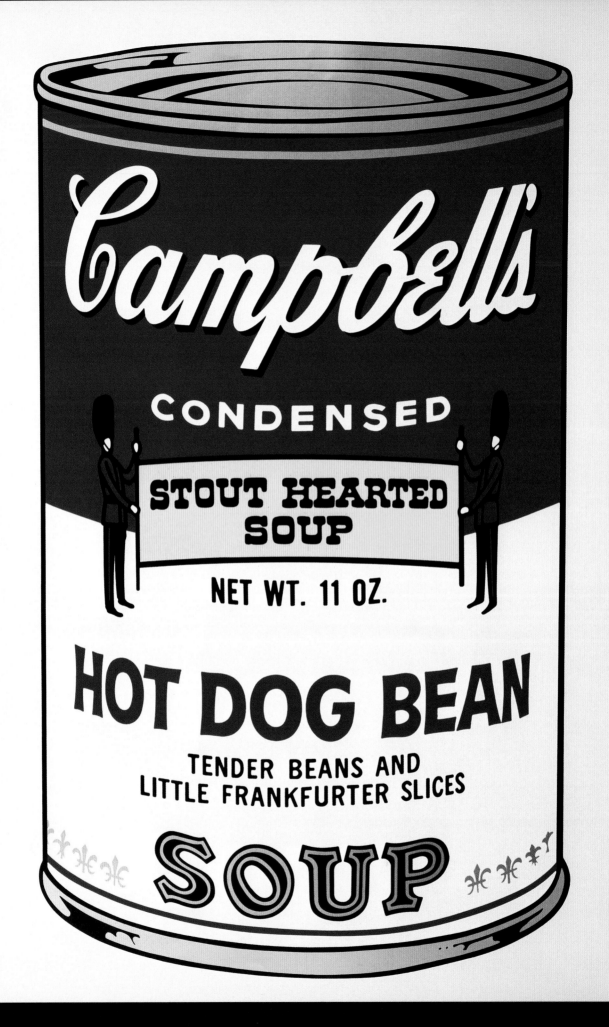

'I just happen to like ordinary things.'

Andy Warhol

1928–1987

UNITED STATES

'I never wanted to be a painter,' said Andy Warhol. 'I wanted to be a tap-dancer.' This may or may not be true. Interviews made Warhol so uncomfortable that he would say almost anything – or almost nothing. He sometimes asked interviewers to make up the answers for him. 'I prefer to remain a mystery,' he said, and he largely got his wish. 'If you want to know all about Andy Warhol, just look at the surface: of my paintings and films and me, and there I am. There's nothing behind it.'

Warhol was a successful commercial illustrator when he set his sights on the world of fine art. His first paintings were of comic-book characters and newspaper advertisements, but when he discovered that a then unknown artist named Roy Lichtenstein was mining the same material, he shifted his focus to what would become some of his signature motifs: Campbell's Soup cans and Coca-Cola bottles, sheets of currency and photographs of film stars and fatal accidents. As an illustrator, he had been known for whimsical handmade drawings. Now he sought a cool, impersonal look. He began to work with photographs and he adopted the technique of photo-silkscreen so that images could repeat across the canvas.

In 1962, an exhibition that brought together Warhol, Lichtenstein and Claes Oldenburg marked the sudden emergence of American Pop Art. After that, things moved quickly. Warhol expanded his motifs to include electric chairs, race riots and, after the assassination of her husband, the President, Jackie Kennedy. He moved his studio to a loft that became known as the Factory, where assistants helped him produce his art, where he turned his attention to making films and where all manner of people came and went. In 1964, he exhibited wooden boxes that faithfully reproduced the boxes in which brand-name products shipped to stores. The

following year, at his first museum retrospective, so many people turned out to see Warhol and his entourage that the art had to be taken down from the walls to protect it. He had become a celebrity.

In 1963, Warhol drove across the United States to California with some friends. Years later, the experience stood out in memory as a moment of marvel, before fame arrived, before the attempt on his life changed him. 'The farther west we drove, the more Pop everything looked on the highways,' he recalled. At a time when most people took it for granted, they remained dazzled by it and suddenly felt like 'insiders' because they saw Pop everywhere. 'It was the new Art. Once you "got" Pop, you could never see a sign the same way again. And once you thought Pop, you could never see America the same way again . . . We were seeing the future, and we knew it for sure.'

Opposite *Hot Dog Bean Soup*, from *Campbell's Soup II*, 1969. Number 63 of an edition of 250, New York, Factory Editions. Screenprint in colours, 81 × 47 cm (31⅞ × 18½ in). Private collection.

Above Portrait of Andy Warhol on the set of *Lonesome Cowboys*, 1968.

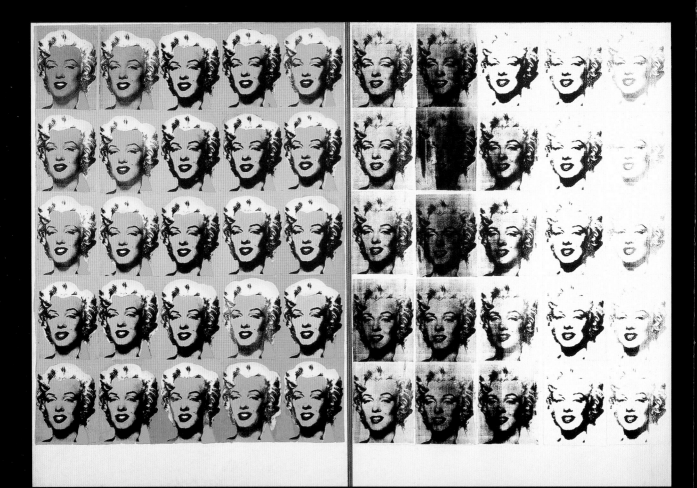

Above *Marilyn Diptych*, 1962. Acrylic paint on canvas, each 205.4 × 144.8 cm (80⅞ × 57 in). Tate, London.

Opposite above *Brillo Boxes*, 1964. Synthetic polymer paint and silkscreen on wood, each 43.5 × 43.2 × 36.5 cm (17⅛ × 17 × 14 in). Museum of Modern Art, New York.

Opposite below *Orange Car Crash (Orange Disaster) (5 Deaths 11 Times in Orange)*, 1963. Silkscreen on acrylic on canvas, 219 × 209 cm (86¼ × 82¼ in). Galleria d'Arte Moderna, Turin. Gift of Doris and Donald Fisher. Acc. nn.: 357.1997 and 358.1997.

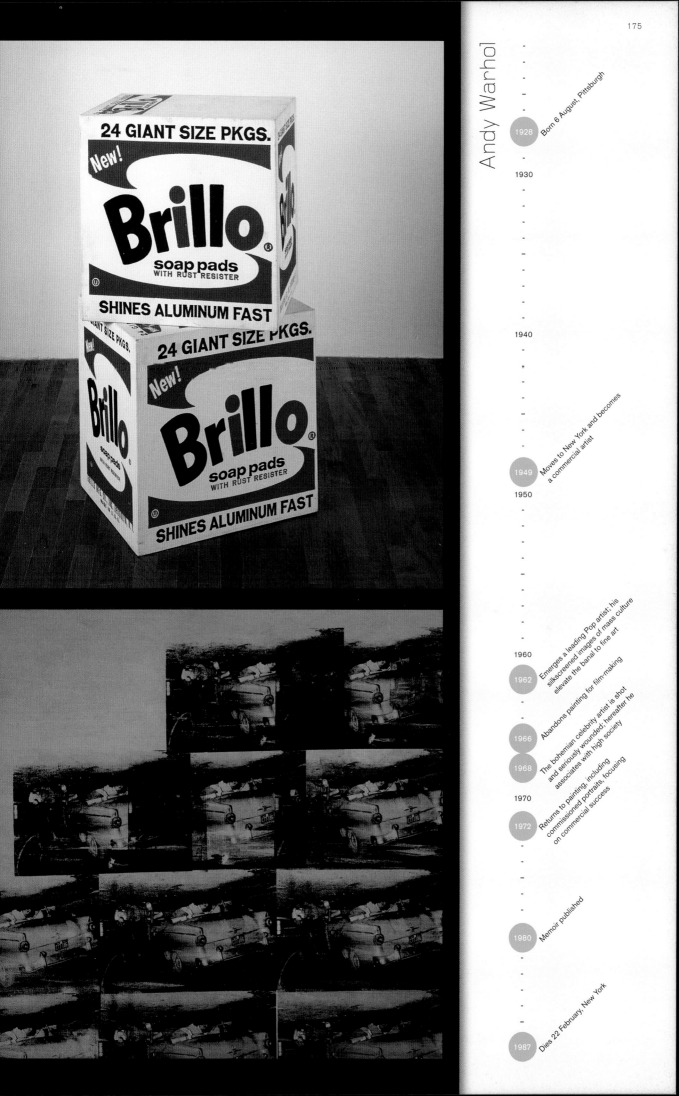

Andy Warhol

1928 Born 6 August, Pittsburgh

1930

1940

1949 Moves to New York and becomes a commercial artist

1950

1960

1962 Emerges a leading Pop artist; his silkscreened images of mass culture elevate the banal to fine art

Abandons painting for film-making

1966 The bohemian celebrity artist is shot and seriously wounded; hereafter he associates with high society

1968

1970 Returns to painting, including commissioned portraits, focusing on commercial success

1972

1980 Memoir published

Dies 22 February, New York

1987

'It's too hard to think about things. I think people should think less anyway.'

Sol LeWitt

1928–2007

UNITED STATES

'I wanted to emphasize the primacy of the idea in making art.' With this one sentence, Sol LeWitt summed up his life's work. His first mature structures – he rejected the word 'sculpture' – consisted of open squares and cubes used as modules to articulate larger forms. Squares and cubes, he said, had the advantage of being relatively uninteresting, standard and universally recognized. 'Released from the necessity of being significant in themselves, they can be better used as grammatical devices from which the work may proceed.'

LeWitt's modular structures were soon joined by serial works, in which a logical system generated a set of variations as its possibilities were worked out. *Serial Project #1 (ABCD) 6*, for example, catalogues the four possible variations for open and closed forms of a three-cube vertical element inserted into the centre of a nine-cube square. It is itself derived from a more extended set that worked out the possibilities for setting one form inside another in both two and three dimensions. 'The serial artist does not attempt to produce a beautiful or mysterious object but functions merely as a clerk cataloguing the results of the premise,' LeWitt said. 'Serial systems and their permutations function as a narrative ... It can be read as a story, just as music can be heard as form in time.'

LeWitt's works were initially understood as part of the trend towards simple forms that critics called Minimalism. But Minimalism, according to LeWitt, never really existed as an idea among artists. Rather, his art was conceptual. 'In Conceptual Art the idea or concept is the most important aspect of the work,' he wrote. 'When an artist uses a conceptual form of art, it means that all of the planning and decisions are made beforehand and the execution is a perfunctory affair. The idea becomes a machine that makes the art.'

LeWitt's most ingenious idea-machines made wall drawings, over 1,100 of them. A wall drawing resided in a set of instructions. The artist could execute them, but ideally they were collaborative works, to be realized by others. The instructions were precise, yet their realization involved making decisions, and no two people, LeWitt knew, would make the same ones. At first, LeWitt's wall drawings were purely linear. Then, while living in Italy, he fell under the spell of early Renaissance frescoes. 'I began to think about how art isn't an avant-garde game,' he said. 'It has to be something more universal, more important.' He began inventing wall drawings of geometric forms overlaid with sumptuous coloured ink washes, in which the ascetic appeal to the mind was accompanied by a sensuous appeal to the eye. In a final and surprising shift, he wrote instructions for wall drawings to be realized in brilliant acrylic paint, their conceptual rigour now a vehicle for joyful optical dazzle.

Opposite *Cubic Construction: Diagonal 4, Opposite Corners 1 and 4 Units*, 1971. Painted wood, 62.2 × 61.6 × 61.6 cm (24½ × 24¼ × 24¼ in). Museum of Modern Art, New York. The Riklis Collection of McCrory Corporation. Acc. n.: 1038.1983.

Above Portrait of Sol LeWitt painting one of his sculptures, by Fred W. McDarrah, 1966.

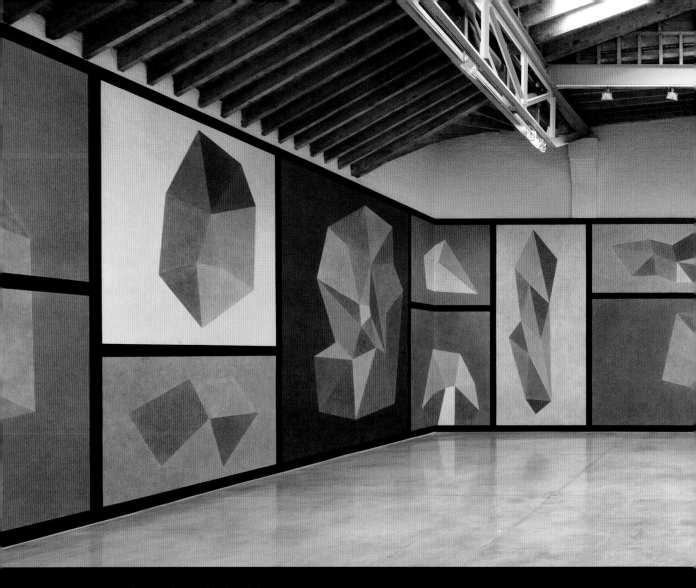

Wall Drawing #564: Complex forms with colour ink washes superimposed, first installation: Venice Biennale, June 1988. Colour ink wash, dimensions variable. First drawn by David Higginbotham, Andrea Marescalchi, Anthony Sansotta, Rebecca Schwab, Jo Watanabe. Installation at Paula Cooper Gallery, New York by Hidemi Nomura, Gabriel Hurier, Michael Vedder, Brianne Doak, Yvonne Olivas, Krysten Koehn, Timothy Wilson, Logan Marshall, Sarah Heinemann, 2013.

Sol LeWitt

Born 9 September, Hartford

Determines to reduce art to essentials while clerking at MoMA

Begins lifelong exploration of modular white cube 'structures'

Conceives temporary 'instruction-based' wall drawings executed on-site by others; champions ideas rather than permanent works by a singular artist

1928 · 1930 · · · · | · · · · 1940 · · · | · · · 1950 · · · | · · · 1960 · · · | · · · 1964 | · · · · 1968 · 1970 · · · ·

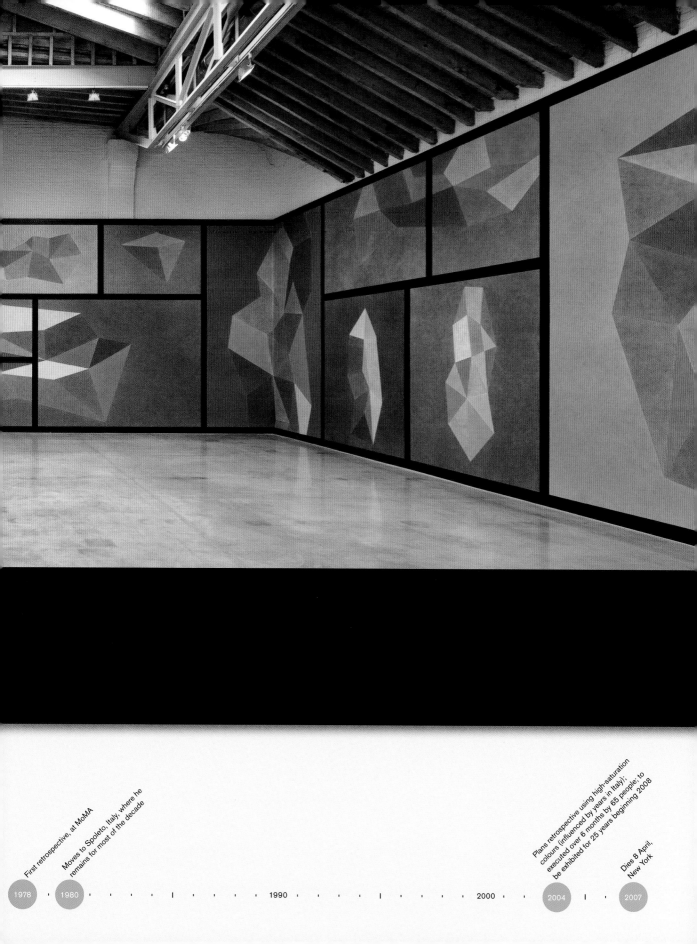

First retrospective, at MoMA

Moves to Spoleto, Italy, where he remains for most of the decade

Plans retrospective using high-saturation colours (influenced by years in Italy); executed over 6 months by 65 people; to be exhibited for 25 years beginning 2008

Dies 8 April, New York

1978 · 1980 · · · · · · | · · · · 1990 · · · · · | · · · · 2000 · · · 2004 · | · · 2007

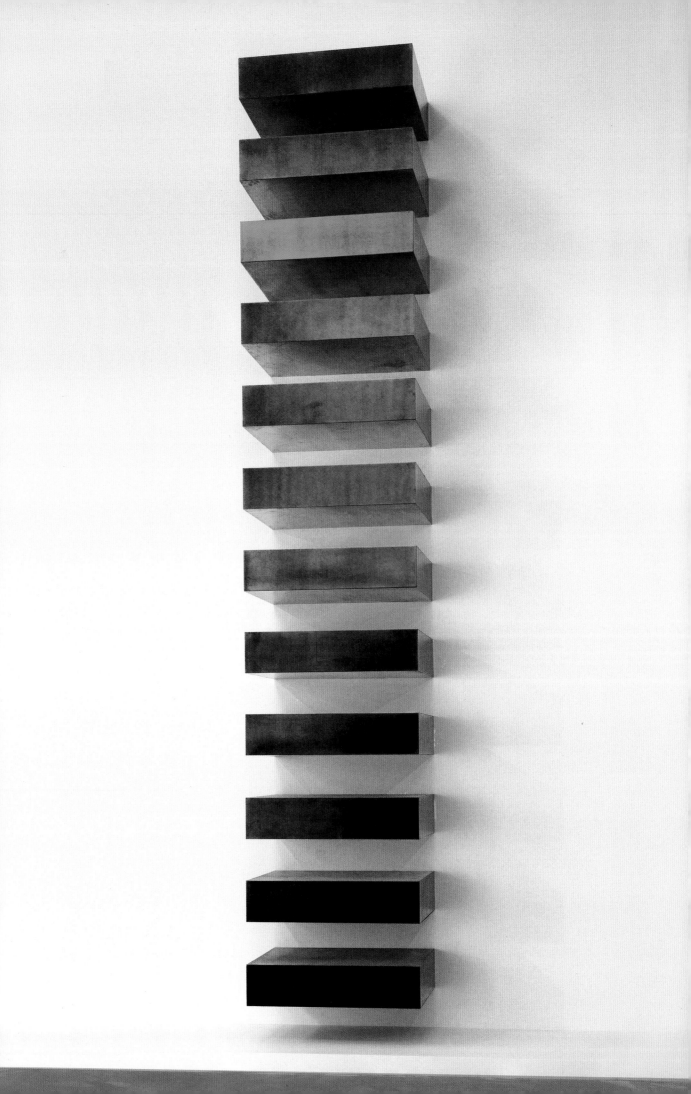

'If someone says his work is art, it's art.'

Donald Judd

1928–1994

UNITED STATES

Donald Judd despaired over the critical practice of grouping artists into trends and movements. 'Very few artists receive attention without publicity as a new group,' he said. 'It's another case of the simplicity of criticism and of the public.' He, himself, had first been recognized as an artist associated with a trend critics came to call Minimal Art. It was a label he objected to vehemently at every opportunity. The situation did not improve even after he was well established. 'Recently I've objected a lot to being pushed into the little category of "geometric abstraction",' he told an interviewer, 'it's worse than "Minimal Art".' Placing work in a category diminished it, Judd felt, obscuring what was new and discouraging attention to the unique qualities of specific objects.

Judd was well qualified to criticize critics: after studying philosophy, studio art and art history, he supported himself by writing criticism for various art journals, focusing especially on contemporary art. During these years, he stopped painting and turned to making objects. The first were made of wood, painted with 'cadmium red light' so their contours and angles could be seen with clarity, and set directly on the floor. 'I was surprised . . . to have something set out into the middle of the room. It puzzled me,' Judd recalled. 'On the one hand, I didn't quite know what to make of it, and, on the other, they suddenly seemed to have an enormous number of possibilities.'

Within a few years, Judd had developed the vocabulary he would employ for the rest of his career. Its fundamental unit was the box, a simple geometric form. At first Judd built the boxes out of wood, but he soon began to have them industrially manufactured from metal. 'I wanted a thinner, more shell-like surface, so that the volume inside would be clear,' he said. Often, the boxes included translucent, coloured Perspex® components.

Larger boxes were set on the floor or attached to the wall, either singly or in rows. Shallow boxes projected from the wall in a stack at intervals equal to their height. All were symmetrical forms, ordered symmetrically – the most obvious way, Judd said, to avoid traditional composition, in which variously weighted parts were brought into visual balance. The only asymmetrical forms Judd allowed himself were horizontal wall pieces based on extruded aluminium tubes, with masses and voids governed by simple mathematical progressions.

Clarity, wholeness and local order tempered by chance were the qualities Judd valued. 'A work needs only to be interesting,' he wrote. 'It isn't necessary for a work to have a lot of things to look at, to compare, to analyze one by one, to contemplate. The thing as a whole, its quality as a whole, is what is interesting.'

Opposite *Untitled* (*Stack*), 1967. Lacquer on galvanized iron, 12 units installed vertically with 22.8-cm (9-in) intervals, each 22.8 × 101.6 × 78.7 cm (9 × 40 × 31 in). Museum of Modern Art, New York. Helen Achen Bequest (by exchange) and gift of Joseph Helman. Acc.

Above Portrait of Donald Judd by Fred W. McDarrah, 1966.

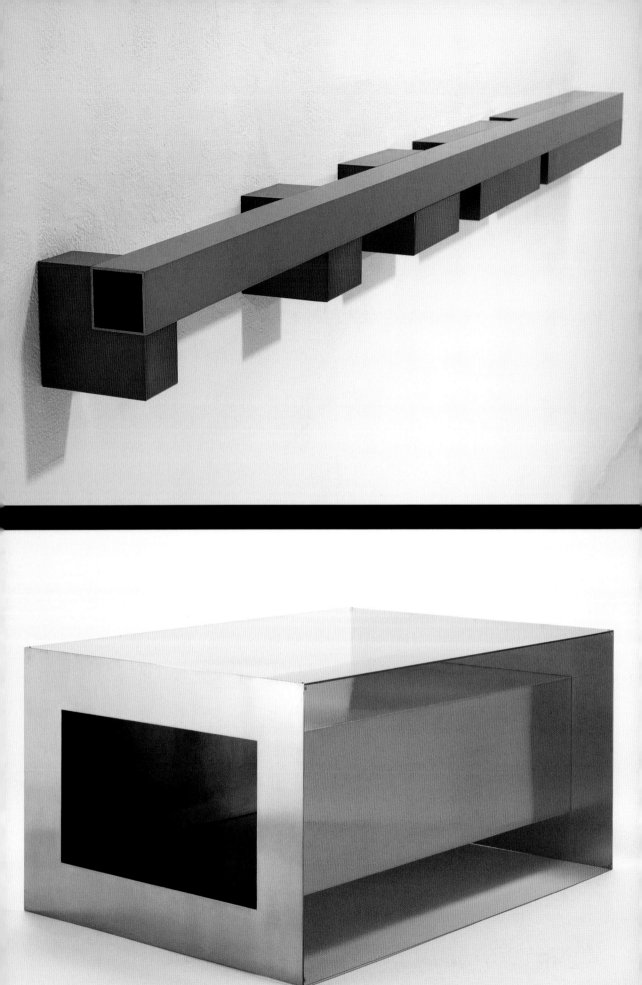

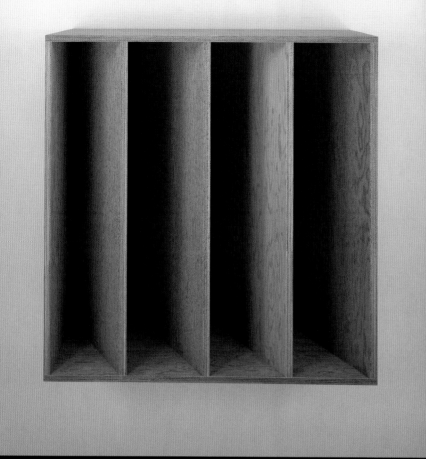

Opposite above *Untitled*, 1987. Purple and red anodized aluminium, 15.2 × 279.4 × 15.2 cm (6 × 110 × 6 in). Courtesy Pace Gallery, New York.

Opposite below *Untitled* (*DSS 145*), 1968. Stainless steel and yellow acrylic, 83.2 × 171.5 × 121.92 cm (32¾ × 67½ × 48 in). Art Institute of Chicago. Gift of the Society for Contemporary Art, 1969.243.

Above *Untitled*, 1989. Plywood and brown Perspex®, 100 × 100 × 502 cm (39⅜ × 39⅜ × 19⅝ in). Courtesy Pace Gallery, New York.

Donald Judd

1920

1928 — Born 3 June, Excelsior Springs

1930

1940

1948 — Studies at the Art Student League of New York

1950

1953 — Completes degree course in philosophy

1959 — Earns living writing art criticism for leading magazines while studying art history; abandons painting for sculpture

1960

1963 — Solo exhibition reveals what becomes a lifelong interest in Minimalist progressions

1965 — Publishes manifesto-like essay 'Specific Objects'; uses machine-fabricated components, challenging the importance of originality and craftsmanship

1970

1971 — Moves to Texas; works at larger scale, gradually creating an open-air museum of permanent installations

1980

1990

1994 — Dies 12 February, New York

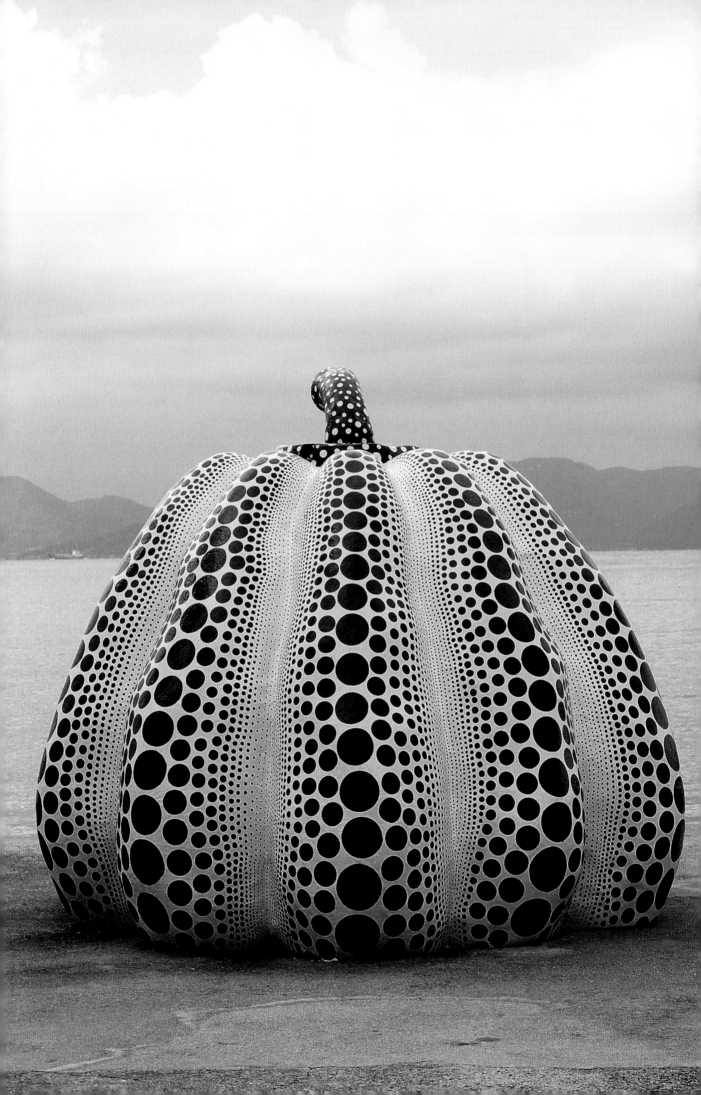

'Our earth is only one polka dot among a million stars in the cosmos.'

Yayoi Kusama

b. 1929

JAPAN

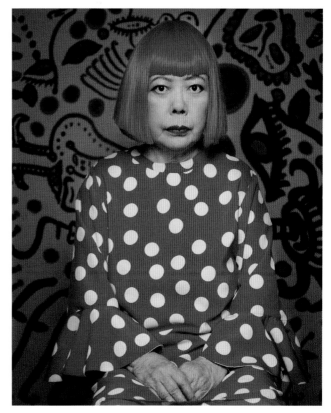

'My art originates from hallucinations only I can see,' Yayoi Kusama told an interviewer. 'I translate the hallucinations and obsessional images that plague me into sculptures and paintings.' Since childhood, Kusama has been prone to obsessive–compulsive behaviour and visited by hallucinations in which small motifs – a bunch of violets, a flower pattern on a tablecloth – multiply uncontrollably until they cover every visible surface. At the age of 10 she was terrified she would dissolve into the infinity of a wildly proliferating pattern. 'It was then that I learned the idea of self-obliteration,' she says. The themes and imagery of Kusama's art have their roots in her illness. The art itself, though, is the product of discipline, will and ambition.

Kusama studied traditional Japanese painting techniques but soon began to experiment with abstraction, producing works on paper at a dizzying rate. After exhibiting successfully in Japan, she set her sights on New York, arriving in 1958. 'At the time, New York was inhabited by some three thousand adherents of Action Painting,' she recalls. 'I paid no attention to them, because it was no use doing the same thing.' What she did pay attention to was the scale on which they worked. Abandoning paper for canvas and watercolour for oil paint, she set about creating her calling-card, a series of enormous monochrome paintings called *Infinity Nets*. 'They were about an obsession: infinite repetition,' she said.

Made of small, looped brush strokes, like crochet stitches in an endless textile, *Infinity Nets* became an instantly recognizable Kusama motif and she continues to paint them. Other ongoing projects were initiated soon afterwards. In *Accumulations*, Kusama covered furniture, shoes, a ladder and even a rowing-boat with stuffed fabric protuberances that were unmistakably phallic. Her first *Infinity Mirrored Room* soon followed, the floor bristling with stuffed fabric phalli printed with red polka dots. Polka dots became Kusama's favoured way of obliterating not only herself but other selves as she largely abandoned making art for galleries in favour of staging happenings in her studio or in public, in which she painted polka dots on the bodies of naked participants. 'Polka dots are a way to infinity,' she proclaimed. 'When we obliterate nature and our bodies with polka dots, we become part of the unity of our environment.'

Kusama returned to Japan in 1973 and four years later took up residence in a psychiatric institution. She works ceaselessly in a nearby studio, making *Infinity Nets* and other paintings, *Infinity Mirror Rooms*, stuffed fabric *Accumulations* and large sculptures of pumpkins and riotously coloured flowers covered in polka dots. Since her first important museum retrospective in 1989, her fame has skyrocketed. 'My fame is the strongest manifestation of my will,' she said. 'I want to impose my will on everything around me. That is why it is satisfying to cover everything with my polka dots.'

Opposite Pumpkin, 1994. Installation at Benesse Art Site Naoshima, Kagawa. Collection of Benesse Art Site Naoshima, Kagawa. Courtesy KUSAMA Enterprise, Ota Fine Arts, Tokyo/Singapore and Victoria Miro, London. © Yayoi Kusama.

Above Portrait of Yayoi Kusama, 2012. Courtesy KUSAMA Enterprise, Ota Fine Arts, Tokyo/Singapore and Victoria Miro, London. © Yayoi Kusama.

Right *Aftermath of Obliteration of Eternity*, 2009. Wood, mirror, plastic, acrylic, LED and aluminium, 415 × 415 × 287.4 cm (163²⁵⁄₆₄ × 163²⁵⁄₆₄ × 113⁵⁄₃₂ in). Installation view at Padiglione d'Arte Contemporanea, Milan, 2010. Courtesy KUSAMA Enterprise, Ota Fine Arts, Tokyo/ Singapore and Victoria Miro, London. © Yayoi Kusama.

Below *Accumulation*, c. 1963. Sewn and stuffed fabric, wooden chair frame, paint, 90.2 × 97.8 × 88.9 cm (35 × 38 × 35 in). Whitney Museum of American Art, New York. Purchase 2001.342. © Yayoi Kusama.

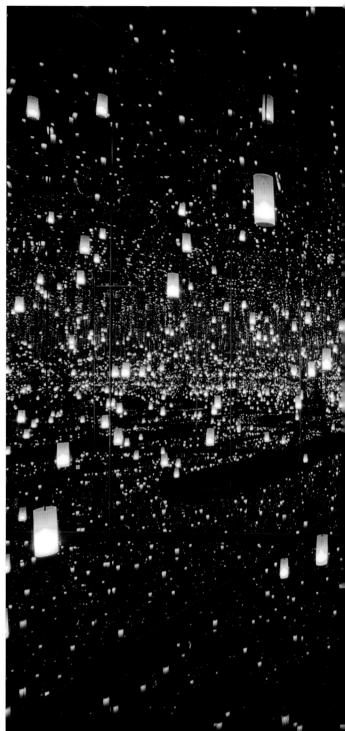

Yayoi Kusama

Born 22 March, Matsumoto City

Begins to study Nihonga painting but soon abandons it as childhood hallucinations drive obsessive paintings of polka dots and Infinity Nets

First solo show, Japan

Moves to New York and establishes herself as part of the avant garde, creating high-publicity happenings, installations and phallic Accumulations

Begins signature dot-patterned fashion line

1929 1930 1940 1948 1950 1952 1957 1960 1968 1970

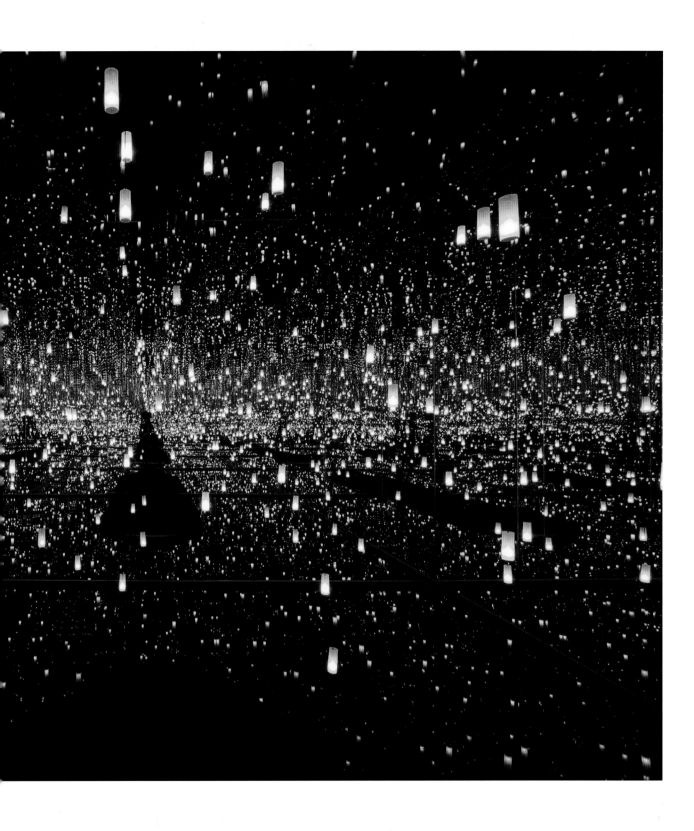

Returns to Japan

Begins permanent voluntary
residence in psychiatric hospital

Represents Japan at
the Venice Biennale

Travelling
retrospective
visiting Madrid,
Paris, London and
New York is well
received

1973 · | · 1977 · | · 1980 · · · · · | · · · · 1990 · 1993 · | · · 2000 · · · | · · · 2010 2011

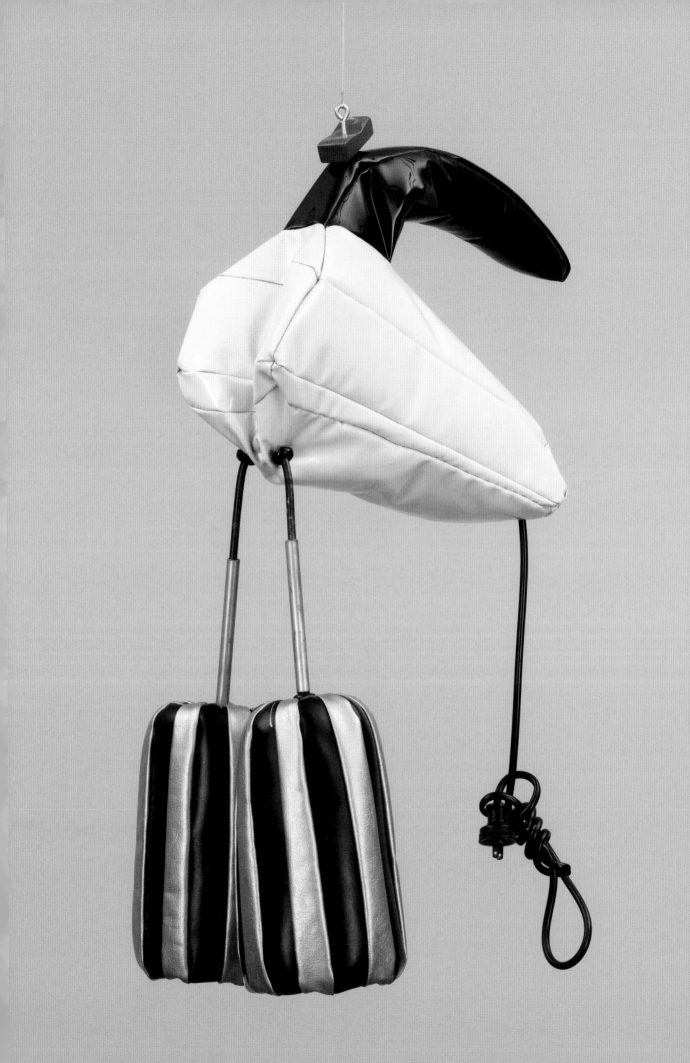

'By making ordinarily hard surfaces soft I had arrived at another kind of sculpture.'

Claes Oldenburg and Coosje van Bruggen

Claes Oldenburg b. 1929

Coosje van Bruggen 1942–2009

SWEDEN/UNITED STATES (OLDENBURG)
NETHERLANDS/UNITED STATES (VAN BRUGGEN)

Claes Oldenburg and Coosje van Bruggen's sculptures and drawings celebrate the objects of everyday life. Mass-produced consumer goods, advertising and cast-off objects found on the street are the stimuli for an imagination that embraces, as Oldenburg has said, 'an art that grows up not knowing it is art at all, an art given the chance of having a starting-point of zero'.

Associated with American Pop Art, Oldenburg began as a figurative painter in the mid-1950s. He soon fell in with a group of artists staging happenings, in which he performed and for which he constructed the scenery and props from urban junk and ready-made materials. 'My procedure was simply to find something that meant something to me, but the logic of my self-development was to gradually find myself in my surroundings.'

Food quickly emerged as a recurrent theme. He explored its qualities, whether luscious, sweet or loathsome, as with the oversized *Two Cheeseburgers, with Everything* (*Dual Hamburgers*), in which the 'everything' is built up of layers of brightly coloured plaster, their jagged edges dripping with paint. Elsewhere he remarks, 'There is a whole series in which the sculpture was done by an unseen set of teeth. I am thinking of eating as a sculptural activity like carving. It's like when you are eating an apple: you examine it and you say, "My God, that's rather nice".'

Many of Oldenburg's works begin as drawings and magazine-clippings of objects that catch his eye. They then undergo what Oldenburg calls formal metamorphosis, through free association of images combined with changes in materials, scale, texture and the inversion of their inherent properties. 'I discovered that by making ordinarily hard surfaces soft I had arrived at another kind of sculpture and a range of new symbols.' Thus, an ordinary household fan transformed into a limp, foam-rubber-filled *Giant Soft Fan* emphasized malleability itself as a sculptural element. A commonplace clothes-peg becomes a 45-foot-tall monument; or working tools – hammer, pliers, screwdriver – are rendered iconic by virtue of their enlargement to gargantuan proportions. The 'poetry of scale', as Oldenburg characterizes it.

These monumental works, now marking urban-scapes worldwide, were created in collaboration with his wife, the art historian Coosje van Bruggen. She described their partnership as 'a game of ping-pong, to and fro, towards its ultimate crystallization, first into a sketch and then into a three-dimensional study or a model, a process of using the senses rather than analysis'.

Opposite Claes Oldenburg, *Soft Dormeyer Mixer*, 1965. Vinyl, kapok wood, aluminium tubing, electric cord and rubber, 79.7 × 51.1 × 30.5 cm (3⅜ × 20⅛ × 12 in). Whitney Museum of American Art, New York, 66.55. © 1965 Claes Oldenburg.

Above Portrait of Claes Oldenburg and Coosje van Bruggen (with *Standing Collar with Bow Tie*) by Jesse Frohman, 1992.

Above Claes Oldenburg, *Two Cheeseburgers,
with Everything* (*Dual Hamburgers*), 1962.
Burlap soaked in plaster, painted with enamel,
17.8 × 37.5 × 21.8 cm (7 × 14¾ × 8⅝ in).
Museum of Modern Art, New York. Philip
Johnson Fund, 1962. © 1962 Claes Oldenburg.

Opposite Claes Oldenburg and Coosje van
Bruggen, *Balancing Tools*, 1984. Steel painted
with polyurethane enamel, 800 × 900 × 610 cm
(315 × 354 × 200 in). Collection Vitra
International AG, Weil am Rhein. © 1984
Claes Oldenburg and Coosje van Bruggen.

Claes Oldenburg and Coosje van Bruggen

Oldenburg born 28 January,
Stockholm

van Bruggen
born 6 June,
Groningen

1900 1910 1920 1929 1930 1940 1942

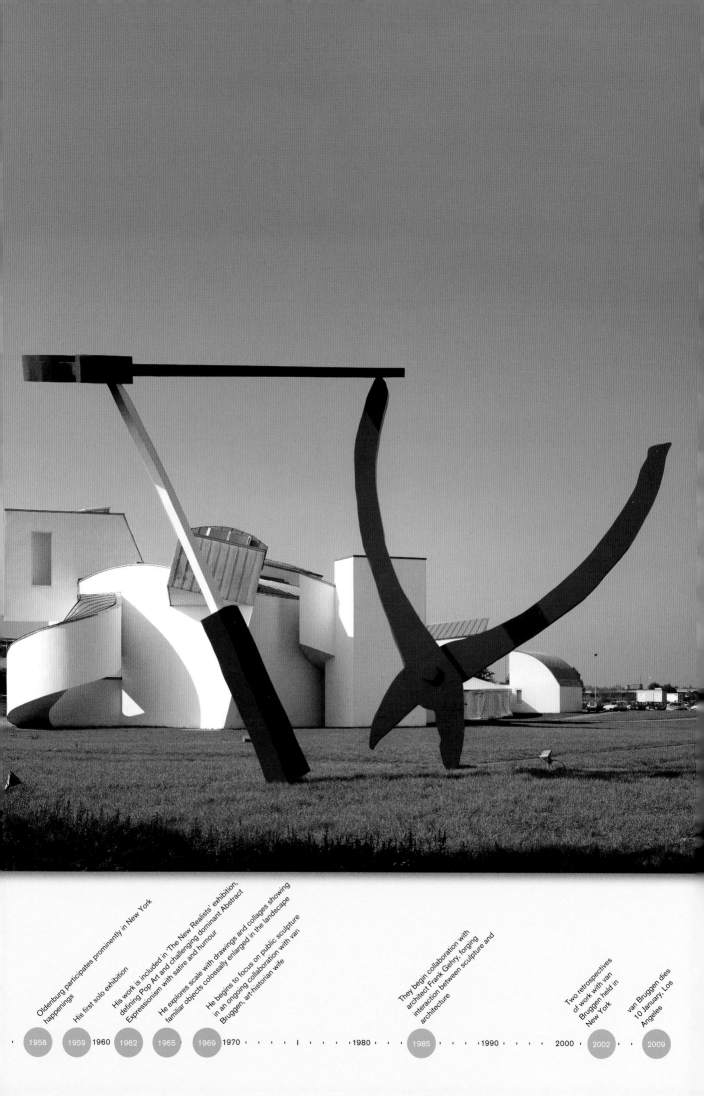

Oldenburg participates prominently in New York happenings

His first solo exhibition

His work is included in 'The New Realists' exhibition, defining Pop Art and challenging dominant Abstract Expressionism with satire and humour

He explores scale with drawings and collages showing familiar objects colossally enlarged in the landscape

He begins to focus on public sculpture in an ongoing collaboration with van Bruggen, art-historian wife

They begin collaboration with architect Frank Gehry, forging interaction between sculpture and architecture

Two retrospectives of work with van Bruggen held in New York

van Bruggen dies 10 January, Los Angeles

1956 1959 1960 1962 1965 1969 1970 · · · · · · · ·1980· · · 1985 · · · · ·1990· · · · 2000 · 2002 · · 2009

'Every work suggests that there is still another work to be done.'

Jasper Johns

b. 1930

UNITED STATES

Jasper Johns may be the only contemporary artist whose big idea came to him while he was asleep. 'I was trying to become a painter and I had been working in various styles.' he recalled. 'One night I dreamed that I'd painted a flag of the United States of America . . .' The next day he bought a flag and set to work. With clearly defined areas that could be measured and transferred to canvas, the flag took the responsibility for the painting's design out of his hands, leaving him free to concentrate on other things. 'The paintings that followed immediately, which were paintings of targets and numbers, gave me the same opportunity to feel removed from the work, neutral towards it, involved in the making but not involved in the judging of it,' he said.

Flags, targets and stencilled numbers were 'things the mind already knows', Johns pointed out. 'They seemed to me pre-formed, conventional, depersonalized, factual, exterior elements.' Facts, and not feelings about facts, were what he was after in his art. The four partial faces he set on top of *Target with Four Faces* are life casts taken from a model who came to his studio. He covered a flashlight with a thin layer of aluminium paste to make a sculpture of a flashlight. He had a coffee can full of paint brushes cast in bronze, then painted the bronze to look like the original. 'I like that there is the possibility that one might take the one for the other,' he said, 'but I also like that, with just a little examination, it's very clear that one is not the other.'

Johns treated his motifs one way and then another until he felt he had exhausted their possibilities. 'Take an object. Do something to it. Do something else to it,' he wrote in his notebooks. One of the most fertile motifs was a crosshatch pattern he saw painted on a passing car. 'It had all the qualities that interest me,' he said, 'literalness, repetitiveness, an obsessive quality,

order with dumbness and the possibility of complete lack of meaning.' The motif occupied him exclusively for a decade, culminating in such works as *Between the Clock and the Bed*.

Once they were finished, Johns's own paintings became useful to him as facts in the world. The simplest way to begin a drawing or a print was to base it on a painting. Sometimes he portrayed his work more literally, as in the four paintings that comprise *The Seasons*. 'Every work suggests that there is still another work to be done,' he said. 'No matter how large-minded you are, at the end of it you see that you have to start another painting. Often there's frustration because there's so much to be done, and the process seems so slow.'

Opposite *Target with Four Faces*, 1955. Encaustic on newspaper and cloth over canvas surmounted by four tinted-plaster faces in wood box with hinged front, 85.3 × 66 × 7.6 cm (33⅝ × 26 × 3 in). Museum of Modern Art, New York. Gift of Mr Robert C. Sculla. 8.1958.

Above Portrait of Jasper Johns by Bob Adelman, 1965.

Above *Between the Clock and the Bed*, 1981. Encaustic on canvas, 3 panels, 183.2 × 321.3 cm (72⅛ × 126⅜ in). Museum of Modern Art, New York. Gift of Agnes Gund. 104.1982.a-c.

Opposite *Device*, 1961–62. Oil on canvas with wood and metal attachments, 183 × 123.8 × 11.4 cm (72¹/₁₆ × 48¾ × 4½ in). Dallas Museum of Art, gift of The Art Museum League, Margaret J. and George V. Charlton, Mr and Mrs James B. Francis, Dr and Mrs Ralph Greenlee, Jr, Mr and Mrs James H. W. Jacks, Mr and Mrs Irvin L. Levy, Mrs John W. O'Boyle and Dr Joanne Stroud in honour of Mrs Eugene McDermott. 1976.1.

Jasper Johns

Born 15 May, Augusta

Moves to New York; associates closely with neighbour Robert Rauschenberg. Together, differently, they reintroduce representational painting

Completes his dream-inspired painting of the American flag; presaging Pop Art, he explores everyday icons viewed but not really seen

First solo exhibition wins fame and wealth

Begins print-making; becomes one of the greatest practitioners ever

1930 · · · | · · · ·1940 · · · | · · · · · · 1950 · · 1954 1955 1958 1960 · · · · |

Abandons neutralized subjects for
more personal, self-referential work

Receives Medal
of Freedom from
President Obama

70 · · · · · | · · · · 1980 · · · · · | · · · · · 1990 · · · · · | · · · · · 2000 · · · · · | · · · · · 2010 2011

'Traditional art is practically dead.'

Gerhard Richter

b. 1932

GERMANY

Visitors to an exhibition of Gerhard Richter's paintings may be forgiven for thinking that they must be seeing the work of more than one artist, so varied and seemingly contradictory are the styles and approaches he has pursued. Critics have interpreted his work as constituting a systematic and even cynical dismantling of twentieth-century painting styles, exposing their essential hollowness, but Richter insists that he is utterly sincere. 'I see no cynicism or trickery or guile in any of this,' he said to an interviewer. 'On the contrary, it all seems rather amateurish to me, the head-on way I've tackled everything and how simple it is to read off what I had in mind and what I was trying to do.'

Born the year before Hitler came to power, Richter experienced the Nazi regime through the war years followed by Communist rule in East Germany, where he trained as a mural painter in the officially approved Socialist Realist style. In 1961, he managed to slip into West Germany a few months before the Berlin Wall was erected. Wary of ideologies, Richter sought a neutral artistic stance, free from style. He found what he called his 'first escape hatch' by painting from black-and-white photographs – amateur snapshots, images clipped from newspapers and magazines, and childhood photographs of his own family – blurring the painted images to distance them and 'to make everything equally important and equally unimportant'.

Richter's involvement with black-and-white photography lessened after a decade, but he reached back to it for *October 18, 1977*, a series of 15 paintings based on photographs surrounding the arrest and death of three members of the Red Army Faction, a domestic German terrorist organization. 'The deaths of the terrorists, and the related events both before and after, stand for a horror that distressed me and has haunted me as unfinished business ever since, despite all my efforts to suppress it,' he wrote. The paintings 'are the almost forlorn attempt to give shape to feelings of compassion, grief and horror'.

Early on during his engagement with photographs, Richter began simultaneously making abstract paintings, which came to dominate his output. Hard-edge colour-chart paintings were followed by grey monochrome paintings, soft-focus paintings based on photographs of details of an abstract painting, gestural abstract paintings in shrill colours he described as embodying 'a kind of tense cheeriness' and paintings made by smearing successive layers of paint with a squeegee. All the while, he continued to make a smaller number of characteristically blurred paintings from photographs – most often colour photographs he had taken himself.

Richter situates himself at the end of the culture of painting, which has been supplanted by film and technology. 'Traditional art is practically dead,' he has said, 'by which I mean this huge, complicated entity – with all its wonderful aesthetic and moral aspirations – that used to be called art.'

Above Portrait of Gerhard Richter by Chris Felver, 1989.

Opposite *Betty*, 1988. Oil on canvas, 102 × 72 cm (40⅛ × 28⅓ in). Saint Louis Art Museum.

Gerhard Richter

Born 9 February, Dresden

Escapes East Germany for greater artistic freedom and begins lifelong extreme stylistic diversity

Exhibits ongoing encyclopaedic Atlas of work

Embraces brightly coloured abstraction, stroke paintings

1932 · | · · · 1940 · · | · · · 1950 · · · | · · · 1960 1961 · · | · · · 1970 · 1972 · | 1976 · · · ·

Opposite *Confrontation 1*, from *October 18, 1977*, 1988. Oil on canvas, 112 × 102 cm (44⅛ × 40⅛ in). Museum of Modern Art, New York. The Sidney and Harriet Janis Collection, gift of Philip Johnson, and acquired through the Lillie P. Bliss Bequest (all by exchange); Enid A. Haupt Fund; Nina and Gordon Bunshaft Bequest Fund; and gift of Emily Rauh Pulitzer. 169.1995.d.

Above *256 Colours*, 1974. Oil on canvas, 222 x 414 cm (87⅖ x 163 in). Kunstmuseum, Bonn.

Starts to use a squeegee on his canvases, a style he continued to develop over succeeding years

First major retrospective

Produces scientific phenomena-based works

Starts to command record-breaking prices for a living artist at auction

1985 1986 1990 2000 2001

'High tech is not a panacea.
It is just a local anaesthetic.'

Nam June Paik

1932–2006

KOREA/UNITED STATES

Prominent among the first-generation video artists who emerged after the advent of low-cost video equipment in 1965, Nam June Paik was possessed of a distinct sensibility, one which merged East and West with a playful provocativeness that masked the essential seriousness of his work. In positing the continuity between video and traditional art, he quipped, 'We are moving in TV away from high-fidelity pictures to low-fidelity, the same as in painting. From Giotto to Rembrandt the aim was fidelity to nature. Monet changed all that. I am doing the same.'

Having trained in musical composition in Japan, and with roots in both Buddhism and Western philosophy, Paik moved to Germany in 1958 to study electronic music. There he encountered John Cage, whose aesthetics of indeterminacy became a source of inspiration for Paik and other Fluxus artists (an informal grouping of international avant-garde artists). He first made his mark through exuberant 'antimusic' concerts in which he smashed pianos, jumped from the stage or threw beans into the audience while playing sound collages that mixed popular and classical music with news announcements and noises. He extended this collage approach of 'variability as a necessary consequence of intensity' to his visual work when he began tinkering with TV sets to produce abstract images on monitors tuned to live-broadcast television. These 'modified TV sets', which were first presented at the 'Exposition of Music – Electronic Television' in Wupperthal, West Germany, marked Paik's first public engagement with television.

Relocating to New York in 1964, Paik soon began producing videotapes using a video synthesizer he had developed with engineer Shuya Abe for colourizing, manipulating and distorting recorded and live video.

The tapes, characterized by staccato editing, quirky soundtracks and kaleidoscopic imagery sourced from original and off-air footage, were subsequently reworked for installations, sculptures and legendary cybernetic remote-controlled robots assembled from an aggregation of TV sets.

Paik's works often manifested his early musical involvement. In *TV Bra*, mini-monitors rigged over cellist Charlotte Moorman's breasts showed images modulated by the sound of her cello. *TV Bra* was criticized as fetishizing the female body, but with typical tongue-in-cheek humour Paik claimed it stimulated viewers 'to look for the new imaginative and humanistic ways of using our technology'.

Paik's work grew from small-scale, closed-circuit camera environments such as *TV Buddha* – an antique Buddha contemplating a video image of his own reflection – to such large-scale installations as *Electronic Superhighway*, a 336-screen work in the form of a map of the United States. The flickering images and audio clips, based on each state's cultural specificities, suggest a media map of the country. His later works included live international satellite–video events.

With roots in Asia, Europe and the United States, Paik implicitly believed that global media leads to the convergence of cultures. He warned however: 'High Tech is not a panacea. It is just a local anaesthetic. There will be many unforeseen problems ahead.'

Opposite Charlotte Moorman performing Nam June Paik's *Concerto for TV Cello and Videotapes,* 1971, at Galeria Bonino, New York. Photo: Peter Moore. © Barbara Moore/Licensed by VAGA, NY.

Above Portrait of Nam June Paik by Jack Mitchell, 1974.

Below *TV Buddha*, 1974. Video installation, closed-circuit, 18th-century Buddha statue, 160 × 215 × 80 cm (63 × 84⅔ × 31½ in). Stedelijk Museum, Amsterdam.

Right *Electronic Superhighway: Continental US, Alaska, Hawaii* (Contintental US only), 1995. Forty-seven-channel closed-circuit video installation with 313 monitors, neon, steel structure, colour and sound, approx. 457 × 975 × 120 cm (180 × 384 × 48 in). Smithsonian American Art Museum, Washington, DC.

Nam June Paik

Born 20 July, Seoul

Completes studies in classical piano; meets John Cage, who inspires him to explore electronics

Stages first television–video exhibition, magnetically altering broadcasts to liberate video from exclusive corporate control; joins Fluxus

Using a cutting-edge portable recorder, he becomes the first video artist to generate original content

1930 · 1932 · | · · 1940 · · | · · · 1950 · · · | · 1956 · · 1960 · 1963 · · 1965 · · · 1970 · · |

First retrospective, at the Kölnischer
Kunstverein, Cologne

Major retrospective at the
Whitney Museum of Art
confirms international celebrity

Erects a 1,003-monitor media tower
for Seoul's Olympic Games

Dies 29 January, Miami

1976 · 1980 · 1982 · 1988 1990 · 2000 · 2006

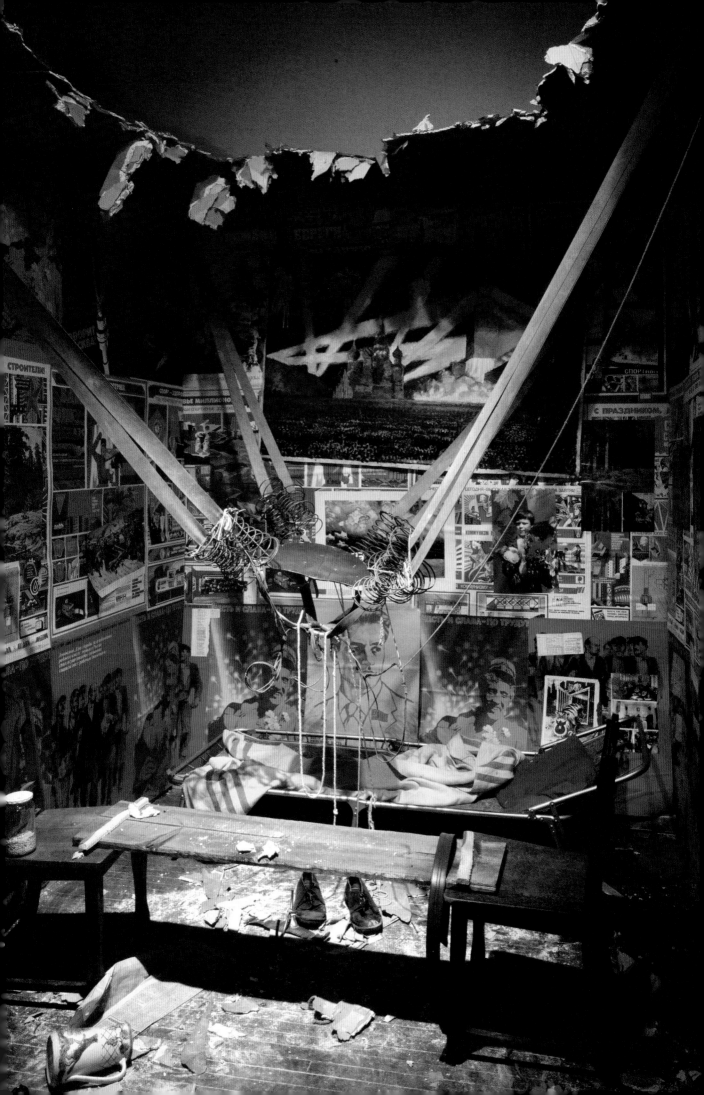

'Fear is the reason for making art. It is a means to freedom.'

Ilya and Emilia Kabakov

Ilya Kabakov b. 1933

Emilia Kabakov b. 1945

UKRAINE (SOVIET UNION)/UNITED STATES

'I see myself a little like a stray dog,' Ilya Kabakov told an interviewer. 'My mentality is Soviet; my birthplace is the Ukraine; my parents are Jewish; my school education and my language are Russian. My dream was to belong to European culture, a dream that was practically unattainable during most of my life.' The Kabakovs' art is rooted in their experience of life in the Soviet Union, a civilization that ceased to exist a few years after Ilya emigrated to the West in 1988 and began working with his future wife Emilia. The installations for which they have become famous grew from works Ilya created as an 'unofficial' artist in an oppressive system that seemed likely to endure for thousands of years. 'If someone had told us that the Soviet system would come to an end in 1989, we would have considered it to be complete delirium,' he said.

Kabakov's work as an 'unofficial' artist was underwritten by his official career as a children's book illustrator and member of the Union of Soviet Artists, which gave him the right to make drawings for himself and to work at home. Unofficial artists were tolerated to varying degrees during the decades following the death of Stalin in 1953, though they were forbidden to show their art publicly. 'In unofficial art there were no leaders,' Kabakov said, 'because everyone was under police observation; it was a very dangerous existence all the time.' Under these conditions, he created his influential *Ten Albums* – witty and ironic fables of failed, eccentric, marginalized lives told through drawings and texts.

After emigrating to the West in 1988, Kabakov's focus shifted from illustrated narratives to installations. He had already created several installations in his studio in Moscow, but now he developed what he called 'total' installations, in which a self-contained space – walls, ceilings, floor and lighting – was built within the confines of a gallery or museum and filled with objects, artefacts and texts. With total installations, the contexts of Kabakov's earlier life and art returned as shabby, unconvincing theatrical sets. The first large installation evoked the cramped, dimly lit interior of a communal apartment – that distinctive Soviet institution in which multiple families lived together, each family crowded into a single small room. Others recreated a public toilet that people had moved into, a leaking provincial museum full of mediocre paintings and an abandoned elementary school.

Conceived in collaboration with his wife, Emilia, Kabakov's installations have been called a 'museum to memory'. 'It is all about images and metaphors,' Kabakov says. 'It is never actually personal or real, it is always metaphorical. Whether it is documentation or fiction, it does not matter.' He places himself in the tradition of nineteenth-century writers such as Nikolai Gogol, Fyodor Dostoevsky and Anton Chekhov. 'This tradition deals with the constant destruction of utopia, which Russia constantly tries to build and constantly fails to achieve.'

Opposite *The Man Who Flew into Space from His Apartment*, 1985. Installation originally created in Moscow. Musée National d'Art Moderne, Centre Georges Pompidou, Paris.

Above Portrait of Ilya and Emilia Kabakov by Roman Mensing, 2002.

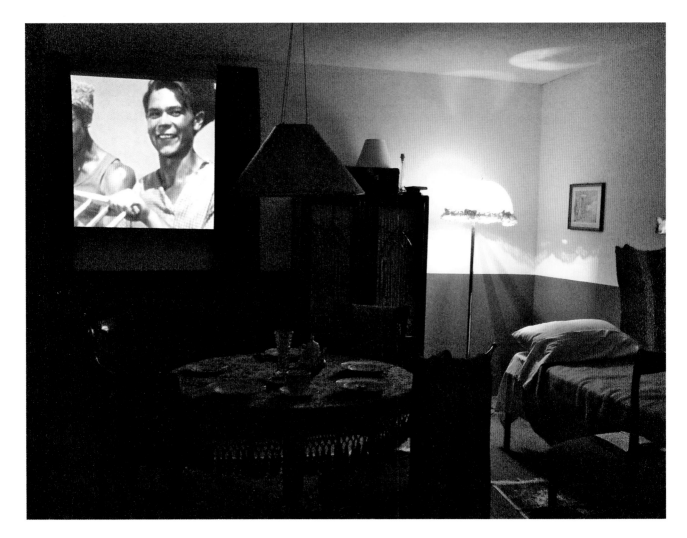

Above *The Happiest Man*, 2000.
Installation view at the Galerie Nationale
du Jeu de Paume, Paris.

Opposite *In the Closet* from *The Palace
of Projects,* 1998. Installation view at
the Armory Building, New York, 2000.
Courtesy of the Museum van
Hedendaagse Kunst, Antwerp.

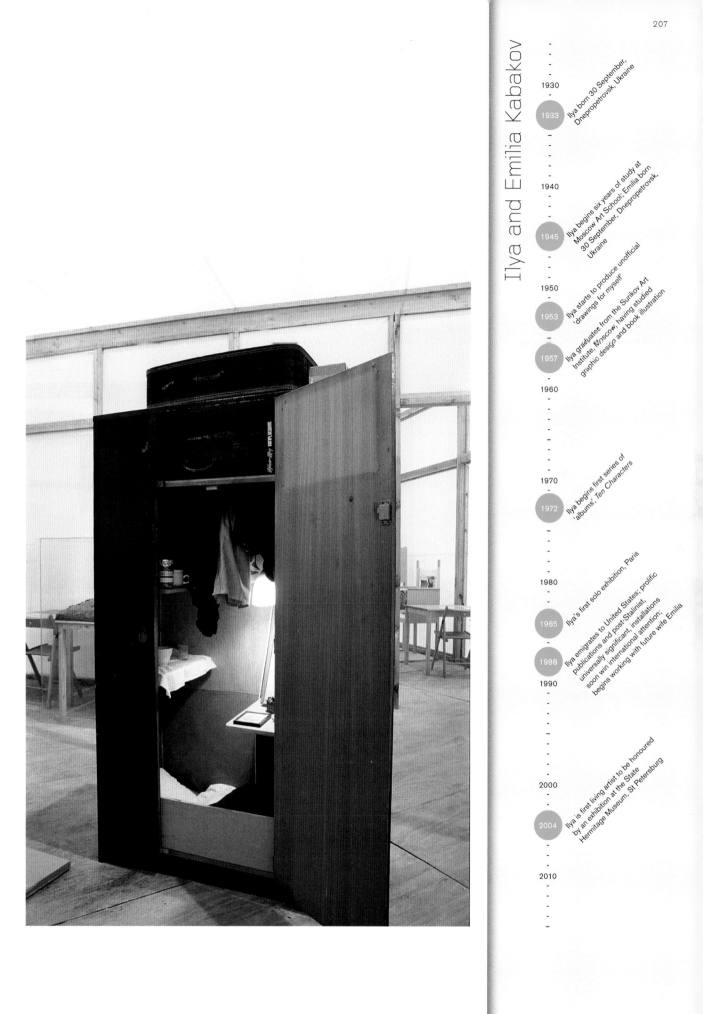

Ilya and Emilia Kabakov

1930

1933 · Ilya born 30 September, Dnepropetrovsk, Ukraine

1940

1945 · Ilya begins six years of study at Moscow Art School; Emilia born 30 September, Dnepropetrovsk, Ukraine

1950 · Ilya starts to produce unofficial 'drawings for myself'

1953 · Ilya graduates from the Surikov Art Institute, Moscow, having studied graphic design and book illustration

1957

1960

1970

1972 · Ilya begins first series of 'albums', *Ten Characters*

1980 · Ilya's first solo exhibition, Paris

1985 · Ilya emigrates to United States; prolific publications and post-Stalinist, universally significant installations soon win international attention;

1988 · begins working with future wife Emilia

1990

2000 · Ilya is first living artist to be honoured by an exhibition at the State Hermitage Museum, St Petersburg

2004

2010

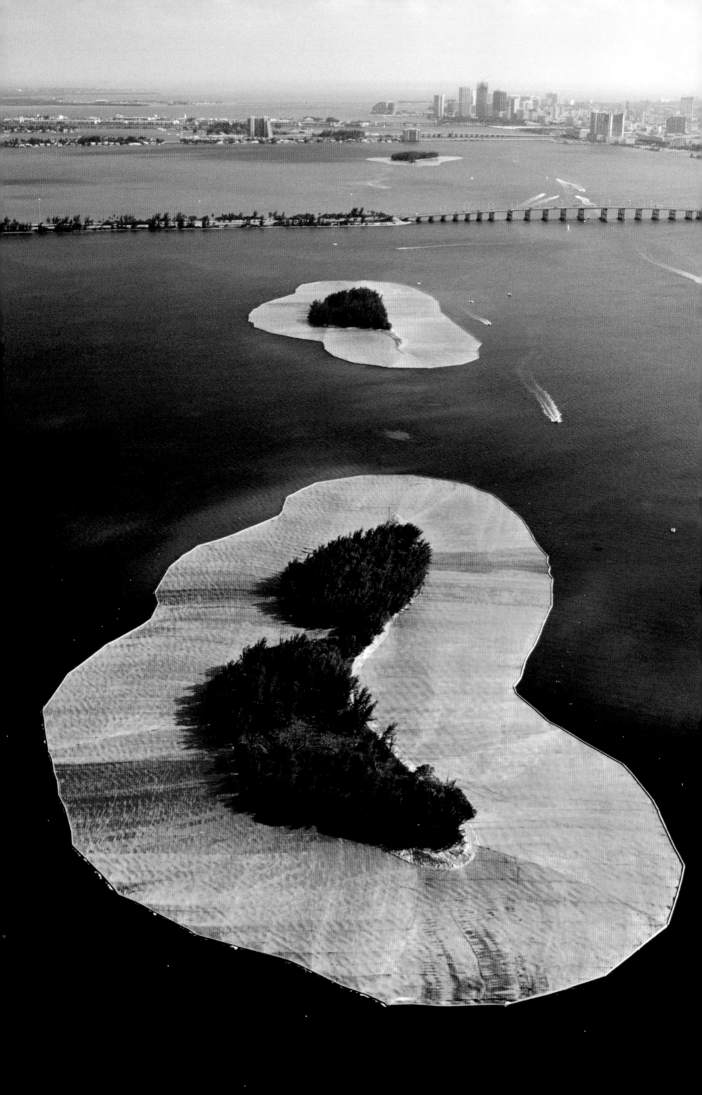

'Every work of art is like a scream of freedom.'

Christo and Jeanne-Claude

Christo b. 1935/Jeanne-Claude 1935–2009

BULGARIA/UNITED STATES (CHRISTO)
FRANCE/UNITED STATES (JEANNE-CLAUDE)

It is not just the work of Christo and Jeanne-Claude that fascinates and provokes, it is also the philosophy that dictates how they lived and thought. Born in separate countries, but on the same hour of the same day, the pair met in Paris where Christo was experimenting with his early wrapped objects. The couple soon started working together. Although many critics interpret their work as political and subversive, they always maintained the importance of its whimsical, Surrealist aspect. They repeatedly referred to it as 'irrational, irresponsible, useless', and said that they created 'work[s] of joy and beauty' that had 'no reason to be there except [as] potential poetical creativity, total creativity'.

Statements about aesthetics are issued despite, or perhaps because of, Christo's Bulgarian (Marxist) education and the overtly political subject of many of their works, for example *Wrapped Reichstag*, Berlin. This piece, begun during the Cold War, engendered such vociferous political opposition it took 24 years to realize. Projects such as these – often, like *Surrounded Islands*, produced on a massive scale – have sparked lengthy controversies, but they are also subtle, and dependant on a profound, otherworldly beauty. Christo and Jeanne-Claude described their pieces as creating 'gentle disturbances' – eliciting fine but perceptible shifts in our encounters with everyday sensations and experiences. For this reason, the location of the works was outside, in an inhabited environment where manipulations are felt and experienced. An example of this was *The Gates*, staged in New York's Central Park. The siting of the works was radical, not just in its desertion of the institution, but in the audience it engendered. The projects stimulated a conversation among people who did not usually engage in debates about art. In this sense, the work moved art outside its ivory tower and forced it to become a cultural and political phenomenon.

Despite the cost of their projects, Christo and Jean-Claude financed everything themselves, using bank loans and sales of preparatory sketches and early work. This, like everything else, was undertaken in the name of freedom. The artists did not want to be beholden to anyone. They also did not want the art itself to be beholden. It was essential that it was free and accessible: 'Nobody can own this project, nobody can buy this project, nobody can possess the project, or charge [for] tickets.' The temporary nature of the projects, which usually lasted between two and three weeks, ensured that no one could circumvent this stipulation. The works could not be possessed; they became unique experiences in the lives of those who visited them. This was perhaps the most extraordinary aspect of the work: its disregarding of art's claim to immortality. As Christo said, 'I think it takes much greater courage to create things to be gone than to create things that will remain.'

Opposite *Surrounded Islands*, 1980–83. Biscayne Bay, Greater Miami, Florida.

Above Christo and Jeanne-Claude, c. 2009.

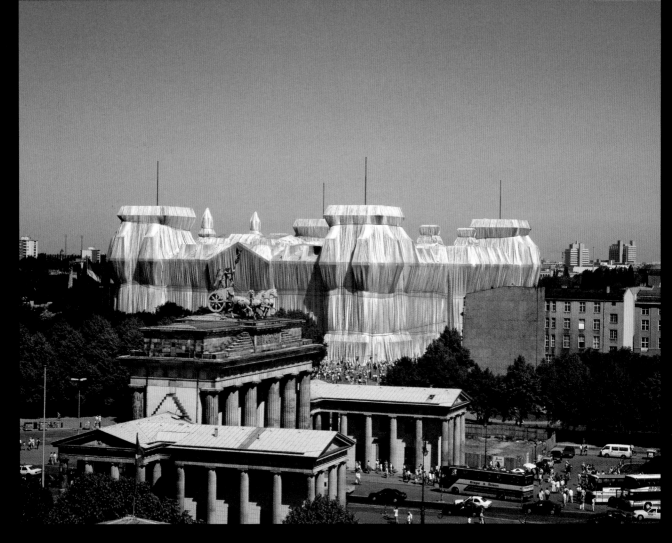

Above *Wrapped Reichstag*, 1971–95. Berlin.

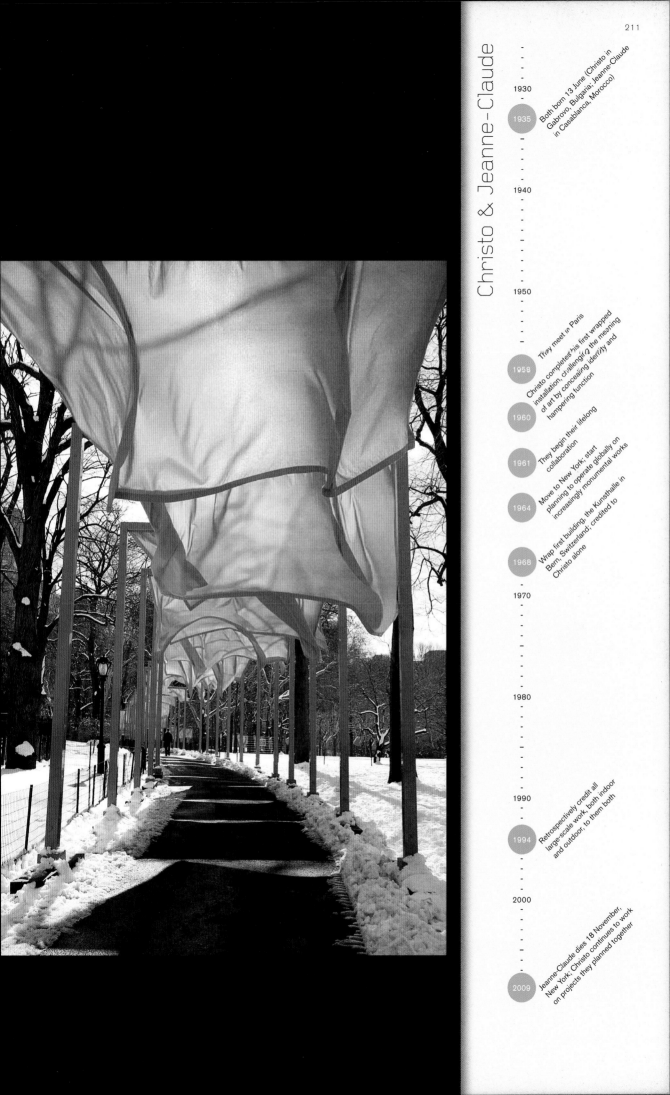

Christo & Jeanne-Claude

1930

1935 — Both born 13 June (Christo in Gabrovo, Bulgaria; Jeanne-Claude in Casablanca, Morocco)

1940

1950

1958 — They meet in Paris. Christo completes his first wrapped installation, challenging the meaning of art by concealing identity and hampering function

1960 — They begin their lifelong collaboration

1961 — Move to New York; start planning to operate globally on increasingly monumental works

1964 — Wrap first building, the Kunsthalle in Bern, Switzerland; credited to Christo alone

1968

1970

1980

1990

1994 — Retrospectively credit all large-scale work, both indoor and outdoor, to them both

2000

2009 — Jeanne-Claude dies 18 November, New York; Christo continues to work on projects they planned together

Untitled (*Seven Poles*), 1970. Aluminium, polyester, polyethylene, synthetic resin, 272 × 240 cm (107⅛ × 94½ in). Musée Nationale d'Art Moderne, Centre Georges Pompidou, Paris.

'I think art is a total thing.... It is an essence, a soul.'

Eva Hesse

1936–1970

UNITED STATES

Ludicrous. Ridiculous. And, especially, absurd. When Eva Hesse praised one of her own works, these were the words she reached for. 'It's the most ridiculous structure I have ever made,' she said of an early sculpture, 'and that is why it is really good.' Life, in Hesse's experience, was absurd and her art responded to it in kind.

A word she was wary of was 'beautiful'. Of a piece that eventually failed, she observed that, as she was working on it, 'it left the ugly zone and went to the beauty zone'. That was a problem. A work that was too beautiful, that had beauty imposed on it by the artist, risked being decorative: 'the only art sin', in her view. The materials she worked with – rope, string, fibreglass and latex – were beautiful enough on their own. Hesse thrilled to the way light streaming through a window in her studio interacted with the clear, thin fibreglass and translucent latex panels of *Contingent*, but she would not add to it or emphasize it.

Perfect was a word she rejected, as those who worked with her came to know. She initially tried to have *Repetition Nineteen* fabricated from a single drawing of a container shape. The result was 19 flawless, uniform units and she hated them. She returned with 19 individual moulds made from wire mesh and papier mâché, each one unique and imperfect and handmade, and had them cast in fibreglass. Imperfections are human, and viewers quickly sense that Hesse's works, in some mysterious, indirect way, are about the human body, the condition of having a body, the unedited experience of being skin and genitals, breasts and hands, neurons and intestines, of being vulnerable and impermanent and a little ridiculous. The repetition that characterizes many of her works only serves to exaggerate their fundamental absurdity.

Impermanence was a concept about which Hesse was ambivalent. She knew that the materials she used would not last. Latex would darken and grow brittle or liquefy, fibreglass would cloud over. She faced this dilemma stoically: 'Life doesn't last; art doesn't last. It doesn't matter.' Yet, at the same time, she admitted that she sometimes did want her work to endure, if only in a photograph.

Time went to work on Hesse's sculpture immediately and today we see them in old age, no longer flexible, brilliant with light, begging to be touched. It has been suggested that they be exhibited next to newly fabricated versions of themselves, so that viewers can see how dazzling they were in their youth. For now, we can only imagine.

Above Portrait of Eva Hesse by Hermann Landshoff, c. 1967.

Above *Accession II*, 1968. Galvanized steel and vinyl,
78.1 × 78.1 × 78.1 cm (30¾ × 30¾ × 30¾ in). Detroit
Institute of Arts. Courtesy of Hauser & Wirth © The
estate of Eva Hesse, Galerie Hauser & Wirth, Zürich.

Opposite above *Contingent*, 1969. Cheesecloth,
latex and fibreglass, overall 350 × 630 × 109 cm
(137¾ × 248¹⁄₃₂ × 42⅞ in). National Gallery of
Australia, Canberra. Purchased 1973.

Opposite below *Repetition Nineteen III*, 1969. Nineteen
tubular fibreglass units, height 48–51 cm × diameter
27.8–32.3 cm (height 19–20¼ × diameter 11–12¾ in).
Museum of Modern Art, New York. Gift of Charles and
Anita Blatt. 1004.1969.a-s.

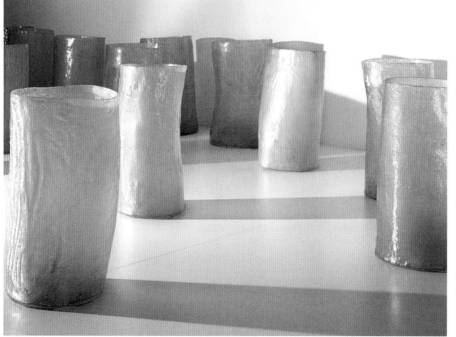

1936 Born 11 January, Hamburg

1938 Sent with her sister to Amsterdam to escape Nazi persecution. The family reunites and emigrates to New York the next year

1940

1950

1954 Begins art studies, later earning degrees at Cooper Union and Yale University

1960

1964 Travels to Germany for 15 months. Begins making sculpture

1968 First one-person show of sculpture

1969 Undergoes operations for brain tumour

1970 Dies 29 May, New York

'Nature is never finished.'

Robert Smithson

1938–1973

UNITED STATES

In 1966 Robert Smithson wrote *Entropy and the New Monument* and sealed his position as unofficial spokesman and ideologist for a generation of young artists that set out to challenge the increasingly institutionalized and self-satisfied American art scene. Over the next seven years, Smithson created some of the most radical works of the century and disseminated them through his writing, photographs and films.

Smithson's early career had coincided with American Pop Art, but as a mature artist he revealed an interest in the darker side of 1960s America, in the decaying industrial landscapes of 'urban sprawl and the infinite number of housing developments of the postwar boom'. Smithson employed the emerging language of Minimalism to engage with his new subject, about which he wrote prolifically. He referred to the decaying landscapes as 'entropic', and he viewed them as the negation of progress, as the rusting remains of civilization. During this period he came to believe that progress is a lie and that everything dissipates over time. He also began physically to go out and engage with landscape and use it in his artwork. The first of these works took the form of a travel 'photologue' called *The Monuments of Passaic*, depicting a series of ruins and wreckages. Inspired by this journey, Smithson took his work out of the gallery and into the land itself, working increasingly monumental and daring pieces into the fabric of the industrial environment. Works such as *Asphalt Rundown* have been described as 'entropy made visible'.

Smithson's engagement with the land did not preclude traditional, gallery-based work but it did mean he reconceptualized the possibilities of gallery-based sculpture. In 1968 he moved the landscape into the gallery with his *Non-Site* installation series, which presents geological artefacts alongside maps and photographs.

These works play with the idea of documentation and, as Smithson said, expose 'the gap between the reality of a site and its representation'. Representation also played a big part in Smithson's most famous Land Art projects, such as *Spiral Jetty*, since most people know these works through photographs or film. Smithson liked this, saying he was interested in how photography works 'as a vehicle for memory', and in how it 'arrests time, like the work does. It creates timelessness . . .'

This timelessness forms a part of Smithson's greater vision. Although his work deals with neglect and industrial wreckage, he has been described as a 'Transcendentalist' and a 'man of possibilities' because he united the romance of nature and science in a peculiarly liberated, American style. For Smithson, entropy did not only represent decay, but exposed the evolving relationship between man and the environment. For him, it was linked to renewal and transformation, as chaos is inextricably linked to order. He sought the equilibrium that exists somewhere between these opposites and he found it in this crumbling, artificial landscape, where he saw an aesthetic potential 'without cultural precedent'.

Above Portrait of Robert Smithson by Jack Robinson, 1969.

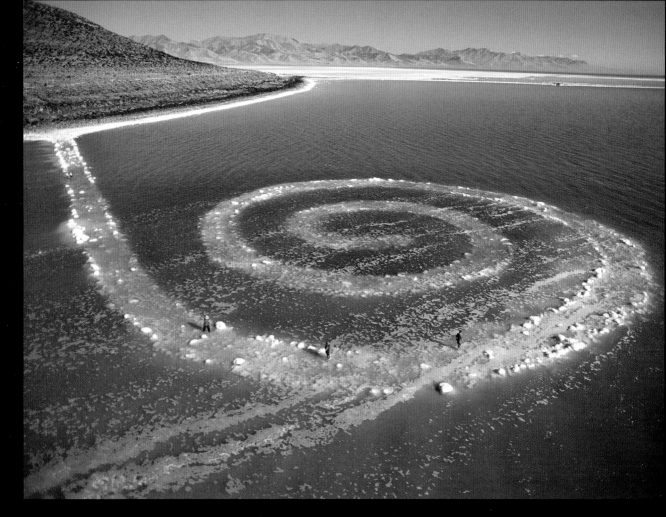

Spiral Jetty, 1970. Black rock, salt crystal
and earth, diameter 18.8 m (160 ft), coil
length 457.2 m (1, 500 ft), coil width
4.6 m (15 ft). Great Salt Lake, Utah. DIA
Center for the Arts, New York.

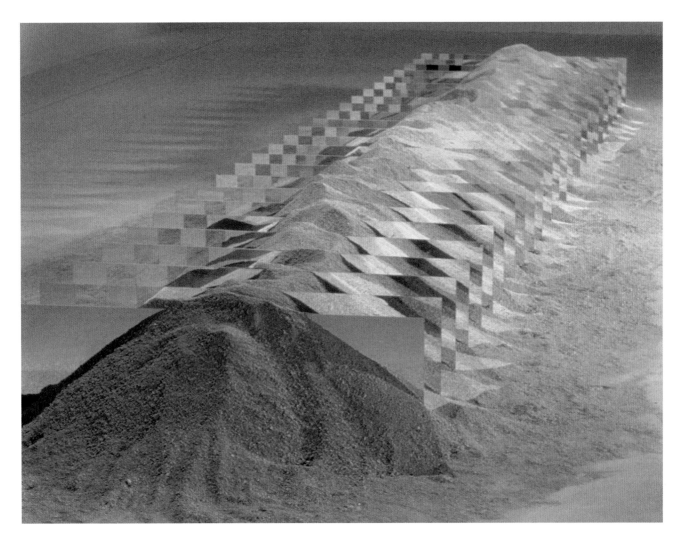

Above *Mirror and Shelly Sand*,
1970. Fifty mirrors, shells and sand,
731.5 × 853.4 cm (288 × 336 in).
Installation for the Museet for
Samtidkunst, Oslo. Collection of
the Dallas Museum of Art.

Opposite *Asphalt Rundown*, 1969.
Outside Rome.

Robert Smithson

Born 2 January, Passaic

Studies painting and drawing
at the Art Students League
of New York

1938 · 1940 · · · · · 1950 · · · · 1955 · ·

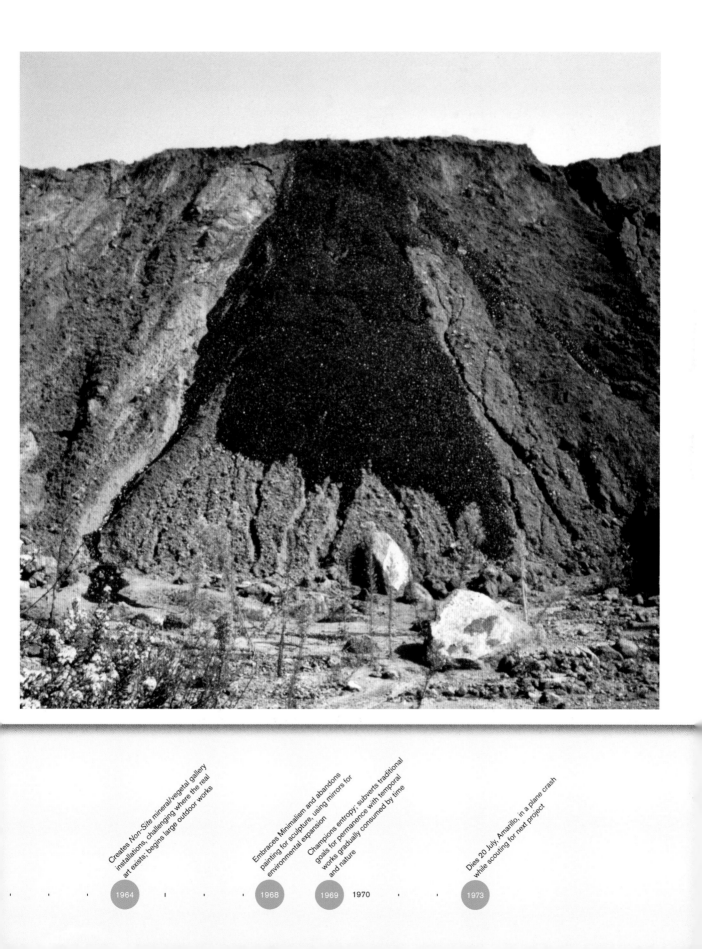

Creates *Non-Site* mineral/vegetal gallery
installations; challenging where the real
art exists; begins large outdoor works

Embraces Minimalism and abandons
painting for sculpture, using mirrors for
environmental expansion

Champions entropy; subverts traditional
goals for permanence with temporal
works gradually consumed by time
and nature

Dies 20 July, Amarillo, in a plane crash
while scouting for next project

1964 1968 1969 1970 1973

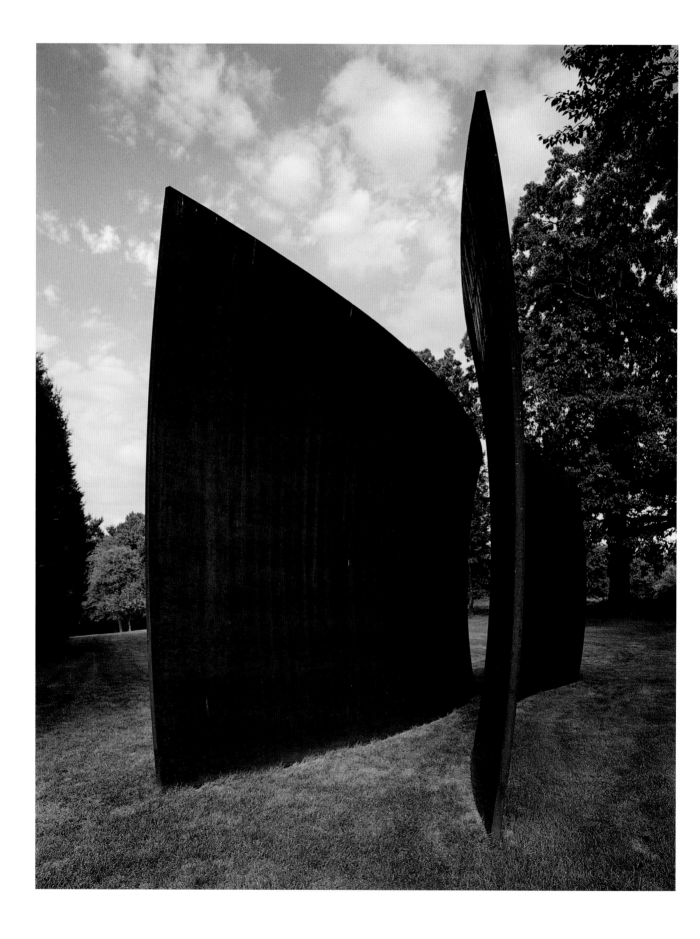

'Artworks are only interesting if they engender other ways of thinking about the world.'

Richard Serra

b. 1939

UNITED STATES

Richard Serra, known primarily for his colossal sculptures – abstract masses of lead and industrial Cor-Ten steel – is uncompromising in his sculptural vision. Works such as *One Ton Prop* embody intrinsically three-dimensional properties: volume, weight and mass. Serra describes his sculpture as being 'about how one deals with and understands space'. He is emphatic about the simplicity of his aims. He does not want to make anything theatrical, metaphorical or illusionistic – all words he associates with early twentieth-century sculpture, which he accuses of treating materials simply as 'picture-making elements'. Serra wants to find a new language for sculpture, one that maintains both a certain truthfulness to materials and an acknowledgement of progress resulting from the Industrial Revolution. One reason Serra has always avoided colour is to engage with these new ways of thinking. He only ever works with exposed surfaces or black, which he does not describe as a colour, but as 'a property, a material,' that 'manifests itself as weight'.

Initially, Serra worked with lead. He began to 'tear' strips from a sheet of lead that he laid on the gallery floor. After that he melted the metal and hurled it against warehouse and gallery walls. Then he systematically explored new ways of fabricating in three dimensions, working his way through a series of verbs that he listed in 1968: 'to roll, to crease, to fold, to bend, to shorten, to twist, to dapple, to crumple . . .' Throughout these experiments Serra avoided the traditional sculptural methods of carving and welding. Instead, he created physically intimidating and psychologically imposing works that loom over the viewer, relying only on balance and natural gravitational forces, which he believes are the natural, elemental and 'truthful' components of sculpture.

Apart from changing how sculpture was made, Serra also wanted to alter how it was engaged with and perceived. He aimed to 'do away with the object, to get sculpture off the pedestal and expand the space of the field'. In pursuit of this aim, he made one of his greatest innovations: the site-specific work. With site-specific pieces the viewer is forced to walk through and around sculptures that have ceased to exist as discrete objects and actively deconstruct space. These pieces dominate the space they are made for, be it outdoors or in a museum. *Torqued Spiral* and other recent works rely on gentler, organic shapes to create passageways through sheets of metal. *Torqued Spiral*, in particular, employs Serra's fundamental understanding of steel to create, simultaneously, a powerful sensation of vulnerability and an impression of freedom as the viewer looks to the opening above. For Serra, who describes space as his 'primary material', this is critical. It is also why the work's interaction with its environment is central to many of his pieces: to remove them is, as he says, to destroy them.

Opposite *Vice Versa*, 2003. Weatherproof steel, 470.5 × 1169.7 × 312.4 cm (185¼ × 460½ × 123 in). Collection Martha and Jeffrey Perelman, Philadelphia.

Above Portrait of Richard Serra by Ludwig Binder, c. 1980.

Richard Serra

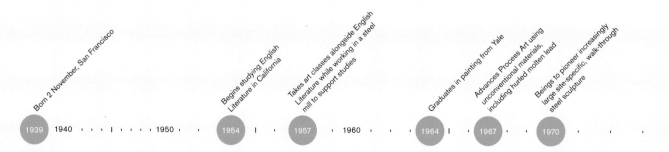

Born 2 November, San Francisco

Begins studying English Literature in California

Takes art classes alongside English Literature while working in a steel mill to support studies

Graduates in painting from Yale

Advances Process Art using unconventional materials, including hurled molten lead

Beings to pioneer increasingly large site-specific, walk-through steel sculpture

1939 1940 · · · · · · 1950 · · 1954 I · 1957 · 1960 · · · · 1964 I · 1967 · · 1970 · · · ·

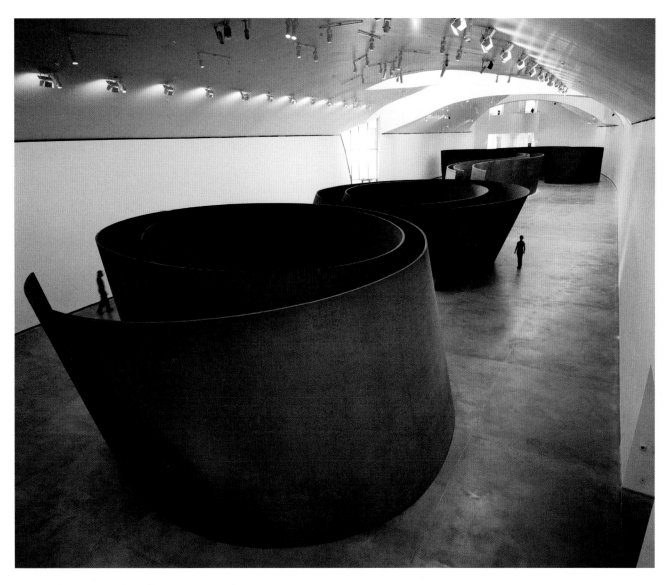

Opposite *Stacked Steel Slabs* (*Skullcracker* series), 1969. Hot rolled steel, approx. 610 × 240 × 310 cm (240 × 94 in × 122 in). Installation at Kaiser Steel, Fontana, CA.

Above *Torqued Spiral (Open Left Closed Right)*, 2003–05. Weathering steel, 427 × 978 × 1,268 cm (168 × 384⅞ × 492⅜ in), plate thickness 5 cm (2 in). Part of *The Matter of Time* installation, Guggenheim Bilbao.

Tilted Arc's removal from lower Manhattan focuses international attention on the governance and participatory role of art in public spaces

MoMA retrospective reinforces Serra's massive influence on late twentieth-century sculpture

1981 1990 2000 2007

Collo rotto braccia lunghe (*Broken neck long arms*), 1989. Embroidery on muslin, 102.6 × 106 cm (40⅜ × 41¾ in). Private collection. Photo courtesy Sperone Westwater, New York.

'I don't ask myself ... if what I do is art. I just want to have adventures.'

Alighiero Boetti

1940–1994

ITALY

The degree to which Conceptual artist Alighiero Boetti fulfilled his own dictum that 'work is adventure', is demonstrated by his decision, aged 33, to start referring to himself as two people. He renamed himself Alighiero 'e' (and) Boetti, and the act was no mere gesture – he taught himself to become ambidextrous in both drawing and writing, thus engaging his art in a constant dialectic between the two sides of his character. This renaming is typical of Boetti's tenacious pursuit of ideas, which emerged from a creativity rooted in a study of philosophy, mathematics and theory. Whether a question took ten minutes or ten years to answer, Boetti pursued it with a persistence that amounted to obsession. The idea of dualism had actually appeared in his work five years before his renaming, in a self-portrait entitled *Twins*. It shows two men holding hands. Both of them are Boetti. As long as a question continued to interest him, he continued to propose answers.

As with avant-garde artists of his generation, Boetti's early pieces, including *Stack,* experimented with everyday, worthless materials that challenged the commerciality and institutionalization of the 1970s art world. Where Boetti was exceptional was in combining these materials with both a formal understanding and an insatiable intellectual curiosity. He was not only interested in the dual aspects of his personality – for him, opposing forces were the root of creativity, whether they were abstract concepts, genuine opposites or simply related entities, such as time and space. Boetti was particularly interested in chance and systems. He was fascinated by numbers, letters and measurements and, as in *Collo rotto braccia lunghe* (*Broken neck long arms),* often sought to expose the patterns (or lack thereof) that lie behind the arbitrary codes we have constructed. In his exploration of systems, he pushed his art to encompass (even considering the context) a surprisingly wide range of materials, including biro, magazine covers, embroidery, postage stamps and even systems and institutions themselves – most frequently the postal service.

Boetti's interest in systems extended to form itself. He famously said of his most well-known work, the map series, that it embodied 'maximum beauty' because it utilized pre-existing codes: 'For that work I did nothing, chose nothing, in the sense that the world is made as it is, not as I designed it, the flags are those that exist, and I did not design them; in short I did absolutely nothing.' This comment hints at the playful light-heartedness that runs through an oeuvre that often incorporates puzzles and puns. Beneath it all, however, lay a seriousness: Boetti's work was political, diverse and global, revealing a deep interest in non-Western traditions. His most serious exploration, though, was time, which he described as 'the only really magical thing there is' and the only system that, in the end, cannot be either constructed or evaded.

Above Portrait of Alighiero Boetti by Chris Felver, 1988.

Above *Mappa del mondo*
(*Map of the world*), 1989.
Embroidery on fabric, 117.5
× 227.7 × 5.1 cm (46¼ ×
87¾ × 2 in). Museum of
Modern Art, New York. Scott
Burton Memorial Fund.
1253.1999.

Left *Catasta* (*Stack*), 1966.
Eternit tubes, approx.
529 × 150 × 150 cm
(208¼ × 59 × 59 in).
Fondazione per l'Arte
Moderna e Contemporanea
– CRT, Turin.

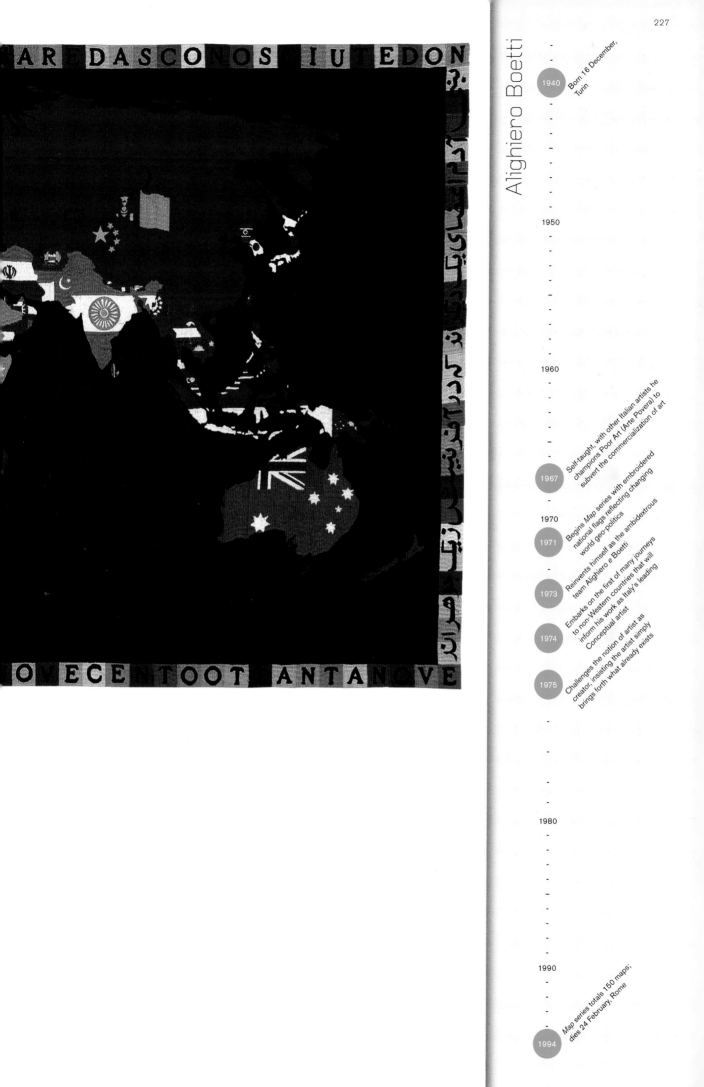

Alighiero Boetti

1940 Born 16 December, Turin

1950

1960

1967 Self-taught, with other Italian artists he champions Poor Art (Arte Povera) to subvert the commercialization of art

1970

1971 Begins *Map* series with embroidered national flags reflecting changing world geo-politics

1973 Reinvents himself as the ambidextrous team Alighiero e Boetti

1974 Embarks on the first of many journeys to non-Western countries that will inform his work as Italy's leading Conceptual artist

1975 Challenges the notion of artist as creator, insisting the artist simply brings forth what already exists

1980

1990

1994 *Map* series totals 150 maps; dies 24 February, Rome

'I love all dots. I am married to many of them. I want all dots to be happy. Dots are my brothers. I am a dot myself.'

Sigmar Polke

1941–2010

GERMANY

Experimental, contradictory, versatile, ironic and playful are terms that have all been applied to the work of Sigmar Polke. His art remains unconventional, its rich layers of meaning mysterious and inscrutable. Polke, who also made photographs and films, chose to paint at a time when canvas was being abandoned for new and more radical modes of creation. First, he dismantled the medium and then, with reckless abandon, he refashioned it into something complex, innovative and almost impossible to pin down.

Throughout his life, Polke resisted critical and biographical interpretation of his work. Nonetheless, the fact that his family settled in Düsseldorf in 1953 is important. There, Polke saw the first postwar exhibition of Dada and the work of Robert Rauschenberg, and studied under Joseph Beuys. Early works, including *Bunnies*, show a close engagement with cutting-edge American Pop. Where he differed was in his absolute refusal to unify personality and style. Instead, in *Modern Art* and other works he questioned the gap between mechanical reproduction and gestural aesthetic, and also exposed the lack of substance in capitalist markets. This interrogation soon developed into a deep scepticism towards politics, social convention and, in fact, tradition of any kind. His work became critical of both communism and capitalism, and deeply cynical about the possibility of truth. His true innovation was the success with which he exposed the flagrant impossibility of the Modernist utopian dream: instead of giving us answers, Polke offers only questions.

Polke's restless mind soon moved him to work with photographic prints, which he altered to create surreal, hallucinatory narratives. These photographs were not traditionally printed, but crushed and crumpled as they dried, treated with radioactive substances, drawn over and painted on. When Polke returned to painting he continued his visceral exploration of materials. He employed, among other things, vegetable juices, beeswax, printed fabrics, snail mucous, silver oxide, granulated meteorite and powdered arsenic. He allowed the materials to react and change on the surface of his multilayered canvases and he used the resulting alchemy to achieve the seemingly impossible: the reconciliation of abstraction with figurative painting.

Polke's exploration of materiality was not purely aesthetic, it was also a declaration of independence: from convention, from the canon and from the expectations of taste. He tore Western art up from the roots and rampaged through its stylistic history, assimilating disparate influences as easily as he exploited materials. He also ruthlessly plundered history itself which, under his hand, became, for the first time in many years, a viable subject-matter. Caustic wit runs through this work, but it is paired with the ability to create unconventional, breathtakingly beautiful images. Although he remains an iconoclast, Polke's work inspired a generation. He is one of the most enigmatic, vibrant and complex of the postwar artists.

Opposite *Bunnies*, 1966. Acrylic on canvas, 149.2 × 99.3 cm (58⁴⁷/₆₄ × 39³/₃₂ in). Hirshhorn Museum, Washington, DC. Joseph H. Hirshhorn Bequest and Purchase Fund, 1992.

Above Portrait of Sigmar Polke by Brigitte Hellgoth, 1986.

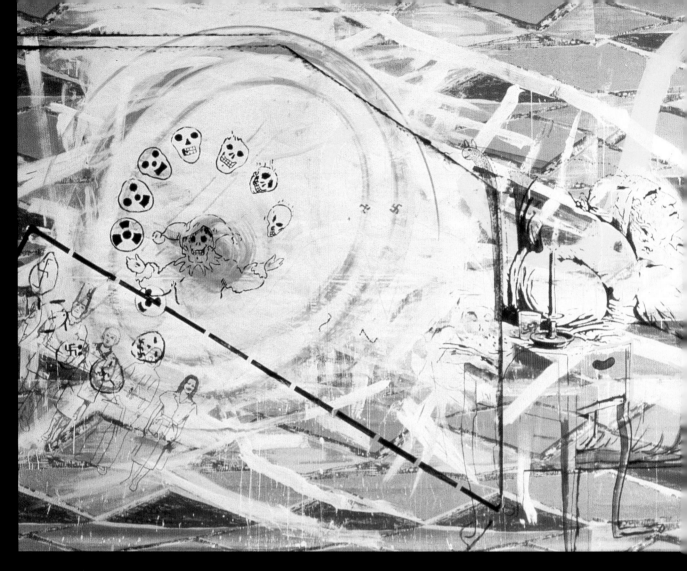

Above *Niccolò Paganini*, 1982.
Dispersion on canvas, 200 × 450 cm
(78¾ × 177 in). Saatchi Collection,
London.

Left *Modern Art*, 1968. Artificial resin
and oil on canvas, 150 × 125 cm `
(59 × 49¼ in). On loan to the
Hamburger Kunsthalle, Hamburg.

Moderne Kunst

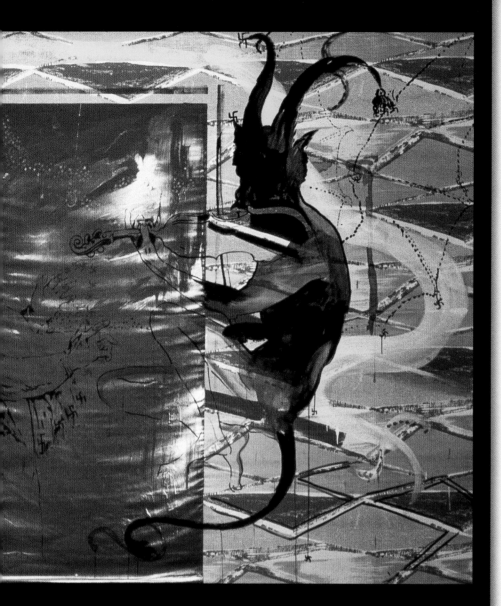

Sigmar Polke

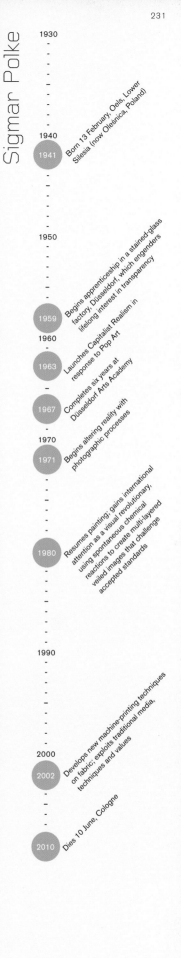

1930

1941 Born 13 February, Oels, Lower
Silesia (now Oleśnica, Poland)

1940

1950

1959 Begins apprenticeship in a stained-glass
factory, Düsseldorf, which engenders
lifelong interest in transparency

1963 Launches Capitalist Realism in
response to Pop Art

1960

1967 Completes six years at
Düsseldorf Arts Academy

1971 Begins altering reality with
photographic processes

1970

1980 Resumes painting; gains international
attention as a visual revolutionary,
using spontaneous chemical
reactions to create multi-layered
veiled images that challenge
accepted standards

1990

2002 Develops new machine-printing techniques
on fabric; exploits traditional media,
techniques and values

2000

2010 Dies 10 June, Cologne

'If you really want to do it, you do it. No excuses.'

Bruce Nauman

b. 1941

UNITED STATES

Bruce Nauman's decision to give up painting early on was motivated by the same restless, questing curiosity that has sustained his long career. One of the most unremittingly brave artists of the twentieth century, Nauman has been versatile and tenacious in expanding his *oeuvre*. His unconventional approach has led him to explore new techniques and practices. He was one of the first artists to utilize film and also one of the first to reject aesthetic decisions, sometimes leaving formal elements to chance or perception. He has revolutionized ideas, not only of how art can be produced, but also how it can be presented in a gallery and how it can be experienced by the viewer.

Nauman's innovative art practice began when, as a young graduate, he realized that his creative output might not be restricted to what he made. 'At this point,' he said, 'art became more of an activity and less of a product.' He often included himself in his work, exploring the role of the artist as well as the object by, among other things, photographing himself spouting water from his mouth. In more extreme works, like *Dance or Exercise on the Perimeter of a Square* he embarked on tasks, 'just to see what would happen'. He pushed himself to do things he did not want to, to cultivate curiosity, test his boundaries and pursue answers, even if these were, often, unattainable.

A student of physics and maths, Nauman's influences also included avant-garde writer Samuel Beckett and the philosopher Ludwig Wittgenstein. His performances began to question the nature of communication: the symbols of language, the codes of behaviour and simple, visual signs. He played with these symbols in a humorous way, often employing word play and anagrams, but always with serious intent. He often pushed codes of communication to their extremes, to

see where they break down into irrationality, and then to see how he (and his audience) would react. Instead of allowing the audience a passive role, he forced them to engage with the work and to reflect on their role within it, frequently addressing them in the second person, and often using the imperative. An extension of this was his interest in incongruity and the unexpected. In works like *Shit in Your Hat – Head on a Chair*, the audience watched the performer follow increasingly demeaning instructions read from a script. This work retained its humanity through humour and through Nauman's use of his body, which he describes as 'a piece of material'.

Nauman's work has been described as 'rough and ready' but 'free', and also as beautiful, messy, silly and humorous. His vision can be seen most clearly 'in relief': when he started producing his signature neon and video pieces in the mid-1960s, most cutting-edge American artists were involved with Minimalism. The Minimalists' art sought to control form and ideology; Nauman sought precisely the opposite. His work is concerned primarily with problems, of which he is utterly unafraid, and it is rooted in spontaneous experience and exploration. Unlike the Minimalists, Nauman immerses himself in his work. In this, he reveals his central philosophy: not that creativity makes us human, but that only through creativity do we become truly alive.

Opposite *The True Artist Helps the World by Revealing Mystic Truths*, 1967. Window or wall sign, neon artist's proof, 149.9 × 139.7 × 5.1 cm (59 × 55 × 2 in). Philadelphia Museum of Art. Purchased with the generous support of the Annenberg Fund for Major Acquisitions, the Henry P. McIlhenny Fund, the bequest (by exchange) of Henrietta Meyers Miller, the gift (by exchange) of Philip L. Goodwin, and funds contributed by Edna Andrade, 2007. 2007-44-1.

Above Portrait of Bruce Nauman by Jason Schmidt, 2008.

Above *Dance or Exercise on the Perimeter of a Square (Square Dance)*, 1967–68. Film still of a 16mm film on video (black-and-white, sound), 8:24 minutes. Distributed by Electronic Arts Intermix. Photo courtesy Sperone Westwater, New York.

Opposite *Shit in Your Hat – Head on a Chair*, 1990. chair, wax head, rear-screen projector and screen, videotape (color, sound), dimensions variable. Colección de Arte Contemporáneo Fundación 'La Caixa', Barcelona. Photo courtesy Sperone Westwater, New York.

Bruce Nauman

Born 6 December, Fort Wayne

Abandons painting for performance, film, neon and sculpture

Having completed studies in mathematics and physics, begins Master of Fine Arts

First solo exhibition, Los Angeles, before graduating as MFA. *Self-portrait as a Fountain* is the first of many works to include himself, exploring the role of artist

First solo show at the Leo Castelli Gallery in New York. Begins to accrue international attention

1940 · 1941 · | · · 1950 · · · | · · · 1960 · · · 1964 · 1965 · 1966 · 1968 · 1970 · ·

Having won international
acclaim, relocates to a
remote part of New Mexico

Away from media attention,
he begins to experiment,
continuing career-long
exploration of diverse media,
and championing the primacy
of the idea over the art object

Featured artist at the American
Pavilion at the Venice Biennale
when the pavilion was awarded
the Golden Lion for Best
National Representation

1979 1980 2008 2009 2010

Odessa, 1989–2003. Six photographs,
three tin biscuit boxes, lights and wire.
Courtesy of the artist and Marian
Goodman Gallery. © Artists Rights
Society (ARS), New York / ADAGP,
Paris High Museum of Art, Atlanta.

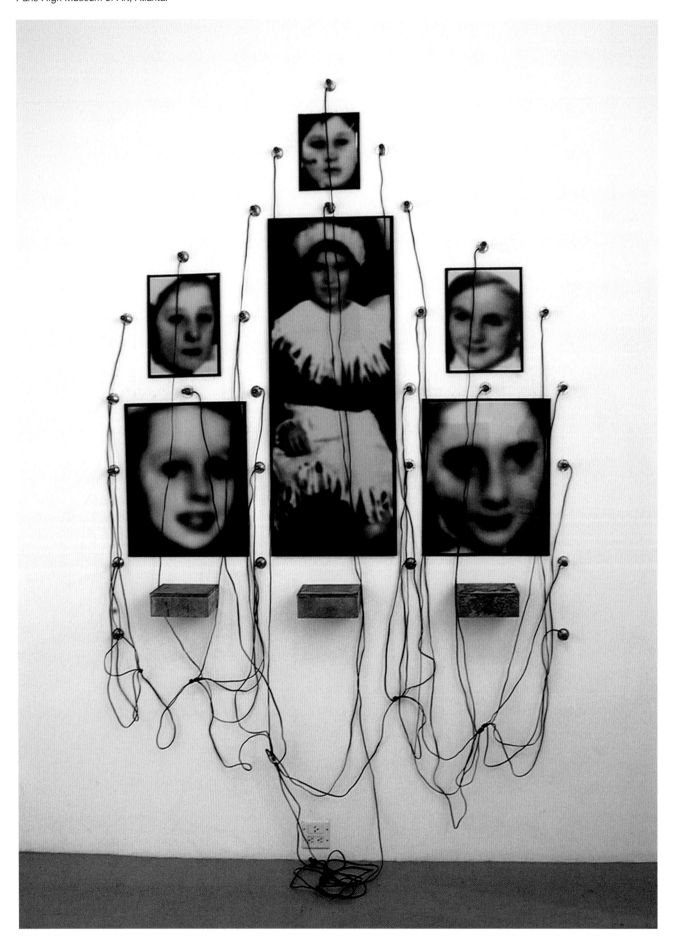

'Aesthetics mean nothing.'

Christian Boltanski

b. 1944

FRANCE

Christian Boltanski is a chronicler of loss. Not his own, but society's. He plays on collective nostalgia and memory, focusing on simple objects and fictitious or anonymous identities to create memorials to bereavement. This may sound a deeply pessimistic project but his work, which has been described as 'a protest against forgetting', also celebrates the continued cycle of existence, the anonymous lives yet to come. 'Life goes on,' he says; we will be replaced. And though Boltanski's subjects – past or future – are unidentifiable, his aim is ultimately very sympathetic: 'What drives me as an artist,' he says, 'is that I think everyone is unique, yet everyone disappears so quickly.'

Boltanski's practice spans many media, from his early works of painting, to photography, installation and sculptures made from unusual materials such as sugar and found objects. His stated aim with all this work is to challenge convention and to probe the gaps between the real and imaginary, the present and the past. He did this most famously with his 1980s installations. These hint at the events of our collective memory by using objects from public spaces: lost property, piles of clothes and anonymous artefacts that become memorials to everyone and no one. In works such as *Odessa*, Boltanski also used found photographs – very ordinary, low-quality images such as school photographs, newspaper pictures or family portraits – in the same way as historic objects. He describes himself not so much as a photographer as a recycler and, through this recycling, his art rescues ordinary people from the void of the past. The images are often presented under harsh and interrogative electric lighting, lighting that both exposes and confuses our reading of the black-and-white faces. For this reason, people are reminded of the Holocaust when they see it. This is not accidental: in *Altar to the Chases High School,* Boltanski deliberately took photographs from a real class of Jewish Austrians who graduated in 1931 – the generation that disappeared. The photographs are exhibited with stacked and rusted biscuit tins. Boltanski describes these as 'sentimental object[s] that evoke something familiar to all Westerners . . . the idea of basic protection (this is the box in which children keep their little treasures), of a funeral urn and, more generally, of storage.' The use of the tins adheres to Boltanski's larger aim of connecting art with life and encouraging his audience not to 'discover but to recognize, to appropriate', to be the final element that makes the piece a work of art by recognizing a part of their own self in it. Boltanski insists on this element as the driving force of his art. 'I think that aesthetics mean nothing,' he has said. 'There is no such thing as a beautiful or non-beautiful thing. There is art that works and art that doesn't. It's about whether a work can touch people.'

Above Portrait of Christian Boltanski by L. Birnbaum, 1995.

Above *Parents' Wedding*, from *Comic Vignettes*, 1974. Gelatin silver print, white ink, 37.9 × 71 cm (14⁵⁹⁄₆₄ × 28 in). Musée National d'Art Moderne, Centre Georges Pompidou, Paris.

Below *Reliquaire*, 1990. Photographs, lamps, six metal drawers and tin biscuit boxes. Israel Museum, Jerusalem. Courtesy of the artist and Marian Goodman Gallery. © Artists Rights Society (ARS), New York / ADAGP, Paris

Opposite *People*, 2010. Installation at the Grand Palais, Paris.

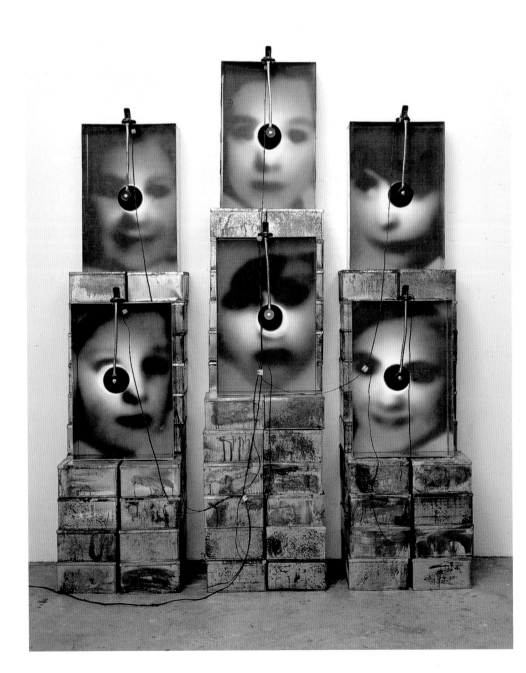

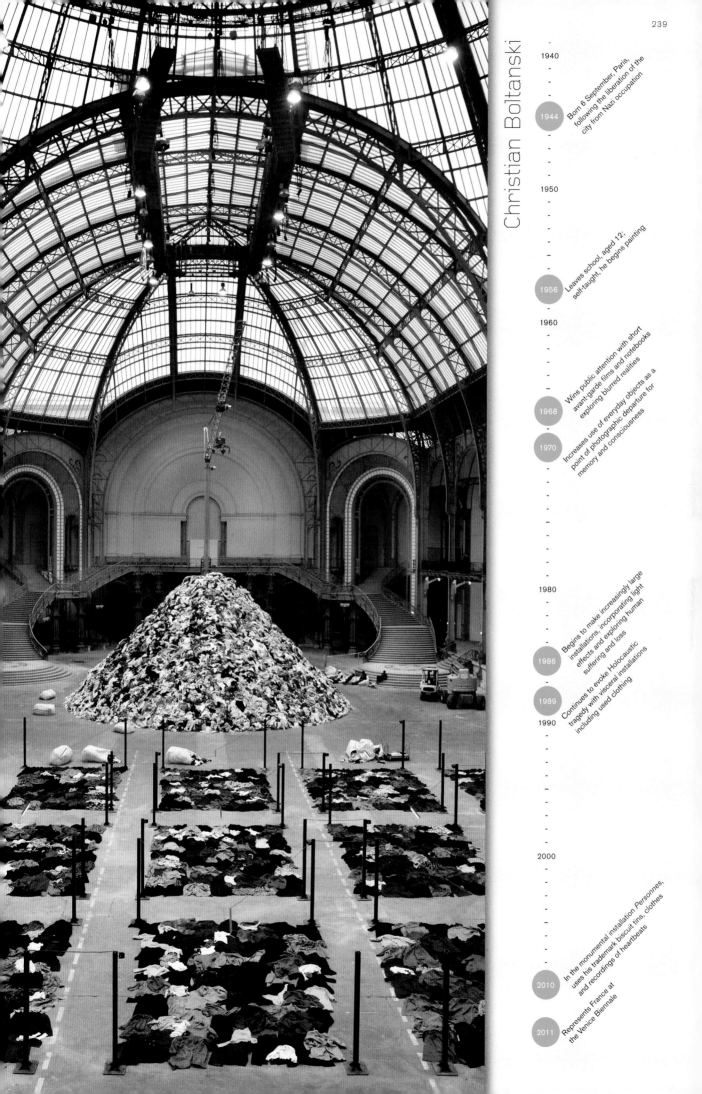

Christian Boltanski

- 1940

1944 — Born 6 September, Paris, following the liberation of the city from Nazi occupation

- 1950

1956 — Leaves school, aged 12; self-taught, he begins painting

- 1960

1968 — Wins public attention with short avant-garde films and notebooks exploring blurred realities

1970 — Increases use of everyday objects as a point of photographic departure for memory and consciousness

- 1980

1986 — Begins to make increasingly large installations, incorporating light effects and exploring human suffering and loss

1989 — Continues to evoke Holocaustic tragedy with visceral installations including used clothing

- 1990

- 2000

2010 — In the monumental installation Personnes, uses his trademark biscuit tins, clothes and recordings of heartbeats

2011 — Represents France at the Venice Biennale

'All art is art.'

Joseph Kosuth

b. 1945

UNITED STATES

Conceptual Art, of which Joseph Kosuth is considered a founding father, has been described as 'the nervous breakdown of Modernism'. In that sense it is some of the most revolutionary of all postwar art, tearing through aesthetic tropes and artistic institutions that had been carefully built over two centuries. Kosuth, who underwent a conventional art-school training, said that abandoning painting was not easy. He described the move as necessary but 'very painful', but he felt it was imperative to confront the Modernist assumption that individual artworks could express ultimate and incontrovertible truth. Kosuth saw this as inflexible and outmoded, but also – crucially – as benefiting a commercial and institutional infrastructure that curtailed art's ability to interrogate and subvert. Although Modernism triumphed, and then calcified, in the 1950s, its formal and ideological tenets lingered. Even the work of contemporary Minimalists such as Donald Judd, who Kosuth admired, became associated with a certain aesthetic and trapped in a commercial cycle. They became, in Kosuth's words, 'a bit like the shape of the Coca-Cola bottle – about product identification.'

Kosuth's response was to go back to ideas first mooted by Marcel Duchamp. He abandoned craft and began to investigate the creation of meaning. He replaced artists with philosophers – in particular Sigmund Freud and Ludwig Wittgenstein – as his points of reference. The resulting work was ephemeral, unpurchasable and, in works such as *Five Words in White Neon,* used visual 'tautology' to provoke the viewer. Kosuth was the first artist to take the attitude 'it's art because I say it is'. His entire opus questions the nature of art and challenges its place in the culture and institutions of the twentieth century. Early conceptual pieces include *One and Three Chairs,* which considers

and challenges the accepted boundaries of an artwork's constitution as well as how it interacts with its audience. It abandons traditional materials and presents itself as a question rather than a statement. Kosuth went further than earlier artists who used found objects when he stated that the choice of chair did not matter, that as long as the 'recipe' remained intact, the 'ingredients' could be chosen by the museum. The important thing was the interrogation of meaning, not the object. In this, Kosuth was the first to abandon the notion that the artist must be fully in control of creative selection, or even of the final manifestation of the piece that bore their name.

Kosuth's interrogation of art did not cease in the 1960s. He continues to investigate the relationship between art, language and philosophy, to 'explore the gap between models', even venturing to create permanent exhibits. These works, however, do not set out to answer all of his questions: they are simply part of the process which, he humbly speculates, 'perhaps adds up to something that is meaningful'.

Opposite *Five Words in White Neon,* 1965. Neon, 8 × 150 cm (3⅛ × 59 in). Private collection.

Above Portrait of Joseph Kosuth by James Croucher, c. 2014.

Above *Dos Tipos de Mapas*, 2008. Installation view. Neon. Private collection.

Opposite *One and Three Chairs*, 1965. Wooden folding chair, photographic copy of a chair, and photographic enlargement of a dictionary definition of a chair; chair, 82 × 37.8 × 53 cm (32⅜ × 14⅞ × 20⅞ in). Museum of Modern Art, New York. Larry Aldrich Foundation Fund. 393.1970.a-c.

Joseph Kosuth

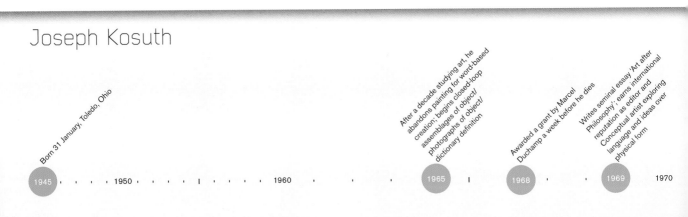

Born 31 January, Toledo, Ohio

After a decade studying art, he abandons painting for word-based creation; begins closed-loop assemblages of object/ photographs of object/ dictionary definition

Awarded a grant by Marcel Duchamp a week before he dies

Writes seminal essay 'Art after Philosophy'; earns international reputation as editor and Conceptual artist exploring language and ideas over physical form

1945 1950 1960 1965 1968 1969 1970

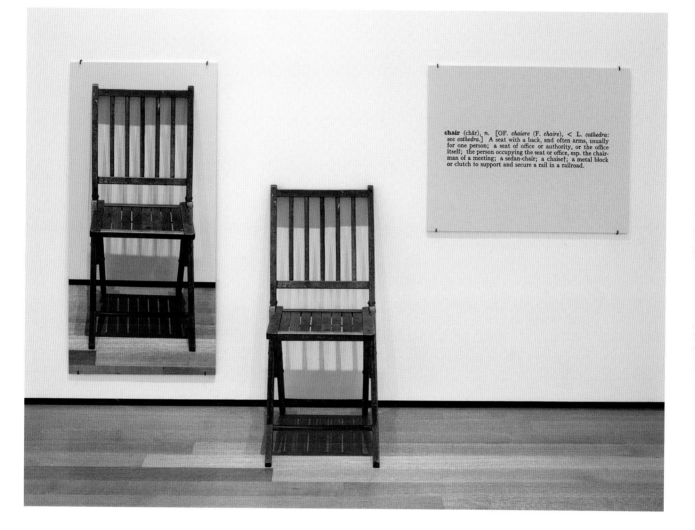

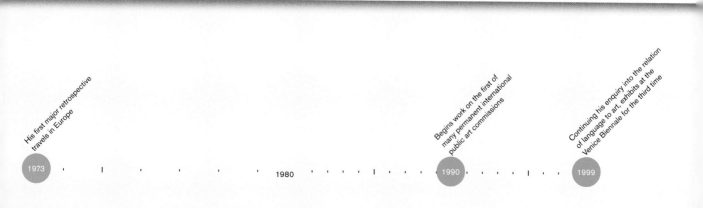

His first major retrospective
travels in Europe

1973

1980

Begins work on the first of
many permanent international
public art commissions

1990

Continuing his enquiry into the relation
of language to art, exhibits at the
Venice Biennale for the third time

1999

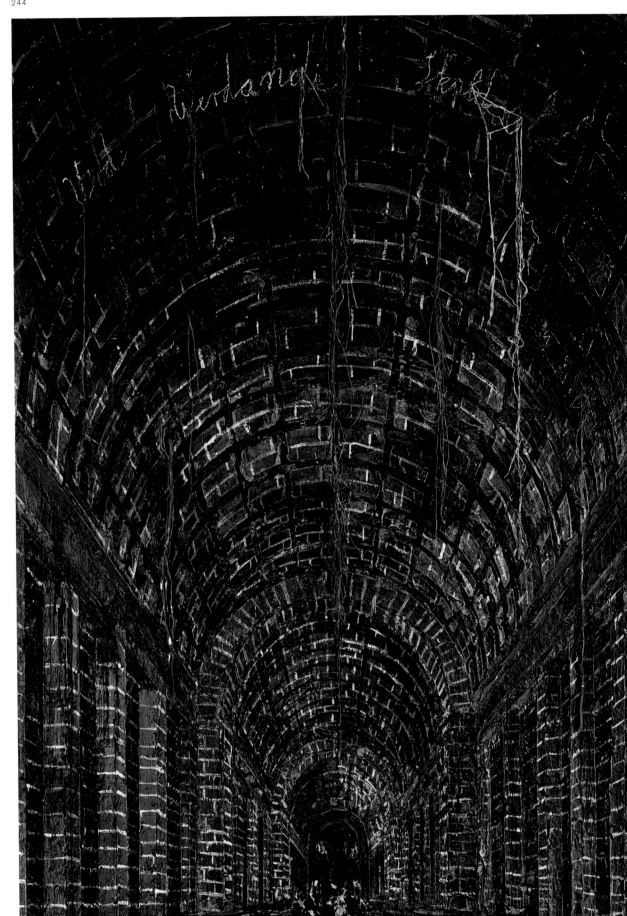

'Art is difficult.
It is not entertainment.'

Anselm Kiefer

b. 1945

GERMANY

While the rest of Europe ran from its history, German artist Anselm Kiefer picked repeatedly at the raw wounds of World War II and the Third Reich. His entire *oeuvre* explores the nature of his personal and national German identity, expanding beyond recent history to embrace the vastness of Teutonic culture and the Romantic tradition.

It is hardly surprising that Kiefer's first work, an unexplained book of photographs that depicted the artist making the *Sieg Heil* (Nazi salute), was interpreted as neo-Nazism. Kiefer was unmoved by cries of protest, stating only that, 'Germans want to forget [the past] and start a new thing all the time, but only by going into the past can you go into the future.' His paintings do just this. Works such as *The Norns* and *Wayland's Song* are filled with Nazi architecture, devastated ruins, the burnt fields of war and a complex panoply of Teutonic symbols and references.

In order to achieve the kind of gravitas that his subject demands, Kiefer works on a grand scale. His paintings from the early 1980s, often more than 2.5 metres (8 feet) tall, exhibit none of the playfulness or irony of many works of the period. Instead, they are heavily laden, not only with symbolic and cultural references, but also with a dense physical layer that consists of thick pigment-paste and materials that include wax, straw, ash, clay and lead. Kiefer was not the first artist to make use of organic matter – he was preceded by the Italian Arte Povera movement – but, inspired by his one-time teacher and fellow countryman Joseph Beuys, he was the first to use them for their materiality, their fragility, simplicity and purity, and for the metaphor that their inevitable decay implied.

Many of Kiefer's contemporaries employed organic materials to rebel against the grand Western canon and its inherent values of permanence and truth. For

Kiefer, however, transience was not the equivalent of ruin or destruction: it represented not decay but 'transfiguration'. Kiefer's materials became a means to explore destruction and ruin, and how these things relate to creativity. For, although in the mid-1980s his art took on a more alchemical nature – increasingly embracing mystical texts and occult symbolism, and moving away from the taboos and terror of recent German history – his aim remained the same: to heal a divided world and to explore the nature of creativity itself. Kiefer's stubborn insistence on the importance of history is unique, but the work reaches beyond its subject-matter to a deeper exploration. Kiefer once said that, 'History has shown us that there is always a darkness inside the light . . . Maybe we should be looking more carefully into the darkness.'

Opposite *Urd Werdandi Skuld (The Norns)*, 1983. Oil paint, shellac, emulsion and fibre on canvas, 420.5 × 289.5 × 0.6 cm (165³⁵⁄₆₄ × 113³¹⁄₃₂ × ¹⁵⁄₆₄ in). Tate, London.

Above Portrait of Anselm Kiefer by Renate Graf, c. 2014.

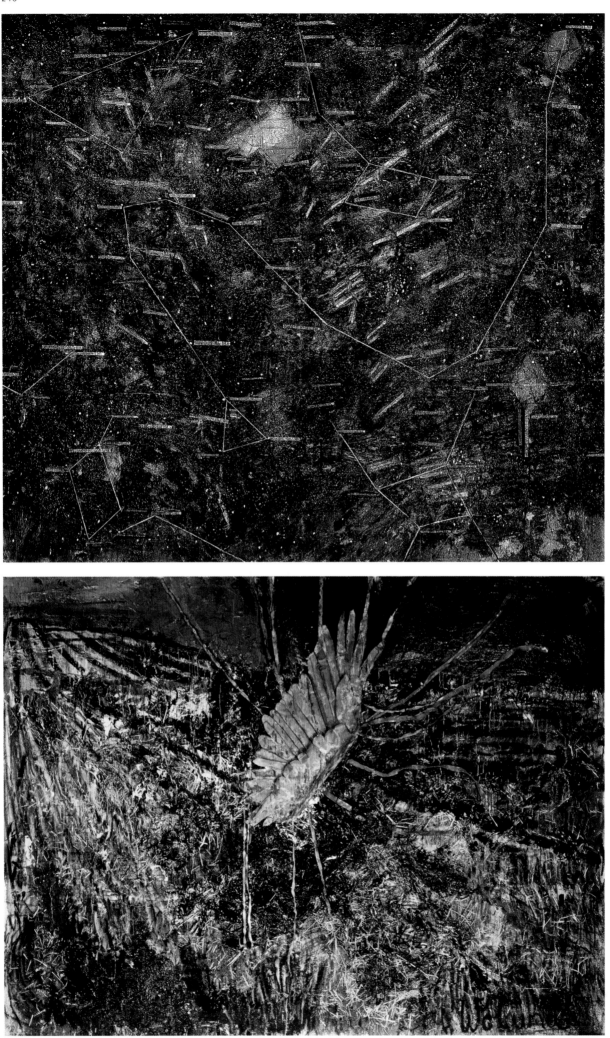

1945 Born 8 March, Donaueschingen

1950

1960

1966 Abandons law studies for art

Gains notoriety with photographic self-portraits in the Nazi salute; the taboo-shattering series was among postwar Germany's most polarizing works

1969 Encouraged by Joseph Beuys, begins several years of exploration into German history, myth and mysticism in apocalyptic landscapes

1970

1980

Begins to explore, in oversized works, more universal, cosmic themes, incorporating unconventional materials, textures; turns to sculpture, especially lead

1984

1990 Moves to France

1991

2000

2008 Awarded the German Book Trade Peace Prize

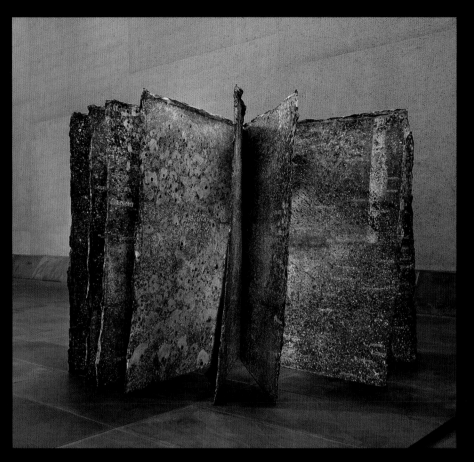

Opposite above *Falling Stars*, 1998. Mixed media on canvas, 464.8 × 528.3 cm (182⁶³⁄₆₄ × 207⁶³⁄₆₃ in). Blanton Museum of Art, University of Texas at Austin. Gift of Mr and Mrs Thomas B. Martin. Jr, 2009. © Anselm Kiefer.

Opposite below *Das Wölund-Lied* (*Wayland's Song*), 1982. Oil, emulsion, straw and photograhpy on canvas with lead wing, 280 × 380 cm (110 × 150 in). Saatchi Collection, London. © Anselm Kiefer.

Above *The Secret Life of Plants*, 2002. Lead, oil, chalk, pigment, 195 × 300 cm (76³⁄₈ × 118¹⁄₈ in), weight 700 kg (1,543¹⁄₃ lbs). National Gallery of Australia, Canberra.
Purchased 2003. © Anselm Kiefer.

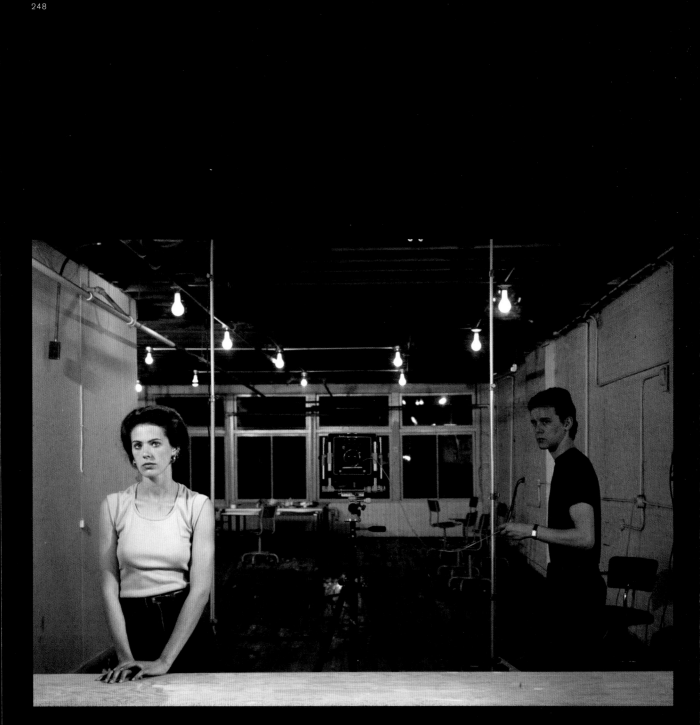

Picture for Women, 1979. Transparency
in lightbox, 142.5 × 204.5 cm (56⅛ ×
80½ in). Courtesy of the Artist.

'I guess you could say I'm like a film director, but my movies have only one frame.'

Jeff Wall

b. 1946

CANADA

In the 1970s, photography was at a turning point. Reportage still dominated the medium and serious photography was almost entirely documentary. Most photographers and critics identified photography as art, but accepted its peripheral position within the canon. Jeff Wall, however, felt this segregation and self-categorization had become an orthodoxy that blocked new and creative ways of approaching the medium.

Trained as a painter, Wall experimented with Conceptual Art throughout the 1960s yet remained convinced of the great potential in picture-making. During the early 1970s he began to see the possibility of a new dialogue between what he valued in painting – longevity, depth and timelessness – and what he saw as the latent power of photography.

By the mid 1970s Wall was experimenting with a form of photography that was originally termed 'pictorialism', then 'staged photography' and eventually (by Wall) 'cinematography'. Cinematography – like painting – permitted the use of various methods and levels of staging and artifice. Images could be composed, altered, even elaborately constructed. *Picture for Women* (1979) deliberately references picture-making by restaging Edouard Manet's nineteenth-century masterpiece, *A Bar at the Folies Bergères*.

Wall also began making his photographs very large, on a scale that he relates to the history of painting. He defines this as 'life scale' – the size of the objects and figures correspond directly to their counterparts in the real world. Often termed a 'tableau', this kind of image drew his photography into a closer relationship with painting and more recent pictorial forms, such as cinema.

This also further distanced Wall's photography from the traditional documentary format. His photographs were often unique objects rather than produced in editions, and sought a level of permanence in their use of the transparency format. They also engaged with popular culture, being printed as transparencies and displayed in the type of light-boxes used for advertising and seen in every kind of public space.

Wall's subject-matter is as various as a painter's or a film-maker's. He has made many pictures that at first glance are indistinguishable from documentary photographs, except for their size. Others, such as *After 'Invisible Man' by Ralph Ellison, the Prologue* are elaborately crafted studio projects, involving the construction or creation of almost everything in the image, worked on over a long period of time, and often composed as digital photomontages made from many negatives.

Wall feels that 'cinematography' permits him to work in different modes and styles, none of which has priority over another. He still works with the documentary character of photography, but approaches it from a new perspective, neither conforming to it nor denying its importance, but working 'in its shadow', as he puts it.

Above Portrait of Jeff Wall by Matt Booth, 2009.

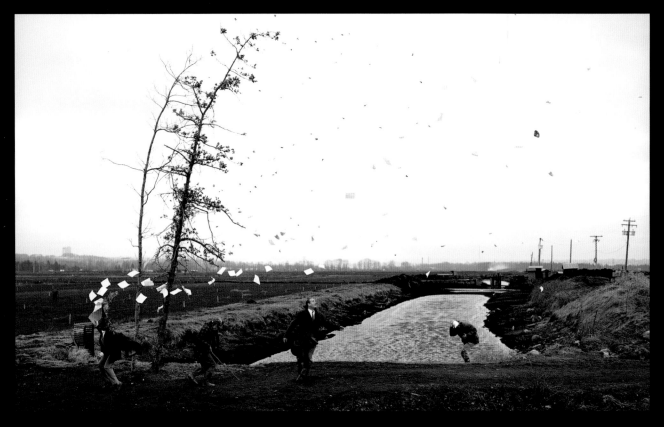

Above *A Sudden Gust of Wind (After Hokusai)*,
1993. Transparency in lightbox, 229 × 377 cm (90⅙ ×
148⅖ in). Courtesy of the artist.

Opposite *After 'Invisible Man' by Ralph Ellison, the
Prologue*, 1999–2001. Transparency in lightbox, 174 ×
250.5 cm (68½ × 98⅗ in). Courtesy of the artist.

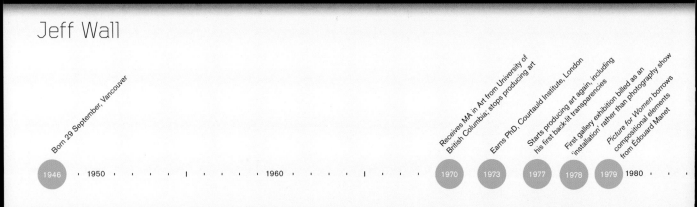

Jeff Wall

Born 29 September, Vancouver

Receives MA in Art from University of
British Columbia; stops producing art

Earns PhD, Courtauld Institute, London

Starts producing art again, including
his first back-lit transparencies

First gallery exhibition billed as an
'installation' rather than photography show

Picture for Women borrows
compositional elements
from Édouard Manet

1946 · 1950 · · · · | · · · · 1960 · · · · | · · · 1970 · 1973 · 1977 · 1978 · 1979 1980 · ·

Completes the oversized photomontage
Sudden Gust of Wind (After Hokusai),
made up of 100 photographs, after a year

Major retrospective pairs his
photos with historical classics

· · 1990 · 1993 · | · · · 2000 · · · · | · · · 2010 2011 · · · | · · | · · ·

'The medium is the body.'

Marina Abramović

b. 1946

SERBIA (FORMERLY YUGOSLAVIA)
/UNITED STATES

Marina Abramović has described her working life as a battle to put Performance Art into a mainstream art context. The self-proclaimed 'grandmother' of Performance Art says that when she started her career in Belgrade in the 1970s, her work was received as if she were 'the first woman walking on the moon'. She persisted, however, and the resulting pieces not only expanded the limits of art, they fundamentally altered the boundaries and, ultimately, changed the rules.

From the beginning of her career, Abramović placed the body at the centre of her practice, using her own physicality as both her subject and her material. In her early work she often subjected herself to pain, exploring her physical limits and, on occasion, putting herself at considerable risk. In *Rhythm 10* she took 20 knives and stabbed at the spaces between her splayed fingers until she cut herself. Each time she inflicted a wound she took a fresh knife. She recorded the performance then repeated it, accompanied by the recording, and attempted to recreate the same mistakes. In this, as in many of her pieces, she was pushing herself to 'experience the edge', to achieve heightened states of awareness and attain self-discovery through repetition, endurance and ritual. Ritual is important for Abramović, who places spirituality at the centre of her practice and often talks in terms of shamanism. She often ritualizes the simplest actions, such as lying, sitting or thinking, as in *The House with the Ocean View,* in which she inhabited three open and exposed platforms built into the Sean Kelly Gallery in New York for 12 days. Ladder-rungs made from large butcher's knives trapped her on the platforms, where she did nothing – neither eating nor speaking. She was observed by spectators through a high-powered telescope.

Engagement with others – both the audience and more personal relations – is critical in Abramović's work. For over a decade from 1976 she abraded her individual artistic identity by collaborating with Ulay, attempting to 'create something like a hermaphroditic state of being'. Some of their most famous pieces explore the nature of reliance on another person. Others, such as *Imponderabilia,* focus on the relationship between artist and audience. In this piece the pair stood naked, flanking the entrance to their exhibition. Anyone who wished to enter had to squeeze between them and had to choose which one to face.

In 2010, Abramović made the relationship with the viewer the essence of her work: *The Artist is Present* involved her sitting motionless and silent on a chair. She sat eight hours a day for three months, and simply allowed the audience to come and sit opposite her. She transcended physical and mental pain and offered herself to the audience. The reaction was phenomenal – thousands of visitors came, many of them wept. Abramović, ultimately vulnerable, captured and dramatized other people's pain and transformed it into a form of ecstasy.

Opposite Marina Abramović and Ulay, *Imponderabilia*, 1977. Performance, 90 minutes, at the Galleria Comunale d'Arte, Bologna, 1977. © Giovanna Dal Magro. Mario Carbone. Courtesy of the Marina Abramović Archives.

Above Portrait of Marina Abramović by Nils Müller, 2014. © Nils Müller and Wertical.

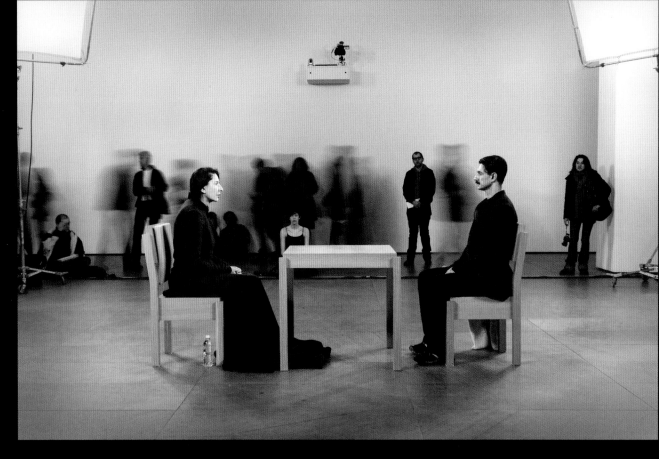

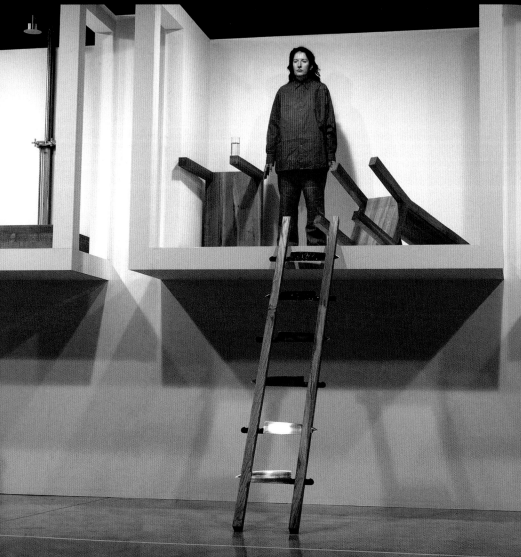

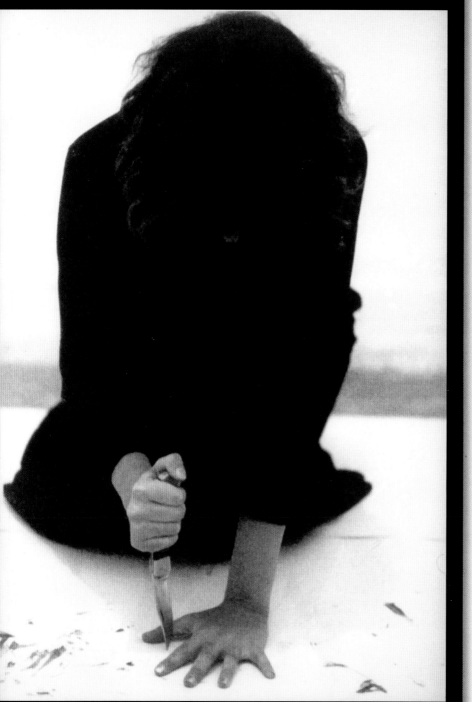

Marina Abramović

1940

1946 Born 30 November, Belgrade

1950

1960

1970

1972 Having first studied art in Belgrade, completes post-graduate studies in Zagreb

1973 First solo performance; uses her body as both subject and medium of her art

1976 Begins collaboration with West German Performance artist Ulay

1980

1988 Starting at opposite ends of China's Great Wall, Abramović and Ulay meet at the midpoint and say goodbye, marking the end of their collaboration

1990

2000

2010 Stages a three-month solo performance at MoMA, pushing physical and mental limits in silent exploration of performer–audience relationships

Opposite above *The Artist Is Present*,
2010. Performance, 3 months, at the
Museum of Modern Art, New York. Photo
by Marco Anelli. Courtesy of the Marina
Abramović Archives.

Opposite below *The House with the
Ocean View*, 2002. Living installation,
12 days, at the Sean Kelly Gallery. Photo
by Steven P. Harris. Courtesy of the
Marina Abramović Archives.

Above *Rhythm 10*, 1973. Performance at
the Museo d'Arte Contemporanea, Villa
Borghese, Rome. © Marina Abramović.
Courtesy of the Marina Abramović
Archives.

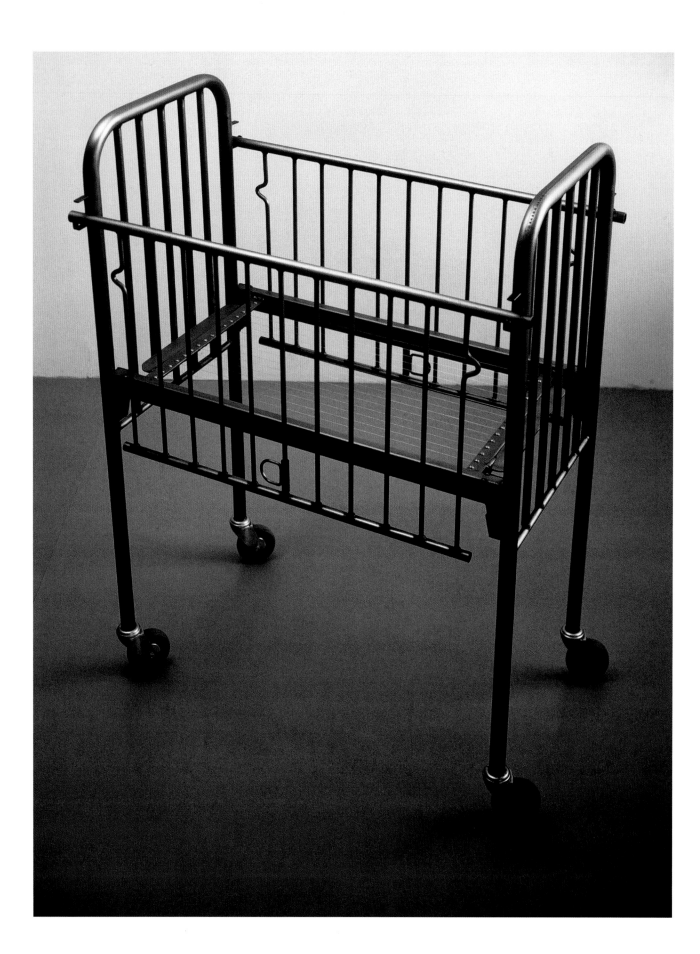

'I want to create a situation where reality itself becomes a questionable point.'

Mona Hatoum

b. 1952

UNITED KINGDOM

Although Mona Hatoum vehemently resists the categorization and biographical readings to which her life and work have always been subject, she acknowledges that dislocation and disjunction, a result of the multiple cultural displacements she has experienced, form the focus for explorations in her performance and installation pieces. This is clear in works such as *Map*, made entirely from glass marbles.

Born to a Palestinian family in Lebanon, she was stranded in London, alone, when the Lebanese civil war prevented her return to her family. She admits that, since early childhood, she had never felt she 'belonged' anywhere. In fact, her engagement with the idea of foreignness runs much deeper than questions of nationality or ethnicity, encompassing an exploration of the body, of femininity and of politics.

Hatoum's first experience of 'foreignness' was in the contemporary art scene in London. Although she was impressed by Minimalist and Conceptual experiments, she was shocked at how intellectualized and 'disembodied' these artists had become. She wanted to make work that would 'appeal to your senses first, to somehow affect you in a bodily way'. She did this with performance pieces that, motivated by political activism, used her own body as a tool. 'It was very much about the here and now, very impulsive and improvised. Nothing stayed behind — except perhaps a photo or two — and I really liked that.'

In the late 1980s Hatoum began to feel that her work was too directly political. She moved away from performance towards sculpture and installation, and increasingly blurred the boundaries between politics and aesthetics. She also left narrative behind and placed more emphasis on formal elements. She has said that she wanted to 'complicate these positions and offer an ambiguity and ambivalence rather than concrete and sure answers'.

Hatoum has achieved this by engaging the viewer in a physical, sensual and emotional way through the creation of uncanny, often frightening pieces. In *Incommunicado* she subverted expectations, particularly of the domestic sphere. She has also, in *Grater Divide*, magnified domestic objects into strange and violent things, effectively making the viewer a foreigner in a familiar land. She has also rendered the body abstract and unfamiliar by magnifying it to the point of abstraction, before diving through orifices on an endoscopic journey through its interior. Ultimately, she says that she does this to complicate things and to challenge perceptions about the world. Inevitably though, the associations of violence and cruelty that run through all her work bring it back to the experience of displacement. This is the sense in which it becomes truly groundbreaking, in forcing the viewer to experience a loss of control, a vulnerability and a lack of understanding.

Opposite *Incommunicado*, 1993. Mild steel and wire, 127 × 49.5 × 95.5 cm (50 × 19½ × 37⅝ in). © Mona Hatoum. Photo: Edward Woodman. Courtesy White Cube.

Above Portrait of Mona Hatoum by Gian Ehrenzeller, 2013.

Above *Grater Divide*, 2002. Mild steel,
204 × 3.5 cm (80⁵⁄₁₆ × 1³⁄₈ in).
© Mona Hatoum. Photo: Iain Dickens.
Courtesy White Cube.

Opposite *Map*, version II, 1999. 14mm
glass marbles, dimensions variable. ©
Mona Hatoum. Photo: Christian Mosar.
Courtesy Casino Luxembourg.

Mona Hatoum

Born in Beirut to Palestinian parents

Lebanese civil war erupts while
Hatoum visits London; she
remains, in exile

Graduates from the Slade
School of Fine Art, London;
dislocation and politics
aggressively inform her
largely body-focused video
and performance work

1950 1952 1960 1970 1975 1980 1981

Turns from performance to reflective installations and sculpture

Begins to move to large-scale, threatening representations of familiar objects

International reputation grows with solo exhibition at Centre Pompidou, Paris

Exhibits for a second time at the Venice Biennale, a decade after first appearance

Publishes monograph of her work

1987–89 1990 · · · 1994 | · · · 2000 · · · 2005 · · · · 2010 2011

'Uncertainty is the footprint of truth.'

Sophie Calle

b. 1953

FRANCE

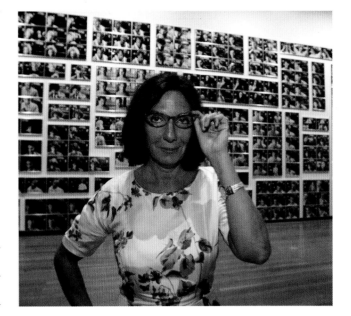

Unflinching honesty and an uncomfortable, direct exploration of personal details are typical of the Conceptual Art and photography of Sophie Calle. She explored what constitutes ourselves, our identity and our privacy long before the now-familiar culture of self-revelation. She did this by pushing against the edges of certainty and truth, blurring and layering reality, proving how irrelevant information ultimately is as a tool for understanding.

She started in the 1970s when, returning to Paris after seven years, she felt lost, directionless and alienated. She occupied herself by following strangers around the city and hypothetically constructing their identities. She claims the journeys were not works of art, simply a thing she did to avoid having to confront reality. In 1980, however, she followed a man all the way to Venice and presented the resulting narrative as a work of art. She took this one step further with *The Shadow*, in which she herself was shadowed by a private detective hired (at Calle's request) by her mother. *The Shadow* uses the typical tools of documentary – photographs and texts – that recount the ritual surveillance of a stranger. The work sent an electric shock through the art world. It was not just Calle's disregarding of privacy, nor that the work amounted to a public confession and was a parody of recent advances in photography (being artless, documentary and reliant on text), it was also that Calle had taken the visual apparatus of Conceptual Art and flipped it on its head. The cool objectivity of the 1970s became subjective and perceptual, and this subjectivity became a challenge. Some viewers were fixated on the 'reality' of the work, but, as Calle said, with admirable flippancy, 'I don't care about truth'. She frequently challenges the veracity of 'documentary' evidence, in some cases even fabricating her surveillance studies

when the reality she imagined does not materialize. This unravelling of one of society's prized commodities – information – is both uncomfortable and, as the work proves, exciting and beautiful.

Although Calle frequently uses intimate material from her life, she denies that the work is about self-exploration: 'If you ruled out private life, you would have to eliminate all poetry.' Her work is, she says, rather about how people relate to one another. It relies on a wide, public realm that is both subjective and quotidian and – perhaps most importantly – inhabited by the viewer. But then, a sincere explanation of the work is very unlikely to come from Calle herself. This is part of the fun: she loves to tease and she loves games. She turns reality into a ritual of chance and coincidence, and the resulting work is always playful and unexpected. A serious exploration does, however, lie at the centre of this 'fiction'. It is an exploration of voyeurism, of loss and attachment, and of control – be that of herself, of other people or simply of that elusive modern phenomena, identity.

Above Portrait of Sophie Calle by Fabian Matzerath, 2004.

1950

1953 — Born 9 October, Paris

1960

1970

1979 — Returns to Paris after seven years' travel. The self-taught artist begins her career by following and photographing strangers

1980 — Publishes her first voyeuristic photo series; begins her lengthy exploration of intimacy and human behaviour via controversial invasions of privacy

1990

1992 — Further explores issues of intimacy between strangers in her collaboration with photographer Gregory Shepard on a film documenting their journey to California

2000

2003 — Comprehensive retrospective, in Paris, celebrates her far-reaching iconoclasm

2007 — Wins international acclaim at the Venice Biennale for a *tour de force* installation of contemporary feminism; the exhibit subsequently travels

2010

Above View of the exhibition 'Rachel, Monique', 2012. Festival d'Avignon, Eglise des Célestins, France, 2012. Photo: André Morin. © Calle/ADAGP, Paris, 2014. Courtesy Galerie Perrotin.

'She was successively called Rachel, Monique, Szyndler, Calle, Pagliero, Gonthier, Sindler. My mother liked to be the object of discussion. Her life did not appear in my work, and that annoyed her. When I set up my camera at the foot of the bed in which she lay dying – I wanted to be present to hear her last words, and was afraid that she would pass away in my absence – she exclaimed: "Finally!"'

Opposite above *The Shadow*, 1981. Set of one text, one colour photograph, 29 black-and-white photographs partly assembled in groups, 11 texts. © Calle/ADAGP, Paris 2014. Courtesy Galerie Perrotin.

'In April 1981, at my request, my mother went to a detective agency. She hired them to follow me, to report my daily activities and to provide photographic evidence of my existence.'

Opposite below Detail of *No Sex Last Night (Double Blind)*, 1992. With the collaboration of Greg Shepard. Film, colour, sound, partly subtitled. Writing, camera and editing: Greg Shepard and Sophie Calle. Editor: Michael Penhallow. Production: Paolo Branco (Gemini Films), Bohen Foundation and Jean-René De Fleurieu (Paris, Skyline). Post-production: San Francisco Art Space. 72 minutes, 35 mm. © Calle / ADAGP, Paris 2014. Courtesy Galerie Perrotin.

'We hadn't been living together for more than a year, but our relationship had worsened to such an extent that we had stopped talking to one another altogether. I dreamed of marrying him. He dreamed of making movies. To get him to travel across America with me, I suggested that we make a film during the trip. He agreed. Our absence of communication gave us the idea of equipping ourselves with separate cameras, making them the sole confidantes of our respective frustrations and secretly telling them all the things we were unable to say to each other. Having established the rules, on January 3, 1992 we left New York in his silver Cadillac and headed for California.'

 g ready to go out. Outside, in ... private detective. He is paid ... but he does not know that. ... a postcard from Mont Saint ... often. Vacation...beautiful ... See you soon. Patrick". The ... wearing grey suede sneakers. ... vincent. Over my shoulder a ... Gassendi and buy marigolds. ... later Montparnasse cemetery ... e. b.1919 d.1903. I continue ... years, when I was going to ... me to imagine that there was ... at he survived only because of ... eft on his gravestone. At the ... met, I buy "Le Monde" and Nathalie walks with me to a ... "him" I am getting my hair ...

At 12:05pm I leave the hairdresser. My hair is electric; the young woman who hands me my raincoat is reassuring: "Outside, it will calm down". Then I walk towards Luxembourg Gardens. I want to show "him" the streets, the places I love. I want "him" to be with me as I go through the Luxembourg where I played as a child and where I received my first kiss in the spring of 1968. I keep my eyes lowered, I am afraid to see "him".

12:30pm. I am waiting for Eugene R., publisher, beneath the statue of Danton at Odeon Square. We're supposed to talk about a book I would like to get published; five minutes go by. My eyes meet, on the other side of the boulevard St. Germain, those of a man about 22, 5'6", short straight light brown hair, who jumps suddenly and attempts a hasty and awkward retreat behind a car. It's "him". A stranger steps up to me and asks where I bought my raincoat. Eugene R. comes at 12:40pm. He kisses me and takes me to an outdoor café nearby. At 1:05pm we say goodbye. I head for the Pantheon. From a phone booth, I call Bernard F. whom I would very much like "him" to see. When I was 9, I was certain Bernard F. was my father. Going through my mother's letters, I found and stole a letter he wrote which began: "My darling, I hope you are seriously thinking of sending our Sophie to boarding school...". When he came to visit my mother, I would sit on his lap and stare expectantly at him. Then Bernard F.'s visits became less frequent. I stopped sitting on his lap, everyone told me how much I looked like my father. By the age of 12, I had forgotten this mistaken lineage. My call wakes him up. He tells me that he is not ready to cope with the street.

1:20pm, I get to my studio, located at 36 rue d'Ulm in the former

premises of the convent of "Adoration Reparatrice". A short stop to pick up some papers. At 1:30pm, I come out again. I decide to stroll around Paris. I take rue Soufflot, Blvd. St. Michel and St. Germain. I'm afraid I've lost "him". Since our "meeting" at Odeon, not once did I feel his presence. I walk in the middle of the streets.

Arriving in front of 31 rue de Seine, Eric Fabre's Gallery, I try to push open the glass door, it does not budge. Further down the same street, in front of #6, I wait for "Roger Viollet, Photographic Archives", to open. I walk in at 2pm and ask for the file on private detectives. I flip through the photographs: All the faces look older than "him". I am reassured by his youth. I have a portrait of Detective Lepage. As I raise my eyes, I notice through the window, sitting on a bench across the street, the same young man I spotted at Odeon Square. Now I trust him. I'm not afraid of losing him anymore. I've become a part of the life of X., private detective. I structured his day, Thursday the 16th of April, in much the same way that he has influenced mine.

At 2:10pm, I move on. I cross the Pont Royal and head for the Louvre. At 2:20pm, after walking quickly through the museum, I find myself in front of Titian's "Man with a Glove". I have always liked this painting. The sad vacant eyes. The pouting mouth. The face as if beheaded, resting on a lace collar. But above all, this hint of a mustache.

At 3:10pm I leave the Louvre. In the garden of the Tuileries a photographer offers to take my picture with my camera. I accept. At 3:20pm I stop at the Tuileries' outdoor café and order a beer. I take pleasure in watching "him" have his drink at the counter.

At 4pm, I leave the Tuileries, cross the Place de la Concorde. At 4:30pm, I enter the "Palais de la Decouverte" (Discovery Exhibition center) which seemed a propos. I have an appointment with Jacques M. I see his silhouette on the second floor. We meander from room to room. In a doorway "he" brushes past us. At 5:45pm we leave the "Palais de la Decouverte". I walk with Jacques M. to his car. I give him a kiss and continue my walk alone. I decide to rest in a movie theatre. I walk up the Champs Elysees and after hesitating between Fassbinder's "Lili Marleen" and Loatner's "Is it Reasonable", a detective comedy, I opt for the first and enter the "Gaumont Colisee" at 5:25pm. Inside, I only think of "him". Is he enjoying this scattered, diffuse and ephemeral day I have offered him—our day. Half an hour later, at 6pm, I leave the theatre. I walk towards Chatelet.

At 7pm, I arrive at Chantal Crousel's Gallery, 80 rue Quincampoix for the "Gilbert & George" opening. There, I meet my father and take him outside with me. I want "him" to see my father. Back at the Gallery I chat, forgetting "him" a little. At 8pm, friends take me by car to a party for George and Gilbert in an apartment at 120 Ave. de Wagram. At midnight I leave in the same car to "Le Palace" where we have been invited, still in honor of George and Gilbert. I get to know Dan J. better, whom I met a few months earlier.

At 2am a taxi takes us both to the "O.K. Bar" at Varin. I eat spaghetti and drink whiskey.

At 5am we grab another taxi to go to his hotel, the "Hotel Tapétante". I am drunk and fall asleep. Before closing my eyes, I think of "him". I wonder if he liked me. Will he think of me tomorrow.

'We are all products of what we want to project to the world.'

Cindy Sherman

b. 1954

UNITED STATES

Cindy Sherman picked up a camera when she realized that she could not (or would not) enter the male-dominated world of painting. Photography was different: younger, less burdened by tradition and with less of a presence in the art world. In fact, its position as fine art was so tentative that, when Sherman produced her earliest experimental photographs as a student, she was promptly failed on technical grounds. Stimulated by what these preconceptions said about the discipline, she thought to herself, 'Well, yeah, let's just play with that'.

Play became a crucial aspect of Sherman's work. As a young artist she began to make the grainy, black-and-white *Untitled Film Stills* for which she is best known. The *Film Stills* are hypothetical recreations of Hollywood 'B' movies, in which the women protagonists (famously all modelled by Sherman herself), recall the vulnerable, ultra-feminine and often fearful roles that Hitchcock popularized in the 1950s. The women intentionally hover like half-remembered scenes from the viewer's memory, appearing as fragments of an open-ended narrative that can only be completed in the viewer's imagination. They are beautiful and the images inspire a certain inquisitiveness. At the same time, the implicit danger, stereotyping and implied voyeurism turn visual curiosity into something that is deeply disturbing.

The *Untitled Film Stills* were made deliberately badly. Sherman rejected the technical aspects of her medium, the ones on which most high-profile photographers had based their careers. Instead, she developed her prints in chemicals that were too hot and cracked the emulsion, making them grainy. She also left her shots slightly out of focus, and effected an unnaturally high contrast because, in her words, she wanted the works to look 'like cheap prints, not art'. She blew these 'cheap prints' up to the size of major paintings (20 × 16 inches,

that is 50.8 × 40.6 cm) and sold them in art galleries. Sherman's success fundamentally altered perceptions about photography. Not only did her work deny the value of technical accomplishment, it also asserted that photography is a viable art form on a level with painting and sculpture.

Throughout her career, Sherman has engaged with stereotypes and challenged accepted norms about identity. Although she has almost exclusively photographed herself, she denies autobiography in the work. Instead, she says that she inhabits a new character when she immerses herself in her roles. These are roles that draw attention to stereotypes in society, particularly those that revolve around femininity, sex and fashion. Her later series, *Society Portraits,* shows a succession of older women clearly cultivating an image of poise and authority, yet incidentally revealing a degree of artifice and insecurity through their self-conscious, forced poses. The understated artifice is typical of Sherman's uncompromising gaze, which penetrates straight through the unspoken tensions and deceptions in daily life, and uses appropriation and imitation to expose the uncomfortable truths of the modern world.

Above Portrait of Cindy Sherman by Herwig Prammer, 2012.

Above *Untitled #228*, 1990. Chromogenic
colour print, 208.3 × 121.9 cm (82 × 48 in).

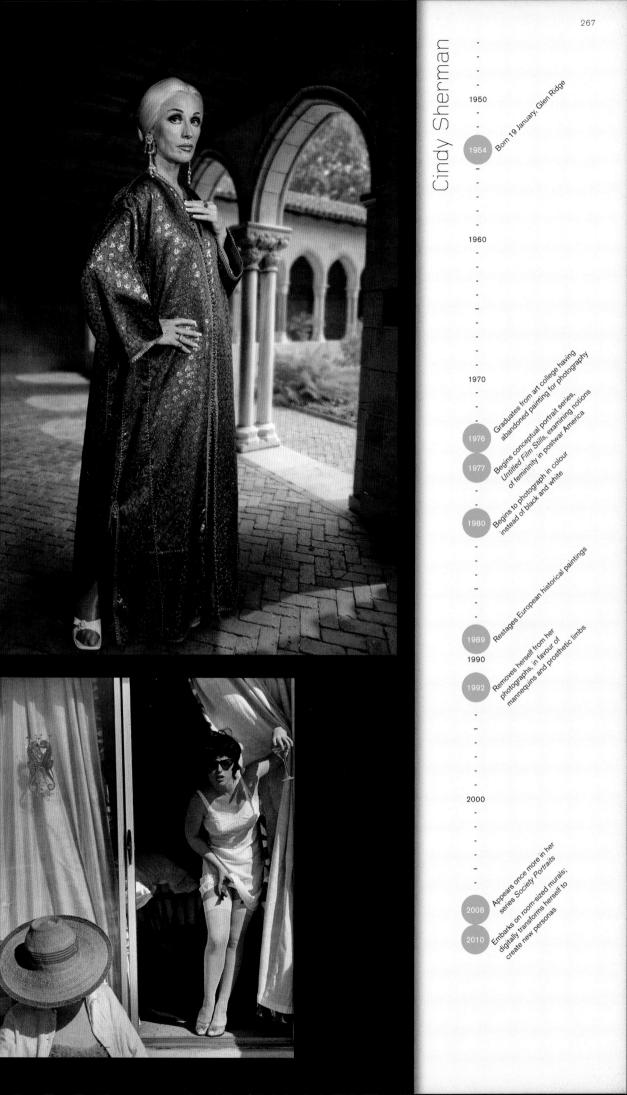

Cindy Sherman

- 1950

- **1954** Born 19 January, Glen Ridge

- 1960

- 1970

- **1976** Graduates from art college having abandoned painting for photography

- **1977** Begins conceptual portrait series, *Untitled Film Stills*, examining notions of femininity in postwar America

- **1980** Begins to photograph in colour instead of black and white

- **1989** Restages European historical paintings

- 1990

- **1992** Removes herself from her photographs, in favour of mannequins and prosthetic limbs

- 2000

- **2008** Appears once more in her series *Society Portraits*

- **2010** Embarks on room-sized murals; digitally transforms herself to create new personas

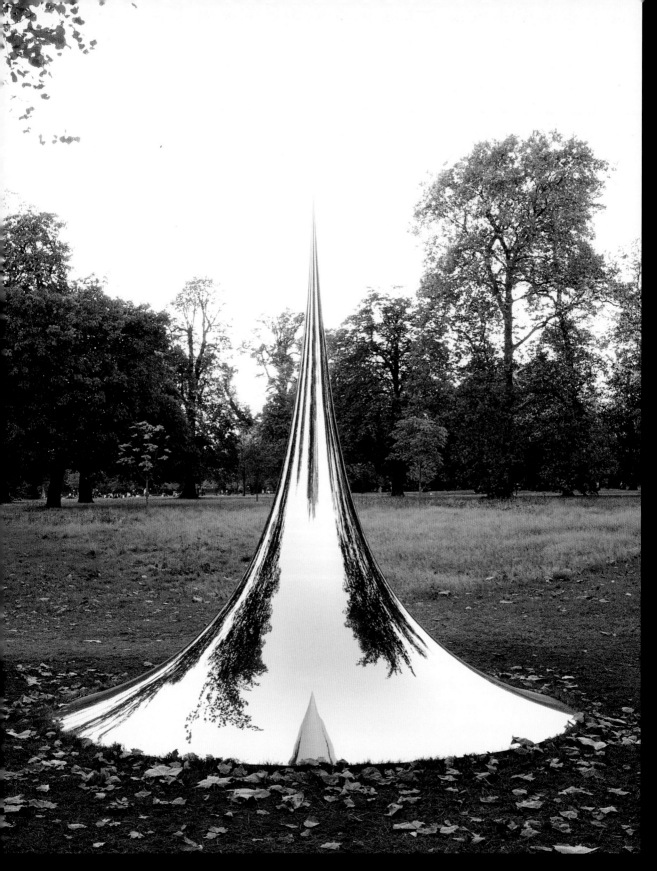

Non-Object (Spire), 2007. Stainless steel
302.2 × 300 × 300 cm (119 × 118⅛ × 118⅛ in).
Kensington Gardens, 2010–11. Photo: Tim
Mitchell. Courtesy: the artist and Gladstone
Gallery. © Anish Kapoor, 2014.

'Without your involvement as a viewer, there is no story.'

Anish Kapoor

b. 1954

INDIA/UNITED KINGDOM

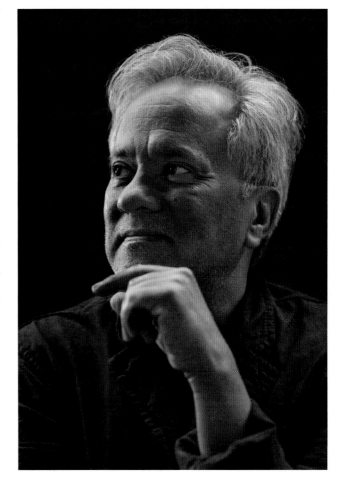

What Anish Kapoor has done, in many different ways throughout his career, is to challenge assumptions about sculpture with his sensual, yet elusive, abstract work. He has, in his own words, 'emptied out' space to create work that is 'all about illusion and the unreal'.

White Sand, Red Millet, Many Flowers, part of Kapoor's seminal early work *1000 Names,* consists of strange, simple forms covered with a novel material – pure, coloured pigment. It engages the viewer with its bright colours and tactility, but also with its inherent contradictions: childish yet aggressive; abstract but somehow natural; architectural, yet fragile enough to dissipate under a heavy breath. These paradoxes are part of Kapoor's practice and he does not try to explain them. 'I think these conditions are very hard, if not impossible, to put into words,' he has said. 'I must let that be the experience of the work.' He speaks in similarly elliptical terms about his subject-matter: 'In any proposition, the opposite is also true.'

Kapoor is more straightforward about space, which he has 'turned inside out'. This exploration also began with *1000 Names,* the individual elements of which he describes as 'submerged, like icebergs'. From this work grew an interest in the 'idea of something being partially there', which he pursued in the 1980s and 1990s. In many works from this period, solidity disappears into a literal void; in others, mirrored objects confuse space and disorientate the viewer.

As Kapoor grew in stature and expanded his practice, his scale increased. In large works like *Melancholia,* he continued to experiment with the idea of the void. He excavated the sculptural form and discovered, somewhat surprisingly, that his work became 'much more physical'. This was a powerful effect and one he has linked the effect it made to darkness and primal fear. Kapoor admits that he wants to create work that has the capacity to terrify.

Many artists deal with fear and death, but few since the 1950s have addressed the mystery of art. Kapoor is not interested in the quotidian: 'The post-Warholian notion that everything in the world is art – it's fine, but what it avoids is the truly poetic, or the poetic of a slightly different order. And it's that order I am interested in.' This does not mean that he has reverted to the Modernist mysteries of personal genius and prophetic vision: quite the opposite. Kapoor seeks to remove the artist's hand entirely, to allow mystery to remain inherent in the object itself. In his public sculptures he does this with scale and spectacular engineering. He has, he admits, sought to create a 'modern sublime'. He refuses to be embarrassed by the ritual, beauty and poetry of art. 'There's very little in life that's really mysterious,' he says. 'One of the things about art is that it can be mysterious, and remain mysterious, you can never quite get hold of it . . . I'm interested in a language where meaning is, if you like, excavated rather than immediately revealed.'

Above Portrait of Anish Kapoor by Jillian Edelstein, 2012.

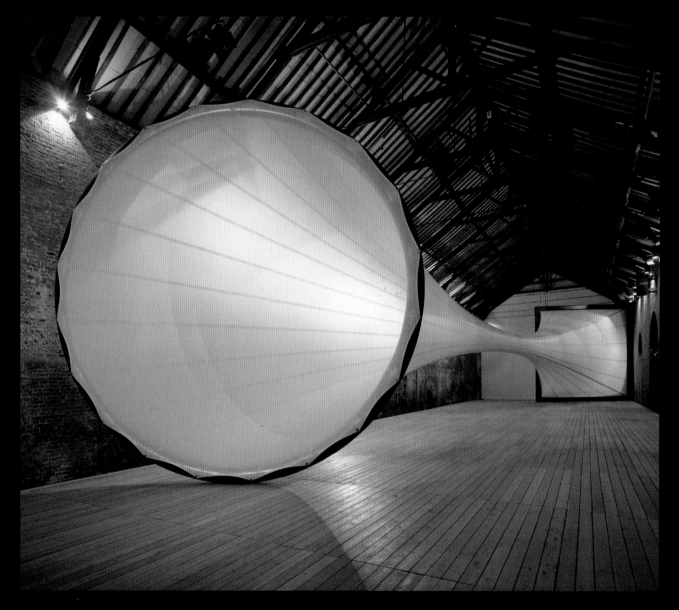

Above *Melancholia*, 2004. PVC and steel,
680 × 1,120 × 3,600 cm (267¾ × 441 × 1,417⅓ in).
Photo: Phillippe De Gobert. © Anish Kapoor, 2014.

Opposite *White Sand, Red Millet, Many Flowers*, from
1000 Names, 1982. Mixed media and pigment,
dimensions variable. Collection: Arts Council, South
Bank Centre, London. © Anish Kapoor, 2014.

Anish Kapoor

Born 12 March, Bombay

Moves to London, begins studies in art

Begins regular visits to his
spiritual/cultural roots in India

Starts to win recognition for brightly
coloured pigment pieces, where objects
apparently recede into powdery surfaces

1954 1960 1970 1973 1979 1980

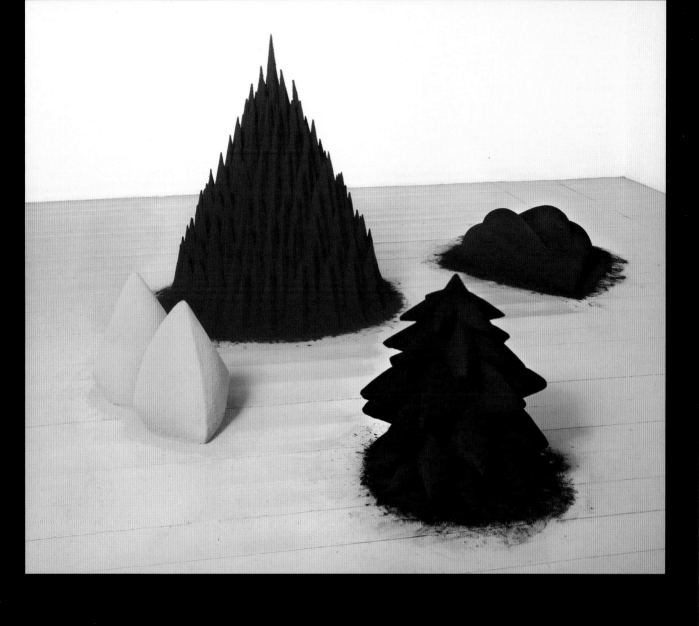

Abandons colour for natural stone;
carving voids into solids, he
begins to explore Hinduism's
metaphysical dualisms

Represents Britain at
the Venice Biennale

Starts working with
mirror-finish stainless steel

Honoured by Royal Academy
of Arts, London, with first solo
exhibition of a living artist

1987 1990 1995 2000 2009

'Art is an humanitarian act.'

Jeff Koons

b. 1955

UNITED STATES

That Jeff Koons has achieved something monumental is not up for debate. Exactly *what* he has achieved certainly is. The work of a man who once advertised a show with photographs that read 'Banality as saviour' polarizes opinion. His work is simultaneously facile and complex. Deemed the 'king of kitsch' by detractors, he has been subject to accusations of cynicism, vacuousness and sterility – in both his work and personality. He has also been lauded for his radical overhaul of taste and his disregarding of art-world hierarchy.

Koons's most famous pieces are blown-up balloon dogs, giant shiny red hearts and enormous puppies. They are, invariably, saccharine, clichéd and, in Koons's words, 'deliberately bourgeois'. They offer newness, transformation and a sense of contemporary abundance and delight. They are also funny, if the viewer can do as Koons asks and 'give in to their past, let go of their guilt and shame'. This breakdown of taste is one of Koons's principal triumphs, what he describes as the creation of an iconography for the middle-classes. Perhaps this is why his work so successfully inhabits our urban environment: Koons has become, more than merely an artist of note, a cultural phenomenon.

It began in the late 1970s when Koons, working as a commodities broker, began exhibiting branded, mass-produced items such as vacuum cleaners. He left them unaltered except that he displayed them in vitrines that recalled the clean lines, but none of the seriousness, of Minimalism. Following the success of these early works he set up a 'factory'. 'I'm the idea person,' he says. 'I'm not physically involved in the production. I don't have the necessary abilities.' Ironically, Koons never uses industrial processes at the factory. He has meticulously designed a system to create hand-crafted objects that look machine-made.

The result is pieces for which collectors will pay a lot of money, with Koons's work regularly breaking auction-house records. The commoditization of art is a thorny issue within criticism but Koons is unembarrassed by it. He admits that he thinks of his works as 'trophies' for the collector, for whom they function (in his opinion) as a 'drug'. This breezy approach to money stems from Koons's refusal to mystify art. He has said: 'I believe in advertisement and media completely. My art and my personal life are based in it.' Many critics find this hard to believe, but their accusations of cynicism and irony are graciously refuted by Koons, who repeatedly and charmingly responds with recycled platitudes about his work's 'optimism', healing qualities and its mission to reassure. By thwarting their interpretations, the man who has been described as the Willy Wonka of the art world whips his audience into an ever-greater frenzy of curiosity that only contributes to the cult of Koons. His work, in the end, is only half the equation: the other half is his life. It is a perverse send-up that is not a send-up after all.

Opposite *Balloon Dog (Magenta)*, 1994–2000. Mirror-polished stainless steel with transparent colour coating, 307.3 × 363.2 × 114.3 cm (121 × 143 × 45 in). © Jeff Koons.

Above Portrait of Jeff Koons by Chris Fanning, 2011.

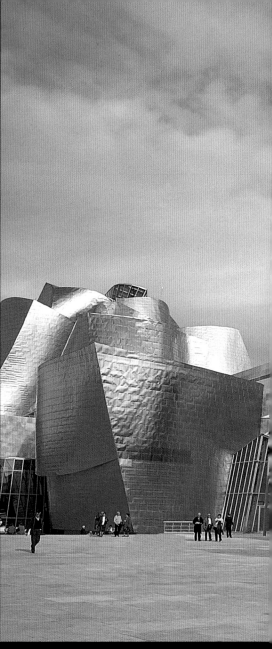

Left above *New Hoover Convertibles, Green, Red, Brown, New Shelton Wet/Dry 10 Gallon*, 1981–87. Four vacuum cleaners, Perspex and fluorescent lights, 251 × 137 × 71.5 cm (98⅞ × 53⅞ × 28³⁄₁₆ in). © Jeff Koons. Tate, London.

Left *Pink Panther*, 1988. Porcelain, 104.1 × 52.1 × 48.3 cm (41 × 20½ × 19 in). © Jeff Koons. Private collection.

Above *Puppy*, 1992. Stainless steel, soil, geotextile fabric, internal irrigation system and live flowering plants, 1,234.4 × 1,234.4 × 650.2 cm (486 × 486 × 256 in). © Jeff Koons. Guggenheim Museum, Bilbao.

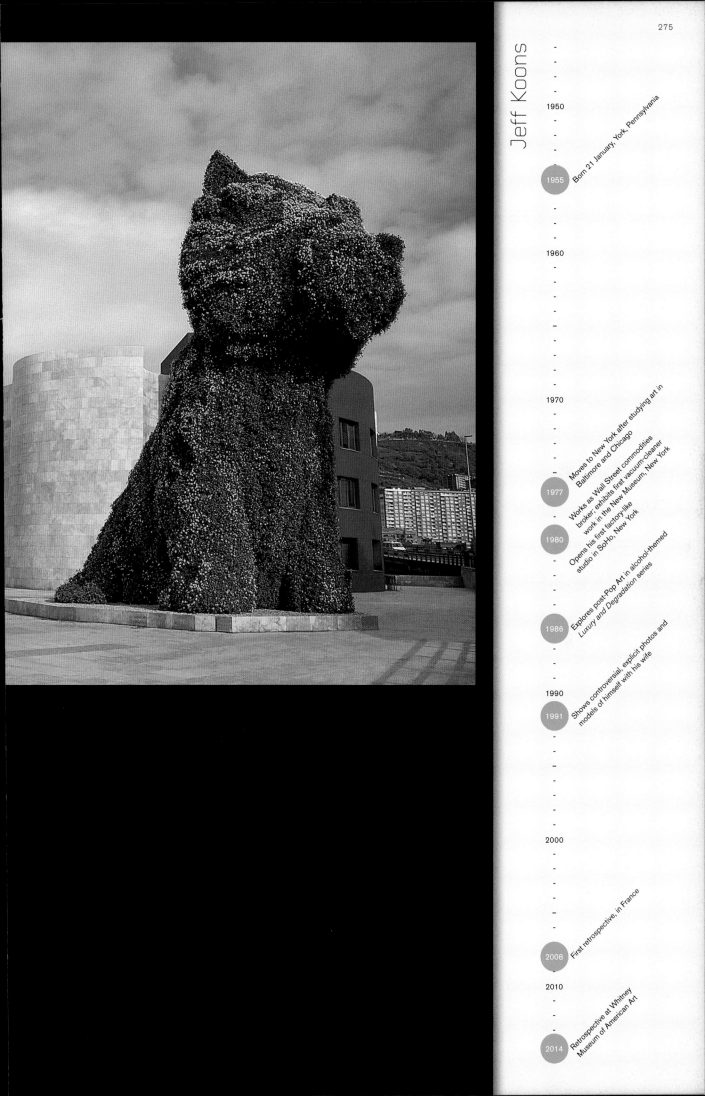

Jeff Koons

1950

1955 Born 21 January, York, Pennsylvania

1960

1970

1977 Moves to New York after studying art in Baltimore and Chicago

Works as Wall Street commodities broker; exhibits first vacuum-cleaner work in the New Museum, New York

1980 Opens his first factory-like studio in SoHo, New York

1986 Explores post-Pop Art in alcohol-themed *Luxury and Degradation* series

1990

1991 Shows controversial, explicit photos and models of himself with his wife

2000

2008 First retrospective, in France

2010

Retrospective at Whitney Museum of American Art

2014

Pyongyang I, 2007. C-print, 307 × 215.5 × 6.2 cm (120⅞ × 84⅞ × 2½ in). Copyright Andreas Gursky / VG
Bild-Kunst, Bonn 2015. Courtesy Sprüth Magers, Berlin, London.

'I am never interested in the individual, but in the human species and its environment.'

Andreas Gursky

b. 1955

GERMANY

After Cindy Sherman and Jeff Wall brought photography into the realm of the fine arts, the path was clear for a younger generation of artists to create large-scale works that explored the questions and themes previously reserved for painting. One of these was German photographer Andreas Gursky. He combined an impartial style with a spontaneity of observation, grandiose scale and colour. His images recorded the conjunction of industry and nature in the German landscape, and the human enjoyment of that landscape, through leisure activities such as swimming, skiing and hiking.

In all these early photographs the vast sweep of nature is photographed from a high vantage point that allows Gursky to subsume humanity within the larger patterns and forms of the land. This methodological, almost abstract, aesthetic became Gursky's hallmark as he began a comprehensive exploration of the contemporary world. In the late 1980s and into the 1990s he increased the scale of his photographs until he was using the largest photographic paper available. His images – which had always been full of information – became packed with more detail than the human eye could realistically perceive. At the same time, he moved his gaze from anonymous leisure activities to the faceless, man-made spaces of modern architecture and industry, including the Mercedes plant in Rastatt, Germany. He travelled all around the world, recording enigmatic, deadpan images of a post-industrial age.

Gursky became convinced, however, that the antiseptic industrial aesthetic he was searching for could not be successfully illustrated in photographic form and decided that 'photography is no longer credible'. He began to use digital retouching to manipulate his final image. Sometimes he combined images, sometimes he removed objects or saturated colours, notably in *Rhine II*. The resulting photographs are extraordinary in their technical accomplishments, which were taken to the furthest extreme in 2001 when Gursky created his first entirely fabricated image.

Despite this, Gursky does not believe he has moved beyond photography – he still seeks to recreate reality and merely uses the digital to 'emphasize formal elements that will enhance the picture', or to create scenes that would otherwise 'be impossible to realize'. In this sense, he engages with a very contemporary idea of truth. He has admitted his fascination with what people think of as the 'authenticity' of photography. In Gursky's opinion, authenticity lies in the mind of the artist: 'I subjugate the real situation to my artistic concept of the picture.' In this respect, his work falls more firmly within the traditional boundaries of 'fine art' than any of his Conceptual predecessors. Like Jeff Wall, Gursky re-engages with the traditional elements of craft and style. He uses these to create visionary landscapes, which in some sense are entirely constructed, artificial and dehumanized, and, in another, entirely true, and ultimately daunting, representations of the early twenty-first-century *zeitgeist*.

Above Portrait of Andreas Gursky by Dominik Asbach, c. 2012.

Andreas Gursky

Born 15 January, Leipzig, to a
commercial photographer father

Above *Rhine II*, 1999. C-print, 206 × 356 × 6.2 cm
(73 × 86⅖ × 2½ in). Copyright: Andreas Gursky /
VG Bild-Kunst, Bonn 2015. Courtesy Sprüth Magers,
Berlin, London.

Opposite *Mercedes, Rastatt*, 1993. C-print, 195.3 ×
210.3 × 5 cm (76⅞ × 82¾ × 2 in).
Copyright: Andreas Gursky / VG Bild-Kunst, Bonn
2015. Courtesy Musée National d'Art Moderne,
Centre Georges Pompidou, Paris.

Studies documentary
photography in Essen

Continues studies in Düsseldorf

Completes studies, having adopted
a dispassionate, systematic
approach in increasingly large works

First solo exhibition

Begins digital enhancements; heightens
colour and expands space beyond what
the human eye can perceive

MoMA retrospective, travels internationally;
first totally fabricated image

Breaks auction
record for a single
photograph
(US$4.3 million)

1978 · 1980 1981 · · | 1987 1988 1990 · · · · | · · 2000 2001 · · | · · · 2010 2011

'Ploughing a field is drawing lines on the land, painting the fields – it's incredibly visual.'

Andy Goldsworthy

b. 1956

UNITED KINGDOM

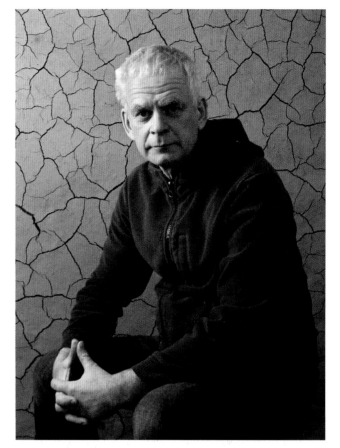

As a child, working on a farm outside Leeds, Yorkshire, Andy Goldsworthy volunteered for repetitive, manual tasks when the other boys started to drive tractors. He drew a lifetime of inspiration from this period, describing farming as 'a very sculptural activity'.

Engagement with the land is the guiding principle of Goldsworthy's sculptural practice. Works are created in the natural environment using only organic, found materials. This includes anything from trees, rocks and minerals, to pine cones and feathers or ephemeral materials including leaves, flowers and snow. He assembles them into apparently effortless simple shapes and patterns – arches, lines, circles, cones and spirals – using thorns, saliva, balance, gravity or whatever else comes to hand. He then photographs the results, which sometimes last for only a moment before the work succumbs to the forces of nature.

Through his unique and uncompromising process, Goldsworthy relinquishes an element of artistic control. He relies not only on the objects he finds, but on the less tangible aspects of place. He engages with the whole environment and says: 'The energy and space around a material are as important as the energy and space within . . . When I touch a rock, I am touching and working the space around it.'

Goldsworthy's method forces him to explore the landscape viscerally as well as aesthetically. He admits that he wants to, 'touch it, get under the skin of it somehow, try and work out exactly what it is'. It also ensures that the work is dynamic – in its conception, in the spontaneous and virtuoso control of precarious materials and unstable elements, and in the race to bring a work to completion before the materials unbalance, wither, melt or are blown away. This sense of ephemerality is potent in the photographs that Goldsworthy uses to document the works, and which he sells as independent pieces as well as in art books.

Goldsworthy's work is located within the tradition of Land and Conceptual Art. It, however, breaks new ground with its lack of cynicism and its unashamed revelling in craft and transient beauty, both of which were firmly rejected by the previous generation. Goldsworthy's work opens our eyes to new ways of perceiving forms, colours and objects. He does not protest against consumerism or the commercial art world; he reflects and reforms what he has found in his close exploration of nature. Neither does he neglect the human element of the landscape. His relationship with the land is first and foremost anthropocentric, with works such as *Storm King Wall* integrating nature with human presence. His completed pieces always reveal a mark of his interference in the land. His process is always implicit: he does not exclusively work with nature, so much as draw our attention to how we engage with and alter it.

Opposite *Penpont Cairn*, 1999–2000. Penpont, Dumfriesshire. Penpont Community Council.

Above Portrait of Andy Goldsworthy, 2014.

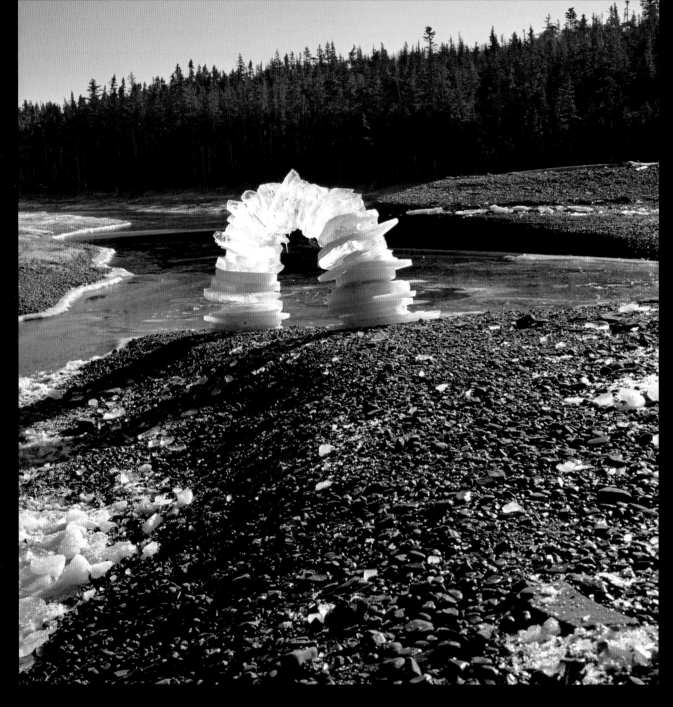

Above *Up early working in the dark before the day became*

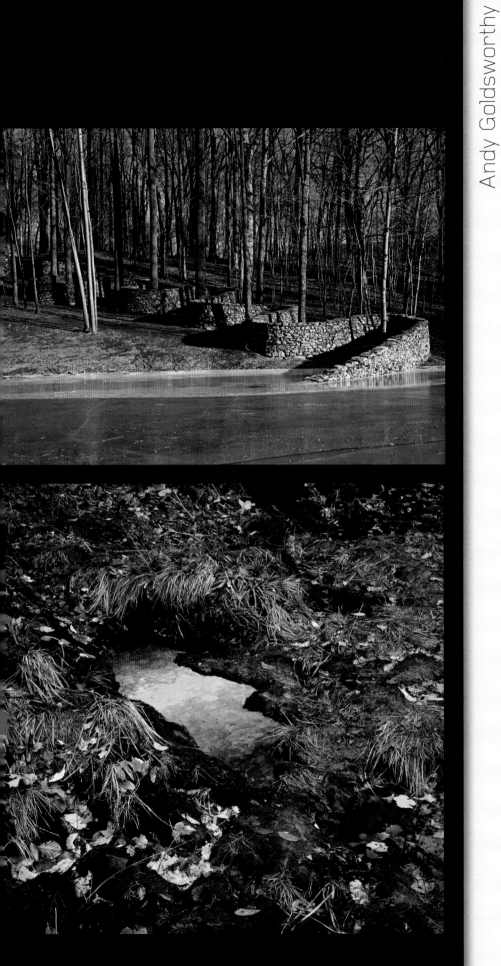

Andy Goldsworthy

1950
·
·
·
·
·
1956 ○ Born July 26, Cheshire
·
·
·
1960
·
·
·
·
·
·
·
·
·
1969 ○ As a teenager, begins working
with the land as a farmhand
1970
·
·
1974 ○ Begins art studies at
Bradford College of Art
·
· Completes studies in Preston, having
1978 ○ already assembled his first earthwork
with shoreline stones
·
· Exhibit at the Serpentine Gallery,
1980 London, marks the start of a rapid rise
1981 ○ to international renown
·
·
·
1985 ○ Moves to Scotland
·
·
·
·
1990
·
·
·
·
·
·
·
·
·
·
· Featured in *Rivers and Tides*
2000 documentary film; begins using
2001 ○ heavy machinery beyond his
customary bare-hand techniques
·
·
· 30-year retrospective at the
2007 ○ Yorkshire Sculpture Park

"Untitled" (USA Today), 1990. Candies individually wrapped in red, silver and blue cellophane, endless supply, overall dimensions vary with installation, ideal weight 136 kg (300 lbs). © The Felix Gonzalez-Torres Foundation. Courtesy of Andrea Rosen Gallery, New York. Installation view of: 'Artist's Choice: Mona Hatoum, Here is Elsewhere'. The Museum of Modern Art in Queens (MoMAQNS), New York. 7 November 2003 – 2 February 2004. Curator Mona Hatoum. Co-curated by Fereshteh Daftari.

'Above all else, it is about
leaving a mark that I existed:
I was here.'

Felix Gonzalez-Torres

1957–1996

UNITED STATES

MADRID 1971

The sculpture of Felix Gonzalez-Torres appears, at first, to have grown out of the Minimalist tradition. This is, in the artist's own words, a deliberate subterfuge: 'This type of work . . . has the image of authority . . . They look so powerful, they look so clean, they look so historical already. But in my case, when you get close to them you realize that they have been "contaminated" with something social.'

The 'social' element of Gonzalez-Torres's work is an intense and sustained critique of commonly held, conservative social attitudes. A homosexual Cuban who grew up in Puerto Rico and moved to New York in his twenties, he was subject to discrimination and actively engaged in cultural activism. Although his art is never explicitly political, it operates, in his words, from 'within the system'. From the beginning of his career he set out to subvert the neutrality and distance inherent in Minimalist sculpture, to reinvest abstraction with personal meaning and to establish a dynamic relationship with the viewer. His mission then, was a subtle one, but no less visionary for it.

His mature period began with his 'paper stacks': many of these featured pieces of paper with text or photographic images, piled in a gallery or museum. The viewer was allowed to take a sheet if they wanted. The 'paper stacks', and related works like the piles of candy – 'candy spills' – grew from an intense meditation on the nature of public art and the decision to start 'pushing certain limits, like the limits of editions, the limits of the inclusion of the viewer, the collector, other people in the work'. Gonzalez-Torres decided that the material components of the work should literally belong to the viewer. Although he admitted that he wanted to

challenge the system of the art-market, he also pointed out that 'it was about being generous to a certain extent'. In 1992, as part of an exhibition at the Museum of Modern Art, the artist exhibited "Untitled", 1991, on 24 billboards throughout New York City. The image used to produce the billboards is a photograph of an unmade bed. While Gonzalez-Torres downplayed aspects of his own life in relation to the understanding of his work, aspects of this 1991 piece have been interpreted as relating to the death of his boyfriend, who died from AIDS in 1991.

Gonzalez-Torres's vision lay in his ceaseless interrogation of art's interaction with its audience. He reinvented how work could be placed, produced and defined as an original project. His challenge transcended the art world. It addressed ideas about how we construct identity, how we deal with reality, mortality, the self and memory. Despite the work's public allure and its inherent tragedy, he sought neither catharsis nor emotion, but reflection. As he said himself: 'I want the viewer to be intellectually challenged, moved and informed.'

Above "Untitled" (Madrid 1971), 1988. C-print jigsaw puzzle in plastic bag and wall lettering. Three parts. Overall 38.1 × 45.7 cm (15 × 18 in); one part 24.1 × 19 cm (9½ × 7½ in); one part 19 × 24.1 cm (7½ × 9½ in); one part 1.27 × 7.6 cm (½ × 3 in). © The Felix Gonzalez-Torres Foundation. Courtesy of Andrea Rosen Gallery, New York.

Felix Gonzales-Torres

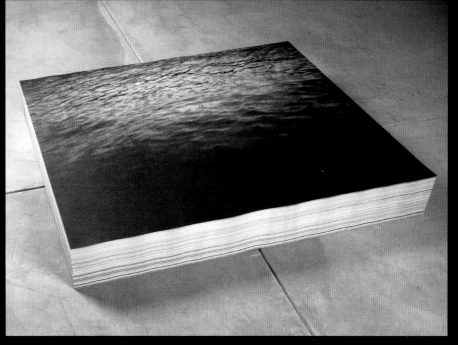

Left "Untitled", 1991. Billboard, dimensions vary with installation. © The Felix Gonzalez-Torres Foundation. Courtesy of Andrea Rosen Gallery, New York. Installation view of: Projects 34: *Felix Gonzalez-Torres*. The Museum of Modern Art, New York, 16 May–30 June1992. Brochure. [With billboards in 24 New York City locations.] Billboard location: 2511 Third Ave./E. 137th St., Bronx.

Above "Untitled", 1991. Print on paper, endless copies, 17.7 cm (7 in) at ideal height × 114.9 × 97.7 cm (45¼ × 38½ in) (original paper size). © The Felix Gonzalez-Torres Foundation. Courtesy of Andrea Rosen Gallery. Installation view of: *Felix Gonzalez-Torres*. Luhring Augustine Hetzler Gallery, Los Angeles. 19 October–16 November 1991.

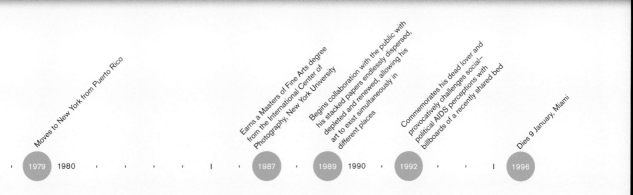

Moves to New York from Puerto Rico

Earns a Masters of Fine Arts degree from the International Center of Photography, New York University

Begins collaboration with the public with his stacked papers endlessly dispersed, depleted and renewed, allowing his art to exist simultaneously in different places

Commemorates his dead lover and provocatively challenges social-political AIDS perceptions with billboards of a recently shared bed

Dies 9 January, Miami

1979 1980 1987 1989 1990 1992 1996

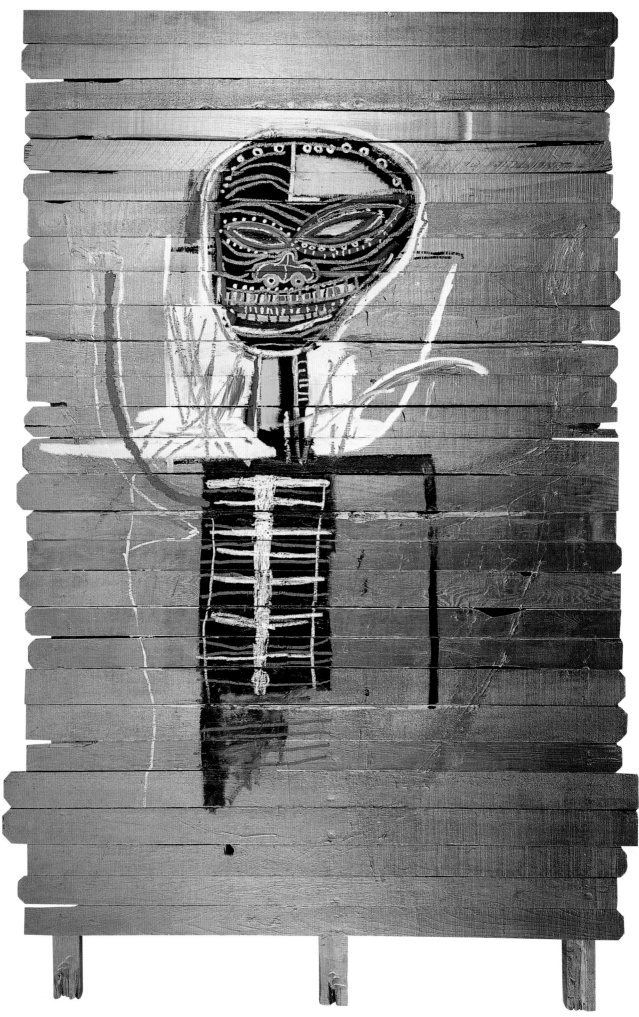

'Influence is not influence. It's simply someone's idea going through my new mind.'

Jean-Michel Basquiat

1960–1988

UNITED STATES

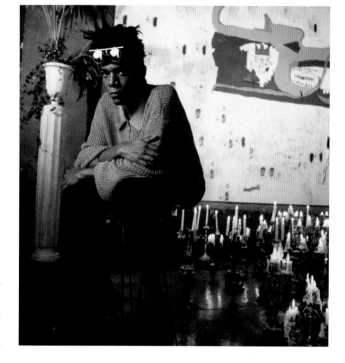

What evolved into an art-world revolution first appeared on the flaking walls and run-down subway stops of New York's D line in the late 1970s. It took the form of graffiti, unusually simple yet enigmatic aphorisms delineated in black spray-paint or in elegant, printed letters. It was tagged by SAMO, which stood for 'same old shit', and was orchestrated by two 17-year-old high-school drop-outs, Al Diaz and Jean-Michel Basquiat.

Basquiat claimed, retrospectively, that he never intended the graffiti as art. He did, however, admit that he was trying to build a name for himself. He succeeded, not only through the graffiti but also by playing music in downtown clubs such as the Mudd Club and CBGB (which stood for country, blue grass and blues) where he met other counter-cultural artists, including Keith Haring, in the early 1980s. This scene, which encompassed hip-hop, post-punk, jazz and Street Art, was a far cry from the sophisticated self-confidence of the impenetrable art-world galleries up in SoHo and it generated a new aesthetic – raw, primitive, political, aggressive and urban.

Basquiat incorporated all of this into his work of the period, which he began producing in earnest in 1979 and which exploded onto the art scene in 1980. He was described by poet Rene Ricard as a guerrilla, bombing out the aesthetic of the white wall. His work found an immediate audience: he had created a new vernacular for the urban viewer. The paintings used the vocabulary and the media of the street. He used whatever he could find – acrylic, oils stick, spray paint – and painted on whatever surface was available: window-frames, football-helmets or, in the case of *Gold Griot*, bits of picket fencing. He also painted recognizable figures from contemporary street life, covering them with the rich colour and expressive, painterly gesture of the great 1950s Modernists.

In his appropriation of style and materials Basquiat has been compared to the hip-hop artists and DJs who were his cultural icons. What made his work visionary, and what continues to make it key to the development of twentieth-century art, was the complexity, anger and intensity that he brought to his subject-matter. He integrated his images with irreverent references and words that expressed – with poetic clarity – his critique of the world in which he found himself. This critique addressed issues ranging from racism to poverty and from colonial history to the rise of materialism. From 1983 Basquiat focused increasingly on the African experience of America. His aesthetic became more chaotic and complex as he began to employ collage and photocopy and later, in 1984, silkscreen. The result was images that are beautiful, intense and accessible. They are dense with references to black heritage, spirituality, politics and contemporary culture, but retain a degree of mystery and originality that make them rivals to the greatest art of the twentieth century.

Opposite *Gold Griot*, 1984. Acrylic and grease pencil on wood, 297 × 185.5 cm (117 × 73 in). The Broad Art Foundation, Los Angeles.

Above Portrait of Jean-Michel Basquiat by Benno Friedman, c. 1986.

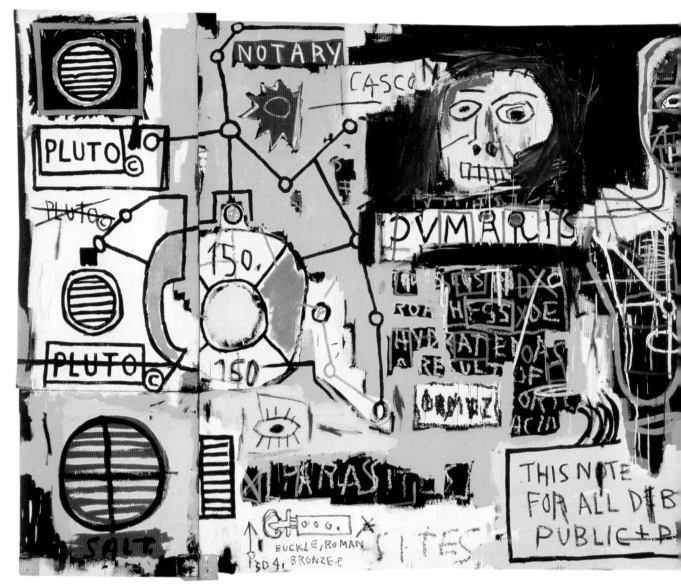

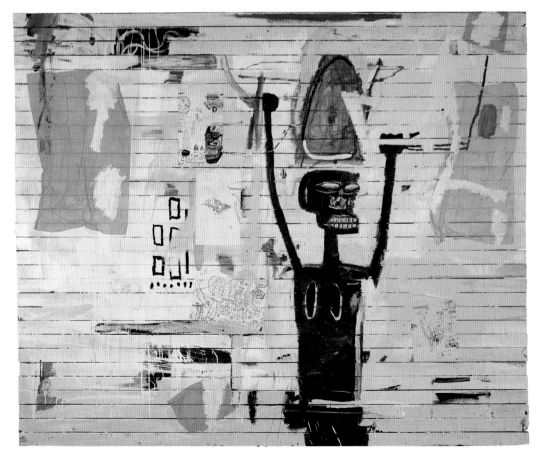

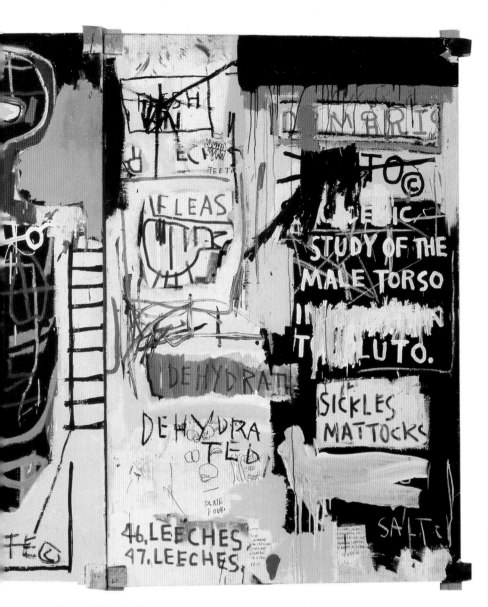

Above *Notary*, 1983. Acrylic, grease
pencil and collage, 180.5 × 401.5 cm
(71 × 158 in). The Shorr Family
Collection, on long-term loan to
Princeton University Art Museum.

Opposite *Potomac*, 1985. Acrylic, oil and
paper sticks on wood, 206 × 244 cm
(81⅛ × 96 in). Private collection.

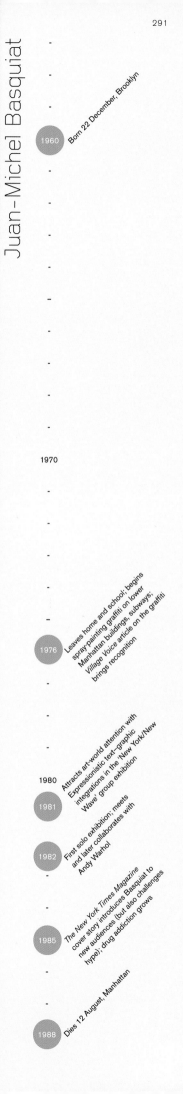

Juan-Michel Basquiat

1960 — Born 22 December, Brooklyn

1970

1976 — Leaves home and school; begins
spray painting graffiti on lower
Manhattan buildings, subways;
Village Voice article on the graffiti
brings recognition

1980

1981 — Attracts art-world attention with
Expressionistic text-graphic
integrations in the 'New York/New
Wave' group exhibition

1982 — First solo exhibition; meets
and later collaborates with
Andy Warhol

1985 — *The New York Times Magazine*
cover story introduces Basquiat to
new audiences (but also challenges
hype); drug addiction grows

1988 — Dies 12 August, Manhattan

Black Kites, 1997. Graphite on skull,
21.6 × 12.7 × 15.9 cm (8½ × 5 × 6¼ in).
Philadelphia Museum of Art. Gift (by
exchange) of Mr and Mrs James P. Magill,
1997. Courtesy of the artist and Marian
Goodman Gallery.

'In reality, the accident is the rule and stability is the exception.'

Gabriel Orozco

b. 1962

MEXICO

Gabriel Orozco's work constantly evolves and innovates – it is restless and searching, international and transformative. It engages with familiar materials, altering and rearranging them to draw attention to our perceptions of the familiar urban environment.

Orozco came of age in the late 1980s, when the lessons learned by the Conceptual artists of the 1960s were regaining currency. He reasserted art's role in radically questioning the world when he dispensed with his studio. He said of this decision: 'The way the work is produced affects the final result – not just the politics, but also the aesthetics. I don't want the responsibility and inertia of a production machine.' Instead, he started to engage with found materials in the urban landscape. Works such as *Until You Find Another Yellow Schwalbe* not only playfully experiment with and transform the everyday, they merge the boundary between 'art' and 'reality'.

Sometimes Orozco's work takes the form of photographs, sometimes sculptures, installations, even paintings such as *Samurai Tree*. There is no way to discern his authorship through style: the work constantly evolves to fit its environment which, as he travels a great deal, is rich and varied. Engaging with the world is important to Orozco. He seeks the poetry in found or discarded objects, for example those in *Working Tables*, not to challenge the art world and its institutions but because he wants his pieces to re-engage with humanity, to break down the barrier between art objects and their environment. By picking up and using the detritus discarded by individuals who inhabit the city he says, 'I try to make language confront reality, the reality of the street and what goes on there'.

Despite these grandiose ambitions, Orozco's art remains intimate. It is accessible even while it deals with the grand narrative of our interaction with the environment. Orozco is adamant that scale is not the 'primary factor'. He wants to engage his audience in a more profound way than through spectacle. 'I think good art makes a person individual and conscious,' he says. 'A good work of art is making a person aware of their individuality in that moment of concentration and awareness. It's not about entertaining or mesmerizing anybody.' Instead, he engages his viewer through humour and playfulness, and also through the use of physicality. Physicality appears in many forms in his work, and attention is often drawn to it through its very absence: in the traces that bodies leave in space, such as the greasy marks where heads rest on a chair or the suspension of sheets of lint (the human hair, dust and cells that are left to collect in drying machines). In one of his most elemental references to the physicality of our bodies, his *Black Kites,* graphite is painstakingly drawn over a real human skull.

Orozco's works are not necessarily beautiful or consistent. He arrests his viewer's consciousness through surprise, disappointment and humour. 'I try to be a realist,' he says. The result of this realism is work that is simultaneously a conundrum and a liberation.

Above Portrait of Gabriel Orozco by Eric Sander, c. 2014.

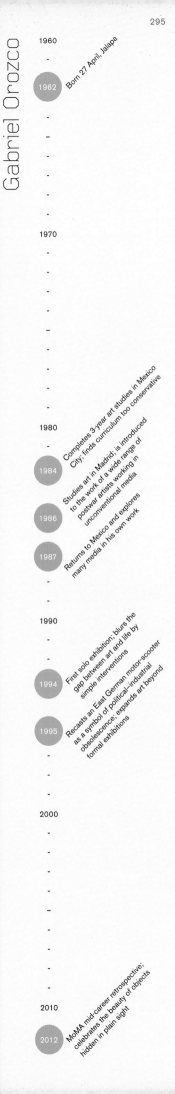

Opposite above *Until You Find Another Yellow Schwalbe*, 1995. One from 40 chromogenic colour prints, each 33.6 × 47.3 cm (13¼ × 18⅝ in). Tate, London. Courtesy of the artist and Marian Goodman Gallery.

Opposite below *Working Tables*, 2000–05. Mixed media including unfired clay, straw, egg container, bottle caps, wire-mesh screen, string, stones, shells, plaster, bark, polystyrene foam, painted wood elements and pizza dough, dimensions variable. Courtesy of the artist and Marian Goodman Gallery.

Below *Samurai Tree* (*Invariant 5*), 2005. Acrylic on linen canvas, 120 × 120 cm (47¼ × 47¼ in). Courtesy of the artist and Marian Goodman Gallery.

Gabriel Orozco

1960

1962 — Born 27 April, Jalapa

1970

1980

1984 — Completes 3-year art studies in Mexico City; finds curriculum too conservative

Studies art in Madrid; is introduced to the work of a wide range of postwar artists working in unconventional media

1986 — Returns to Mexico and explores many media in his own work

1987

1990

1994 — First solo exhibition; blurs the gap between art and life by simple interventions

1995 — Recasts an East German motor-scooter as a symbol of political–industrial obsolescence; expands art beyond formal exhibitions

2000

2010

2012 — MoMA mid-career retrospective; celebrates the beauty of objects hidden in plain sight

'It's almost like taking photographs or making prints of space.'

Rachel Whiteread

b. 1963

UNITED KINGDOM

Despite enrolling for painting as an undergraduate at Brighton Polytechnic, Rachel Whiteread was repeatedly drawn to the sculpture department. She went to a casting workshop and decided to cast the space around an ordinary domestic spoon. This was the turning-point of her thought process and the beginning of her career. As she said, her cast revealed an object that 'simultaneously both lost and retained elements of its essential spoon-ness . . . I knew it was challenging and interesting that something so simple could change your perception of objects.'

Whiteread continued to pursue her interest in space, particularly the internal, negative or lost spaces we tend to ignore. She has worked almost exclusively with casts, exhibiting these in their raw form rather than using them, in the traditional manner, simply to create moulds for finished pieces. Her casts turn empty spaces into material realities (such as the hollows underneath 16 school-room chairs). By inverting spatial expectations, she forces the viewer to confront their understanding of solids and voids. She describes this method as 'mapping, a process of making traces solid'.

Whiteread's casting practice is unusual but not innovative. Her materials – plaster, concrete, rubber, resin – were the industrial materials of the Minimalists and, years earlier (in 1968), Bruce Nauman produced a work entitled *Cast of the Space Under My Chair.* Whiteread's own practice, however, transformed earlier forms and ideas because in her own words she 'never made anything up'. Everything she has ever created has been cast from real life. As a student she used flotsam, junk and her own body, but gradually she turned to her past for inspiration. *Ghost,* a plaster cast of a Victorian sitting-room, was inspired by early childhood memories. It is similar to the house in which she grew up and her

motivating factor was a desire to 'mummify the air'. Her project was not simply the exploration of form; it was the exploration of meaning. For Whiteread, meaning resides in the familiar, household spaces that we so often overlook. By turning these empty spaces into solid objects, she grants them solidity and physicality so they seem to embody abstract notions such as memory, absence and loss.

As Whiteread's career has progressed her themes have grown. *Holocaust Memorial* is a library, but a library in which the shelves are reversed and the viewer is shut out. Whiteread described it as 'really about being on the outside of something and looking in . . . there's nothing. It's just this blank space.' This work made the invisible visible in a very public forum. It also expanded on Whiteread's interest in memory, insisting on its mystery and impenetrable nature. Like so many of her works, it bears something that she has admitted to admiring in other artists: the absoluteness of silence.

Opposite *Holocaust Memorial,* 1995–2000. Judenplatz, Vienna. Concrete, 380 × 700 × 1,000 cm (150 × 276 × 394 in). © Rachel Whiteread. Photo: Werner Kaligofsky.

Above Portrait of Rachel Whiteread, 2005.

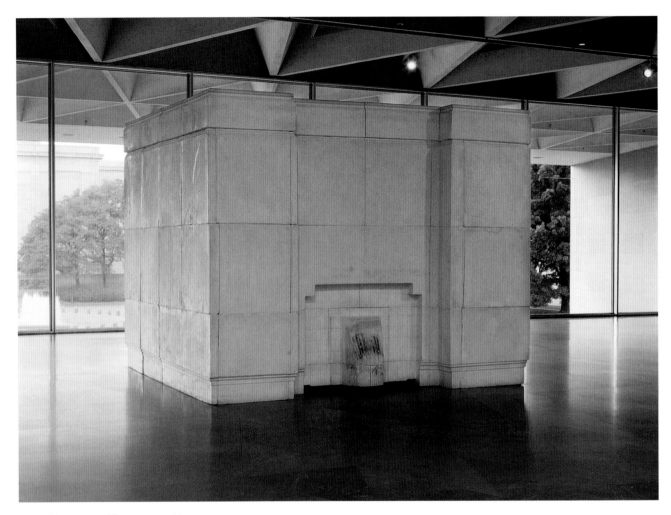

Above *Ghost*, 1990. Plaster on steel frame,
269 × 355.5 × 317.5 cm (105⅞ × 139¹⁵⁄₁₆ × 125 in).
National Gallery of Art, Washington, DC. Gift of The
Glenstone Foundation, 2004.121.

Opposite *Threshold II*, 2010. Resin, 196 × 76 ×
7.5 cm (77⅛ × 29⅞ × 3 in). © Rachel Whiteread.
Courtesy of the artist, Luhring Augustine, New York,
Lorcan O'Neill, Rome, and Gagosian Gallery.

Rachel Whiteread

Born 20 April, London

1960 1963 1970 1980

Wins attention with full-size cast of a sitting-room

Sprays concrete into a condemned terraced house and demolishes exterior walls; wins Turner Prize for best young British artist (first woman ever)

The remaining solid interior of *House* proves controversial and is demolished by the local council

Represents Britain at the Venice Biennale

Casts books to create a nameless library, Austria's *Holocaust Memorial*

Completes frieze for historic Whitechapel Gallery, London; recognized as a major sculptor of monumental public art

1990 · · 1993 1994 · 1997 · · 2000 · · · · · · · 2010 · · 2012

'I've never really felt the need to be original – most of my ideas are stolen.'

Damien Hirst

b. 1965

UNITED KINGDOM

In 1988 Damien Hirst was a student and co-organizer of an exhibition of student work called 'Freeze', staged as a very deliberate attempt to revolutionize the art world. The work itself was not exceptional – even the man who was to become its principal patron and supporter, Charles Saatchi, admitted that he was primarily attracted by its 'hopeful swagger'. Saatchi, millionaire and advertising mogul, subsequently found in Damien Hirst precisely what he had been looking for: reckless bravado, good enough work, a genius for manipulating the media and a profound interest in one of society's most recent and overriding concerns – money.

Saatchi maintained an interest in the former students throughout the 1990s. In 1991 he offered Hirst the chance of a lifetime: funding for any project of Hirst's choice. The result was Hirst's famous shark in formaldehyde, *The Physical Impossibility of Death in the Mind of Someone Living*. First exhibited in 1992 and made at a cost £50,000, the work instantly became the 1990s' most significant cultural and Pop icon.

Hirst has said that 'Art is about life and it can't really be about anything else . . . there isn't anything else.' While life (and death) factor in all his work, this comment is disingenuous. For what makes the shark so successful is not only its engagement with death, but its simple, playful and bullish mode of communication. Hirst made his work pithier and more accessible than any of the previous generation. He openly confesses that he engaged with science in works such as *Holidays* because 'science seemed to be getting people's attention and art didn't, so I hitched a ride on that'. His stated aim is to incite debate and he will do this however he can: by repackaging old Conceptualist ideas in a beautiful format that entirely contradicts the Conceptualist ethic; by exploiting the media and

the art market; by shocking the public, be it with a shark, a medicine cabinet or the public use of a team of assistants who turn his ideas into the painstakingly made 'spot paintings'.

Above and beyond all of this, Hirst deals with money. Whether he challenges, exposes or simply explores the role of consumerism in our society, he has finally made manifest the remark of his great hero, Andy Warhol: 'Well, I thought department stores were the new museums.' His work, and his approach to selling it, has been the catalyst in transforming art into a luxury item. *For the Love of God,* his notorious, diamond-studded platinum skull, was made expressly to be the most expensive work of art ever created. His dialogue with consumerism culminated in 2008, when he took the unprecedented step of selling an entire show directly at auction. Held the day before the Lehmann brothers collapse, the sale raised £111 million. His response was: 'I don't believe in genius, I believe in freedom.'

Above Portrait of Damien Hirst with *The Kingdom* by Billie Scheepers, 2008.

Opposite *The Physical Impossibility of Death in the Mind of Someone Living*, 1991. Glass, painted steel, silicone, monofilament, shark and formaldehyde solution, 217 × 542 × 180 cm (85⅓ × 213⅓ × 70⁹⁄₁₀ in).

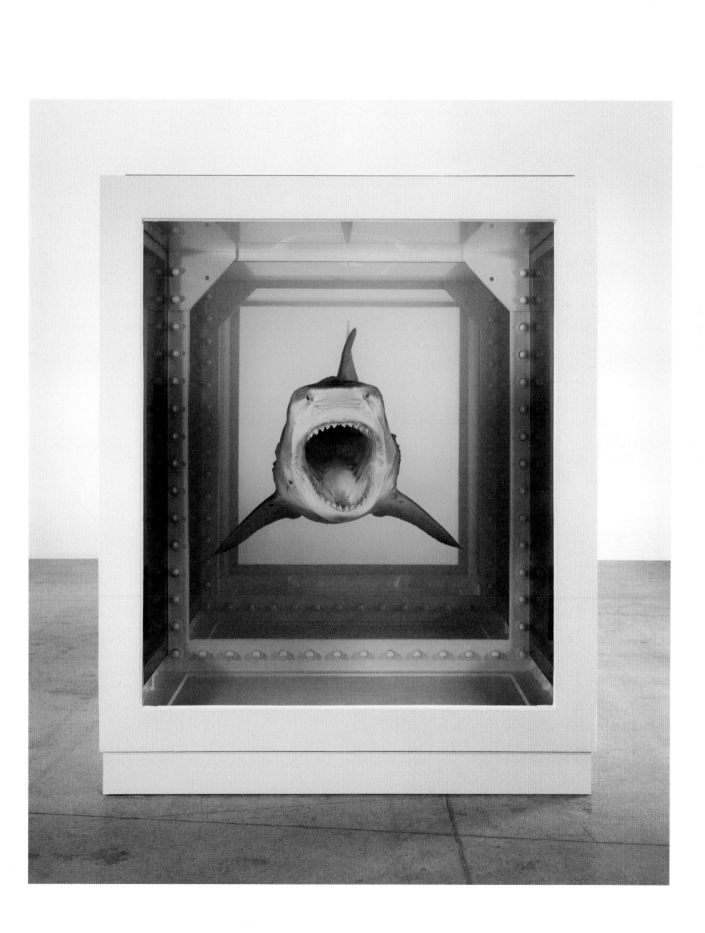

Damien Hirst

1960

1965 — Born 7 June, Bristol

1970

1980

1986 — Begins degree in Fine Art at Goldsmiths, University of London

Achieves prominence as part of 'Young British Artists' with shocking exhibition of rotting cow's head; death themes remain central to his art

1990 — Creates Britart icon with formaldehyde-suspended shark

1991 — Wins Turner Prize; champions the creative idea (assistants execute his numerous works)

1995

2000

2008 — Breaks precedent of selling through a gallery by direct auction at Sotheby's; becomes UK's richest artist

2010 — Major retrospective at Tate Modern (elicits criticism for death of 9,000 butterflies)

2012

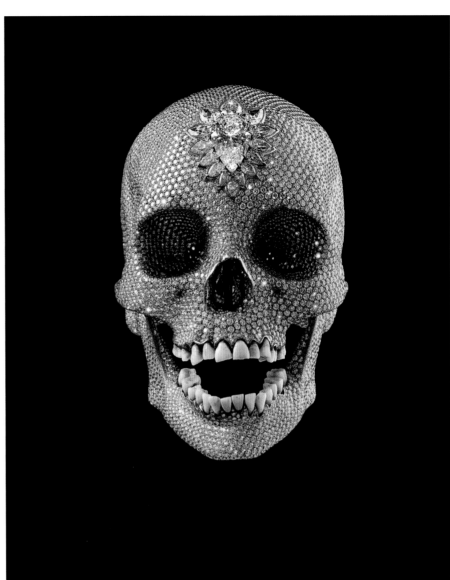

Opposite above *For the Love of God*, 2007. Platinum, diamonds
and human teeth, 17.1 × 12.7 × 19.1 cm (6¾ × 5 × 7½ in).

Opposite below *Apotryptophanae*, 1994. Houshold
gloss on canvas, 205.7 × 220.9 cm (81 × 87 in).

Above *Holidays*, 1989. Glass, faced particleboard,
ramin, plastic, aluminium and pharmaceutical
packaging, 137.1 × 101.6 × 22.8 cm (54 × 40 × 9 in).

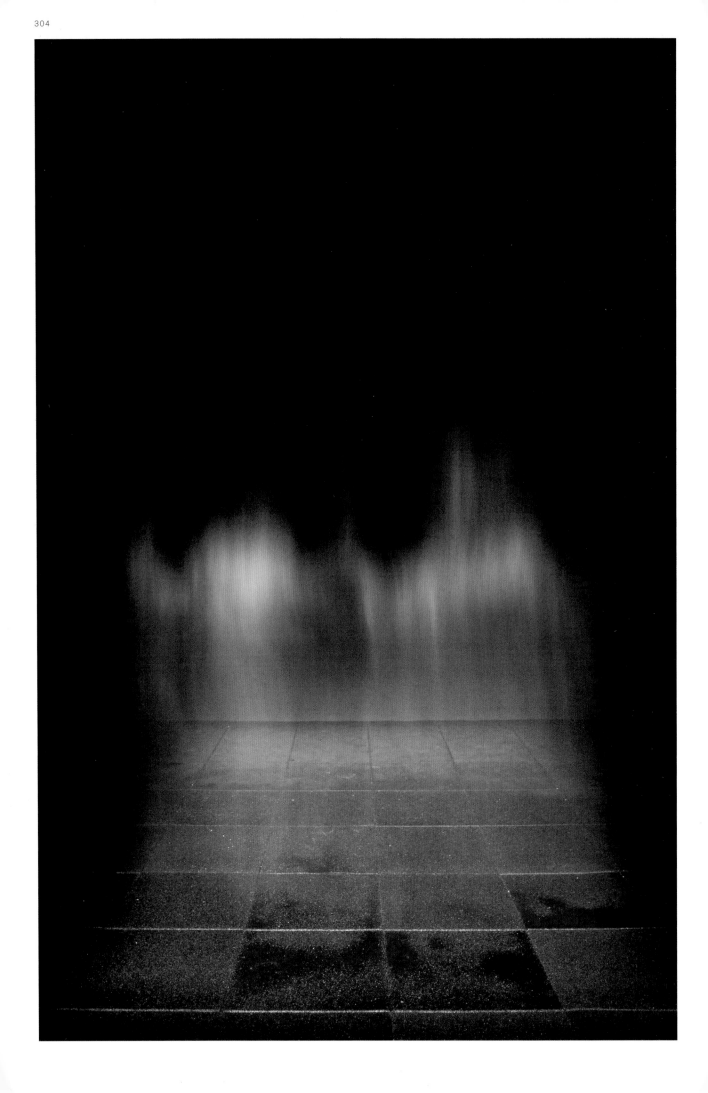

'I don't think we should be afraid to do something very beautiful.'

Olafur Eliasson

b. 1967

DENMARK/ICELAND

The work of Olafur Eliasson is spectacular and awe-inspiring. It eschews irony and cynicism, and instead engages with something about which artists since the 1950s have been rather ambivalent, if not wary – beauty. Elíasson admits that beauty is one of the greatest challenges, both to himself and to contemporary art: 'I don't think we should be afraid to do something very beautiful and very engaging and very, somehow, seducing.' He always, however, balances beauty with what he refers to as the more 'rigorous' aspect of his work – the intellectual and emotional enquiry – admitting that he is interested in exploring the 'blurred area' between the two.

The resulting pieces reveal a masterful equilibrium between form and cerebral enquiry. Eliasson explores this equilibrium through a range of media, from photography to light installation and architecture, and, to great public acclaim, through his creation of immersive spaces. He often, as in *Moss Wall,* uses natural phenomena in artificial spaces or alters intangible qualities such as light: in *360° Room for All Colours,* the viewer is enveloped by slowly modulating colour. He says, however, that the materials themselves hold no interest for him, that he is less interested in the boundary between the organic and the artificial, than he is in questions such as, 'Do you feel a part of this world?' and 'How do you use your senses?'

Eliasson uses the undisguised artifice in his work to force the viewer to engage with their perception of reality and to consider the degree to which their everyday experiences are mediated by artificial interjections. His manipulations of light, space and natural phenomena are achieved through painstaking scientific and architectural research, and he is careful to leave elements of the technology exposed in the final pieces. In this sense, Eliasson's work is intensely political. By encouraging his viewers to reassess how they experience space, or colour, or light, he forces them to consider how they exist in the world. In Eliasson's words, his goal is to make his viewers think, consciously, every time they 'take a step'. It is 'not just about decorating the world . . . it's obviously also about taking responsibility,' he says. The only way we will learn to take responsibility is to become aware of how 'culturally produced' our senses are and, consequently, our entire process of perception. Eliasson's genius is that by creating works that have to be experienced physically by the viewer, he allows each person to discover this fissure between reality and artifice individually, on their own terms, while remaining connected by the shared experience of art. This is important to Eliasson, who has also said that his work is about community and collectivity, about 'being together'. His work is unique in that it creates a truly democratic art that never relents in its rigorous pursuit of a truth that is firmly rooted in the experience of the twenty-first century.

Opposite *Beauty*, 1993. Spotlight, water, nozzles, wood, hose, pump. © 1993 Olafur Eliasson.

Above Portrait of Olafur Eliasson in his Berlin studio. © 2012 Olafur Eliasson.

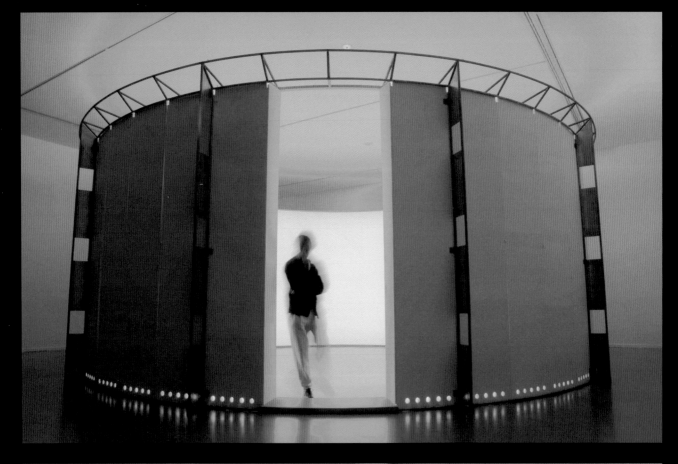

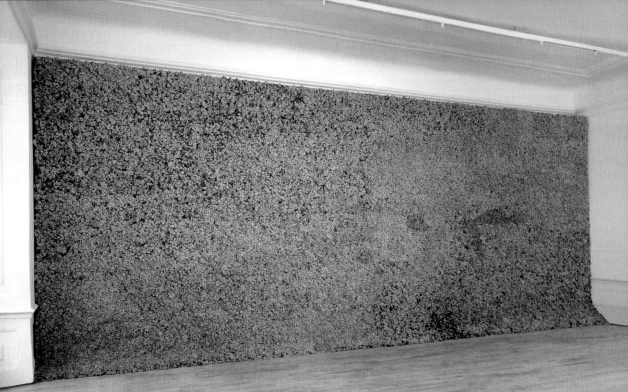

Opposite above *360° Room for All Colours*, 2002. Stainless steel, wood, fluorescent lights, colour filter foil (red, green, blue), projection foil. © 2002 Olafur Eliasson.

Opposite below *Moss Wall*, 1994. Moss, wood, wire. © 1994 Olafur Eliasson.

Below *La situazione antispettiva*, 2003. Stainless steel, stainless steel mirror. © 2003 Olafur Eliasson.

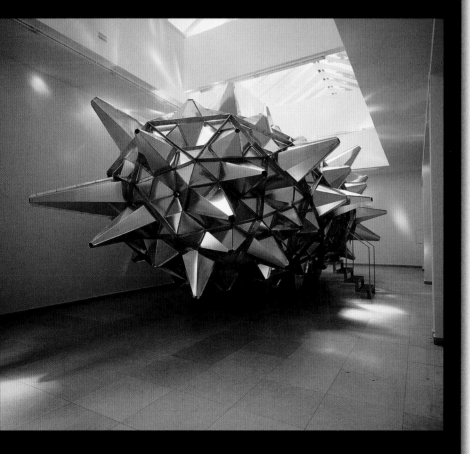

Olafur Eliasson

1967 Born 5 February, Copenhagen

1970

1980

1990

1995 Completes six-year study of traditional arts in Copenhagen, including a spell in New York working as a studio assistant; interested in neurology and perception

1996 Begins collaborations with architects and other specialists on ephemeral installations involving temperature, pressure, light, sound and other intangibles

2000

2003 Creates Britart icon with *The Weather Project* indoor weather with mist, illuminated 'sun disc' and mirror; draws millions to Turbine Hall, Tate Modern, London

2007 First major retrospective (travels internationally); encourages viewer involvement through sensory engagement

2008 Focuses attention on New York's frequently overlooked natural resources with temporary man-made waterfalls

Further Reading

Antliff, Mark, and Patricia Leighten. *Cubism and Culture* (London: Thames & Hudson, 2001).

Balken, Debra Bricker. *Abstract Expressionism* (London: Tate Publishing, 2005).

Bashkoff, Tracey, et al. *Art of Another Kind: International Abstraction and the Guggenheim, 1949–1960* (New York: Guggenheim Museum, 2012).

Batchelor, David. *Minimalism* (Cambridge: Cambridge University Press, 1997).

Beardsley, John. *Earthworks and Beyond: Contemporary Art in the Landscape*, 4th ed. (New York: Abbeville Press, 2006).

Behr, Shulamith. *Expressionism* (London: Tate Publishing, 1999).

Benson, Timothy O. *Expressionism in Germany and France: From Van Gogh to Kandinsky* (Munich: Prestel, 2014).

Bergdoll, Barry, and Leah Dickerman. *Bauhaus 1919–1933: Workshops for Modernity* (New York: Museum of Modern Art, 2009).

Bishop, Claire. *Installation Art: A Critical History* (London: Tate Publishing, 2005).

Brettell, Richard R. *Modern Art 1851–1929: Capitalism and Representation* (Oxford: Oxford University Press, 1999).

Carlin, John, and Jonathan Fineberg. *Imagining America: Icons of 20th-Century American Art* (New Haven: Yale University Press, 2005).

Causey, Andrew. *Sculpture Since 1945* (Oxford: Oxford University Press, 1998).

Chipp, Herschel B. *Theories of Modern Art: A Source Book by Artists and Critics* (Berkeley: University of California Press, 1968).

Christov-Bakargiev, Carolyn, ed. *Arte Povera* (London: Phaidon, 1999).

Collins, Bradford R. *Pop Art: The Independent Group to New Pop, 1952–1990* (London: Phaidon, 2012).

Comer, Stuart, ed. *Film and Video Art* (London: Tate Publishing, 2009).

Cox, Neil. *Cubism* (London: Phaidon, 2000).

Dickerman, Leah. *Inventing Abstraction, 1910–1925: How a Radical Idea Changed Modern Art* (New York: Museum of Modern Art, 2012).

Foster, Hal, et al. *Art Since 1900: Modernism, Antimodernism, Postmodernism,* 2nd ed. (London: Thames & Hudson, 2011).

Gale, Matthew. *Dada & Surrealism* (London: Phaidon, 1997).

Gillen, Eckhart, ed. *German Art from Beckmann to Richter: Images of a Divided Country* (Cologne: DuMont Buchverlag, 1997).

Godfrey, Tony. *Conceptual Art* (London: Phaidon, 1998).

Goldberg, RoseLee. *Performance Art: From Futurism to the Present,* 3rd ed. (London: Thames & Hudson, 2011).

Gooding, Mel. *Abstract Art* (London: Tate Publishing, 2001).

Green, Christopher. *Art in France, 1900–1940* (New Haven: Yale University Press, 2000).

Greene, Vivien, ed. *Italian Futurism 1909–1944: Reconstructing the Universe* (New York: Guggenheim Museum Publications, 2014).

Gualdoni, Flaminio. *Art: The Twentieth Century* (Milan: Skira, 2008).

Heartney, Eleanor. *Postmodernism* (London: Tate Publishing, 2001).

Hopkins, David. *After Modern Art, 1945–2000* (Oxford: Oxford University Press, 2000).

Hopkins, David. *Dada and Surrealism: A Very Short Introduction* (Oxford: Oxford University Press, 2004).

Hughes, Robert. *The Shock of the New*, rev. ed. (New York: Knopf, 1991).

Jenkins, Janet, ed. *In the Spirit of Fluxus* (Minneapolis: Walker Art Center, 1993).

Klar, Alexander. *Fluxus at 50* (Bielefeld: Kerber, 2012).

Livingstone, Marco. *Pop Art: A Continuing History* (London: Thames & Hudson, 2000).

Lumley, Robert. *Arte Povera* (London: Tate Publishing, 2004).

Meyer, James Sampson, ed. *Minimalism* (London: Phaidon, 2000).

Perry, Gill, and Paul Wood, eds. *Themes in Contemporary Art* (New Haven: Yale University Press in association with the Open University, 2004).

Peters, Olaf, ed. *Degenerate Art: The Attack on Modern Art in Nazi Germany, 1937* (Munich: Prestel, 2014).

Prendeville, Brendan. *Realism in 20th Century Painting* (London: Thames & Hudson, 2000).

Rosenthal, Mark. *Abstraction in the Twentieth Century: Total Risk, Freedom, Discipline* (New York: Guggenheim Museum, 1996).

Rosenthal, Mark. *Understanding Installation Art: From Duchamp to Holzer* (Munich; New York: Prestel, 2003).

Rush, Michael. *New Media in Art* (London: Thames & Hudson, 2005).

Rush, Michael. *Video Art* (London: Thames & Hudson, 2003).

Storr, Robert. *Modern Art Despite Modernism* (New York: Museum of Modern Art, 2000).

Terraroli, Valerio, ed. *Art of the Twentieth Century*, 5 vols. (Milan: Skira, 2006–2010).

Tufnell, Ben. *Land Art* (London: Tate Publishing, 2006).

Whitfield, Sarah. *Fauvism* (London: Thames and Hudson, 1991).

Wood, Paul, ed. *Varieties of Modernism* (New Haven: Yale University Press in association with the Open University, 2004).

Wood, Paul, et al. *The Great Utopia: Russian and Soviet Avant-Garde, 1915–1932* (New York: Guggenheim Museum, 1992).

Wood, Paul. *Conceptual Art* (London: Tate Publishing, 2002).

Index

Figures in **bold** refer to main entries and figures in *italics* refer to images.

Picture Credits

Laurence King Publishing Ltd, the author and the picture researcher wish to thank the institutions and individuals who have kindly provided photographic material for use in this book. Numbers below are page numbers. While every effort has been made to trace the present copyright holders we apologize in advance for any unintentional omission or error and will be pleased to insert the appropriate acknowledgement in any subsequent edition.

ADAGP Société des Auteurs dans les Arts Graphiques et Plastiques, Paris
ARS Artists Rights Society, New York
BAL Bridgeman Art Library
BPK bpk, Bildagentur für Kunst, Kultur und Geschichte, Berlin
DACS © Design and Artists Copyright Society, London 2015
DeAgostini DeAgostini Picture Library
MMA Image copyright The Metropolitan Museum of Art
MNAM Photo © Centre Pompidou, Musée National d'Art Moderne, Munich
RMN Réunion des musées nationaux, Paris
Scala © Photo Scala, Florence
SIAE Società Italiana degli Autori ed Editori
VAGA Visual Arts and Galleries Association, New York
VEGAP Visual Entidad de Gestión de Artistas Plásticos, Madrid

t–top; b–bottom; l–left; r–right

Front Cover Picasso with his sculpture "Tête de femme (Female head), Vallauris, 1951. Photo akg-images/ullstein bild

Page 6 © Bob Adelman/Corbis; **8** Solomon R Guggenheim Museum, New York/akg-images; **9** Private Collection/Roger-Viollet, Paris/BAL; **10tl** Solomon R Guggenheim Museum, New York/akg-images;

Acknowledgements

In London, thanks go to Laurence King and Kara Hattersley-Smith, who conceived the project and approved the artists; to senior editor Donald Dinwiddie, who patiently nudged the manuscript along; and to picture manager Julia Ruxton and copy-editor Jessica Spencer. In New York, I am grateful to Janet Adams Strong for distilling the chronologies and to Catherine Ruello for help with four thorny cases. Last and most certainly not least, I express my gratitude to my co-author, Annabel Howard, for agreeing to participate in this slightly mad and altogether fascinating undertaking.

Mark Getlein

The Authors

Mark Getlein is the author of *Living with* Art, a best-selling introduction to art now in its 10th edition. As a writer and development editor, he helped to create several ground-breaking textbooks in art and literature, among them *Art History* and *A History of Art in Africa*.

Annabel Howard has a degree in art history from Christ Church, Oxford, and a Masters in Biographical writing from the University of East Anglia. She has taught and lectured in museums throughout the United Kingdom and Italy, and has contributed articles to magazines including *Glass*, the *Spectator*, and the *White Review*.